Gauguin to Moore

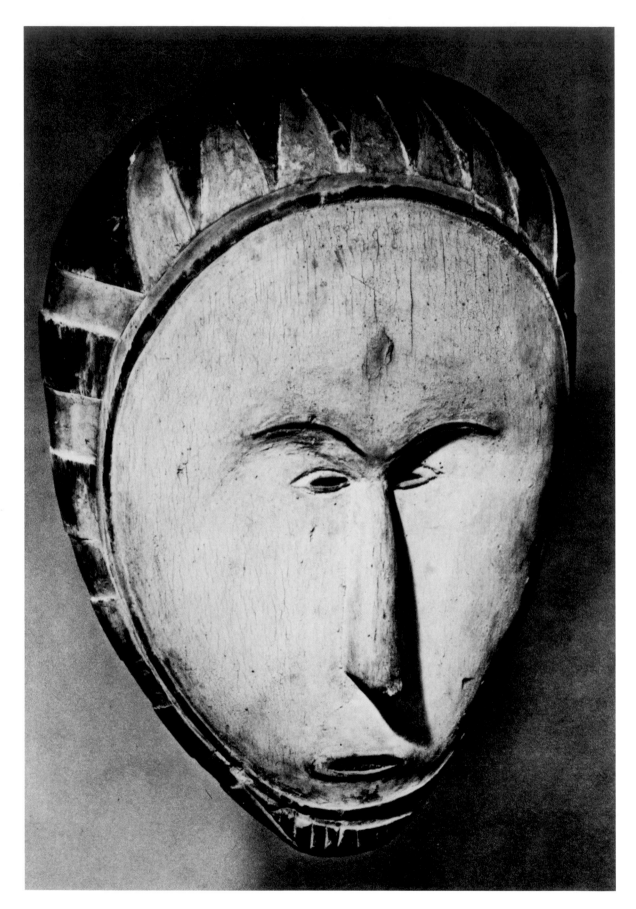

Fang (Gabon)
Dance Mask
Wood, whitened with kaolin: H. 48.0 cm
Ex-collection André Derain

GAUGUIN TO MOORE

Primitivism in Modern Sculpture

Alan G. Wilkinson

November 7, 1981 – January 3, 1982

Art Gallery of Ontario
Musée des beaux-arts de l'Ontario
Toronto/Canada

The exhibition is made possible by
a grant from Mobil Oil Canada, Ltd.

Copyright © 1981 Art Gallery of Ontario
ISBN: 0-919876-76-5

Canadian Cataloguing in Publication Data

Wilkinson, Alan G.
 Gauguin to Moore

Catalogue of an exhibition held at the Art Gallery
of Ontario, Nov. 7, 1981 - Jan. 3, 1982.

ISBN 0-919876-76-5

1. Sculpture, Modern - 20th century - Exhibitions.
2. Primitivism in art - Exhibitions. I. Art Gallery
of Ontario. II. Title.

NB198.5.P7W55 735'.23'0740113541 C81-094970-9

The Art Gallery of Ontario is funded
by the Province of Ontario, the
Ministry of Culture and Recreation,
the Municipality of Metropolitan
Toronto, and the Government of
Canada through the National
Museums Corporation and the Can-
ada Council.

Graphic Design:
Michael van Elsen Design Inc.
Typesetting: Trigraph
Colour Separations: Graphic Litho
Printing: Ashton Potter Ltd.
Binding: Hunter Rose
Typeset in Plantin Typeface and
printed on Warren's Cameo Dull
paper.

On the cover:
top left, No. 12 Paul Gauguin,
 Hina and Te Fatou 1892
top right, No. 57 Constantin Brancusi,
 The Kiss c. 1912
bottom, No. 124 Henry Moore,
 Reclining Woman 1930

Photo Credits

All photography by Larry Ostrom,
Photographic Services, Art Gallery
of Ontario, with the following
exceptions:
Victor Honoré, Quimperlé, fig. 1;
Wadsworth Atheneum, Hartford,
fig. 3; British Museum, fig. 5; The
Museum of Decorative Art,
Copenhagen, fig. 48; Museum of
Mankind, London, figs. 52, 68;
Field Museum of Natural History,
Chicago, fig. 88; Alan G.
Wilkinson, figs. 54, 98, 113; West
Park Studios, London, fig. 93;
Denise Varda, Ottawa, fig. 18; The
Baltimore Museum of Art, Nos.
44, 65; Henning Rogge,
Brücke-Museum, Nos. 89, 90, 91;
Museum of Fine Arts, Boston,
No. 105, fig. 27; Greenberg-May
Prod. Inc., Albright-Knox Art
Gallery, No. 16, fig. 81; The Art
Institute of Chicago, Nos. 13, 19,
21, 25, 26, 60, 98, 107, figs. 34, 86;
Cincinnati Art Museum, No. 27;
The Cleveland Museum of Art,
Nos. 18, 33; Scottish National
Gallery of Modern Art, No. 104;
J.F. Willumsens Museum, No. 9,
fig. 4; Allen Newbourn, The
Museum of Fine Arts, Houston,
No. 110; The Tate Gallery, Nos.
81, 114, figs. 55, 64, 65, 99, 101;
The Minneapolis Institute of Arts,
No. 75; Yale University Art
Gallery, No. 84, fig. 58; The
Museum of Modern Art, New
York, Nos. 5, 20, 29, 62, 70, 77,
95, 97, 106, figs. 28, 35;
Robert E. Mates, The Solomon R.
Guggenheim Museum, No. 99;
The Chrysler Museum, No. 48,
fig. 7; National Gallery of Canada,
Nos. 3, 6, 22, 23, 87, 124;

Service de Documentation
Photographique de la Réunion des
Musées Nationaux, Paris, Nos. 11,
15, 31, 32, 34, 35, 36, 38, 39, 40,
45, 47, 53, 54, 59, 80, 85, 113, 115,
figs. 21, 33, p. 15 left; Musée
Picasso, Paris, fig. 37; Musée
Matisse, Nice, fig. 45;
Philadelphia Museum of Art, No.
57, figs. 22, 31; The Art Museum,
Princeton University, Nos. 4, 37;
The St. Louis Art Museum, No.
86; Hirshhorn Museum and
Sculpture Garden, Smithsonian
Institution, Nos. 14, 50, 61, 72,
102, 126; National Gallery of Art,
Washington, Nos. 2, 17, 68;
Thomas Colville Inc. Fine Art,
New Haven, No. 7; Stephen
Hahn, Inc., New York
(Eeva-Inkeri), No. 43; Latner
Family Collection, Toronto, No.
67; Galerie Louise Leiris, Paris,
No. 116; Marlborough Fine Arts
(London) Ltd., No. 93;
Marlborough Gallery, New
York, Nos. 94, 96; Hickey and
Robertson, Menil Foundation
Collection, Houston, No. 109; The
Henry Moore Foundation, Much
Hadham, England, Nos. 117, 118,
119, 127, 128, 129, figs. 87, 90, 94,
108, 114, 115, 116, p. 15 right;
Anthony d'Offay Gallery, London,
Nos. 73, 74, 76, 78, 82, 83; Perls
Galleries, New York, Nos. 66, 69;
The Robert Gore Rifkind
Foundation, Beverly Hills, No.
88; Mr. & Mrs. B.J. Sampson,
No. 93; Photographic Section,
Anglo-American Corp. S.A. Ltd.,
No. 10.

In memory of
Sir Philip Hendy
1900 – 1980

Lenders to the Exhibition

Baltimore
The Baltimore Museum of Art:
Nos. 44, 65

Berlin
Brücke-Museum: Nos. 89, 90, 91

Boston
Museum of Fine Arts: No. 105

Buffalo
Albright-Knox Art Gallery: No. 16

Chicago
The Art Institute of Chicago:
Nos. 13, 19, 21, 25, 26, 60, 98

Cincinnati
Cincinnati Art Museum: No. 27

Cleveland
The Cleveland Museum of Art:
Nos. 18, 33

Edinburgh
Scottish National Gallery
of Modern Art: No. 104

Frederikssund, Denmark
J.F. Willumsens Museum: No. 9

Houston
The Museum of Fine Arts: No. 110

London
The Tate Gallery: Nos. 81, 114

Minneapolis
The Minneapolis Institute of Arts:
No. 75

New Haven
Yale University Art Gallery: No. 84

New York
The Museum of Modern Art: Nos.
5, 20, 29, 62, 70, 77, 95, 97, 106

The Solomon R. Guggenheim
Museum: No. 99

Norfolk
The Chrysler Museum: No. 48

Ottawa
National Gallery of Canada: Nos. 3,
6, 22, 23, 87, 124

Paris
Musée national d'art moderne–
Centre Georges Pompidou: Nos.
59, 80, 85, 113, 115

Musée d'Orsay/Galerie
du Jeu de Paume: Nos. 11, 15

Musée Picasso: Nos. 45, 47, 53, 54

Musée Rodin: Nos. 31, 32, 34, 35,
36, 38, 39, 40

Philadelphia
Philadelphia Museum of Art:
No. 57

Princeton
The Art Museum, Princeton
University: No. 37

St. Louis
The St. Louis Art Museum: No. 86

Toronto
Art Gallery of Ontario: Nos. 12, 28,
30, 46, 52, 55, 63, 64, 71, 103, 108,
120, 121, 122, 123, 125, 130, 131, 132,
134, 135, 136, 137

Washington
Hirshhorn Museum and Sculpture
Garden, Smithsonian Institution:
Nos. 14, 50, 61, 72, 102, 126

National Gallery of Art: Nos. 2,
17, 68

Bruce A. Beal: No. 96

Thomas Colville Inc. Fine Art,
New Haven: No. 7

Stephen Hahn, Inc., New York:
No. 43

Mr. Gustav Kahnweiler: No. 133

Latner Family Collection, Toronto:
Nos. 1, 56, 67

Galerie Louise Leiris, Paris: No. 116

Marlborough Fine Arts (London) Ltd.:
Nos. 51, 58, 112

Marlborough Gallery, New York:
No. 94

Menil Foundation Collection,
Houston: No. 109

The Henry Moore Foundation,
Much Hadham, England: Nos. 117,
118, 119, 127, 129

Anthony d'Offay Gallery, London:
Nos. 73, 74, 76, 78, 79, 82, 83

The Henry and Rose Pearlman
Foundation, Inc.: No. 4

Perls Galleries, New York: Nos. 66, 69

Mr. Perry T. Rathbone: No. 42

The Milton D. Ratner Family
Collection: Nos. 100, 101, 107

The Robert Gore Rifkind Foundation,
Beverly Hills: No. 88

Mr. & Mrs. B.J. Sampson: No. 93

Mrs. Bertram Smith: No. 41

Anonymous Lenders: Nos. 8, 10, 24,
49, 92, 111, 128

Contents

Foreword

The primitive artist, wrote Henry Moore, "shows an instinctive understanding of his material, its right use and possibilities." The sculptors featured in the exhibition, *Gauguin to Moore: Primitivism in Modern Sculpture*, found a source of creative energy in the elemental works of exotic and primitive art. They took that inspiration, and with it fashioned a new legacy of sculpture for modern times.

We are proud to join with the Art Gallery of Ontario to bring this unprecedented exhibition before the Canadian public. It is an exhibition that demonstrates that artists do not work in isolation; that their sculpture is the outcome of a complex interplay of social and cultural forces and of far-ranging non-European sources: Egyptian, Sumerian, Oceanic, and African art. We are offered the opportunity to compare and contrast; to see first-hand the powerful influence of primitive sculpture on modern sculptors.

Mobil Oil Canada believes that business, like the arts, cannot flourish in isolation and, to be successful, must recognize the forces that shape society. Our sponsorship of this exhibition reflects that belief.

D.G. LITTLE,
President and General Manager,
Mobil Oil Canada, Ltd.

Preface

When in the late 1960s discussions began with Henry Moore about the possibility of building The Henry Moore Sculpture Centre as part of the new extension to the Art Gallery of Ontario, Mr. Moore expressed the hope that his gift of his original plasters, bronzes, drawings, and prints from his own collection would not simply be a static display of his own work. He hoped it would act as a catalyst to interest the public in the art of sculpture of all periods perhaps focusing on the work of his contemporaries Picasso, Brancusi, Epstein, Lipchitz, Arp, Giacometti, and Hepworth. Since the opening of the Moore Centre in the autumn of 1974, the Curator of the Centre, Dr. Alan G. Wilkinson, had three major objectives: through acquisitions and gifts to make The Moore Collection more representative of all periods of Moore's activities as a sculptor and draughtsman during sixty years of intense creativity; to organize the first retrospective exhibition entitled *The Drawings of Henry Moore*, which the Gallery organized jointly with The Tate Gallery in 1977; and to publish a fully illustrated catalogue of the 126 Moore sculptures and seventy-three drawings in the collection of the Art Gallery of Ontario, which was published in 1979.

With these objectives achieved, Dr. Wilkinson, now Curator of Modern Sculpture, is in the present exhibition hoping to fulfil Henry Moore's wish that his gift would generate interest in the work of other masters of modern sculpture, some of whom influenced his own work. The period examined in this exhibition covers eighty-five years, from Gauguin's 1889 Brittany-period wood carvings to Moore's 1964 *Moon Head*. The exotic and primitive influences evident in many of the carvings and bronzes by the nineteen sculptors represented here show these works in the context of 20,000 years of world sculpture, from Paeleolithic fertility figures to African and Oceanic carvings dating for the most part from the nineteenth century. In their rejection of the Greek and Renaissance traditions, the artists in this exhibition sought inspiration from the rich and varied non-European cultures: Egyptian, Sumerian, Far Eastern, Oceanic, African, Pre-Columbian, and Peruvian; as well as from prehistoric, Cycladic and Archaic Greek sculpture. In so doing they followed an inscription Moore noted in a 1926 sketchbook: "Keep ever prominent the world tradition/the big view of Sculpture."

Dr. Alan G. Wilkinson's interest in this subject developed during his doctoral research at the Courtauld Institute of Art, University of London, on the drawings of Henry Moore. In researching the sources of Moore's work in the art of the past, and in particular trying to identify the many sketchbook drawings of Paeleolithic, Etruscan, Cycladic, Sumerian, prehistoric Greek, Egyptian, Peruvian, Pre-Columbian, Oceanic, and African art, he realized the importance of these periods and styles on Moore's development, and also their impact on other artists such as Gauguin, Picasso, Brancusi, Matisse, Modigliani, Epstein, Gaudier-Brzeska, and Giacometti.

The Art Gallery of Ontario has contributed fifteen sculptures, eight drawings and prints, and the superb Steichen photogravure of Matisse at work on *La Serpentine* to this exhibition – a representation indicative of one of the major strengths of our Permanent Collection. With the largest public collection of Moore's work housed here, it is not surprising that twelve carvings, original plasters, bronzes, prints, and drawings comprise an important contribution to the Moore section. But in addition, there are major works by Gauguin, Picasso, Matisse, Duchamp-Villon, and Giacometti from the collection.

Sculpture, particularly wood carvings, are perhaps the most vulnerable of all the major media of the fine arts – painting, drawings, watercolours and prints – to changes in temperature and humidity which inevitably occur in the movement of works from far and near. We are deeply grateful to those museums and private collectors who have agreed to lend wood carvings by Gauguin, Picasso, Gaudier-Brzeska, Schmidt-Rottluff, Kirchner, and Moore, from Ottawa and Toronto, Buffalo, New Haven, New York, Washington, Paris, Frederikssund (Denmark), Berlin, and Johannesburg. Without their generosity and trust, the initial impact of primitive art on the artists mentioned above (who, like the sculptors of Africa and Oceania, for the most part worked in wood) could not have been fully realized in this exhibition.

Although space does not allow us

to thank each individual lender, special mention should be made of the following: The Baltimore Museum of Art; the Brücke-Museum, Berlin; The Art Institute of Chicago; Scottish National Gallery of Modern Art; J.F. Willumsens Museum, Frederikssund, Denmark; The Museum of Modern Art, New York; The National Gallery of Canada, Ottawa; Musée national d'art moderne – Centre Georges Pompidou; Musée d'Orsay (Galerie du Jeu de Paume); Musée Picasso; Musée Rodin; Philadelphia Museum of Art; Hirshhorn Museum and Sculpture Garden, Smithsonian Institution; and the National Gallery of Art, Washington, D.C. We are also most grateful to: The Latner Family Collection, Toronto; Marlborough Fine Art (London) Ltd.; The Henry Moore Foundation; Anthony d'Offay Gallery, London; and The Milton D. Ratner Family Collection.

We would especially like to recognize and thank Mobil Oil Canada, Ltd. for the important part they have played as sponsor of this exhibition. Their contribution is an illustration of just how industry can and does play a key role in making exhibitions of this magnitude possible.

As Director I wish to thank Dr. Alan Wilkinson for his original concept as well as his dedicated scholarship. Both have been devoted without stint to the realization of this beautiful exhibition.

As with every exhibition a number of key works, such as Gauguin's great polychromed panel *Be in Love and You Will be Happy* (1889), Derain's stone *Crouching Figure* (1907), and a number of wood carvings by Brancusi, were requested but deemed too fragile to travel. Nevertheless, it is hoped that the eighty-seven sculptures and fifty related drawings, prints, and photographs will be representative of one of the most important and fascinating themes in the history of modern sculpture from Gauguin to Moore.

It is also hoped that this exhibition will focus attention on the Gallery's commitment to the art of sculpture. Earlier this year Dr. Wilkinson was responsible for another sculpture exhibition, *African Majesty: From Grassland and Forest*, The Barbara and Murray Frum Collection. In preparation is *The Klamer Family Collection of Inuit Art* scheduled for the fall of 1983. This emphasis in our program is, of course, directly related to the extraordinary donation of his own works to the Art Gallery of Ontario by Mr. Henry Moore in 1974.

WILLIAM J. WITHROW,
Director,
Art Gallery of Ontario

Acknowledgements

I wish to thank the following members of staff of the Art Gallery of Ontario for their efforts in assisting me with the many organizational details related to this exhibition: Dr. Roald Nasgaard, Chief Curator; Katharine Lochnan, Curator of Prints and Drawings; Mrs. Eva Robinson, Registrar, for her tireless efforts in arranging the insurance and shipment of the works of art to Toronto; Kathy Wladyka, Assistant Registrar; Parin Dahya, Clerk; Anne Lawrie, Loans Clerk; Cynthia Ross, Traffic Coordinator; Bob Soutar, Head of Shipping and Receiving; Barry Simpson, Manager of Exhibitions; Ches Taylor, Manager of Technical Services; Ed Zukowski, Conservator; John Ruseckas, Chief Preparator and his staff; Maia-Mari Sutnik, Coordinator of Photographic Services, and her assistant Faye Craig; Larry Ostrom, Head Photographer; Powey Chang, Photographer; Karen McKenzie, Head Librarian; Lawrence Pfaff, Reference Librarian; Randall Speller, Information Officer; Marie DunSeith, Development Manager; Alex MacDonald, Manager of Public Affairs; Gail Hutchison, Head of Communications; Jan Marsh, Manager of Marketing; Elizabeth Murray, Coordinator of Gallery Activities; Lynn Burgess, Manager of Membership Services; Joyce Turner, Coordinator of Volunteer Activity; Peter Gale, Senior Education Officer; David Wistow, Assistant Education Officer.

I owe a special debt of gratitude to my secretary Josephine Moore for typing the manuscript, loan forms, and much correspondence related to this exhibition. Denise Bukowski, Head of Publications, has given much of her time amid a busy schedule to edit the manuscript and coordinate the production of the catalogue. It has been a pleasure working with the designer Michael van Elsen, of Michael van Elsen Design Inc., whose professionalism is combined with a willingness to incorporate a number of suggestions by the author. Jim Chambers, former Head Photographer at the Art Gallery of Ontario, photographed a number of works for the catalogue. Madame Lucie Amyot has been invaluable in assisting the author with many aspects of the organization of the exhibition and catalogue. She has managed to track down a number of lesser-known works which, without her tenacious and thorough research, would not appear in this exhibition. She has also written all the biographies in the catalogue, and assisted in translating letters and quotations from French to English. In a number of cases her diplomatic powers of persuasion have convinced several reluctant collectors and museums to lend certain major sculptures for this exhibition. I am deeply grateful for her enthusiasm and dedication.

Needless to say, without the generosity of many museums, foundations, art dealers, and private collectors, this exhibition would not have been possible. I am particularly indebted to M. Dominique Bozo, Curator of the Musée Picasso (and recently appointed Director of the Musée national d'art moderne – Centre Georges Pompidou), who despite the demands of the major Picasso exhibitions in recent years agreed to lend two rare Picasso wood carvings of 1907, never before shown in North America, as well as the two important bronzes of 1932. Mrs. Lise Funder, Keeper, Ny Carsberg Glyptotek, Copenhagen, was most hospitable and helpful during my visit to Denmark in April.

My discussions with Mr. William Fagg and Miss Hermione Waterfield were extremely helpful in identifying works of primitive art related stylistically to sculptures in this exhibition. Dr. Harold Joachim, Curator of Prints and Drawings at The Art Institute of Chicago, generously agreed to lend four superb Gauguin woodcuts, as well as two drawings by Gauguin and Brancusi. His hospitality and help in tracking down other works of art related to this exhibition are greatly appreciated. I am indebted to Mr. and Mrs. Adrian Doull, who were instrumental in arranging the loan of one of Gauguin's greatest carvings from his first trip to Tahiti (No. 10). I am most grateful to Prof. Robert Welsh and Prof. Bogomila Welsh-Ovcharov for their generosity in sharing their research on Gauguin's 1880s Brittany period and for lending the rare photograph of the diningroom of Marie Henry's inn at Le Pouldu (fig. 1), where two of the Gauguin sculptures in this exhibition were part of the decorative scheme of the room, and are now re-united (Nos. 4 and 6). Miss Jacqueline Hunter, Chief Librarian at the National Gallery of Canada, and her staff were

most helpful and supportive. My thanks to Barbara and Murray Frum, whose superb collection of African art was exhibited at the Art Gallery of Ontario earlier this year, for their encouragement and for stimulating my interest in and knowledge of African sculpture. For their encouragement and hospitality at home and on trips abroad, I would like to thank most warmly Anna McCowan, Esmond Butler, Paddy Ann and Latham Burns, John and Helen O'Brian, John W. Rowley, Julia Brown, Dr. John Golding, and Dr. Christopher Green.

Henry Moore's generosity to the Art Gallery of Ontario needs no introduction. I would like to thank Mr. and Mrs. Moore for lending important works from their own collection and from The Henry Moore Foundation. As always, Mrs. Betty Tinsley, Henry Moore's secretary, Ann Garrould and David Mitchinson of The Henry Moore Foundation have been most helpful and supportive.

I know that Henry Moore joins me in dedicating this catalogue to our friend, the late Sir Philip Hendy, former Director of the National Gallery, London. His death last year deprived the art world of a distinguished art historian, and his friends and family of a much loved man.

ALAN G. WILKINSON,
Curator of Modern Sculpture,
Art Gallery of Ontario

Introduction

"Have before you always the Persians, the Cambodians, and a little of the Egyptian. The great error is the Greek, however beautiful it may be. . . . You will always find nourishing milk in the primitive arts, but I doubt if you will find it in the arts of ripe civilizations."[1]
– Paul Gauguin

"The world has been producing sculpture for at least some thirty thousand years. Through modern development of communication much of this we now know and the few sculptors of a hundred years or so of Greece no longer blot our eyes to the sculptural achievements of the rest of mankind."[2]
– Henry Moore

Gauguin and the generation of Picasso and Moore "discovered" the arts of Africa and Oceania, Mexico, and the Far East, in the sense that artists in the early quattrocento in Florence – Donatello, Ghiberti, and Masaccio – discovered, but in a slower and more gradual way, antique sculpture. In both cases it was not so much a discovery as a new perception of works of art that had long existed but had hitherto been ignored – a new perception that radically altered the direction of European art during the early Renaissance, and again during the late nineteenth and early twentieth centuries.

The theme of this exhibition is the discovery of primitive art, as well as prehistoric, Egyptian, Sumerian, and Far Eastern art, and its influence on the work of European sculptors from Gauguin to Moore. Although the word "primitive" is used less and less in the titles of books and exhibitions devoted to the sculpture of Africa and Oceania, it is included in the title of this exhibition both because of brevity and because, for artists such as Gauguin, the term embraced not only, for example, the carvings and decorative designs of Polynesian art, but also the work of the early Renaissance; as well as the art of the Assyrians, Egyptians, and Japanese, which were outside the classical Greek tradition. For the Symbolists, the word "primitive" was a term of praise. For Moore, primitive art "is generally used to include the products of a great variety of races and periods in history, many different social and religious systems. In its widest sense it seems to cover most of those cultures which are outside European and the great Oriental civilisations."[3] As Robert Goldwater emphasized in his pioneering study, *Primitivism in Modern Art* (1937, revised edition 1967), "the art of the so-called primitive peoples is not itself 'primitive,' i.e., neither technically crude, nor aesthetically unsubtle."[4]

Although Gauguin was the first European artist whose work incorporated motifs based on primitive art, beginning with his Peruvian inspired ceramics of the mid 1880s, he was by no means the first to appreciate the aesthetic qualities of non-European art. As early as 1520 Albrecht Dürer recorded in his diary his admiration for the beautiful objects that Cortés sent from Central America to the Spanish emperor Charles V. Even earlier, in 1504 – 05, the Portuguese collected and brought back to Europe ivories from the Guinea Coast. In the second half of the eighteenth century, Oceanic art that Captain Cook brought back from his voyages to the South Seas entered Montague House, London (later to form part of the British Museum). But it was not until the nineteenth century, with the colonization by European powers of much of Africa and Oceania, that ethnographic studies began in earnest. This period saw the foundation of ethnological museums and departments in London, Oxford, Cambridge, Paris, Tervuren, Basel, Berlin, Leipzig, Dresden, Hamburg, Stockholm, Oslo, Copenhagen, and Rome.

As Goldwater has pointed out, "the consideration of the aesthetic values of primitive art comes late in the development of museums of ethnology. It comes, indeed, not only considerably after the beginning of such an appreciation on the part of artists and private collectors . . . not until some time after the ethnologists themselves had begun to revise their low opinion of primitive art."[5] The scholarly, scientific interest was gradually augmented by an aesthetic appreciation. "Thus the original purely documentary presentation of the objects and their unconsidered mixture with other, purely scientific ethnological evidence, typical of the end of the nineteenth century, was increasingly in the twentieth century no longer considered adequate to their special artistic character."[6]

In this introduction it would be

redundant to reiterate in detail the complex background material and related subjects that have been thoroughly explored in Goldwater's *Primitivism in Modern Art* and in the exhibition catalogue, *World Cultures and Modern Art* (Munich, Haus der Kunst, 1972). In the former, the chapters of particular relevance are: "The Accessibility of the Material"; "The Evaluation of the Art of Primitive Peoples"; "Gauguin and the School of Pont-Aven"; "The Brücke"; "The Direct Influence of Primitive Sculpture"; and especially, "Primitivism in Modern Sculpture". The Munich catalogue deals with, as the sub-title states, "The encounter of 19th and 20th century European art and music with Asia, Africa, Oceania, Afro- and Indo-America," and includes a number of scholarly articles of particular relevance to the more specialized theme of the present exhibition. This author has relied heavily on the above publication as well as numerous books and detailed articles on the artist represented here.

For the most part, the sculptures selected for this exhibition reflect either direct borrowings from specific works of primitive art, or at least close similarities to well known styles. An example of the former is Moore's 1953 *Mother and Child* (No. 131), clearly based on the complex motif on a Peruvian pot (fig. 107). The second type of influence is of a more general nature, such as Modigliani's elongated *Head of a Woman* of about 1910 (No. 68), in which he adopted the elegant, refined forms of Baule dance masks from the Ivory

Coast (fig. 50). But it is not known if Modigliani owned a Baule mask or where he might have seen examples.

The present author disagrees with Goldwater's statement in his chapter "Primitivism in Modern Sculpture" that "direct formal adaptations have been few, and, except perhaps for Brancusi himself, very little modern sculpture even recalls the general proportions and rhythms of any specific primitive tribal style."[7] As the notes and comparative illustrations in this catalogue try to show, it is not only possible to compare many of the sculptures in the exhibition to specific styles of African, Pre-Columbian, Peruvian, Egyptian, Sumerian, and Javanese art, but in some instances one is able to identify direct borrowings from works that the artists either owned or had seen in collections, books or museums. For example, Gauguin's adaptations from the two photographs he owned of the Javanese Temple of Borobudur (figs. 15 and 24) are well known, as is his incorporation of a Marquesan war club (fig. 8) in his carving, *Wood Cylinder with Christ on the Cross* of 1891–92 (No. 10). The notched band below the two deities in *Hina and Te Fatou* of 1892 (No. 12) was, as Christopher Gray has convincingly shown, based on a Marquesan *Fan Handle* (fig. 12). Picasso's *Head of a Woman* of 1932 (No. 54) is almost certainly related to the Baga *Dance Mask* (fig. 37) that occupied the entrance hall of his Chateau de Boisgeloup. Brancusi's *The First Cry* of 1917 (No. 58) has been compared to the gouged-out features of an *Ancestral Figure* from the Upper

Niger (fig. 43). Epstein's *Tomb of Oscar Wilde* of 1912 (see No. 74) was inspired by an Assyrian *Colossal Human-Head Bull* in the British Museum (fig. 54). Gaudier-Brzeska's *Hieratic Head of Ezra Pound* of 1914 (fig. 62) was based on colossal Easter Island heads (fig. 63). Giacometti's wood *Disagreeable Object* of 1931, which appears in his lithograph *Objects mobiles et muets* of the same year (No. 103) was obviously based on a bird figure from Easter Island (fig. 76). Two of the best known adaptations in modern sculpture are Moore's 1929 stone *Reclining Figure* (fig. 93), and the National Gallery of Canada's 1930 *Reclining Woman* (No. 124), both inspired by the eleventh-to twelfth-century AD Toltec-Maya *Chacmool* (fig. 95). And as William Fagg pointed out to the author, Moore's 1964 *Moon Head* (No. 137) derives from the Mama *Mask of a Buffalo* in the Nigerian Museum (fig. 117).

Rodin's 1907–08 bronze portrait studies of the Japanese actress Hanako (Nos. 31–34), and his stunning 1906 watercolours of Cambodian dancers (Nos. 38–40) do not reflect non-European stylistic influences in the sense that Picasso's work imitated the forms of African masks; they reflect rather Rodin's fascination with the exoticism of the Far East: the extraordinary dramatic facial expressions peculiar to Japanese theatre and the oriental dance movements of the Cambodians. His was a continuation of the European artists' interest in exotic, foreign subjects, as exemplified in the first half of the nineteenth

century in the work of Ingres and Delacroix. It is often forgotten that Rodin greatly admired and collected the arts of India, China, and Japan, even though the style of his own work was not influenced by non-European sources.

The fifty drawings, prints and photographs included in this exhibition have been chosen for a number of reasons. Some of the drawings are preparatory studies for sculptures that were not available for this exhibition. Others are directly related to the theme of the show, such as the Gauguin drawing, which includes a sketch of a Marquesan car ornament (No. 19). In some cases the drawings are studies for or after carvings shown here. Few examples better illustrate Epstein's obsession with primitive art than his *Totem* drawings of c.1913 (No. 78), a transformation of relief carvings in priests' dwellings in the village of Kani Kambole (fig. 57). Some of the beautiful Gauguin woodcuts were based on completed sculptures (Nos. 13, 25, and 26); others depict the lush, tropical landscapes of Tahiti (No. 20). As a group, particularly the Polynesian subjects, they lend an air of the exotic and the mysterious (Nos. 22 and 23).

Although this is primarily a sculpture exhibition, all the sculptors included were also draughtsmen, and their drawings often provide information about their interest in primitive art before the ideas were realized in sculpture. For example, the first visual evidence of Moore's awareness

Paul Gauguin
First Study for Parau Nave Varua Ino
Pencil: 22.2 × 21.4 cm
Musée du Louvre, Cabinet des Dessins

Henry Moore
Page from Sketchbook for Relief on the Underground Building 1928
Pencil: 22.9 × 18.1 cm
The Henry Moore Foundation

of the *Chacmool* (fig. 95) appears in a sketchbook page from the early 1920s (fig. 94), five or six years before the influence of the Pre-Columbian sculpture erupts in the Leeds *Reclining Figure* of 1929 (fig. 93). Some of the artists – Gauguin, Picasso, Matisse, Modigliani, Schmidt-Rottluff, Kirchner, and Ernst – are far better known as painters than sculptors. It is hoped that this exhibition, particularly in the case of Gauguin and Modigliani, will emphasize the importance of sculpture in their total *oeuvre*. If the influence of primitivism in the broadest sense of the term is the major theme that unites the works discussed in the catalogue notes, a secondary theme is the often close stylistic ties among the works themselves: for example between Gauguin's 1892 *Hina and Te Fatou* (No. 12) and Brancusi's 1912 *The Kiss* (No. 57); between Modigliani's 1910 *Head of a Woman* (No. 68) and Lipchitz's 1913 *Mother and Child* (No. 93); and between Giacometti's *Woman with Her Throat Cut* of 1932 (No. 104) and Moore's *Four-Piece Composition* of 1934 (No. 126).

Any study of primitivism in modern sculpture must inevitably begin with the work of Gauguin. Not only was he the first European artist to assimilate and incorporate the forms of primitive art in his work, but in his romantic escapism to the South Seas and his rejection of European values and society he was the first artist to embrace a genuinely primitive life. Although for example both Picasso and Moore were probably vaguely aware of the magical and religious function of African masks and the Mexican rain spirit, their interest in primitive art was centred on its formal qualities. Gauguin, on the other hand, was fascinated by ancient Maori religion (see No. 12), delving into the cultural and religious traditions of Oceania as well as borrowing both figurative and decorative motifs from Marquesan art and many other sources. The Tahiti he first visited in 1891 was for the most part a paradise lost, where the French colonial authorities and missionaries had undermined traditional values and religion. Although he identified himself with the savage (*oviri*), he remained a European whose perception of the setting, its people, and their ancient lost religion was more imagined than real. But it was his example, both in his life and art, that profoundly influenced the generation of Picasso and Brancusi, Kirchner and Nolde.

In 1904-05 Maurice Vlaminck happened upon several African carvings in a bistro and was later given a number of sculptures by a friend of his father. One of these he sold to Derain (see frontispiece). By 1906 Picasso had met Matisse and Derain, both of whom were familiar with African art, but it was not until a visit to the Palais de Trocadéro in May or June 1907 that he felt the full impact of African sculpture, which led him in early July to repaint the heads of the two figures at right in *Les Demoiselles d'Avignon* (fig. 28). Four of Picasso's little known 1907 primitivistic wood carvings shown here (Nos. 45, 46, 47, and 49) reflect both the influence of Gauguin and Picasso's discoveries of primitive art in Paris. During the following six or seven years, in Paris and London, Brancusi, Modigliani, Lipchitz, Epstein and Gaudier-Brzeska became familiar with primitive art; its influence on their work is discussed in the catalogue notes.

In 1905, within a year of Vlaminck's discovery of African art, Kirchner saw the painted bas-relief house beams from the Palou Islands (Micronesia) in the Ethnographic Museum, Dresden. But it was not until the summer of 1910, which Kirchner spent with Heckel and Pechstein, that the impact of primitive art was manifest in their art. The Brücke artists are the true heirs of Gauguin, for as Manfred Schneckenburger has written, "the enthusiasm of the Brücke painters for 'primitive' art is bound up with their enthusiasm for the 'primitive' life."[8]

As indicated by the 1929 Surrealist map of the world (published in *Variétées*), the interest in primitive art during the 1920s had shifted from Africa to the Pacific Islands. New Guinea and Easter Island are shown on the same scale as Africa. As André Breton wrote: "the development of Surrealism at the outset is inseparable from the power to seduce and to fascinate that Oceanic art possessed in our eyes."[9] The more fantastic and erotic imagery of Oceanic art was ideally suited to the concerns of the Surrealists, and is reflected in a number of Giacometti's sculptures of the late 1920s and early 1930s (see Nos. 101, 103, 106, and 197).

Although the influence of primitive art on Moore's work is most

pronounced in the 1920s and 1930s, there are in the 1950s and 1960s isolated examples (Nos. 131–37) that clearly reflect his continuing interest, particularly in African and Peruvian art.

In 1920 Roger Fry wrote in an article on "Negro Sculpture" that appeared in *Vision and Design* (1920):

> What a comfortable mental furniture the generalizations of a century ago must have afforded! What a right little, tight little, round little world it was when Greece was the only source of culture, when Greek art, even in Roman copies, was the only indisputable art, except for some Renaissance repetitions.[10]

The influence of rich and varied world traditions radically altered the course of Western sculpture in the late nineteenth and twentieth centuries. Equally important, through the artist's admiration for primitive art, we have come to appreciate the sculpture of Africa, Oceania, Mexico, and Peru on equal terms with the art of the West. Like the allusions to earlier literature in T.S. Eliot's poem "The Waste Land," the process is a two-way, imaginative affair. While Moore's *Reclining Woman* of 1930 (No. 124) strongly echoes the Pre-Columbian *Chacmool* carving (fig. 95), a visitor to the Museo Nacional de Antropologia in Mexico City will be reminded of the Moore sculpture.

The patronizing attitude of nineteenth-century ethnologists toward primitive art has been shattered forever. We now see the works in this exhibition as a very recent addition to what Moore called "the world tradition" of sculpture, from prehistoric fertility figures to African and Oceanic carvings of the nineteenth century – exotic and primitive traditions to which the artists of the last hundred years owed so much.

1. Robert Goldwater, *Primitivism in Modern Art* (New York: Vintage Books, 1967), p. 66.

2. Henry Moore, *Henry Moore on Sculpture*, edited with an introduction by Philip James (London: Macdonald, 1966), p. 57.

3. *Ibid*, p. 155.

4. Goldwater, p. *xvii*.

5. *Ibid*, p. 11.

6. *Ibid*, p. 15.

7. *Ibid*, p. 246.

8. *World Cultures and Modern Art* (Munich: Haus der Kunst, 1972), p. 268.

9. Dawn Ades, *Dada and Surrealism Reviewed* (Arts Council of Great Britain, 1978), pp. 463–4.

10. Roger Fry, *Vision and Design* (Harmondsworth, Middlesex: Penguin Books, 1961), p. 85.

Paul Gauguin 1848–1903

French painter, sculptor, printmaker, and ceramist Paul Gauguin was born in Paris, the son of a French journalist and a mother of half Peruvian-Spanish extraction. In 1849 the family emigrated to Lima, Peru; his father died on the voyage, but Paul lived in Peru with his mother and sister until 1855, when they returned to France. He studied in Orléans and in Paris and between 1865 and 1871 he served in the merchant marine and the French navy. Back in Paris in 1871, on the recommendation of his guardian, Gustave Arosa, he entered the brokerage firm of Bertin, where he met Emile Schuffenecker and started to draw and paint. In 1873 he married Mette-Sophie Gad, of Copenhagen; they had five children. He met Pissarro and other Impressionists probably through Arosa (to whom Pissarro had been recommended in 1874) and collected their works. In the summer of 1879 he went to Pontoise to paint with Pissarro; Cézanne joined them in the summer of 1881.

Gauguin first exhibited at the *Salon* of 1876, and contributed to the last five Impressionist exhibitions (1879–86). He learned the rudiments of sculpture from Paul Bouillot, his landlord. His first attempts were of classical inspiration: a bust of his wife, Mette, modelled by him in 1877 but carved in marble by Bouillot, then a bust of his son Emile; both were exhibited in the *Impressionist Exhibition* of 1880. In 1881 he exhibited two sculptures in wood: *La Petite Parisienne* and the relief *The Singer*; they mark his debut as a wood carver and a break with the conventionality of his earlier work. Wood remained the preferred material for the rest of his career.

In 1883 Gauguin abandoned the world of finance to devote all his time to his art. Later that year he moved to Rouen with his family and in 1884–85 to Denmark, where he had his first one-man exhibition in 1885 at the Society of the Friends of Art, Copenhagen; the exhibition was closed after five days. He returned to Paris with his son Clovis, leaving the rest of his family in Denmark.

In the late spring he met the French ceramist Ernest Chaplet, then left for Brittany, where he lived in Pont-Aven until mid-November; upon his return to Paris he worked on his first ceramic sculpture in the *atelier* of Chaplet. He travelled to Panama and Martinique with Charles Laval in 1887. During the winter of 1887–88 his artistic activity was largely limited to ceramics produced in collaboration with Chaplet. From February to October he worked mostly in Pont-Aven, where, as he wrote to Shuffenecker, "I find the savage, the primitive." From October to December he joined Vincent van Gogh at Arles. In the fall of 1888 he had his first one-man exhibition in Paris at the Boussod and Valadon gallery. He spent most of 1889 and part of 1890 in Brittany, at Pont-Aven and Le Pouldu, where he carved the *Bust of Meyer de Haan*. In 1889 he also produced eleven lithographs on zinc, exhibited at the *Volpini Exhibition* at the Café des Arts at the Universal Exposition in Paris. In 1890 he sent only wood and ceramic sculptures to the exhibition of *Les XX* in Brussels.

In April 1891, after a successful auction of his paintings, Gauguin left for Tahiti. There he carved, among other works, *Hina and Te Fatou*. From August 1893 to February 1895, back in France, he worked in a new medium: he made a series of woodcuts of Tahitian subjects. In Tahiti in 1895 he continued to paint, carve, and do some woodcuts. In 1901 he moved to the Marquesas Islands, where he died on May 8, 1903, in Atuona on the island of Hiva-Oa (Dominique).

1.
Paul Gauguin
Barrel 1889
Wood with iron stays and traces of
colouring: L. 37 cm
Latner Family Collection

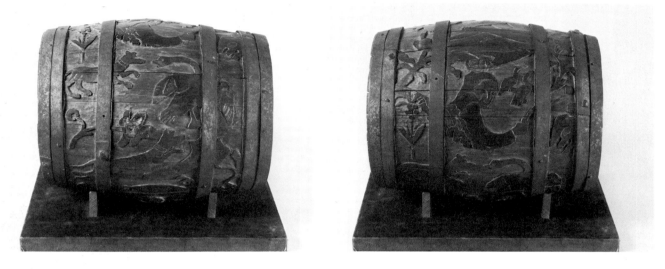

In his use of varied materials and media, Gauguin was undoubtedly the most versatile artist of the Impressionist and Post-Impressionist generation. In addition to his painting and drawing, he explored many materials in his sculpture – marble, clay, wood, stoneware, *coco de mer* (No. 16) – and carved utilitarian items, such as wooden shoes from Brittany and this barrel. In 1893 an anonymous author wrote:

> He made use of wood, clay, paper, canvas, walls, anything on which to record his ideas and the result of his observations. I still remember a cask on the staves of which he carved a series of fantastic animals that seemed to dance.[1]

This passage may possibly be a reference to the barrel shown here, in which the dog attacking the goose and the rooster with one leg raised do suggest a sort of dance.

Stylistically, the barrel is one of the earliest examples in Gauguin's work in which he combines disparate motifs; in this case on one side of the barrel an exotic nude, related to Martiniquan subjects, and on the other a Breton peasant woman. The goose, rooster, and birds are also related to Breton subjects. The uniqueness of Gauguin's imagery in this work and later paintings and sculpture lies not only in the fact that he borrowed freely from many sources – Egyptian, Javanese, and Oceanic art and Breton stone calvary sculpture – but also that he sometimes united unrelated motifs in a single work. For example, in the magnificent wood *Cylinder with Christ on the Cross* (No. 10), made during his first trip to Tahiti, the figure of Christ is surrounded by Polynesian motifs.

In this barrel the clothed Breton peasant woman is in marked contrast to the exotic seated nude on the other side. The closeness of the latter figure to the 1889 oil *Caribbean Woman*, painted on the door of Marie Henry's inn at Le Pouldu, and the fact that the barrel originally belonged to her strongly suggest that

Fig. 1
Photograph of the diningroom of the inn of Marie Henry, Le Pouldu (After the photograph of c. 1924 by Victor Honoré, Quimperlé.)
Collection B. and R. Welsh

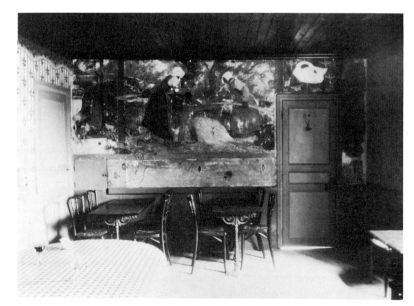

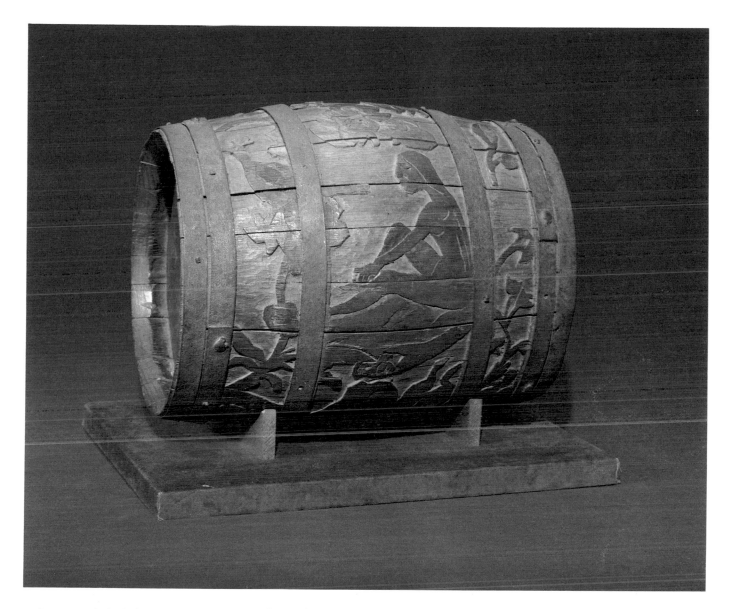

it was made in Brittany toward the end of 1889 or in early 1890. The goose motif below the peasant woman is the subject of Gauguin's painting above the door in the diningroom of Marie Henry's inn (fig. 1). The flowers and foliage that were later to play such an important decorative role in Gauguin's Tahitian carvings (see Nos. 12 and 17) also serve to relate this work to his painting from the autumn of 1889, such as *Breton Peasant Girl Spinning: Joan of Arc* (Museum of Fine Arts, Houston), which was also part of the decorative scheme of the inn at Le Pouldu.

During one of his two trips to the South Seas, Gauguin again used barrels as a point of departure for his sculpture, although unfortunately nothing remains but the recollections of a local inhabitant. As Christopher Gray points out, in the late 1930s Renée Hamon discovered the fate of a number of these Tahitian-period sculptures. Hamon recorded the memories of some of the surviving inhabitants who had known Gauguin. Gray writes:

Lenore, the guardian of the cemetery in Papeete, who had known him, stated that Gauguin carved everything, no matter what: trunks of trees, boxes of conserves, even the staves of wine barrels.[2]

1. John Rewald, *Post-Impressionism from van Gogh to Gauguin* (New York: The Museum of Modern Art, 1956), p. 300.

2. Christopher Gray, *Sculpture and Ceramics of Paul Gauguin* (New York: Hacker Art Books, 1980), p. 68.

2.
Paul Gauguin
A Pair of Wooden Shoes 1889
Polychromed wood: L. 32.7 cm
National Gallery of Art,
Chester Dale Collection 1962

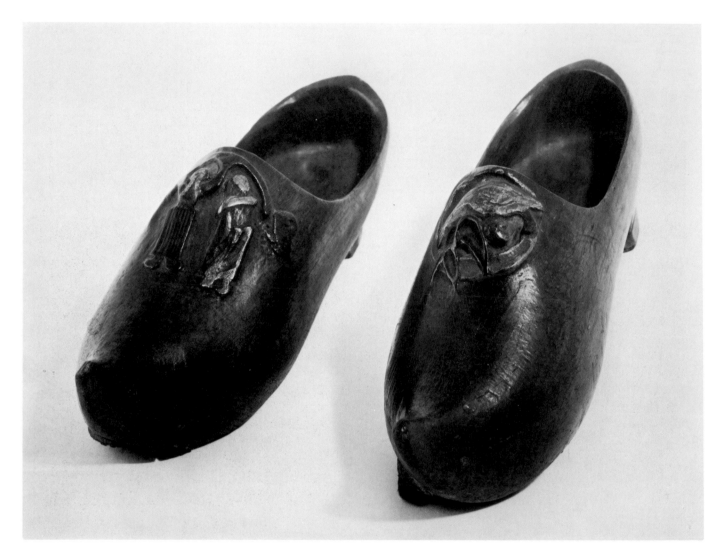

This is one of the three pairs of Breton *sabots* with carved and painted decorative motifs by Gauguin.[1] According to Charles Morice, the artist caused a sensation by wearing *sabots* in Paris.[2] Gray suggests that this pair belonged to Marie Henry and mentions a photograph of them taken in 1889 with the *Figure of a Martiniquan Negress* (No. 4). These were probably carved and polychromed in the autumn of that year. The left shoe is decorated with a goose, crescent, and fruit, common Brittany motifs found in many of Gauguin's paintings, sculptures, drawings, and ceramics from the Brittany years (see No. 1).

A goose was the subject on one of Gauguin's painted panels in the *salle* of Marie Henry's inn at Le Pouldu. On the right shoe, the figure with raised arms and pleated skirt is closely related to the stoneware *Vase Decorated with the Figure of a Breton Woman*, and may well have been based on earlier sketchbook drawings.

In the landscape and peasant life of Brittany Gauguin found something of the primitive rural setting for which he was searching and which later took him to the South Seas. In a letter to his friend Emile Schuffenecker he wrote:

I love Brittany. I find wildness and primitiveness there. When my wooden shoes ring on this granite, I hear the muffled, dull, powerful tone I seek in my painting.[3]

1. Christopher Gray, *Sculpture and Ceramics of Paul Gauguin* (New York: Hacker Art Books, 1980), cat. nos. 82 and 83.

2. *Ibid*, p. 200.

3. Robert Goldwater, *Paul Gauguin* (New York: Harry N. Abrams, Inc., 1957), p. 82.

3.
Paul Gauguin
Breton Women at a Gate 1889
Zincograph: 16.0 × 21.5 cm
Signed lower left: P. Gauguin
National Gallery of Canada, Ottawa

This work is from a set of eleven lithographic prints (made in January to February 1889 on zinc plates and therefore referred to as zincographs) made for the *Volpini Exhibition* held at the Café des Arts at the Universal Exposition in Paris in spring 1889. The seated woman behind the fence is wearing wooden *sabots* (see No. 2). In this charming scene, Gauguin has lovingly portrayed the Pont-Aven customs, the peasant women, and the unspoilt Brittany landscape that inspired many of his finest Impressionist and later his Symbolist paintings.

4.
Paul Gauguin
Figure of a Martiniquan Negress 1889
Terracotta painted green:
H. 19.7 cm
Lent by the Henry and Rose
Pearlman Foundation Inc.

Gauguin's first sculpture, the marble portrait of his wife, Mette, was carved in 1877. During the next ten years, his activities as a sculptor included a few figurative works in the round, such as the stained red wood *La Petite Parisienne* (Private Collection) exhibited at the sixth *Impressionist Exhibition* in 1881, as well as carved decorative panels for the 1881 *Cabinet* (Private Collection) and the 1884 *Wooden Box with Carved Reliefs of Ballet Dancers*.

Undoubtedly Gauguin's most important three-dimensional works from 1886 to 88 were his extraordinarily varied glazed and unglazed stoneware ceramics, many of which were directly inspired by Peruvian pottery. (Unfortunately, a number of the Peruvian-inspired ceramics requested for this exhibition were deemed too delicate to travel.) Gauguin's career as a ceramist is discussed in detail in Christopher Gray's *Sculpture and Ceramics of Paul Gauguin* (New York: Hacker Art Books, 1980), and in Merete

Bodelsen's *Gauguin's Ceramics: A Study in the Development of his Art* (London: Faber and Faber, 1964).

The three carved and printed wood panels of Martinique subjects and this terracotta study mark the beginning of a period when Gauguin devoted more time to his sculpture, culminating in the great 1889 wood relief *Be In Love and You Will Be Happy* in the Museum of Fine Arts, Boston (fig. 27) and in the National Gallery of Canada's *Bust of Meyer de Haan* from the same year (No. 6). Although Gauguin continued to make ceramics in the late 1880s and in the 1890s, including the terracotta *Vase in Burnt Clay with Reliefs of Tahitian Gods* (fig. 14) and the stoneware *Oviri* (fig. 23), the ceramics are far outnumbered by his wood carvings. This may in part be explained by the lack of facilities for firing ceramics in rural Brittany and in Tahiti.

Gauguin's trip to Panama and Martinique from April to November 1887 was his first experience of an

exotic tropical paradise. In addition to his Martinique landscapes and figure studies executed *in situ*, after his return to France he made two lithographs (see No. 5), the stoneware *Pot in the Shape of the Head of a Martiniquan Woman* and the following wood panels, all based on Martiniquan subjects: *Martinique*, an oak carved and painted panel in the Ny Carlsberg Glyptotek, Copenhagen; *The Locusts and the Ants*, whose whereabouts is unknown (fig. 2); and *Martinique Women*, whereabouts also unknown. This little terracotta figure is the only known Martinique-inspired sculpture in the round.

The scant documentary evidence makes it difficult to date precisely

Fig. 2
Paul Gauguin
The Locusts and the Ants c. 1889
Wood
Whereabouts unknown

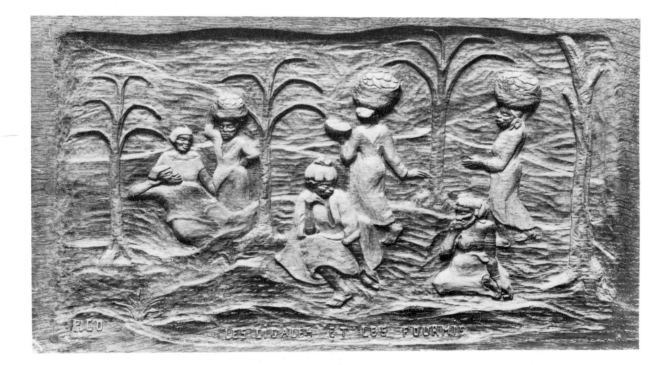

Gauguin's sculpture of the late 1880s. This author's conversations with professors Robert Welsh and Bogomila Welsh-Ovcharov have been most helpful in establishing a general chronology for Gauguin's pre-Tahitian sculpture. Welsh-Ovcharov's excellent chronology of Gauguin's activities in the 1880s, published in her recent exhibition catalogue, *Vincent van Gogh and the Birth of Cloisonism* (Toronto: Art Gallery of Ontario, 1981, pp. 168– 171), is a reliable and indispensable account of this period.

Figure of a Martiniquan Negress and the oak *Bust of Meyer de Haan* (No. 6) were part of the decorative scheme, including sculpture, paintings, and graphics, in the *salle* of Marie Henry's inn in Le Pouldu, Brittany.[1] Charles Chassé's 1921 *Gauguin et Le Groupe de Pont-Aven* provides an invaluable account, ultimately based on Marie Henry's memory, of the works in the decorative scheme at the inn.

On the mantelpiece on the wall opposite the windows facing the street, Chassé wrote that there was:

> in the centre, the important bust of Meyer de Haan [No. 6], larger than life, sculpted and painted by Gauguin from a massive oak block. . . . On each side of the bust

were gray pots illustrated with small, amusing, rustic motifs. On little shelves fixed to the wall, on each side of the mantelpiece, the painted plaster negress [No. 4] and the Javanese statuette.[2]

The latter work was a fragment of a dancer from the Javanese Pavilion at the 1889 Paris Universal Exposition.

Chassé mentioned among the sculptures done at Le Pouldu in 1889 several wood bas-reliefs of Martiniquan negresses made from a lithograph on yellow paper.[3] This may be a reference to the wood *The Locusts and the Ants* (fig. 2), perhaps based on the lithograph of the same title (No. 5). The little terracotta figure is, in fact, related in a general way to the seated woman in the right foreground of the lithograph. In his lithographs of January to March 1889, which were shown at the *Volpini Exhibition* in the spring of that year, and in his bas-reliefs, Gauguin used Marquesan subjects derived from his 1887 visit to the tropics. This terracotta was probably made at Le Pouldu in the autumn of 1889.

The youthful body may represent one of the polarities of youth and old age; age is the subject of another sculpture from this period, *Standing Figure of an Old Woman* (No. 7). The

vertical position of the hand, also found in the original version of *Luxure*, may echo Indian or Javanese sculpture, which was to profoundly influence Gauguin's Tahitian paintings and sculpture. (See, for example, the raised hands in *Hina and Te Fatou* [No. 12].)

This sculpture, as do a number of his ceramics, appears in a painting, the 1890 *Roses and Statuette* in the Musée des Beaux-Arts, Reims. *Figure of a Martiniquan Negress* was one of four Gauguin sculptures in this exhibition owned by Marie Henry (see also Nos. 1, 2, and 6).

1. Professor Robert Welsh has provided the information about the sculpture in Marie Henry's *salle*.

2. Charles Chassé, *Gauguin et Le Groupe de Pont-Aven* (Paris: H. Floury, 1921), pp. 47–48 (translated by A.G.W.).

3. *Ibid*, p. 40.

5.
Paul Gauguin
*The Locusts and the Ants: Souvenirs of
Martinique* 1889
Zincograph: 21.8 × 26.2 cm
The Museum of Modern Art, New
York. Lillie P. Bliss Collection

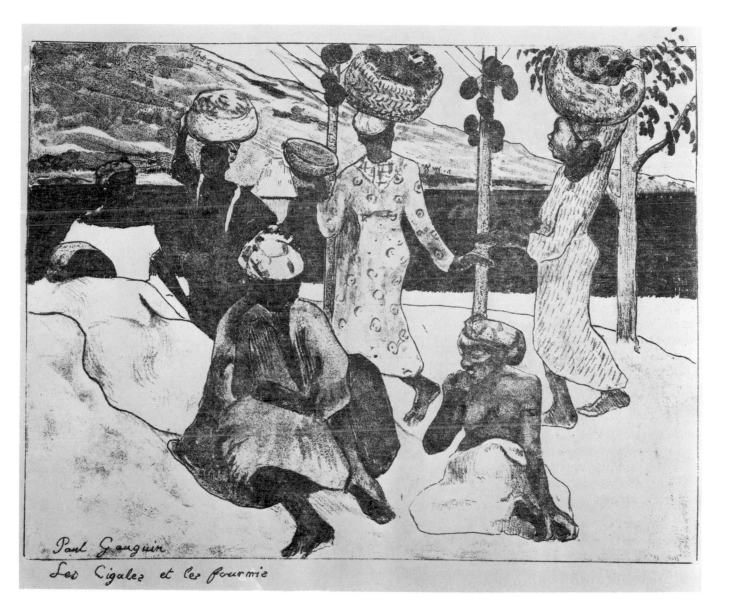

Paul Gauguin
Les Cigales et les fourmie

This evocative souvenir of Gauguin's first trip to the tropics in 1887 is based on La Fontaine's tale, "The Ant and the Grasshopper." In the foreground the three idle figures, the grasshoppers, sleep, sit, and eat, while the figures in the middle distance, the ants, busily go about their daily chores. The pose of the seated figure just right of centre, obviously an older woman, and the armband below her left shoulder appear again in the terracotta *Figure of a Martiniquan Negress* of 1889 (No. 4). Gauguin also made a carved relief on the theme of *The Locusts and the Ants* (fig. 2) that is closely related to this zincograph.

6.
Paul Gauguin
Bust of Meyer de Haan 1889
Polychromed oak: H. 58.4 cm
National Gallery of Canada, Ottawa

This rugged, powerful portrait of the Dutch painter, Jacob Meyer de Haan (1852–1895), which formed part of the decorative scheme of the diningroom of Marie Henry's inn at Le Pouldu, is undoubtedly Gauguin's most important fully three-dimensional work from his Brittany period. Charles Chassé described its place in this room: "On the same mantelpiece, in the centre, the important bust of Meyer de Haan, larger than life, sculpted and painted by Gauguin from a massive block of oak."[1] It is reunited in this exhibition with the terracotta *Figure of a Martiniquan Negress* (No. 4), which was situated on a small shelf to one side of the fireplace. On a shelf on the other side was a fragment of a dancer, which had fallen off the

Javanese pavilion at the 1889 Paris Universal Exposition.

The Dutch painter arrived in Paris in 1888, and soon after moved in with Theo van Gogh. He spent the month of August 1889 at Le Pouldu with Gauguin, and from October through December resided with Gauguin and paid for his expenses at Marie Henry's inn at Le Pouldu. Bogomila Welsh-Ovcharov chronicles:

> Gauguin reports to Schuffenecker and Bernard that "his student" de Haan is making excellent progress. Towards mid-November Gauguin writes Vincent that he and de Haan have a large *atelier* and inexpensive lodgings on the coast of Brittany and that de Haan now

works in "our manner," but without losing his own personality or his love of Rembrandt and the Dutch masters.[2]

De Haan's fresco (transferred to canvas) *Labo(r): Breton Women Scutching Flax*, from the autumn of 1889, was the largest work on the adjacent wall to the right of the fireplace in the diningroom of Marie Henry's inn (fig. 1). This bust of de Haan was, according to Robert Welsh, executed at Le Pouldu between October and December 1889.[3]

Compared to the oil and turpentine on silk *Nirvana: Portrait of Meyer de Haan* of 1889 (1890?) in the Wadsworth Atheneum, Hartford (fig. 3), the facial features of the deformed Dutch painter in the Ottawa carving are less problematic. In the former, the slanted eyes and Oriental appearance of the face have led to comparisons with the fox motif that appears in *Be In Love and You Will Be Happy* (fig. 27) and in *Luxure* (No. 9) and which we know Gauguin thought of as "an Indian symbol of perversity." As Bogomila Welsh-Ovcharov has written of the Wadsworth portrait, "With this interpretation Meyer de Haan is seen as governed by wily thoughts and lewd designs and the title *Nirvana* is logically seen as intended perversely in the manner Gauguin admitted to with *Be in Love*" (fig. 27).[4] In the *Bust of Meyer de Haan*, with the eyes almost closed and the chin resting on his hand, he is depicted in an intensely contemplative mood, in keeping with the Jewish painter's interest in music, literature, and Jewish and Oriental philosophies.

In contrast to the solemnity of de Haan, deep in thought, the hen or rooster sitting on his head, looking down as if to share his thoughts, adds a touch of humour both by its presence and by the obvious pun on the Dutchman's name, which means "the rooster." It is tempting to

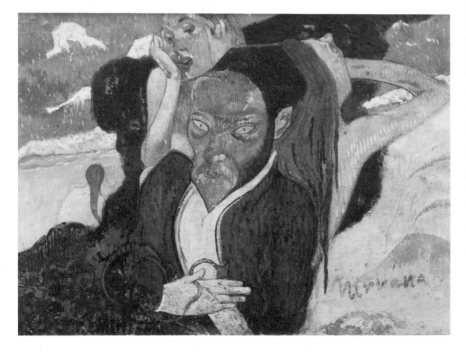

Fig. 3
Paul Gauguin
Nirvana: Portrait of Meyer de Haan 1889 (1890?)
Oil and turpentine on silk:
20.0 × 29.0 cm
Wadsworth Atheneum, Hartford; Ella Gattlup Sumner and Mary Gatlin Sumner Collection; Courtesy Wadsworth Atheneum, Hartford

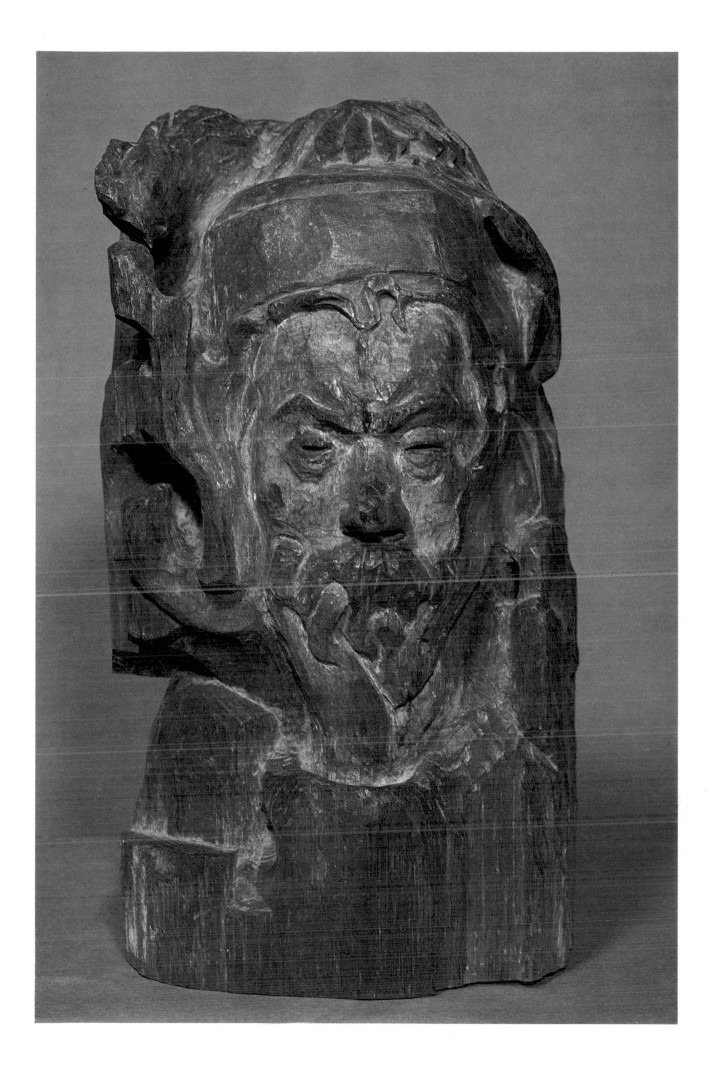

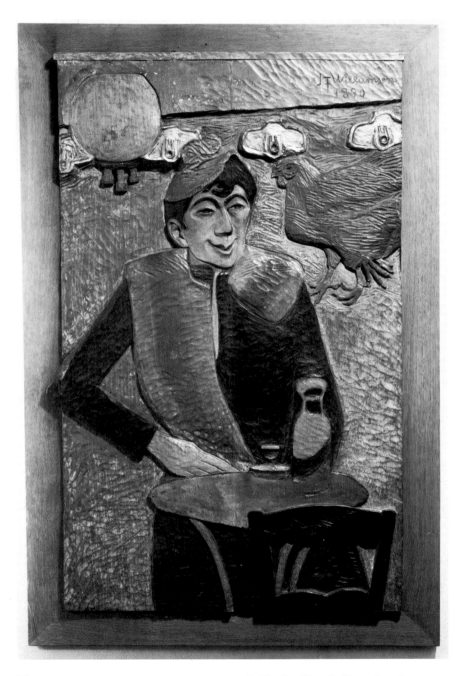

speculate that the Danish painter J.F. Willumsen, who met Gauguin in Brittany in the summer of 1890, had seen the *Bust of Meyer de Haan* and alluded to the hen in his own 1890 carved and painted panel, *Prostitute Awaiting Her Prey in "Montagnes russes"* (fig. 4).

This portrait, as well as the *Barrel* (No. 1) and *A Pair of Wooden Shoes* (No. 2), were originally owned by the innkeeper Marie Henry. All three, like many of Gauguin's wood carvings from Brittany and Tahiti, were painted. Both his frequent use of colour and his preference for relief sculpture suggest, as Christopher Gray has remarked, that in his carving "he sought to enrich his fundamental conception of painting. Even in sculpture, he tended to think in terms of line and colour rather than abstract formal elements."[5] Almost certainly his use of colour was to influence Picasso's painted, primitivistic wood sculptures of 1907 (Nos. 46, 47, 49).

Fig. 4
J.F. Willumsen
Prostitute Awaiting Her Prey in "Montagnes russes" 1890
Wood relief painted, gilded, and silvered: 133.0 × 60.0 cm
J.F. Willumsens Museum, Frederikssund, Denmark

1. Charles Chassé, *Gauguin et Le Groupe de Pont-Aven* (Paris: H. Floury, 1921), pp. 47–48 (translated by A.G.W.).

2. Bogomila Welsh-Ovcharov, *Vincent van Gogh and the Birth of Cloisonism* (Toronto: Art Gallery of Ontario, 1981), p. 349.

3. Professor Robert Welsh's research on the decorative scheme of the inn will be published in a forthcoming article.

4. Welsh-Ovcharov, *Vincent van Gogh*, p. 222.

5. Christopher Gray, *Sculpture and Ceramics of Paul Gauguin* (New York: Hacker Art Books, 1980), p. 48.

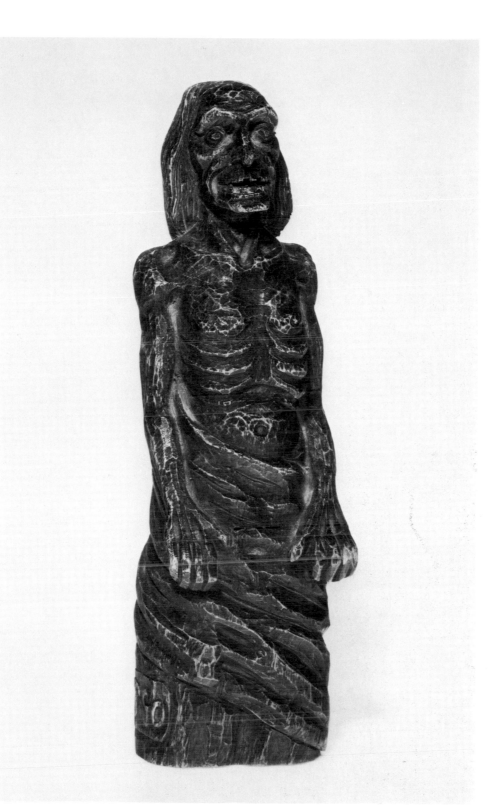

7.
Paul Gauguin
Standing Figure of an Old Woman
1889
Wood (oak?) stained green:
H. 29.25 cm
Signed lower left: PGO
Thomas Colville Inc., Fine Art,
New Haven, Connecticut

Very little is known or has been written about this powerful and disturbing sculpture. Gray states that according to J.B. de la Faille, Gauguin gave the carving to his friend Emile Schuffenecker.[1] Although the lack of documentary evidence and closely related works makes exact dating very difficult, it was probably done in Brittany in

1889–90. Both in subject matter and in the carving technique, particularly of the arms, the sculpture is similar to the old woman at centre right of Gauguin's *Be in Love and You Will Be Happy* (fig. 27), which dates from the autumn of 1889.

There is some doubt as to whether this figure represents an old man or an old woman. In this author's

opinion, the face and long hair, as well as Gauguin's sexual preoccupations and his interest in the polarities of youth and old age and life and death, suggest here an image of a crone. Perhaps the beautiful, youthful *Figure of a Martiniquan Negress* (No. 4) and this wrinkled, toothless old hag were conceived as polarities, symbolizing youth and old age. With Rodin's 1885 bronze *She Who Was Once the Helmet Maker's Beautiful Wife*, this carving is one of the most devastating representations of aging in modern sculpture. But unlike Rodin's bronze, in which the helmet maker's wife, absorbed in herself and resigned to her fate, looks down at her withered body, this figure stands erect with her hands clenched at her side and confronts us with a look of defiance. The diagonal folds of drapery around the lower half of the body echo the prominent rib cage, which appears to be almost without flesh. It is possible that this work was in part inspired by the Easter island carvings (fig. 5) known as *Moai Kavakava* (emaciated men), which Gauguin may have seen at the 1889 Paris Universal Exposition.

1. Christopher Gray, *Sculpture and Ceramics of Paul Gauguin* (New York: Hacker Art Books, 1980), p. 196.

Fig. 5
Easter Island (Polynesia)
Standing Figure in the Form of a Man
H. 47.0 cm
British Museum

8.
Paul Gauguin
Les Ondines 1889
Oak, blackened and tinted green:
16.5 × 56.5 cm
Private Collection (New York)

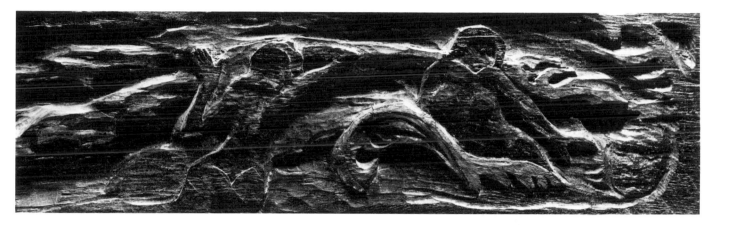

Of all Gauguin's Brittany period carvings in this exhibition, *Les Ondines* is, both in style and subject matter, the one most closely related to his paintings and prints of the period. The figure on the left facing the bank of waves is the subject of the 1889 oil *Undine: In the Waves* in the Cleveland Museum of Art, and is almost identical to the figure at right in *Aux Roches noires* (fig. 6), used as the frontispiece for the catalogue of the *Volpini Exhibition* in spring 1889. In fact, the figure facing the waves in the carving is so close to the one on the frontispiece as to suggest that the carving figure may have been based directly on the frontispiece figure. Like other sculptures of 1889, such as *Figure of a Martiniquan Negress* (No. 4) and *Standing Figure of an Old Woman* (No. 7), this carving was stained green and was probably made in Brittany in autumn 1889.

Both the truncated figure at left and the wave motif are almost certainly indebted to Japanese prints. The symbolism of the woman in the wave has been given quite different interpretations. For Wayne Andersen, she represents a fallen Eve about to commit suicide:

> courting death rather than truth, maturing to the stage of Contemplative Anguish before proceeding along a fixed route to the moment of Abandonment, at which point she throws herself with a cry into overwhelming waters.[1]

Writing of the painting *Undine: In the Waves*, Bogomila Welsh-Ovcharov points out that:

> the title *Undine*, which Gauguin himself gave this painting as early as the 1891 Drouot sale, refers not

to a fallen mortal, but to a sea nymph who remains soulless only so long as she hasn't married a mortal and borne him a child.[2]

This author argues convincingly that the figure in the painting and in the catalogue illustration is a metaphor for procreation:

> Her iconography is hence in keeping with the Western Venus of the Sea iconography, and her spiritualized intercourse with the waves of the sea is no less evocative of ritualized love-making for being viewed voyeuristically from behind.[3]

The woman facing the waves is the central and major figure in Gauguin's 1890 linden wood carved and painted relief *Be Mysterious* in the Musée d'Orsay, Paris.

In the frontispiece illustration for

the *Volpini Exhibition* catalogue (fig. 6) Gauguin includes, beside the woman facing the waves, the seated figure of Eve; in this carving, the second figure is a half-length female nude with her back to the high bank woman on the right is returning from the sea after ritualistic love-making and recoils from the brooding head.

Compared to the carefully worked, highly finished surfaces of the *Be In Love* and *Be Mysterious* carvings, the dimensional works in their own right. With some justification, it may be claimed that Gauguin was one of the finest relief sculptors since the Renaissance masters, Pisano, Ghiberti, and Donatello.

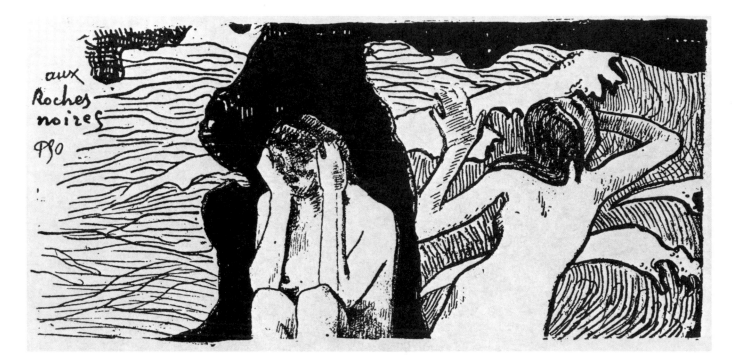

of waves behind her. She appears to be riding the crest of a smaller wave as she recoils from the mask-like face at the lower right, which possibly represents a personification of the sea or some celestial body. Single, isolated heads appear in a number of relief panels of the late 1880s and early 1890s such as *Martinique*; in another carving in the Ny Carlsberg Glyptotek, *Eve and the Serpent*; and in the two great carvings *Be In Love and You Will Be Happy* (fig. 27) and *Be Mysterious*. To pursue Welsh-Ovcharov's interpretation of the procreation metaphor, perhaps the handling here is rough and crude, which gives this relief, like the Ottawa *Bust of Meyer de Haan* (No. 6), a primitive power. It would be difficult to overestimate the importance of relief carving in Gauguin's sculptural *oeuvre*. With the exception of the *Bust of Meyer de Haan* (No. 6), his finest pre-Tahitian wood sculptures are carved and painted reliefs. And it is obvious from the Tahitian carvings in this exhibition (Nos. 10, 12, 14, and 15) that he continued to find relief sculpture an ideal means both of translating his pictorial ideas and of creating three-

Fig. 6
Paul Gauguin
Aux Roches noires
Frontispiece of the *Volpini Exhibition* catalogue, 1889

1. Bogomila Welsh-Ovcharov, *Vincent van Gogh and the Birth of Cloisonism* (Toronto: Art Gallery of Ontario, 1981), p. 205.

2. *Ibid*, p. 205.

3. *Ibid*, p. 205.

9.
Paul Gauguin
Luxure 1890–91
Oak, painted with touches of gilding:
H. 70.5 cm
Signed to right of fox's head: PGO
J.F. Willumsens Museum,
Frederikssund, Denmark

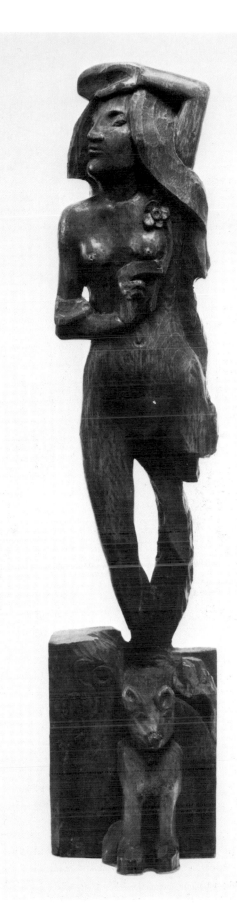

In the autumn of 1890 Gauguin wrote to Emile Bernard about the original clay or plaster version of *Luxure*:

> I am sending you a photo of my statue which I have unfortunately broken . . . it does not give in this condition what I was trying to achieve in the movement of the two legs.[1]

In this original and in the wood panel *Caribbean Woman* of 1889, painted on the door of the *salle* in Marie Henry's inn, the right hand is in a vertical position between the breasts, an attitude similar to the hand in the 1889 *Figure of a Martiniquan Negress* (No. 4). This hand position may well derive from Indian or Far Eastern art. We know that in the late 1880s Gauguin owned photographs of the reliefs of the Javanese temple of Borobudur (fig. 15) and that he was much interested in the Javanese pavilion at the 1889 Paris Universal Exposition. John Rewald[2] has suggested that stylistically the painted panel *Caribbean Woman* may reflect the influence of the fragment from a frieze from the Javanese village; Gauguin had taken the fragment to Le Pouldu and placed it on a small shelf on one side of the *Bust of Meyer de Haan* (No. 6), with *Figure of a Martiniquan Negress* on the other. (See notes for No. 4). Charles Chassé describes this fragment as a dancer,[3] and given Gauguin's interest "in the movement of the two legs," this description certainly supports the view that the original clay or plaster *Luxure* may have been made in Brittany in the last six months of 1889.

The fact that Gauguin does not mention this wood version (now in the Willumsens Museum) in his August 1890 letter to Bernard suggests that he had not begun work on it at that time. While the basic pose of the oak carving follows the original fairly closely, several changes and additions have been made. In the carving the woman holds a flower in her right hand which, unlike the Eastern position of the right hand in the original, is here placed below the left breast. The photograph of the original ends a little below the truncated right knee; therefore it is

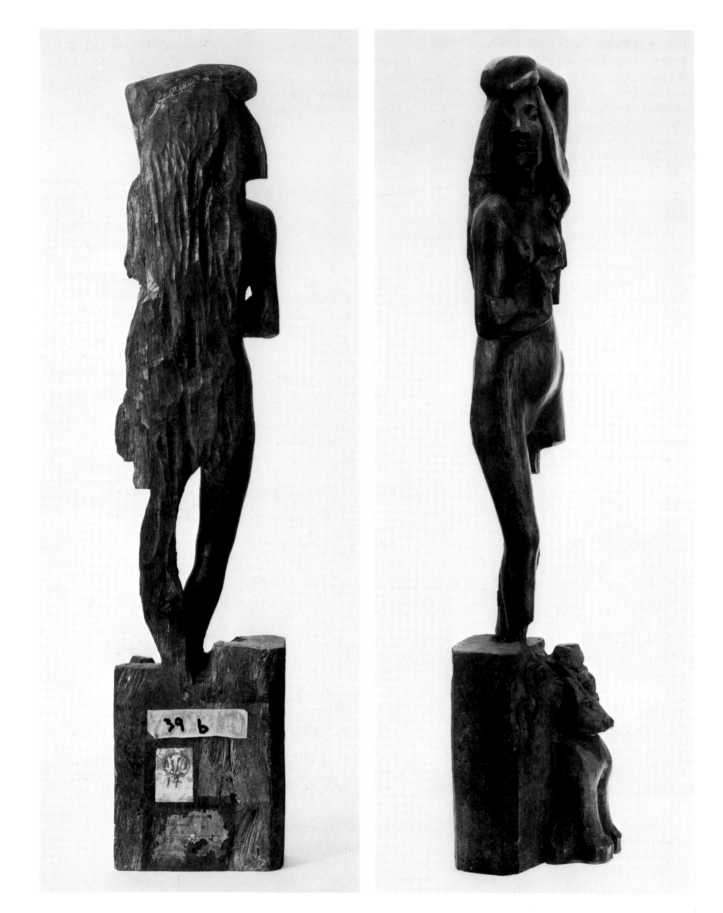

impossible to know if, before it was broken, the figure included the full lengths of the legs and the feet or if, like the wood carving, it grew out of a base. With Gauguin's interest in the movement of the legs, surely the sculpture was a full-length figure. In the carving in this exhibition, as the photograph of the back view clearly shows, the figure and base were carved from a single block of oak. The fox, however, was made separately and fixed to the base with a nail through the nose.

In discussing this sculpture with

Bogomila Welsh-Ovcharov, we were struck by the similarity of both the fox and flower motifs and the hair and facial features to the iconography of one of Gauguin's most important symbolist paintings, *The Loss of Virginity*, of the winter 1890–91 in the Chrysler Museum at Norfolk (fig. 7). In the earlier wood relief *Be In Love and You Will Be Happy* (fig. 27) from the autumn of 1889, Gauguin identified the significance of the fox as "an Indian symbol of perversity," and Gray suggests he may have identified with the image.[4] The position of the fox beneath the old woman in the Boston carving[5] appears again in *Luxure*. In *The Loss of Virginity*, the reclining nude holds a flower in her right hand. The fox sits on her chest and is held by her left arm. As Welsh-Ovcharov has pointed out, the model for the Chrysler oil was presumably the seamstress Juliette Huet, "who would bear Gauguin a daughter following his departure for Tahiti."[6]

While it is not easy to determine if he knew of this pregnancy, Welsh-Ovcharov concludes that "it is difficult not to believe that self-identification with the seducer-fox was by that time an association that came automatically."[7] A similar interpretation and date would seem plausible for *Luxure*.

Since most of the wood sculptures carved in Brittany were of oak, *Luxure* was probably done there or possibly back in Paris in late 1890 or early 1891. It is always possible that Gauguin transported materials to Paris and worked there at his carvings or completed sculptures begun in Brittany; but certainly many of his major wood sculptures of the period were executed in Pont-Aven or Le Pouldu.

Sometime in winter to spring of 1890–91, Gauguin exchanged *Luxure* for the Danish painter J.F. Willumsen's oil *Breton Woman Walking Towards the Spectator*, dated Pont-Aven 1890 and now in the Willum-sens Museum. The two artists had first met in Brittany in the summer of 1890 and they met again in Paris during the winter of 1890–91. In a letter to John Rewald, written in April 1949, Willumsen described a visit to Gauguin's barren studio near the Odeon:

> The only object I saw there was a small sculpture on the mantel-piece. It was done in wood and Gauguin had just finished it. It represented a woman in an exotic style; possibly it was a dream of Tahiti by which Gauguin was then haunted. He has left the legs unfinished. Gauguin called it *Lewdness*, maybe because the woman was inhaling the perfume of a flower. He gave it to me in exchange for one of my Brittany paintings.[8]

Fig. 7
Paul Gauguin
The Loss of Virginity (La Perte du pucelage) winter 1890–91
Oil on canvas: 90.0 × 130.0 cm
The Chrysler Museum, Norfolk, Virginia

1. Christopher Gray, *Sculpture and Ceramics of Paul Gauguin* (New York: Hacker Art Books, 1980), p. 208 (translated by A.G.W.).

2. John Rewald, *Post-Impressionism from van Gogh to Gauguin* (New York: The Museum of Modern Art, 1956), p. 286.

3. Charles Chassé, *Gauguin et Le Groupe de Pont-Aven* (Paris: H. Floury, 1921), p. 40.

4. Gray, *Sculpture and Ceramics*, p. 43.

5. See Bogomila Welsh-Ovcharov, *Vincent van Gogh and the Birth of Cloisonism* (Toronto: Art Gallery of Ontario, 1981), cat. nos. 56 and 59.

6. *Ibid*, p. 224.

7. *Ibid*, p. 224.

8. Rewald, *Post-Impressionism*, p. 467.

10.
Paul Gauguin
Wood Cylinder with Christ on the Cross
c. 1891–92
Toa wood: H. 50 cm
Signed on top: PGO
Anonymous Loan

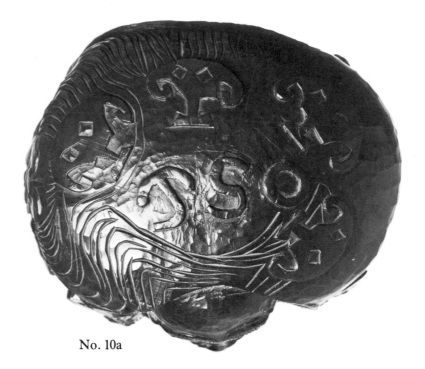

No. 10a

On his 1887 trip to Panama and Martinique, and during his many often-lengthy visits to Brittany from 1886 to 1890, Gauguin experienced something of the exotic, primitive life and the escape from European civilization that were soon to lead him, in his total rejection of bourgeois society, to the islands of the South Seas. About February 1891, two months before he left France for Tahiti, he wrote to his wife, Mette:

> The day may come (and perhaps soon) when I shall flee to the woods on an island in Oceania, to live there on ecstasy, on calm and on art. Surrounded by a new family, far from this European struggle for money. There in Tahiti I will be able, in the beautiful silence of the tropical nights, to hear the soft murmuring music of the movements of my heart in loving harmony with the mysterious beings of my surroundings. Free at last, without worries about money, and I will be able to love, to sing and to die.[1]

Gauguin sailed from Marseille for Tahiti in early April 1891, and arrived in Papeete, the colonial capital, in early June. Ironically, he found that the indigenous native art and religion, which he had hoped to study first-hand, had largely died out. According to his friend in Papeete, Jénot:

> He asked me if one would find in Tahiti figures sculpted in wood or stone and was astonished when I replied that to my knowledge nothing of the sort existed on the island or on the archipelago, that I had seen reproductions of the sculpted stones from the Easter Islands, but that these islands are a great distance from Tahiti. Likewise the sculpted figures from New Caledonia and New Zealand were unknown to the inhabitants of Papeete.[2]

Gauguin probably began working at his sculpture soon after his arrival in Tahiti. In his evocative description of his life in Tahiti in a manuscript called *Noa Noa*, he recounts setting out with a native friend to chop wood for his sculpture. Although he was plagued by illness and by problems with the local authorities, here we sense a kind of Rousseauesque oneness with nature and his identification with the savage, ritualistic chopping of the trees:

> We were walking both naked to the waist with axe in hand, crossing and recrossing the river . . . the deep silence, broken only by the murmur of the water on the rocks, monotonous as silence. And we were well, the two of us, two friends, he a youth and I nearly an old man in body and soul, worn out by the vices of civilization, and lost illusions . . . from all this youthfulness, from this perfect harmony with nature which surrounded us emanated a beauty, a perfume (*noa noa*) which enchanted my artist's soul.[3]

He goes on to describe the ferocity with which they attacked the trees:

> The two of us, savages, we attacked with our axes a magnificent tree which we had to destroy to obtain a branch that would please me. I struck with rage and with my hands covered in blood, I chopped finding pleasure in my satisfied brutality in the destruction of I know not what.[4]

While the dating of Gauguin's sculpture from his two trips to the South Seas (1891–93 and 1895–1903) is problematic – there is little known documentary evidence – one impor-

38

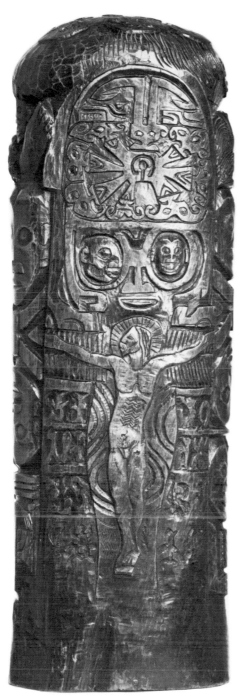

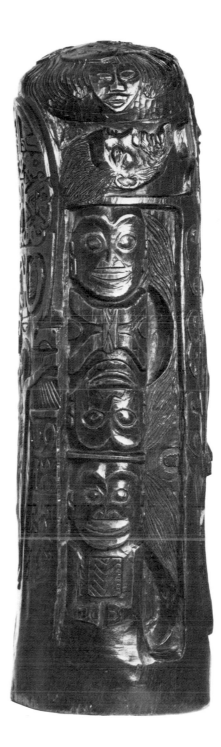

No. 10b No. 10c

tant event during his first visit did have a profound effect on the iconography of his work. This was the discovery, in late 1891 or early 1892, of ancient Tahitian legends as recounted in J.A. Moerenhout's *Voyages aux îles du Grand Océan* (1837), which the lawyer Auguste Goupil had lent to Gauguin. Ziva Amishai-Maisels has convincingly argued that two carvings, *Idol with Shell* (Musée d'Orsay, Galerie du Jeu

de Paume, Paris) and *Wood Cylinder with Christ on the Cross*, were made before Gauguin had read Moerenhout, and therefore date from the second half of 1891. Of the latter, Amishai-Maisels writes:

> The iconography of this statue is highly appropriate to the pre-Moerenhout period during which Gauguin, having no native myths to rely on, fell back on Christian

symbols, trying to translate them into native forms as he did in *Ia Orana Maria* of December 1891.[5]

The enormous impact of Moerenhout's book is discussed in conjunction with *Hina and Te Fatou* (No. 12).

This magnificent carved cylinder, with its personal symbolism and the fusion of a Christian subject with figurative and decorative motifs

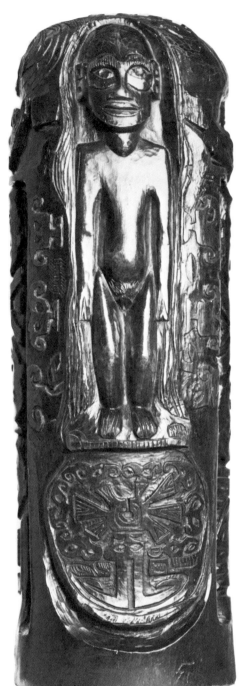

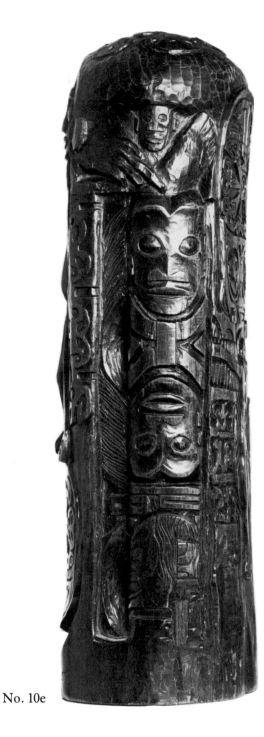

No. 10d No. 10e

based on Polynesian art, is Gauguin's greatest and most complex sculpture from his Tahitian and Marquesan periods. Above the figure of Christ and below the standing man on the other side of the carving are designs directly based on Marquesan ceremonial war clubs (fig. 8). The Easter Island script on each side of the cross was based on a photograph later found among Gauguin's effects.[6] On each side of the sculpture are a series

of heads that clearly derive from Marquesan *tikis* (fig. 9). Robert Goldwater describes the figure of Christ as having "Marquesan features, with bodily proportions and rendering derived from Easter Island statuettes."[7] (fig. 5). The way in which the standing male figure on the other side stands out in high relief is remarkably similar to a Marquesan figure on a carved trumpet (fig. 10). As Amishai-Maisels has

pointed out, the horizontal head near the top of the left side of the cylinder, directly above the *tiki*-like heads, and the hand and foot in the same area on the right side derive from Holbein's *Dead Christ* (Offentliche Kunstsammlung, Basel). This head was the subject of a wood engraving, *Tête d'homme couché*, which Gauguin sent to his friend Georges Daniel de Monfreid in the winter of 1896–97.

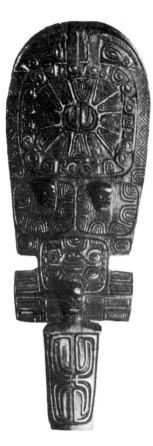

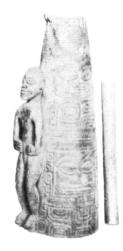

Fig. 8
Marquesas Islands (Polynesia)
War Club
Wood
(Photograph from Karl von den Steinen, *Die Marquesaner und ihre Kunst*; 3 vols., Berlin, 1925–28, reprinted 1969.)

Fig. 9
Marquesas Islands (Polynesia)
Oar Decorated with Two Tiki Figures
Wood
(Photograph from von den Steinen, *Die Marquesaner und ihre Kunst*)

Fig. 10
Marquesas Islands (Polynesia)
Wooden Trumpet
(Photograph from von den Steinen, *Die Marquesaner und ihre Kunst*)

Gauguin's interest in Christian iconography is reflected in three important paintings of 1889: *Christ in the Garden of Olives* (Norton Gallery and School of Fine Art, West Palm Beach, Florida); *The Yellow Christ* (Albright-Knox Gallery, Buffalo); and *The Breton Calvary: The Green Christ* (Musées Royaux des Beaux-Arts de Belgique). In *The Yellow Christ* and *The Green Christ* Gauguin had also used local sources: he based the first work on a polychrome wood crucifix in the Chapel at Trémalo and the second on the stone Breton Calvary at Nixon near Pont-Aven. In all three works, but particularly in *Christ in the Garden of Olives*, Gauguin identified his own troubled life with the sorrowing Christ. This would logically suggest that, in the wood cylinder, the artist may also have identified with both the figure of Christ on the cross and the head of the dead Christ near the top of the left side of the carving. For all his attachment to Oceanic art and to the ancient legends and exotic life of Tahiti, Gauguin may have intended the figure of Christ on the cross, surrounded by Polynesian figures and decorative schemes, to symbolize his own isolation, suffering, and eventual martyrdom in an alien culture.

1. Christopher Gray, *Sculpture and Ceramics of Paul Gauguin* (New York: Hacker Art Books, 1980), p. 53.

2. Ziva Amishai-Maisels, "Gauguin's Early Tahitian Idols," *The Art Bulletin*: 60, no. 2 (June 1978): 332.

3. Vojtech Jirat-Wasiutynski, *Paul Gauguin in the Context of Symbolism* (New York: Garland Publishing Company, 1978), p. 285 (translated by Lucie Amyot).

4. *Ibid*, p. 286 (translated by Lucie Amyot).

5. Amishai-Maisels, "Gauguin's Early Tahitian Idols": 337.

6. *Ibid*, p. 337, footnote 36.

7. Robert Goldwater, *Primitivism in Modern Art* (New York: Vintage Books, 1957), p. 70.

11.
Paul Gauguin
Gauguin's Cane c. 1891–92
Wood, figures heightened with gold:
H. 86 cm
Signed in red beneath carving at top:
PGO
Musée d'Orsay (Galerie du Jeu de Paume)

In addition to the wood carvings, reliefs, and terracotta in this exhibition, Gauguin's extraordinary versatility as a sculptor is well documented by the carved wooden shoes (No. 2), the barrel (No. 1), *Coco de Mer* (No. 16), and the two canes made in Polynesia. Christopher Gray states[1] that this cane was given by the artist to his friend Emile Schuffenecker on his return to France, where he remained from August 1893 to March 1895 before sailing again for Tahiti. The closeness of the two figures above the signature on the cane to similar Marquesan figurative motifs on the side of his 1891 ironwood carving, *Idol with a Shell*, inspired by Marquesan oar handles, suggests that he may have carved this cane sometime between his arrival in Tahiti, on June 1, 1891, and the end of the year.

There are records of at least six canes carved by Gauguin.[2] Photographs exist of only two other canes in addition to this one – No. 15 and *Cane Decorated with Polynesian Motifs* (Private Collection) are almost completely covered with figurative and decorative forms inspired by Polynesian art and mythology.

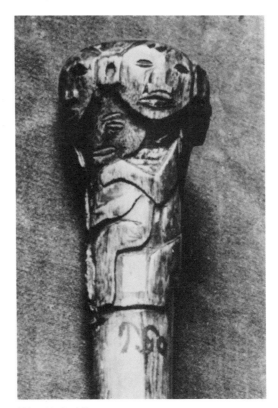

No. 11 detail.

1. Christopher Gray, *Sculpture and Ceramics of Paul Gauguin* (New York: Hacker Art Books, 1980), p. 235.

2. *Ibid*, p. 237.

42

12.
Paul Gauguin
Hina and Te Fatou 1892
Tamanu wood: H. 32.7 cm
Signed on top: PGO
Art Gallery of Ontario, Gift from the
Volunteer Committee Fund, 1980

J.A. Moerenhout's account of
ancient Oceanic religion in *Voyages
aux îles du Grand Océan* (Paris, 1837)
became for Gauguin a substitute for
the non-existent indigenous religious
traditions that he had hoped to find
when he first arrived in Tahiti in
June 1891. Although his earliest
carvings, such as the superb 1891
Wood Cylinder with Christ on the Cross
(No. 10), include figurative and
decorative motifs based on Mar-
quesan and Easter Island art, the
syncretic blending of primitive and
Christian iconography strongly
suggests that he was as yet unaware
of Tahitian mythology, which was
soon to influence profoundly the
subject matter of his paintings,
sculpture, and prints. The Art
Gallery of Ontario's beautiful tamanu
wood carving *Hina and Te Fatou*
must surely be one of the first
sculptures made after Gauguin had
read Moerenhout.

It is generally agreed that in late
1891 or early 1892 Gauguin read
Voyages aux îles du Grand Ocean,
which had been lent to him by the
lawyer Auguste Goupil. On the
evidence of a letter of March 25,
1892, to the painter Paul Serusier, he
was by that time enraptured by
native religion:

> What a religion, that ancient
> Oceanic religion. What a marvel!
> It makes my head spin and all that
> this suggests to me will certainly
> frighten them. If they fear my
> earlier works in a *salon*, what then
> will they say of the new ones.[1]

At the end of 1891 or in early 1892
Gauguin transcribed passages from
Moerenhout's book in his own
manuscript, *Ancien culte mahorie*
(fig. 11). One legend that held a
special fascination for him was the
dialogue between Hina, goddess of
the moon, and Te Fatou, god of the

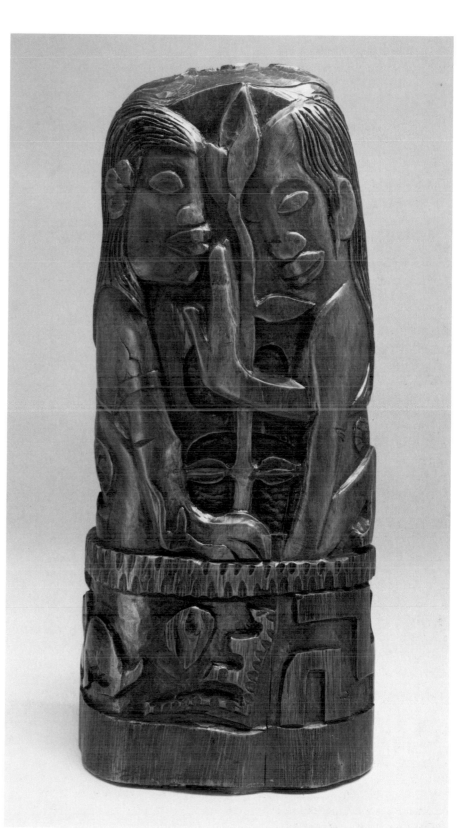

No. 12a

Fig. 11
Paul Gauguin
Page 13 of manuscript, *Ancien culte mahorie*
(Photographed from facsimile of *Ancien culte mahorie* published by La Palme, Paris, 1951.)

earth, concerning the eternity of matter, which appears on page 13 of *Ancien culte mahorie*. It reads:

Hina said to Fatou: Bring back to life or resuscitate man after death. Fatou replies: No, I will not bring him back to life. The earth will die; the vegetation will die; it will die as well as the men who are nourished by it; the earth which gives them life will die. The earth will die, the earth will end; it will end never to be reborn.
Hina replies: Do as you wish; as for me I will bring the moon back to life. And what Hina possessed continued to be; and what Fatou possessed perished and men had to die.[2]

Beneath this text, watercolour studies show the god and goddess

Opposite: No. 12b

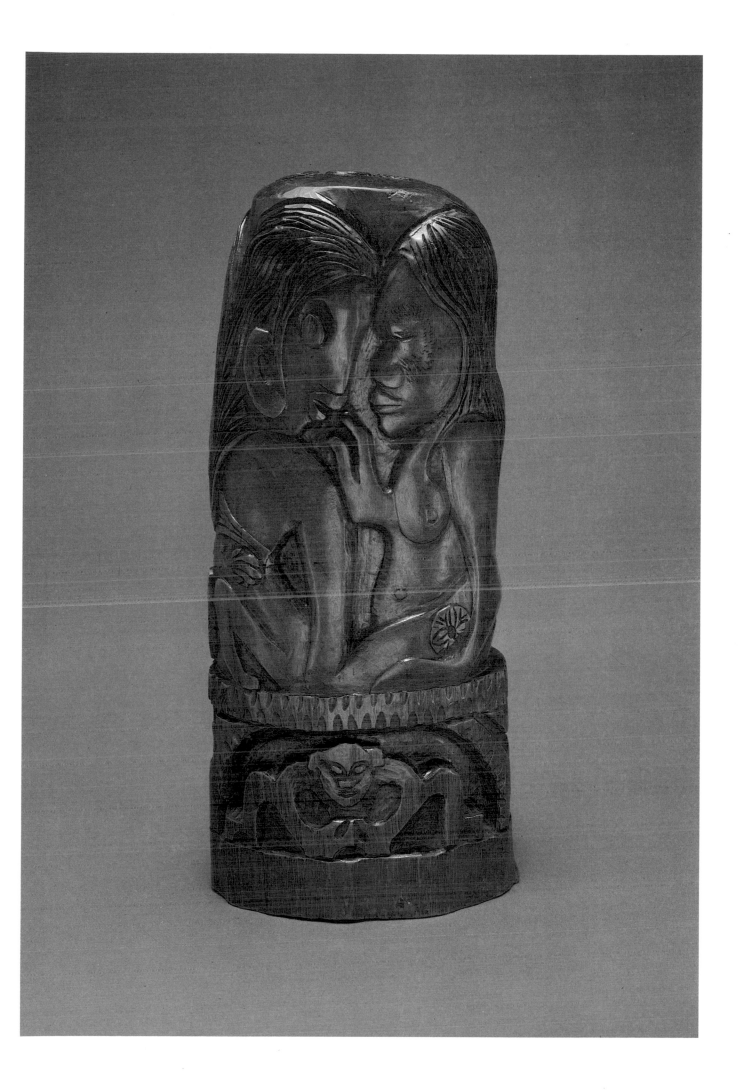

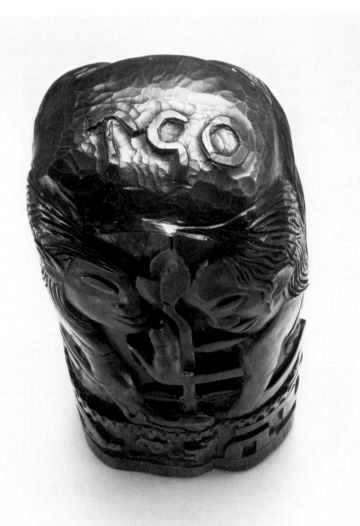

No. 12c

seated on the ground facing each other, but at a distance, unlike their position on one side of the sculpture *Hina and Te Fatou*, where their foreheads touch.

The Toronto carving and its pendant in the Hirshhorn Museum and Sculpture Garden (No. 14) are two of Gauguin's most sumptuous sculptures based on Polynesian mythology, made during his first visit to Tahiti (1891–93). Although the standing figure of Hina in the Hirshhorn work is more obviously seductive, the relationship between the two deities in the Toronto carving – as well as the decorative motifs and the strange animal at the base of the sculpture – present a more mysterious and complex group of images and powerful symbols. Directly beneath the figures the notched, carved band around the cylinder was, as Christopher Gray has pointed out, based on the handle of a Marquesan fan (fig. 12).[3] The geometric forms below this band probably derive from Marquesan tattooing patterns (fig. 16). The hare or rabbit may be a symbol of fertility. On one side of the sculpture, a strange animal or human form appears below the notched band, centred beneath *Hina and Te Fatou* (see colour plate); it is, like the two dieties, split and curved round the cylindrical shape. Jehanne Teilhet has written of the creature's possible source and significance:

> The visual pun represents one more primitive art form that Gauguin found, was delighted with, and used, not as a copyist, but used as the Marquesan artists used it. On the base, or below the groundline, where Hina and Te Fatou sit, Gauguin has employed the split motif, which is seen in the curious animal whose "front view is formed by two profile views." This curious animal could be read, as discerned from the profile views, as a split motif of a human figure with a *tiki*-like head seen crawling on its knees. This is the first sculpture in which Gauguin employs the visual pun and the split motif device. He was to become so fascinated by it that he used it on his figures whom he united by the hairline, back, rear, and legs so that their back view was formed by two profile views.[4]

One of the most ingenious aspects of this work is the way in which the two figures are shown in profile in the relief carving on the two broadest sides of the sculpture, and split at the back so that they each wrap around half the cylinder. Interestingly, neither the facial features nor the proportions of their bodies are consistent on the two sides of the carving. In the profile views above the strange animal (see colour plate), there can be no doubt that Hina is on the right, with the breast curving down as a continuation of her hair. While the Tahitian features of her face appear to be based on the observation of the local inhabitants, the awkward, chinless head of Te Fatou appears closer to primitivistic sources or to an imaginative interpretation of the god of the earth.

On the opposite side, the figure of Hina is on the left, with a flower in her hair; Te Fatou is on the right with his large right hand raised in an attitude probably borrowed from the Javanese relief from the Borobudur Temple (fig. 15) or from an Indian Buddha. The facial features of the figures, particularly the eyes, and the

Fig. 12
Marquesas Islands (Polynesia) *Fan Handle* Carved from sperm-whale tooth (Photograph from von den Steinen, *Die Marquesaner und ihre Kunst*)

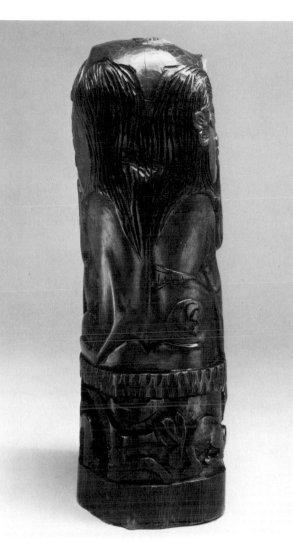

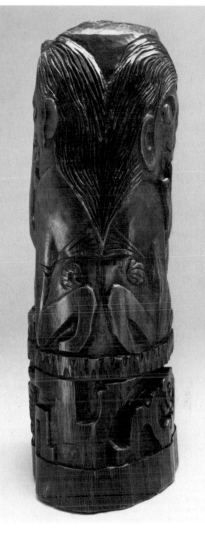

No. 12d No. 12e

positions of their heads (one upright, the other looking down) are very close indeed to those of the two deities in the watercolour on page 13 of *Ancien culte mahorie* (fig. 11); this side of the carving may be related to the watercolour. If this is the case, in the sculpture Gauguin has given Hina the facial features of Te Fatou and Te Fatou those of Hina. Also the flora motif in the manuscript page appears in the carving as a strong vertical flower that separates the two figures.

The fact that Gauguin recreated this ancient legend from a literary source is indicative of the idealized character of his imagination. It is the European mind assimilating, from an account of an earlier visitor to Polynesia, the long-forgotten mythology of the region. As Gray has pointed out, there were no indigenous carvings of this legend:

Essentially what he found was a parable, an idea as to the hidden essence of an historical event – for in primitive society the boundary between history and myth becomes indistinguishable. It is this allegorical scene which he represents.[5]

Fig. 13
Paul Gauguin
Hina and Te Fatou c. 1892
Pencil
Whereabouts unknown

The figures of Hina and Te Fatou on the side of the cylinder with the strange animal or human form appear in four other known works in other media: a pencil drawing (fig. 13); a monotype of 1894 entitled *Parau Hina Te Fatou*; on two sides of *Vase in Burnt Clay with Reliefs of Tahitian Gods* (The Museum of Decorative Arts, Copenhagen), fig. 14, of which there are three versions; and in the c. 1893–94 woodcut *Te Atua (The Gods)* (No. 13). This legend is also the subject of the 1893 oil *Hina Te Fatou* in the Museum of Modern Art, New

47

York, although in this work the figures are unrelated to those in the Toronto carving. Of all the legends that Gauguin read in Moerenhout's book, this was undoubtedly the one that most strongly gripped his imagination.

The Toronto carving originally belonged to Gauguin's great friend and supporter, Georges Daniel de Monfreid, who, in his undated woodcut of the artist (No. 29), included a detail of the head of Hina (see colour plate). De Monfreid depicted the side of the sculpture that appears in the related prints, drawing and ceramic. *Hina and Te Fatou* was shown at the great *Gauguin Retrospective* at the *Salon d'Automne* in Paris in 1906, where the Rumanian sculptor Constantin Brancusi may well have seen it. The first version (1907) of his famous carving *The Kiss* (No. 57) was perhaps suggested by the closeness of the kneeling Polynesian deities that had haunted Gauguin's imagination fifteen years earlier.

1. Richard S. Field, *Paul Gauguin: The Paintings of the First Voyage to Tahiti* (New York: Garland Press, 1977), p. 75 (quotation translated by Lucie Amyot).

2. Translated by Lucie Amyot.

3. Christoper Gray, *Sculpture and Ceramics of Paul Gauguin* (New York: Hacker Art Books, 1980), p. 222.

4. I am indebted to Hermione Waterfield of Christie's, London, for quoting this passage in her letter to this author of July 1, 1981.

5. Gray, *Sculpture and Ceramics*, p. 61.

Fig. 14
Paul Gauguin
Vase in Burnt Clay with Reliefs of Tahitian Gods c. 1893–94
Terracotta: H. 33.7 cm
The Museum of Decorative Art, Copenhagen

13.
Paul Gauguin
Te Atua (The Gods) 1893–94
Woodcut: 20.3 × 34.9 cm
The Art Institute of Chicago:
1948.262. The Clarence Buckingham
Collection

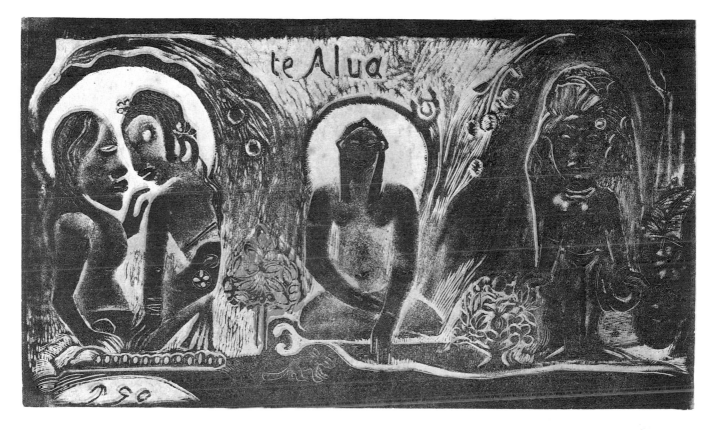

Gauguin's woodblocks, from which his woodcuts were printed, were an extension of his activities as a sculptor. "Here," as Harold Joachim has written, "the draftsman and the sculptor in him formed a perfect union, and the blocks as objects are a pleasure to behold."[1]

In August 1893 Gauguin returned from Tahiti and later that year, or in early 1894, began carving the set of ten woodblocks of Tahitian subjects that were intended to illustrate his autobiographical manuscript, *Noa Noa*. This woodcut is one of four from the *Noa Noa Suite* included in this exhibition (see also Nos. 20, 21, 22).

Although individual figures based on his sculpture appear in a number of Gauguin's prints, such as *Oviri* (No. 26) and *Tahitian Idol* (No. 25), this is the only woodcut to include three carvings. The figures at the left, Hina and Te Fatou, goddess of the moon and god of the earth, were based on the figures on one side of the tamanu wood cylinder in the Art Gallery of Ontario (No. 12); at centre, the seated figure in the yoga pose was based on the 1891–92 tamanu wood *Idol with a Pearl* (Musée d'Orsay, Galerie du Jeu de Paume), which in turn may have derived from a figure in another photograph (fig. 24) that Gauguin owned of the Javanese Temple of Borobudur (see also No. 12); and, at right, the standing figure of Hina was based on another tamanu wood

sculpture of 1891–92, *Hina* (Private Collection). The fact that these three groups of figures in the woodcut follow so closely the sculptures themselves suggests either that Gauguin brought the three carvings with him to France or that he had made detailed drawings of them.

1. The Art Institute of Chicago, *Gauguin: Paintings, Drawings, Prints, Sculpture* (Chicago: 1959), p. 77.

49

14.
Paul Gauguin
*Cylinder Decorated with the Figure of
Hina and Two Attendants* c. 1892
Wood with painted gilt: H. 37.1 cm
Signed on top: PGO
Hirshhorn Museum and Sculpture
Garden (Smithsonian Institution)

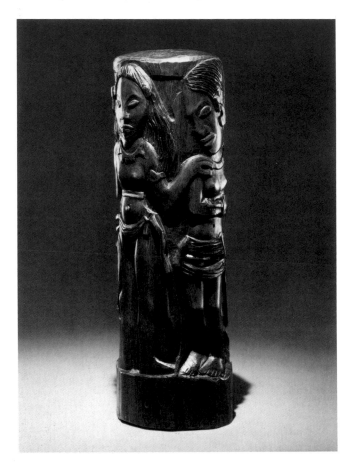 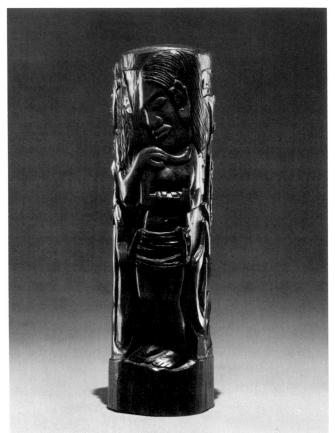

Both thematically and stylistically, this carving is so closely related to the Art Gallery of Ontario's *Hina and Te Fatou* (No. 12) that it is difficult not to think they were conceived at the same time, as a pair. The facial features and shape and position of the head of the standing attendant, on whose right shoulder rests Hina's left hand, are almost identical to those of Te Fatou on the side of the Toronto carving, in which the flower separates the two figures. Both the raised hand and the leg of the kneeling attendant (not visible here) are also closely related to several passages in *Hina and Te Fatou*.

The central image is the beautiful standing figure of the goddess of the moon, with her arms raised and her feet splayed. No documentary evidence is known to this author that

would indicate which of the two carvings Gauguin made first. But judging from his detailed transcription of the Hina and Te Fatou legend in *Ancien culte mahorie* (and later in *Noa Noa*) and from the known drawing, ceramic, and prints based on one side of the Toronto sculpture, it is tempting to surmise that he first became obsessed with the dialogue between the god of the earth and the goddess of the moon, and later chose to isolate the figure of Hina. Between 1892 and 1898, Hina, as represented in the Hirshhorn carving, appears in at least six paintings,[1] the earliest of which is the 1892 *Parau Hanohano* (*Terrifying Words*) (Private Collection). In this work, the sculptural treatment of the loin cloth on Hina's right side suggests that Gauguin may have based the figure directly on the

sculpture. In the paintings Hina usually stands in the middle distance or background, a Polynesian idol that Gauguin has created and placed among contemporary Tahitian figures. She appears in the middle distance in the right half of Gauguin's last great artistic testament, the allegorical *Where Do We Come From? What Are We? Where Are We Going?* of 1897, in the Museum of Fine Arts, Boston.

Christopher Gray has suggested that, in the Hirshhorn carving, Hina probably derives from the photograph of reliefs from the Javanese Temple of Borobudur that Gauguin took with him to Tahiti; specifically, the second standing woman from the left in the lower portion of the photograph (fig. 15).[2] While the frontality of the pose may be related

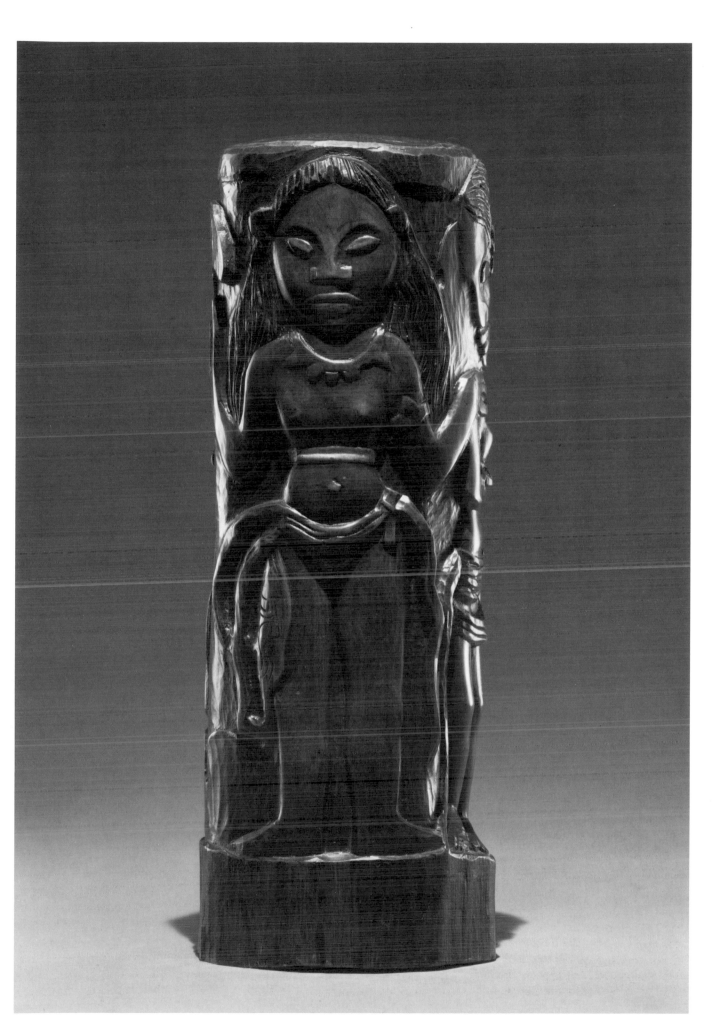

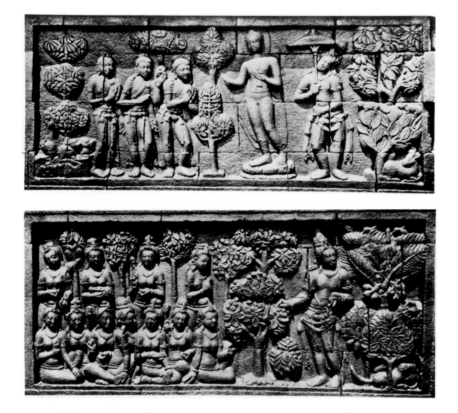

Fig. 15
Reliefs from the Javanese Temple of Borobudur. Above: *The Meeting of Buddha and the Three Monks on the Benares Road*; below: *The Arrival of Maitrakanyaka at Nandana*

to this figure, certain details, such as the low-slung position of the loin cloth, the high waist, and the shape and position of the armband, are closer to the large standing figure on the right side of the relief.

The shape of whatever is being carried by the standing attendant in the Gauguin carving must be based on a similar object in the arms of the figure second from the left in the Javanese relief. As always, Gauguin felt free to borrow from the art of the past, be they details or an entire figurative passage. His daring and original combinations of disparate sources from Egyptian, Javanese, Peruvian, Japanese, Oceanic, and Christian art give this work its exotic and primitive character, and mark the beginning of primitivism in modern art. And it was his example in the early years of this century that stimulated the interest of Picasso and Matisse in non-European sources. As he wrote to Georges Daniel de

Monfreid in 1902, who originally owned both the Toronto and Hirshhorn carvings: "You have known for a long time, what it has been my purpose to vindicate: the right to dare anything."[3]

1. Georges Wildenstein, *Gauguin* (Paris: Editions Les Beaux Arts, 1964), Nos. 460, 497, 513, 514, 561, 568.

2. Christopher Gray, *Sculpture and Ceramics of Paul Gauguin* (New York: Hacker Art Books, 1980), p. 220.

3. Robert Goldwater, *Paul Gauguin* (New York: Harry N. Abrams, Inc., 1957), p. 44.

15.
Paul Gauguin
Cane c. 1892
Wood with iron band: H. 91 cm
Signed on the iron band below strap:
PGO inlaid in gold
Musée d'Orsay (Galerie du Jeu de Paume)

Whereas in No. 11 only the handle was decorated, in this and in *Cane Decorated with Polynesian Motifs* (Private Collection), the entire length of the cane has been worked in great detail. The standing figure of Hina, goddess of the moon, was probably based on the Hirshhorn Museum's wood *Cylinder Decorated with the Figure of Hina and Two Attendants* (No. 14), which was carved in 1892 or 1893 after Gauguin had read of the legend of Hina and Te Fatou in Moerenhout's *Voyages aux îles du Grand Océan*. (For a discussion of this legend see *Hina and Te Fatou* [No. 12].)

The portion of this cane above the leather strap is a separate piece of wood. The decorative designs on the entire length of this cane below the strap and the signature on the metal band were based on Marquesan tattooing patterns (fig. 16). We know from the recollections of Gauguin's friend in Papeete, Jénot, that the artist owned photographs of Marquesan tattoo designs:

> He showed photographs of Marquesans bearing on half their body, tattoos whose designs he admired and was surprised that these artists capable of tattooing such figures had never thought of reproducing them in wood or stone.[1]

1. Ziva Amishai-Maisels, "Gauguin's Early Tahitian Idols," *Burlington Magazine* 60, no. 2 (June 1978): 332 (translation by A.G.W.).

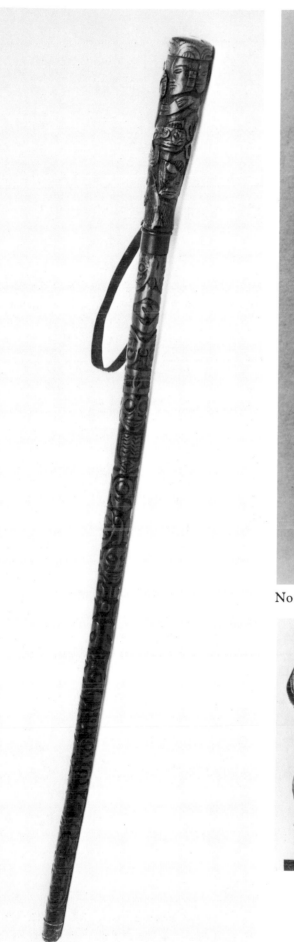

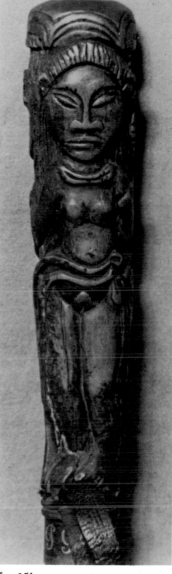

No. 15b

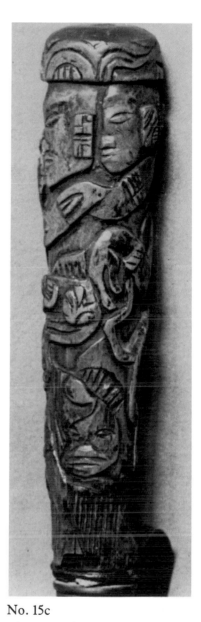

No. 15c

Fig. 16
Marquesan tattooing patterns on two wooden legs and on the leg of a man (Photograph from von den Steinen, *Die Marquesaner und ihre Kunst*)

No. 15a

16.
Paul Gauguin
Carved Coco de Mer c. 1901–03
27.9 × 30.5 cm
Sea coconut, with metal hinges and
two hooks

Inscribed: *P. GAUGUIN*
A MR. PAILLARD
Albright-Knox Art Gallery, Buffalo,
New York. A. Conger Goodyear
Fund, 1964

In April 1901, Gauguin left Tahiti and moved to Atuona on the island of Dominique (Hiva-Oa) in the isolated Marquesas Islands, where he spent the remaining two years of his life. The earlier, though somewhat questionable, *Coconut Carved as a Coin Bank* is thought to have been made before Gauguin's second trip to Tahiti in 1895.

The *coco de mer*, or sea coconut, one of the rarest fruits in the world, grows only in the Seychelles Islands in the Indian Ocean. In India, according to Tantric tradition, it was venerated as representing the *yoni* or vulva of the Mother goddess, and its flesh was eaten as a love potion. As Katy Kline has written, "Although there is no evidence that Gauguin was aware of this Indian tradition, it is clear that the form of the object, suggestive of both the male and female external genitalia, held particular meaning for him at the end of his life."[1] This *Coco de Mer* and the 1891–92 *Wood Cylinder with Christ on the Cross* are two of Gauguin's most densely decorated carvings. Surrounded by curvilinear decorative patterns is a menagerie of mammals, birds, insects, and snakes. As well, on each half of the shell are two seated male figures (not visible here), each addressing a dog. The inscription above one of the figures reads *A MR. PAILLARD*, a reference to the Catholic missionary bishop on the Marquesas Islands of whom Gauguin made a wood carving entitled *Père Paillard (Father Lechery)* (No. 17). For Gauguin, the bishop's mission – to convert the native inhabitants to European morals and dress – represented everything he was hoping to escape from in his South-Sea island retreat. As Kline has pointed out, although neither of the seated figures can be conclusively identified as Père Paillard it is at least possible that the carving on this shell represents the dog, or artist, encountering the constraints of civilization, all set against the luxuriant background of flora and particularly fauna which earlier signified for Gauguin various aspects of unbridled sexuality.[2]

Decorative carving of gourds and coconuts was practised in various cultures, including Peru, where Gauguin had lived from 1851 to 1855. Unlike his earlier Tahitian sculpture (Nos. 12, 14), this *coco de mer* does not include Marquesan figurative motifs; but Gauguin may have been inspired to carve this material by the many examples he must have known of figurative and decorative designs on wooden covers for calabash vessels made by the inhabitants of the Marquesas Islands (fig. 17) or by the carved gourds from Peru (fig. 18).

1. Steven A. Nash et al, *Painting and Sculpture from Antiquity to 1942* (Buffalo: Albright-Knox Art Gallery, 1979), p. 228.

2. *Ibid*, p. 228.

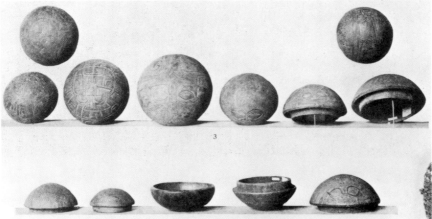

Fig 17.
Marquesas Islands (Polynesia)
Wooden Covers for Calabash Vessels
(Photograph from von den Steinen, *Die Marquesaner und ihre Kunst*)

Fig. 18
Peru
Gourd before 1930: 15.0 × 16.5 cm
Jean-René Ostiguy Collection

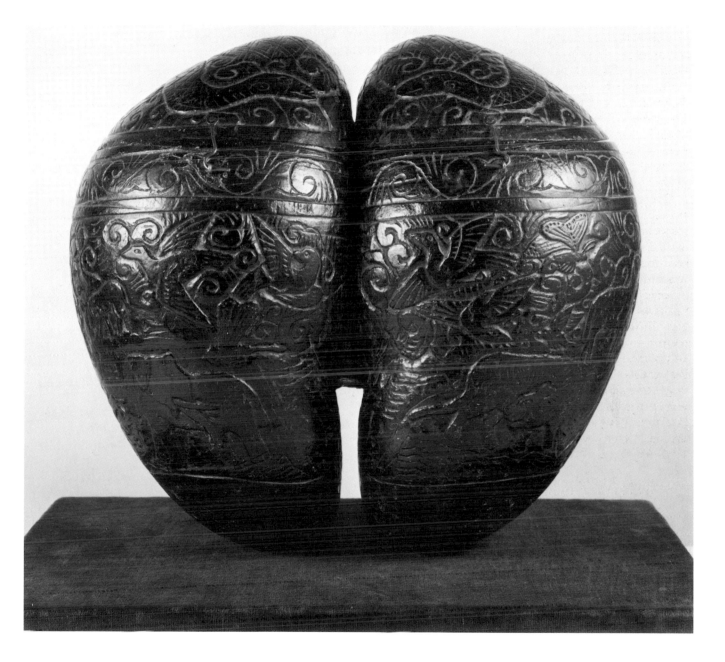

17.
Paul Gauguin
Père Paillard (Father Lechery)
c. 1903
Wood: H. 67.9 cm
Signed left side at bottom: PGO;
carved in relief at front near bottom:
PÈRE PAILLARD
National Gallery of Art. Chester
Dale Collection, 1962

In 1901, Gauguin moved to the remote Marquesas Islands; he went in the hope of finding unspoiled native culture and a living artistic tradition (which, to his great disappointment, he had failed to find when he first arrived in Tahiti in June 1891). His ship, the *Croix du sud*, arrived at Atuona on Hiva-Oa Island on September 16. Again he was to be disappointed. As Bengt Danielsson explained:

> Life in the Marquesas was certainly in its way more savage than in Tahiti. But not because the natives there had been more successful in preserving their ancient customs and traditions; on the contrary, they had almost completely lost their native culture, while at the same time they had acquired only a tithe of the Western artifacts, ideas and institutions their Tahitian kinsmen had been blessed with. In short, they lived in a kind of cultural vacuum, where sheer anarchy often reigned.[1]

On September 27, 1901, Gauguin bought from the Catholic mission a vacant plot of land on the main street of the village of Atuona, and within about a month his house was completed. The ground floor, according to Danielsson, included a wood-carving studio.[2] On the lintel above the door on the second-floor level, reached by outside steps, were the words *MAISON DU JOUIR*

(house of pleasure).[3] This panel formed part of the *Carved Door Frame from Gauguin's House in the Marquesas*, now in the Musée d'Orsay (Galerie du Jeu de Paume). Obviously, wood carving continued to play an important role in

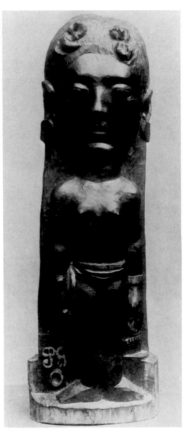

Fig. 19
Paul Gauguin
Thérèse
Wood: H. 66.0 cm
Private Collection

Gauguin's art during the last twenty months of his life.

Père Paillard, its companion piece, *Thérèse* (Private Collection) (fig. 19), and *Saint Orang* (Musée d'Orsay, Galerie du Jeu de Paume) (fig. 33), all carved in the Marquesas, are the most important surviving three-dimensional works from Gauguin's last years. *Père Paillard* represents the Catholic Bishop Martin, who strongly disapproved of Gauguin's "immoral" life. While openly critical of the fact that the artist lived with the fourteen-year-old Vaeoho, who bore him a daughter on September 14, 1902, Bishop Martin himself was thought to have had a love affair with a native servant named Thérèse. In *Avant et après*, Gauguin mockingly described the subjects of his two carvings of the bishop and his mistress:

> His reverence is a regular goat, while I am a tough old cock and fairly well seasoned. If I said that the goat began it I should be telling the truth. To want to condemn me to a vow of chastity! That's a little too much. . . .
>
> To cut two superb pieces of rosewood and carve them after the Marquesan fashion was child's play for me. One of them represented the horned devil, the other a charming woman with flowers in her hair. It was enough to name her Thérèse for everyone without exception, even the school

No. 17a

No. 17b

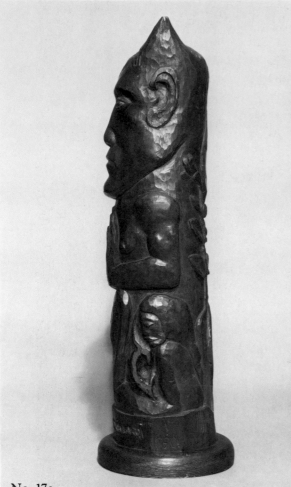

No. 17c

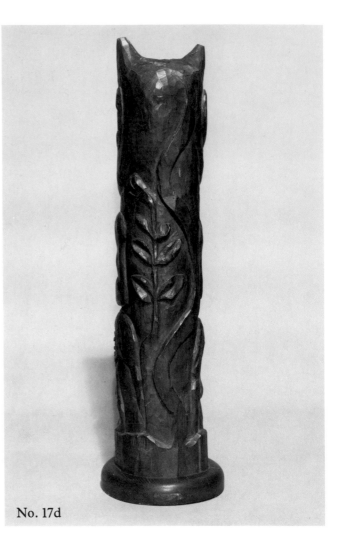

No. 17d

children, to see in it an allusion to the celebrated love affair.

Even if this is all a myth, still it was not I who started it.[4]

Gauguin placed these two carvings, as recorded in Danielsson, for everyone to see in front of the steps leading to the upper floor of the House of Pleasure.

Unlike the carving of Thérèse, in which the figure is treated in high relief in the front half of the sculpture with the other half rounded (but, judging from the photograph of the side view, without decoration), *Père Paillard* was carved all around the cylindrical form. While the arms and legs are carved in high relief, the enormous head seems to have a fully three-dimensional identity. Although the proportions of the figure echo those of Marquesan *tiki* sculptures (fig. 29), the features are clearly those of the European bishop, so that the carving lacks the intensely primitivistic character of Gauguin's Tahitian idols, made on his first trip to Polynesia in 1891–93 (No. 12).

On each side of the sculpture, below the arms, is a half-length female figure, possibly representing youth and old age. On the back in the central area is a flower and to the right of this, running the entire height of the figure, is a twisting form perhaps symbolizing a serpent and temptation, to which Père Paillard had succumbed. Gauguin caricatures, with a devastating irony, the hypocrisy of the bishop – hands in front of his chest in prayer – who not only made the already tragic life of the dying artist more difficult, but who also represented, on the artist's very doorstep, everything Gauguin had travelled halfway round the world to escape.

1. Bengt Danielsson, *Gauguin in the South Seas* (London:George Allen and Unwin Ltd., 1965), p. 231.

2. *Ibid*, p. 239.

3. As Christopher Gray points out [*The Sculpture and Ceramics of Paul Gauguin* (New York: Hacker Art Books, 1980), p. 77, footnote 44]: "The title *Maison du jouir* strongly suggests the Polynesian *fare popi*, or 'pleasure house,' that was used by unmarried young people as a sort of club where they gathered to play and sing, and to sleep and have intercourse."

4. Gray, *Sculpture and Ceramics*, p. 78.

18.
Paul Gauguin
Head of a Tahitian Woman c. 1891
Pencil: 30.6 × 24.5 cm
The Cleveland Museum of Art.
Mr. and Mrs. Lewis B. Williams
Collection

Because many of Gauguin's drawings
are closely related to, and are often
studies for, his paintings, his works
in oils are helpful in dating the
drawings. Ronald Pickvance has
identified this drawing as a study for
the seated woman in the middle
distance at centre in the 1891 oil *Les*

Parau Parau (Conversation) in the
Hermitage Museum, Leningrad; the
drawing must have been executed
about the same time. Obviously
drawn from life, it presents the
far-from-idealized, saddened expres-
sion of his model.

1. Ronald Pickvance, *The Drawings of
Gauguin* (London: Paul Hamlyn,
1970), p. 34.

19.
Paul Gauguin
Tahitian Women and Marquesan Ear Plug c. 1892
Pencil, pen and ink: 23.8 × 31.7 cm
The Art Institute of Chicago:
1950.1413. The David Adler
Collection

Fig. 20
Marquesas Islands (Polynesia)
Drawing of Women's Ear Ornaments (Taiana)
(Photograph from von den Steinen, *Die Marquesaner und ihre Kunst*)

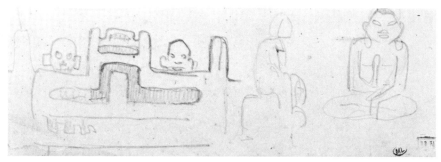

Fig. 21
Paul Gauguin
Sheet of Studies
Pencil: 6.0 × 17.6 cm
Musée du Louvre, Cabinet des Dessins

Fig. 22
Paul Gauguin
Parahi Te Marae (There is the Temple)
1892
Oil on canvas: 68.0 × 91.0 cm
Philadelphia Museum of Art: Gift of
Mrs. Rodolphe Meyer de Schauensee

According to Ronald Pickvance, less than one hundred independent drawings by Gauguin have survived, excluding those sheets that have been dismembered.[1] With his interest in working in so many varied media, and in breaking down the barriers between them, Gauguin, Pickvance writes, saw his woodcuts, lithographs, and monotypes "as an extension of drawing; he refers to them as '*dessins*' in his letters."[2]

In this beautiful sheet Gauguin has drawn two important subjects that inspired much of his painting and sculpture from his years in the South Seas: studies of Tahitian women and of Marquesan art, such as this fairly

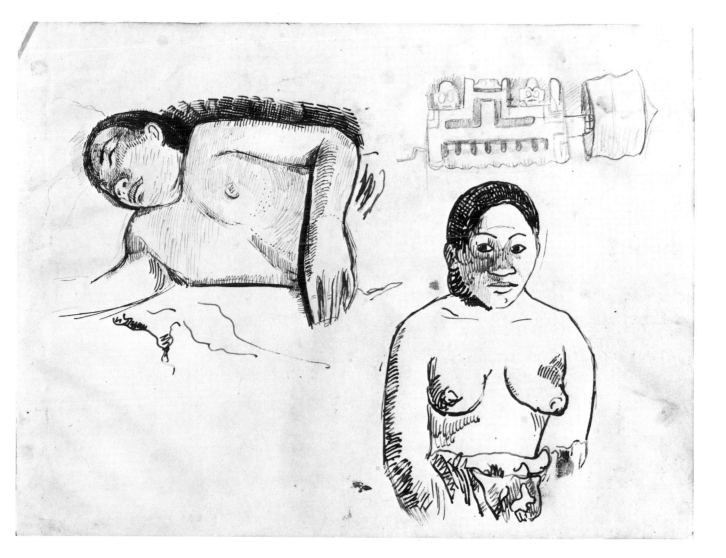

detailed copy of a Marquesan ear ornament (fig. 20). It is not known if he made this drawing from the original work or from a photograph. A small sketch page in the *Cabinet des Dessins*, Musée du Louvre (fig. 21) includes a less finished study of an ear ornament, possibly the same one that appears in this drawing.

This study is of great interest not only as one of the few surviving examples in which Gauguin drew an actual work of primitive art, but as an indication of the imaginative way he made use of non-European sources. The fence in the foreground of his 1892 oil *Parahi Te Marae* (*There is the Temple*) (fig. 22) is clearly based on the heads and openings of the geometric structure of Marquesan ear ornaments. Perhaps he worked from this drawing in transforming this primitive motif in the Philadelphia painting.

1. Ronald Pickvance, *The Drawings of Gauguin* (London:Paul Hamlyn, 1970), p. 6.

2. *Ibid*, p. 15.

20.
Paul Gauguin
Nave Nave Fenua (Wonderful Earth)
1893–94
Woodcut printed in colour:
35.5 × 20.4 cm
The Museum of Modern Art, New
York. Gift of Abby Aldrich
Rockefeller

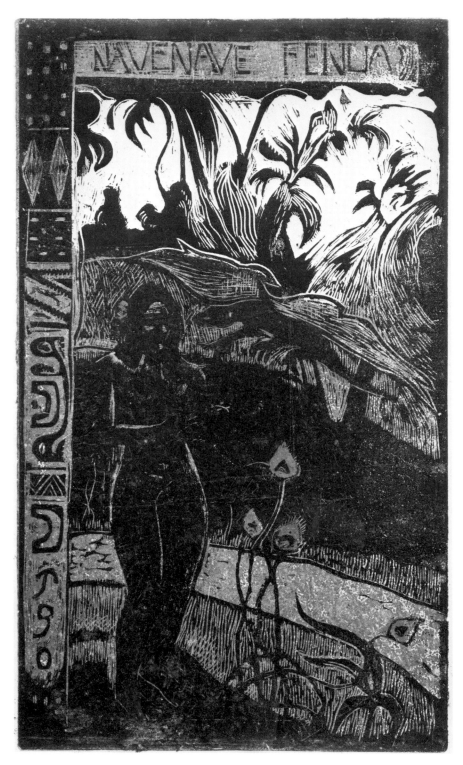

This woodcut, one of Gauguin's most
sumptuous figure-and-landscape
compositions, was, like many prints
from the *Noa Noa* manuscript from
which this comes (see No. 13), based
on a work completed during his first
visit to Tahiti – the 1892 oil *Te Nave
Nave Fenua* (Ohara Museum,
Kurashiki). Before he left France for
Tahiti, Gauguin had based his 1890
Exotic Eve (Private Collection) on
the standing figure at right in the
lower half of the photograph he
owned of the Javanese Temple of
Borobudur (fig. 15). This figure, in
the guise of a Tahitian woman, was
the source for a number of his
paintings, drawings, watercolours,
and prints, including this woodcut.

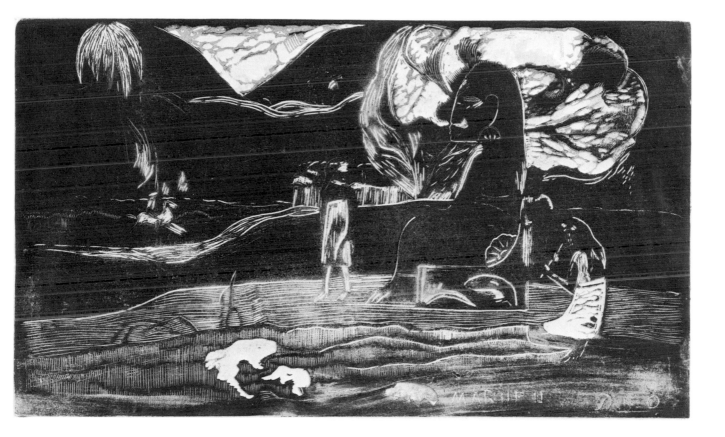

21.
Paul Gauguin
Maruru (Thank You) 1893–94
Woodcut printed in brown and red:
27.5 × 50.0 cm
Inscribed in block: Maruru PGO
Art Institute of Chicago: 1950.1444.
Gift of Frank B. Hubachek

The composition of this third *Noa Noa* woodcut (see No. 20) in the exhibition was directly based on Gauguin's 1893 painting *Hina Maruru (The Feast of Hina)* (Private Collection), which shows an enormous statue of the goddess of the moon (see No. 14) surrounded by three Tahitian women.

As mentioned in No. 14, the figure of Hina, both in the standing pose of the Hirshhorn carving and in the seated position in this woodcut, appears in many of Gauguin's paintings and prints. Perhaps the scale was suggested by the Easter Island statues (fig. 63). A similar representation of Hina appears on the hillside in *Parahi Te Marae (There is the Temple)* of 1892 (fig. 22).

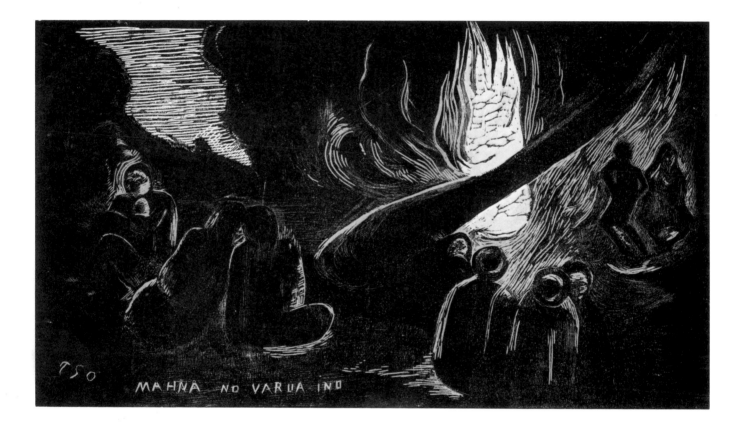

22.
Paul Gauguin
Mahna No Varua Ino (The Devil Speaks) 1893–94
Woodcut in colours: 20.1 × 35.3 cm
National Gallery of Canada, Ottawa

In this woodcut, the last of the *Noa Noa Suite* included in this exhibition, Gauguin brilliantly evokes the dark night of a primitive ritual in which the dancing and seated figures are confronted by a fiery horned devil. The scene was based on a painting of 1891, *The Dance of Fire or the Devil Speaks*. Works such as this woodcut are representations of both the barbaric and mysterious forces of nature and of Gauguin's technical mastery and innovations with the medium; such works were to profoundly influence German Expressionists such as Heckel (No. 87), Schmidt-Rottluff (Nos. 89, 90, 91, 92), Kirchner (No. 88), and Nolde in their attitudes toward primitive art and life.

23.
Paul Gauguin
Manao Tupapau (Watched by the Spirit of the Dead) 1894
Lithograph: 42.0 × 57.3 cm
National Gallery of Canada, Ottawa

This lithograph was based on Gauguin's 1892 painting *Manao Tupapau* (General Ansor Conger Goodyear), although several additions and changes have been made. The dark half-figure of the spirit of the dead, seen in profile beside the which derives from the goddess of the moon in the Hirshhorn carving (No. 14).

As with his last great allegorical painting *Where Do We Come From? What Are We? Where Are We Going?* of 1897 (Museum of Fine Arts, Boston), Gauguin took the trouble to explain in some detail the meaning of the 1892 oil *Manao Tupapau*:

A young native girl lies on her belly, showing a portion of her frightened face. She lies on a bed covered with a blue *pareo* and a the picture is all set out. . . .

I see only fear. What kind of fear? Certainly not the fear of Suzanna surprised by the elders. That does not exist in Oceania. The *tupapau* (Spirit of the Dead) is clearly indicated. For the natives it is a constant dread. . . . Once I have found my *tupapau* I attach myself completely to it, and make it the motif of my picture. The nude takes second place.

What can a spirit be, for a Maori? She knows neither theatre or novels, and when she thinks of

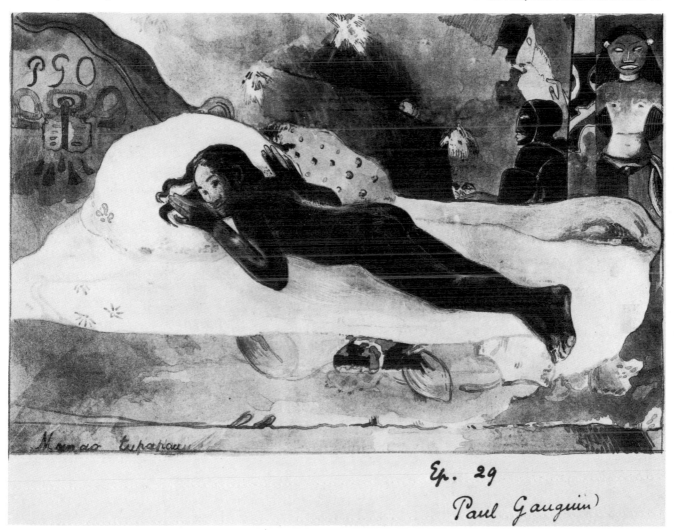

post behind the bed, is proportionally smaller than in the painting of this subject. This was to leave room for the head above (not included in the 1892 oil), which may be related to the head of Te Fatou in the Art Gallery of Ontario's carving *Hina and Te Fatou* (No. 12) that also appears in the woodcut *Te Atua* (No. 13). Another addition in this woodcut is the standing figure of Hina, light chrome-yellow sheet. . . .

The *pareo* being closely linked with the life of a Tahitian, I use it as a bedspread. The sheet, of bark-cloth, must be yellow, because, in this color, it arouses something unexpected for the spectator, and because it suggests lamplight. . . . I need a background of terror, purple is clearly indicated. And now the musical part of someone dead, she thinks necessarily of someone she has seen. My spirit can only be an ordinary little woman. The title has two meanings, either she thinks of the spirit; or, the spirit thinks of her.[1]

1. Robert Goldwater, *Paul Gauguin* (New York: Harry N. Abrams, Inc., 1957), p. 114.

24.
Paul Gauguin
Tahitian Girl in a Pink Pareo 1894
Watercolour monotype:
22.9 × 14.0 cm
Anonymous Loan

Gauguin returned to France in August 1893, having spent two years in Tahiti. In early May of the following year he arrived in Brittany, where he remained until November, during which time he worked on a series of monotypes of Tahitian subjects, which almost certainly included this ravishing study of a girl in a pink *pareo*. Richard Field has described the special status of the monotype print:

> The monotype is a special hybrid of print and drawing. It shares with printmaking the transfer of an image from one surface to another. But, as in a drawing or watercolour, this image is carried only by the pigment and not by physical or chemical structures that form part of the printing surface. For this reason the act of printing usually transfers the total image and creates a single, unique, printed drawing.[1]

A fainter image of the same figure appears in a watercolour monotype of the same title in the Art Institute of Chicago[2]; the Chicago work was, in turn, based on the watercolour on cardboard, *Little Tahitian Girl in Red* (Private Collection), done in Tahiti in 1891.

1. Richard S. Field, *Paul Gauguin: Monotypes* (Philadelphia: Philadelphia Museum of Art, 1973), p. 13.

2. *Ibid*, catalogue no. 22, p. 66.

25.
Paul Gauguin
Tahitian Idol 1894
Woodcut: 14.1 × 9.8 cm
The Art Institute of Chicago:
1948.268. The Clarence Buckingham
Collection

The 1891–92 tamanu wood carving
of *Hina* (Private Collection), the
subject of the figure on the right of
the woodcut *Te Atua* (No. 13) from
the *Noa Noa Suite*, appears again in
this print, which was probably made
before Gauguin returned to Tahiti in
1895.

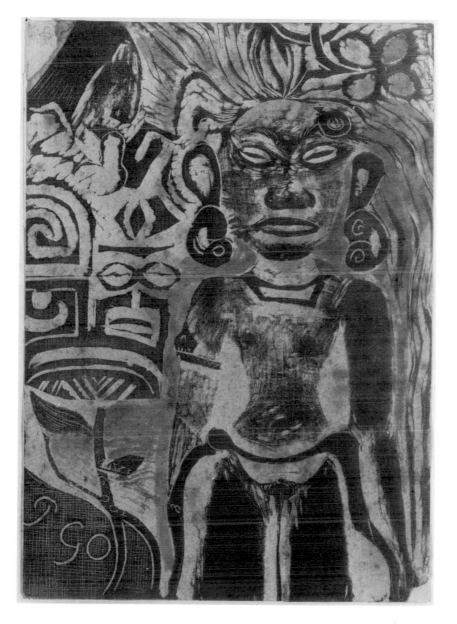

26.
Paul Gauguin
Oviri (The Savage) c. 1894–95
Woodcut: 20.3 × 11.8 cm
The Art Institute of Chicago:
1948.273. The Clarence Buckingham
Collection

Gauguin's greatest achievement as a
ceramist was his stoneware sculpture
Oviri (fig. 23), which was probably
done in France in the winter of
1894–95. The image of Oviri appears
more often in other media than does
any other Gauguin sculpture. And,
as he wrote to his friend Georges
Daniel de Monfreid in October 1900,
he wanted the figure placed over his
grave, a wish that was never realized.
Oviri also appears in another wood-
cut, *Woman Picking Fruit and Oviri*,
in two watercolour monotypes,[1] in a
pen-and-sepia drawing,[2] and in two
paintings, *E Haere Oe I Hia (Where
Are You Going?)* of 1892 (Private
Collection) and *Rave Te Hiti Ramu
(Presence of the Evil Monster)* of 1898
(Hermitage Museum, Leningrad).
According to Christopher Gray,

> Gauguin has based the features,
> dominated by the great empty
> staring eyes, on two sources, the
> features of a Marquesan idol, and
> the mummified skull, eye sockets
> filled with mother-of-pearl, of a
> great chief who has passed beyond
> death to become a god.[3]

Fig. 23
Paul Gauguin
Oviri (The Savage) c. 1894–95
Stoneware: H. 74.0 cm
Private Collection

As Barbara Landy points out,

> The pose of the body is first found
> in a painting *Où vas-tu?* of 1892,
> and ultimately comes from a
> Javanese figure of the type repro-
> duced by N. J. Krom, a female
> figure with animal attribute in the
> Museum of Djakarta (Batavia),
> Java.[4]

In the ceramic sculpture, Oviri
stands on the dead she-wolf and
crushes and tears at the body of the
whelp. Neither animal appears in the
woodcut. Landy interprets the
sculpture in terms of Gauguin's wish
to return to the south seas, of "the
destruction of the civilized self and
the rejuvenation of the savage."[5]
Gauguin's identification with the
savage is well known. In the painted
plaster *Self-Portrait of Gauguin* he
inscribed above his head, "OVIRI."
The sculpture's presence continued
to live in his painting as late as 1898:
"The last embittered cry against a
hostile Europe he would destroy in
himself, the hope for a rebirth into
harmony in the South Seas, the *Oviri*
is indeed a fitting marker for his
grave."[6]

1. Richard S. Field, *Paul Gauguin:
 Monotypes* (Philadelphia: Philadel-
 phia Museum of Art, 1973), Nos. 30
 and 31.

2. Marcel Guérin, *L'Oeuvre gravé de
 Gauguin* (San Francisco: Alan Wofsy
 Fine Arts, 1980), p. XXVII.

3. Christopher Gray, *Sculpture and
 Ceramics of Paul Gauguin* (New
 York: Hacker Art Books, 1980),
 p. 65.

4. Barbara Landy, "The Meaning of
 Gauguin's 'Oviri' Ceramic," *Bur-
 lington Magazine* 109, no. 769 (April
 1967): 245.

5. *Ibid*, 245.

6. *Ibid*, 246.

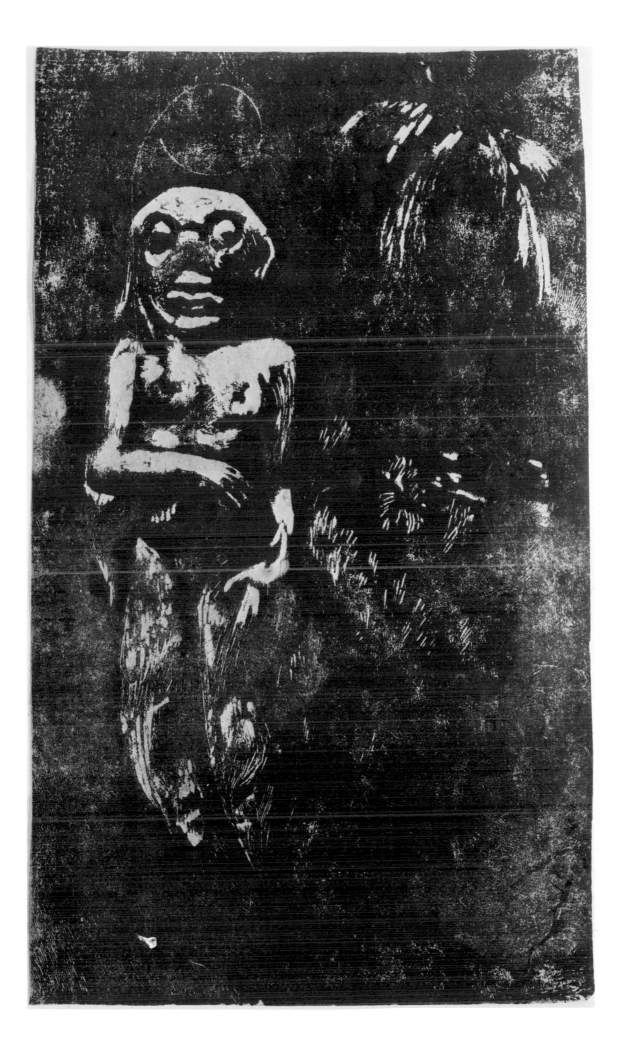

27.
Paul Gauguin
The Buddha c. 1899
Woodcut: 30.0 × 22.2 cm
Cincinnati Art Museum. The Albert
P. Streitmann Collection

Gauguin used again and again a
limited number of poses and figure
types borrowed from Eastern
sources. Perhaps the one used most
frequently in his paintings, draw-
ings, and prints was that of the
standing female nude in the *Noa
Noa Suite* woodcut, *Nave Nave
Fenua* (No. 20), based on one of the
figures from the Javanese Temple of
Borobudur (fig. 15). As in the 1891–
92 wood carving *Idol with a Pearl*
(Musée d'Orsay, Galerie du Jeu de
Paume), which appears at the centre
of the woodcut *Te Atua* (No. 13), the
yoga pose of the Buddha in this
woodcut may derive from the central
seated figure at the top of one of the
photographs that Gauguin owned of
another section of the Javanese
temple (fig. 24).

Fig. 24
Reliefs from the Javanese Temple of
Borobudur. Above: *Assault on Mâra*;
below: *Scene from the Life of
Bhallâtiya-Jataka*.

28.
Paul Gauguin
Seated Woman Seen from the Back
c. 1900 (verso)
Pencil: 15.2 × 19.5 cm
Art Gallery of Ontario. Gift of Sam
and Ayala Zacks, 1970

On the recto of this sheet is a traced monotype printed in ochre. The drawing on the verso has been squared, which, as Richard Field remarked, "indicates that Gauguin used it directly for drawing on the verso of *La Case*, if indeed a drawing is present."[1] *La Case*, a traced monotype of about 1900, shows two Tahitian women ironing.

As a draughtsman, Gauguin was certainly not equal to the genius Degas; but the searching outlines and sometimes awkward passages in his drawings bear comparison with those of Paul Cézanne. But this superb study, one of Gauguin's first pencil figurative works, is beautifully resolved, with the undulating out-

lines of the Tahitian's shoulders, arms, and dress contrasting with the sparse geometric shape of the window at upper left. Gauguin's back view of a female nude, the 1901–02 traced monotype *Crouching Tahitian Woman Seen from the Back* (fig. 25), belonged to Maillol, who based his terracotta *Woman with a Crab* (c. 1905) on it (No. 30).

Gauguin died in his "House of Pleasure" in the Marquesas Islands on May 8, 1903. Three years later, at the great 1906 *Gauguin Retrospective Exhibition* at the *Salon d'Automne* in Paris, his extraordinary achievements in painting, sculpture, ceramics, and prints made an enormous impact on younger artists in

France. It was through the example of his art, in its assimilation of diverse styles from Egyptian, Peruvian, Oceanic, and Javanese traditions, that the interest in primitive art gathered momentum in the early years of the century and soon became, as this exhibition illustrates, one of the major influences on the generation of Picasso and Moore.

1. Richard S. Field, *Paul Gauguin: Monotypes* (Philadelphia: Philadelphia Museum of Art, 1973), p. 75.

Georges Daniel de Monfreid
1856–1929

French painter, sculptor, and printmaker Georges Daniel de Monfreid was born in Paris. "The Captain," as he was called, divided his time between cruising on the Mediterranean on his schooner, farming on a property he owned in the Pyrenees, and painting. Although his output was limited, he exhibited at the *Salon d'Automne* and the *Salon des Indépendants*. He died in an accident on November 26, 1929.

It is not as an artist that de Monfreid is remembered today, but as Gauguin's devoted and faithful friend. They met in early 1889 at Emile Schuffenecker's home, and both exhibited at the *Volpini Exhibition* that Gauguin and Schuffenecker organized to coincide with the 1889 Paris Universal Exposition. In 1891 de Monfreid offered Gauguin the use of his studio in the Plaisance quarter of Paris. On February 23, at the Hôtel Drouot, thirty of Gauguin's paintings were auctioned to raise money for his trip to Tahiti, and from this sale de Monfreid acquired two works. He corresponded faithfully with Gauguin, as did Gauguin with him. In many ways he supported Gauguin as Theo van Gogh had given moral, practical, and financial help to his brother Vincent.

29.
Georges Daniel de Monfreid
Paul Gauguin n.d.
Woodcut: 17.3 × 12.2 cm
Signed lower right: G.D.M.;
numbered lower left: 85/100
The Museum of Modern Art, New
York. Purchase Fund

Georges Daniel de Monfreid owned some of Gauguin's finest wood carvings executed during his two trips to Polynesia. Three are included in this exhibition: No. 14, *Cylinder Decorated with the Figure of Hina and Two Attendants* (Hirshhorn Museum and Sculpture Garden); No. 12, *Hina and Te Fatou* (Art Gallery of Ontario); and No. 10, *Wood Cylinder with Christ on the Cross* (Private Collection).

In the woodcut *Paul Gauguin*, the artist is shown with two of his wood carvings done on his first trip to Tahiti (1891–93), both of which de Monfreid owned. At left is *Idol with a Pearl*, with a man in a yoga pose, which was almost certainly based on the figure at centre in the upper half of a photograph that Gauguin owned of the reliefs from the Javanese Temple of Borobudur (fig. 24). At upper right, the detail of the profile of the head of Hina is directly based on the relief carving of the goddess of the moon in the Art Gallery of Ontario's *Hina and Te Fatou* of 1892 (No. 12, colour plate). The fact that de Monfreid included two carvings in this print attests to the importance he attached to Gauguin's sculpture.

Aristide Maillol 1861–1944

Aristide Maillol, French sculptor, painter, printmaker, and tapestry designer, was born at Banyuls-sur-mer (Pyrénées-Orientales). From 1874 to 1879 he was in school at Perpignan. Having decided to become a painter, he went to Paris in 1881, where after many attempts he was finally admitted to the Ecole des Beaux-Arts in 1885; he worked under Gérôme and Cabanel. In Paris he met Bourdelle and Gauguin, whose work he admired. In 1892, disillusioned by the teaching at the school, he became interested in the tapestries in the Musée de Cluny, and in 1893 he created a tapestry workshop in Banyuls.

In 1895 Maillol started to make sculptures, and in 1896 he exhibited one wax and three carved wood statuettes. In 1900, his eyesight affected, he abandoned tapestry to devote himself to sculpture. Dealer Ambroise Vollard bought some of his works and gave him his first one-man exhibition in 1902. In 1903 he settled in Marly-le-Roy, on the outskirts of Paris, to be closer to his Nabis friends Denis, Roussel, and Vuillard, but he continued to spend winters in Banyuls.

After years of poverty and lack of recognition, his large sculpture *La Méditerranée* was acclaimed at the *Salon d'Automne* of 1905 and purchased by Count Harry Kessler, who became his patron and with whom he travelled to Greece in 1908. He received a number of commissions for monuments – to Auguste Blanqui, to Paul Cézanne, to Claude Debussy, and for municipal monuments for the cities of Céret, Port-Vendres, Elne, and Banyuls, all in his native region. He also illustrated several books. In 1939 he retired to Banyuls, where he worked until his death in September 1944. In 1964 eighteen of his works were placed in the Jardin du Louvre to form the new Musée Jardin Maillol.

30.
Aristide Maillol
Woman with a Crab c. 1905
Terracotta: H. 17.1 cm
Art Gallery of Ontario. Gift of Sam
and Ayala Zacks, 1970

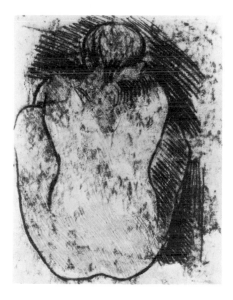

Fig. 25
Paul Gauguin
Crouching Tahitian Woman Seen from the Back 1901–02
Traced monotype: 31.7 × 26.6 cm
Private Collection

The sculpture of Maillol, like that of Renoir to whom he owed much, has a timeless, classical serenity that is far removed from the theme of this exhibition. This work is included to illustrate Gauguin's influence on the younger sculptor. As Richard Field has pointed out, *Woman with a Crab* was based on the Gauguin monotype of 1901–02, *Crouching Tahitian Woman Seen from the Back* (fig. 25), which Maillol himself owned.[1] He was deeply impressed by Gauguin's Brittany paintings. Maillol exhibited his tapestries in Paris in 1892 and in Brussels the following year, and on the latter occasion Gauguin admired his work.

Maillol must have been familiar with the various media in which Gauguin worked: oil, wood, ceramics, woodcuts, and monotypes. In the summer of 1904 Maillol took Derain and Matisse to visit Daniel de Monfreid's Gauguin collection at his house in the south of France, at which time they would have almost certainly seen the carvings that de Monfreid owned (see No. 29).

In *Woman with a Crab* the proportions of the squatting figure are much fuller than those of the Tahitian woman in Gauguin's monotype. The legs are not held in close to the body but are splayed out, with the upper portion of the body leaning forward between them. Maillol's borrowings from Gauguin did not include those primitive and decorative aspects of Oceanic art that had fascinated the great Post-Impressionists. It was the poses and

the heavy-set Polynesian women in Gauguin's paintings that appealed to Maillol. George Heard Hamilton has remarked on the striking similarity between *La Méditerranée* of 1902–05, one of Maillol's greatest bronzes, and the foreground figure in Gauguin's 1891–92 *Aha Oi Feii (What? Are You Jealous?)* in the Hermitage Museum, Leningrad.[2]

The date of this sculpture is difficult to establish with certainty. A bronze of the subject was dated about 1905 in Andrew Carnduff Ritchie's Albright Art Gallery catalogue of the 1945 Maillol exhibition. John Rewald dated another terracotta version of this work as about 1930.[3]

1. Richard S. Field, *Paul Gauguin: Monotypes* (Philadelphia: Philadelphia Museum of Art, 1973), p. 101.

2. George Heard Hamilton, *Painting and Sculpture in Europe 1880–1940* (Harmondsworth: Penguin Books Ltd., 1967), p. 97.

3. John Rewald, *Maillol* (London: Hyperion Press, 1939), pp. 108–109 and 166.

Auguste Rodin 1840–1917

French sculptor, draughtsman, and designer Auguste Rodin was born in Paris, son of a modest employee at the Préfecture de Police. From 1854 to 1857 he studied at the Petite Ecole (Ecole impériale spécial de Dessin et de Mathématiques) under Lecoq de Boisbaudran. He failed three times to gain entry to the Grande Ecole (Ecole des Beaux-Arts), and worked as an ornamentalist, moulder, sculptor's assistant, and designer for goldsmiths and cabinetmakers. From 1864 to 1870 he worked at Sèvres under Carrier-Belleuse and followed him to Brussels in 1871. He remained in Belgium until 1877, earning his living doing mainly decorative sculpture and continuing his own research in his free time. In the winter 1875–76 he travelled in Italy, where "Michelangelo helped him to free himself from academism."

In 1877 Rodin exhibited *The Age of Bronze* in Brussels and Paris; when he was accused of having worked with the aid of a life-cast, well known artists came to his defence. The controversy benefited him, for in 1880 he was commissioned by the state to make the monumental bronze doorway for the planned Musée des Arts Décoratifs. Known as *The Gates of Hell*, the project was never completed; it contained nearly 200 figures, many of which were used by Rodin as the source for individual sculptures. Many other commissions followed, but seldom met with unanimous approval; some were refused, others were not installed for many years. In 1889 he shared an exhibition with Monet at the Galerie Georges Petit, Paris. In 1900, during the Universal Exposition, Rodin organized a highly successful large retrospective of his own work in a pavilion at the Place de l'Alma.

From then on he had an international reputation, which brought him commissions for monuments and portrait busts. He enjoyed sketching dancers, acrobats, or the spontaneous gyrations of inspired studio models and Cambodian religious rituals. He donated the works in his possession to the French State to form a Musée Rodin. He died in Meudon on November 17, 1917.

31.
Auguste Rodin
Hanako Head Type A 1907
Bronze: H. 17.5 cm
Signed and dedicated behind the
hair: *à l'Admirable et/géniale artiste/
Loïe Fuller/A. Rodin*
Musée Rodin, Paris

The Japanese actress Ohta Hisa
(1868–1945), known as Hanako,
was, according to Monique Laurent,
Curator of the Musée Rodin, the
only exotic model Rodin represented
in sculpture. Numerically, the fifty-
three studies of Hanako in the Musée
Rodin represent the most important
group of sculptures based on a single
model. In any study of the Hanako
portraits, an essential work of refer-
ence is the exhibition catalogue,
Rodin et l'Extrême-Orient (Paris:
Musée Rodin, 1979).

On the occasion of the Colonial
Exposition, Rodin met Hanako
briefly in Marseille. He had followed
King Sisowath (see No. 36) and his
Cambodian dancers there from Paris,
where he had first seen them
perform in the Bois de Boulogne on
July 10, 1906 (see Nos. 37, 38, 39,
40). He left for the French port with
the intention of representing Hanako
as she appeared on stage at that
terrifying moment when she is about
to kill herself with a dagger.

Although it is usually suggested
that Hanako began posing for Rodin
in 1908, Monique Laurent has
convincingly shown that the sessions
began in 1907 and lasted intermit-
tently until 1911. Of the seven types
of masks and heads, assigned the
letters A to G in the catalogue *Rodin
et l'Extrême-Orient*, four are included
in this exhibition.

The fact that Rodin gave a plaster
version of Type A, dedicated and
signed 1907, to his friend John
Marshall suggests that from the
beginning the sculptor "concentrated
on the gamut of expressions inspired
by anguish which he translated by
the knitted eyebrows, by squinting,
and by the subtle working of the clay,
slightly prodded, and by the open
mouth."[1] Rodin's biographer, Judith
Cladel, who watched him working on
some of the heads, must have been

referring to studies such as this one
when she wrote:

Hanako did not pose like other
people. Her features were con-
tracted in an expression of cold,
terrible rage. She had the look of a
tiger, an expression totally foreign
to our occidental countenances.
With the force of a will which the
Japanese display in the face of

death, Hanako was enabled to
hold this look for hours.[2]

1. Musée Rodin, *Rodin et l'Extrême-
Orient* (Paris: 1979), p. 27. Trans-
lated by A.G.W.

2. John L. Tancock, *The Sculpture of
Auguste Rodin, The Collection of the
Rodin Museum, Philadelphia*
(Philadelphia: Philadelphia Museum
of Art, 1976), p. 546.

32.
Auguste Rodin
Hanako Grand Mask Type D 1908
Bronze: H. 55.0 cm
Signed: A. Rodin
Musée Rodin, Paris

expressing savagery as well as serenity, agony or mystery. . . . There emanated from Hanako such energy and interior emotion that Rodin was led beyond physical resemblance to use this face as the embodiment of great forces. He dreamed of using it to personify Beethoven.[1]

A terracotta of Type D was given to Hanako after Rodin's death. The fact that a clay or plaster version of Type D was one of the two heads of Hanako that Steichen photographed in 1908 (No. 41) underlines the importance of this facial type.

Toward the end of his life Rodin enlarged two of the Hanako portraits, this one and Type C, and also the head of one of the Burghers of Calais, *Colossal Head of Pierre de Wiessant*, in about 1889, and the *Large Head of Iris* in 1890–91. In enlarging these heads far beyond a human scale, Rodin anticipates Bourdelle's large 1901 *Portrait of Beethoven*, Picasso's colossal bronze heads of 1932 (No. 54), and Giacometti's *Monumental Head* of 1960.

The largest of the three versions of Type D shown in the 1979 Musée Rodin exhibition, this head is undoubtedly the famous "*Tête d'angoisse de la mort*," representing that facial expression and state of mind that had fascinated Rodin when he saw Hanako for the first time in Marseille in 1906. The sittings for the portraits lasted for approximately twenty minutes. Hanako often complained of tired eyes, the result of first rehearsing facial expressions in front of a mirror and then posing for the sculptor. What prompted Rodin to execute the proliferation of studies of Hanako was, Monique Laurent has written,

the expressive intensity of an exceptional model, capable of

1. Musée Rodin, *Rodin et l'Extrême-Orient* (Paris: 1979), p. 25. Translated by A.G.W.

79

33.

Auguste Rodin
Mask of Japanese Actress Hanako
[Type E] c. 1908
Bronze: H. 17.5 cm
Signed sinister side of neck and
inside sinister side in relief: A. Rodin
The Cleveland Museum of Art. Gift
of Garrie Moss Halle in memory of
Salmon Portland Halle

After the ferocious intensity of Types
A and D (Nos. 31, 32), Types E and
G recall the last lines of Milton's
poem *Samson Agonistes*: "And calm
of mind all passion spent." The fact
that Hanako was given a bronze cast
of this facial type at the same time
she received a plaster of the *Tête
d'angoisse de la mort* (see No. 32)
suggests that Rodin had selected for
his model works representing the
two extremes of facial expressions.
Hanako's account of the circumstan-
ces that gave rise to the serenity and
calm of Type E is summarized by
Monique Laurent:

> During a walk to relax between
> sittings for the tragic head
> [No. 32] Rodin was struck by the
> dreamy expression ["*l'expression
> vaguement rêveuse*"] of the
> Japanese and would capture it in
> this mask, hurriedly executed, and
> called *Tête de la rêverie* or *Rêverie
> de Hanako*.[1]

Five versions of Type E in terracotta,
plaster, bronze, and *pâte le verre*
were shown in the 1979 Musée Rodin
exhibition; this bronze would appear
to be close to or one of the edition of
that exhibition's catalogue No. 20.
Whereas some of the Hanako studies
were never cast in Rodin's lifetime
(see No. 34), this one was cast before
the sculptor's death in 1917, as was
the cast formerly in the Musée du
Luxembourg, now in the Musée
Rodin.

1. Musée Rodin, *Rodin et l'Extrême-
Orient* (Paris: 1979), p. 34. Trans-
lated by A.G.W.

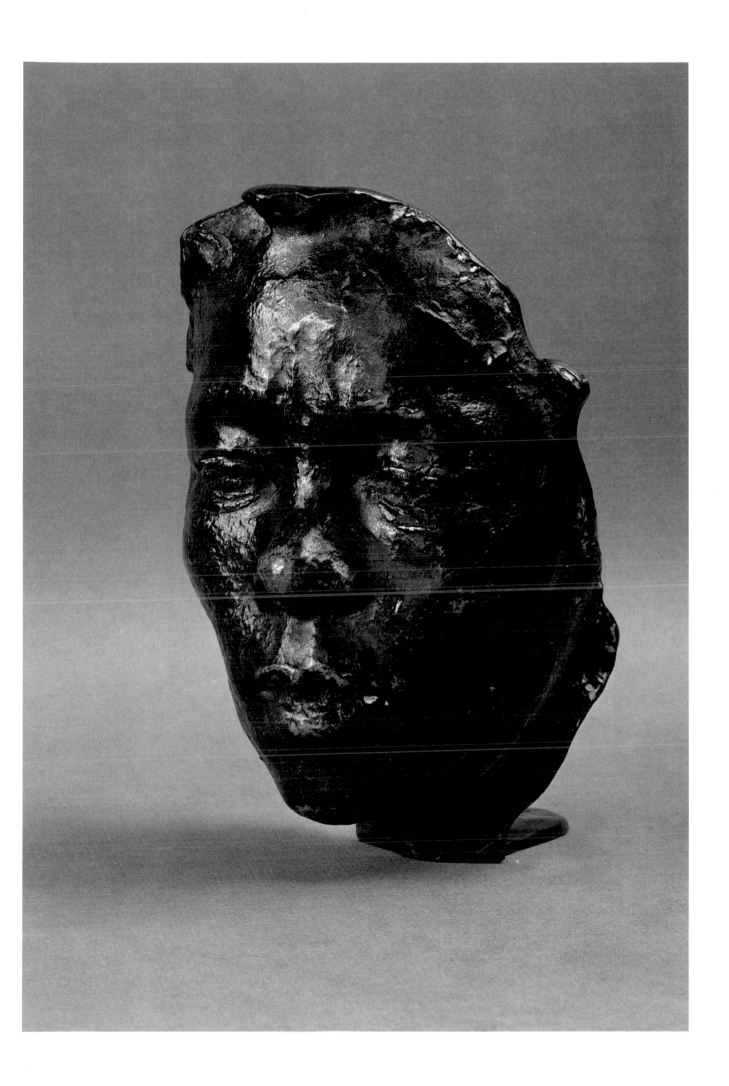

34.
Auguste Rodin
Hanako Mask Type G 1907–08
Bronze: H. 15.5 cm
Signed under left ear: A. Rodin; cast
by Musée Rodin 1963, No. 0
Musée Rodin, Paris

In this beautiful little mask, the calm
features and far-away look are akin to
those in the slightly larger Cleveland
version representing a relaxed
expression (No. 33). Nowhere is
Rodin's practice of making many
versions of a single subject better
illustrated than in his portraits of
Hanako. A parallel can be drawn
here with Monet's series of paintings
of haystacks and of Rouen Cathedral,
in which he sought to portray the
changing effects of light on a given
subject at different times of day and
in different seasons. Rodin, with
subtle changes in surface modelling,
captured in his Hanako portraits the
changing psychological states of his
model.

As Judith Cladel perceptively
remarked:

> Rodin practised sculpture the way
> an engraver does etchings – by
> states. So as not to overwork his
> clay by excessive retouching, he
> had casts made and worked anew
> on successive proofs, sometimes
> repeating this operation ten or
> even twelve times.[1]

Monet believed that his haystack
series "only acquire their full value
by the comparison and succession of
the whole series."[2] Similarly, the
subtlety and range of Rodin's
Hanako portraits can only be fully
appreciated when at least part of the
series is seen together.

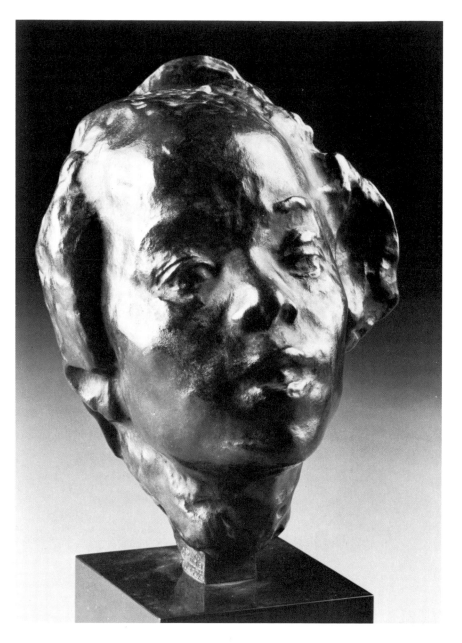

1. Judith Cladel, *Rodin: Sa Vie
 Glorieuse, Sa Vie Inconnue* (Paris:
 Bernard Grasset, 1936), p. 275.
 Translated by A.G.W.

2. Royal Academy of Arts, *Post-
 Impressionism* (London: 1979),
 p. 100.

sculpture.[1] Rodin's own description of Hanako indeed suggests that, characteristically, he was fascinated not only by her range of facial expressions but by her Oriental anatomy:

> She has no fat at all. Her muscles are clean-cut and prominent like those of a fox terrier. She is so strong that she can stand for a long time on one leg with the other lifted at right angles straight in front of her. When like that, she looks as firm as a tree rooted in the ground. Her anatomy is quite different from that of Europeans, but is very beautiful, and has extraordinary power.[2]

35.
Auguste Rodin
Portrait of Hanako between 1906 and 1910
Pencil, watercolour, and gouache:
32.3 × 24.5 cm
Musée Rodin, Paris

This sketch and a watercolour in the Metropolitan Museum of Art, New York, show Hanako in a similar pose. In this charming and spontaneous study, with all the assurance and confidence of an experienced draughtsman, Rodin shows only the head, shoulders, and hands of his model. The hurried pencil lines beneath suggest that the bust is mounted on a block, a feature that appears in a number of portraits of the period such as the 1904 bronze *La France* and the 1905 marble *Miss Eve Fairfax* (Musée Rodin, Paris).

It is known that Hanako posed in the nude for Rodin, and as well as the life drawings of her he may have done several figure studies in

1. Musée Rodin, *Rodin et l'Extrême-Orient* (Paris: 1979), p. 25 and catalogue No. 29.

2. John L. Tancock, *The Sculpture of Auguste Rodin, The Collection of the Rodin Museum, Philadelphia* (Philadelphia: Philadelphia Museum of Art, 1976), p. 546.

36.
Auguste Rodin
King Sisowath 1906
Pencil, watercolour, and gouache:
32.5 × 24.5 cm
Musée Rodin, Paris

37.
Auguste Rodin
Portrait of a Cambodian c. 1906
Pencil and brown, rose, and
blue-gray watercolour washes:
31.5 × 23.6 cm
The Art Museum, Princeton
University (Platt Collection)

Although this drawing has been
identified as a portrait of King
Sisowath, comparison with No. 36
and the four other studies in the 1979
Musée Rodin catalogue suggests
otherwise.[1] Like most of the draw-
ings of the king, this version shows
the face in profile, but depicts, in the
more elongated head and slightly
hooked nose, features distinctly at
odds with the turned-up nose and
rounder head of the king. The
present drawing is almost certainly
one of a group of studies of
Cambodians, and is in fact remark-
ably similar to the figure at left in
Two Profiles of a Cambodian,
No. 102 in the Musée Rodin exhibi-
tion catalogue. J. Kirk T. Varnedue
has suggested that this work is a
tracing of a previous life study.[2]

In 1906, King Sisowath of Cambodia
brought his troupe of eighty dancers
and musicians to France on the
occasion of the Colonial Exposition
in Marseille. They arrived in Paris at
the end of June, and on the evening
of July 10 Rodin saw them perform
in the Bois de Boulogne. Two days
later he went to their Paris hotel and
asked if some of the dancers would
pose for him (see No. 38). It was
probably on that day, according to
Claudie Judrin, that Rodin made his
portrait drawings and watercolours
of the king.[1] In contrast to the
frontality of his drawings of Hanako
(No. 35), four of the five portraits of
King Sisowath in the Musée Rodin
exhibition (including this one) show
him in profile to the left.[2]

1. Musée Rodin, *Rodin et l'Extrême-
Orient* (Paris: 1979), p. 67.

2. *Ibid*, catalogue Nos. 93, 95, 96, 97.

1. Musée Rodin, *Rodin et l'Extrême-
Orient* (Paris: 1979), catalogue
Nos. 93–97.

2. J. Kirk T. Varnedue, *19th and 20th
Century French Drawings from the Art
Museum, Princeton University: An
Introduction* (Princeton, N.J.: The
Art Museum, Princeton University,
1972), p. 70.

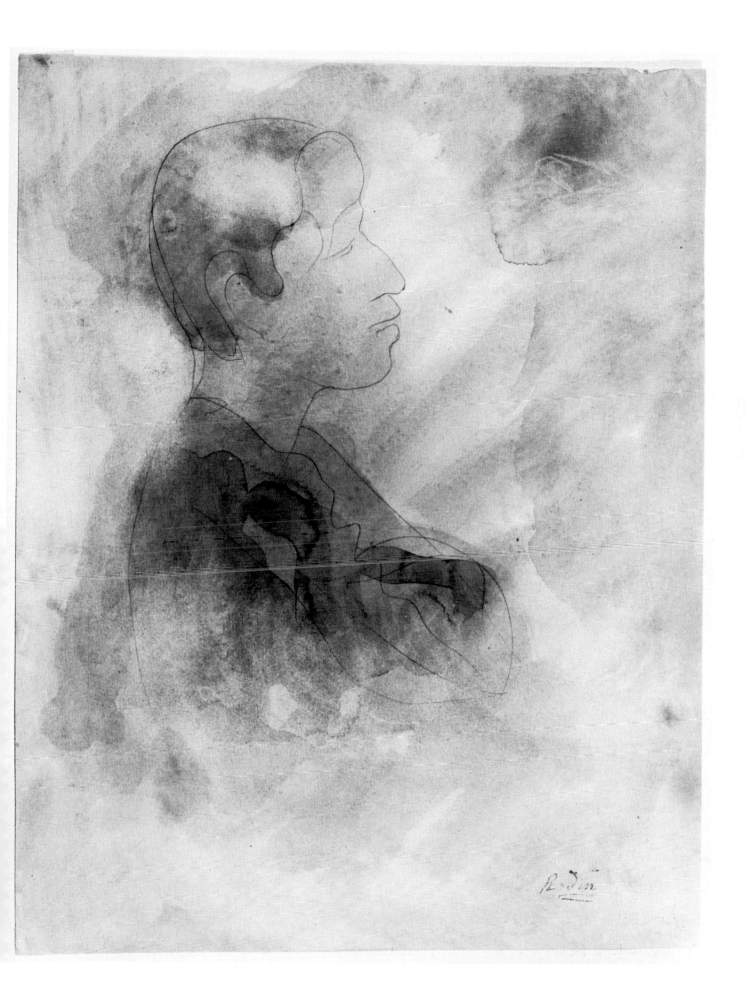

38.
Auguste Rodin
Three Studies of Dancers 1906
Pen and brown ink, watercolour, and
gouache: 34.0 × 21.5 cm
Musée Rodin, Paris

> I contemplated them in
> ecstasy. . . . What emptiness they
> have left in me! When they
> departed, I was left cold and in
> shadow. I thought they had carried
> away the beauty of the world . . . I
> followed them to Marseille.[1]

On July 12, the day he made the
drawings of King Sisowath (No. 36),
Rodin set off on *Le Petit Marseillais*,
probably the same train that brought
the Cambodian dancers back to
Marseille. A detailed account of
Rodin's drawings of Cambodian
dancers appears in the exhibition
catalogue, *Rodin et l'Extrême-Orient*
(Paris: Musée Rodin, 1979), pp.
67–71.

Almost all the studies of standing
dancers show the knees flexed; often
one leg is raised. Rodin noted:

> They have even found a new
> movement unknown to me: the
> staccato shudders that the body
> makes and in which it descends.
> And then, the great resource is
> that they keep their legs continu-
> ally flexed; this permits the leaps
> which they can model as they will
> and grow tall at a given moment.[2]

1. Musée Rodin, *Rodin et l'Extrême-
 Orient* (Paris: 1979), p. 67. Translated
 by A.G.W.

2. Elisabeth Chase Geissbuhler, *Rodin's
 Later Drawings*, with interpretations
 by Antoine Bourdelle, (London:
 Peter Owen, 1963), p. 38.

39.
Auguste Rodin
Cambodian Dancer 1906
Pencil and watercolour:
30.0 × 19.7 cm
Musée Rodin, Paris

Rodin's late works – the portraits of
Hanako, the Cambodian dancers, his
marvellous, compressed little 1911
bronze (cast posthumously),
Nijinsky, and the explosive *mouve-
ments de danse* sculptures of can-can
dancers – were not conceived for the
public domain, as were the great
controversial commissions like *The
Burghers of Calais* of 1884 – 86 and the
Monument of Balzac, completed in
1897. This drawing, showing the
dancer in profile, reflects Rodin's
fascination with the uniquely Orien-
tal movements of the Cambodians.

40.
Auguste Rodin
Cambodian 1906
Pencil and watercolour:
30.5 × 20.4 cm
Musée Rodin, Paris

This work, showing the dancer wearing a pointed headdress, is one of the most heavily worked of all Rodin's many watercolours of the Cambodians. Two studies of hands appear in the right half of the sheet. In his sculpture Rodin had made many studies of hands – both independent works, such as the well known bronze *The Mighty Hand* (*Grande main crispée*) of 1884 – 86 and the stone *The Cathedral* of 1908, and preparatory studies for his figurative work, such as *The Burghers of Calais*. Rodin also made a number of watercolours of the hands of the Cambodian dancers, whose flexible, snake-like movements play such an important expressive role in their choreography. The frenzied swirling and zigzag lines suggest both movement and flowing drapery, yet the body's outline can be clearly read. As Rodin wrote:

Also the articulations of the fingers can be stretched and are very flexible, they have besides, a tremor which is exceptional! Each single finger has its particular movement. The pulleys of the articulations are much more extended for the repetition of movements; and all are cultivated from childhood. . . . Their costume, like all that is beautiful, does not hide a line. It seems one great complication, which it is not, for it allows the line of the nude to be seen.[1]

The late works were the outcome of private passions, and in their sense of abandon and spontaneity, in their lack of the symbolism, sentimentality, and oppressive sexuality of much of his earlier work, these drawings and small sculptures are among Rodin's finest creations.

1. Elisabeth Chase Geissbuhler, *Rodin's Later Drawings*, with interpretations by Antoine Bourdelle, (London: Peter Owen, 1963), p. 38.

M.R
4457

Edward Steichen 1879–1973

This American photographer and painter was born Eduard Jean Steichen in Luxembourg. He went to the USA with his family in 1881. His formal education ended at the age of fifteen, when he began a four-year apprenticeship in a lithographing company. He took his first photograph in 1896; initial recognition as a photographer came at his first public showing in the *Second Philadelphia Salon* in 1899. The next year he went to Paris for the Universal Exposition, where he was impressed by the work of Rodin. He had his first large showing in the exhibition of the *New School of American Photography*, which was held by the Royal Photographic Society in London in 1900, and which travelled to Paris in 1901. His work was included in the Paris *Salon de 1901*.

His first one-man show of paintings and photographs was held at La Maison des Artistes in Paris, from June 3 to 24, 1902. Within a few years he had become prominent in the pictorial movement; he exhibited his photographs in Europe and the United States, and was elected a member of the Linked Ring (1901), the more advanced photographic society of London. In 1902 he became one of the founders of the Photo-Secession, and designed the cover of *Camera Work* (its voice from 1902 to 1917). By midsummer 1902 he had returned to New York, impoverished, and took a studio at 291 Fifth Avenue, which was to become in 1905 The Little Galleries of The Photo-Secession, subsequently known as The 291 Gallery. There he collaborated with Stieglitz to present works of art in all media; he designed the galleries and installations and in 1908 initiated the showing of modern art in America with the exhibition *Drawings by Rodin*, whom he had first met in 1901. Other artists were subsequently introduced – Matisse in 1908, Cézanne in 1910, Picasso in 1911, and Brancusi in 1914. In 1911 he began painting large mural decorations for the home of Mr. and Mrs. Eugene Meyer, Jr.; he concentrated on painting for several years, but in 1922 – after supervising aerial photographic operations for the US army during World War I – he gave up

painting to concentrate on photography and burned all the canvases remaining in the Voulangis studio. In 1924 he experimented with Howard M. Edmunds' machine to make sculpture from photographs. In 1926 he successfully brought suit (financed by Mrs. Harry Payne Whitney) against the US government to prove that Brancusi's *Bird in Space*, which he had purchased from the sculptor, was a work of art. The court ordered the return of duty Steichen had paid. During World War II Steichen served with the US navy. In 1947 he became Director of the Department of Photography of The Museum of Modern Art, New York; to obtain more objectivity in judging the work of others he gave up his own photography. He organized many exhibitions for the museum, including *The Family of Man*, which opened in 1955 in New York and circulated to many countries; in 1959, in his eightieth year, Steichen went to Russia for its opening in Moscow and also visited photographers in Stockholm, Paris and London. In 1961, the retrospective exhibition *Steichen the Photographer* opened at The Museum of Modern Art, New York, and plans were announced for The Edward Steichen Photography Centre in the new building planned for The Museum of Modern Art.

His many awards, degrees, and decorations include the Presidential Medal of Freedom awarded by President John F. Kennedy in 1963. He died on March 25, 1973.

41.
Edward Steichen
Rodin's Portrait of Hanako 1908
Gelatin silver print (modern print by
Rolf Petersen): 24.4 × 20.6 cm
Mrs. Bertram Smith Collection

Among the finest photographs of
sculptors and their work from the
earliest years of the twentieth cen-
tury are those of Edward Steichen.
The most famous are the portraits of
Rodin and the studies of his work –
his large plaster *Balzac* and his
portraits of the Japanese actress
Hanako (No. 33) – as well as the
superb 1909 study of Matisse work-
ing on *La Serpentine* (No. 63).

A year before he photographed
Matisse with his sculpture, Steichen
took his famous series of photo-
graphs of a plaster version of Rodin's
great 1897 *Monument to Balzac*. The
sculptor moved the plaster into a
field near his studio at Menton,
where Steichen photographed it by
moonlight. In the same year,
Steichen made photographs of at
least two of the many versions of
Rodin's portraits of Hanako, of
which four are included in this
exhibition (Nos. 31, 32, 33, 34). The
one shown here is unquestionably
one of the versions of the *Tête
d'angoisse de la mort*, and therefore
closely related to *Hanako Grand
Mask Type D* (No. 32), although it is
probably one of the smaller versions.
The fact that the terrifying realism of
this photograph is so animated and
life-like as to suggest the living
model herself attests to the brillance
both of Steichen as a photographer,
and of Rodin as one of the greatest
portrait sculptors of his time.

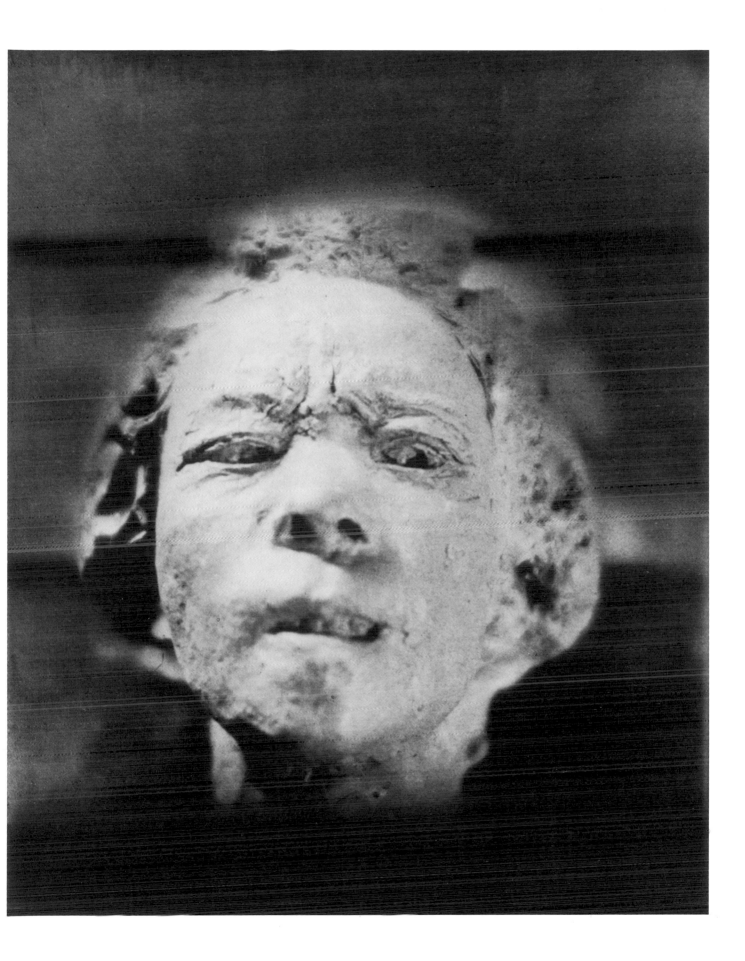

Pablo Picasso 1881-1973

Spanish-born painter, draughtsman, sculptor, printmaker, and ceramist, Pablo Picasso was born in Málaga, the son of an art teacher. He showed precocious artistic talents, and in 1892 his father enrolled him in the School of Fine Arts in La Coruña. In 1895 Picasso was admitted to advanced classes at the School of Fine Arts in Barcelona; starting in the fall of 1897 he studied for a few months at the Royal Academy San Fernando in Madrid. He made his first visit to Paris in 1900 and returned in 1901, when dealer Ambroise Vollard gave him an exhibition in his gallery. In 1906 he saw the exhibition, at the Louvre, of Iberian sculptures recently excavated from Osuna; Gertrude Stein introduced him to Matisse and soon he met Derain and Braque. His interest in primitive art dates from this period, as do his first experiments in Cubism, such as *Les Demoiselles d'Avignon* (1907).

Picasso's first sculpture was done in 1901. Vollard had a series of bronzes cast for him in 1905, and in 1907 Picasso carved some wooden figures inspired by primitive art; in 1909 he produced the faceted bronze *Head of a Woman*. The 1912 *Guitar*, a relief construction in sheet metal and wire, represented a revolutionary departure from traditional modelling and carving and opened the way for constructed sculpture. In his *The Glass of Absinth* of 1914, the original was modelled and the six casts, commissioned by D.H. Kahnweiler, were each painted differently, some with the texture of sand.

Between 1914 and 1928 Picasso almost abandoned sculpture, and designed costumes and sets for Diaghilev's ballets. In 1928 he began a collaboration with Julio Gonzalez, whose technical expertise in modelling metals resulted in several open-form figural assemblages. In the following decades sculpture was an important part of the varied and inventive *oeuvre* of Picasso.

Picasso was not only the most prolific painter, draughtsman, and printmaker of the twentieth century, but also one of the most prolific sculptors, whose extraordinarily varied work in many media – wood, stone, bronze, iron, sheet metal, wire – comprises more than 650 works. His enormous contribution to the development of modern sculpture has come to be appreciated relatively recently, with major exhibitions in Paris, London, and New York in 1966 – 67; with the publication in 1971 of Werner Spies' *Picasso Sculpture with a Complete Catalogue*; and with the two major exhibitions, *Picasso: Oeuvres reçues en paiement des droits de succession*, at the Grand Palais, Paris, in 1979 – 80, and *Pablo Picasso: A Retrospective*, at The Museum of Modern Art, New York, in 1980.

From the late forties Picasso spent most of his time in southern France; he died at Mougins on April 8, 1973.

42.
Pablo Picasso
A Very Beautiful Barbaric Dance
c. 1904 (sketches)
Pen and ink: 40.0 × 29.2 cm
Inscription at bottom: *Une tres belle
danse barbare*
Perry T. Rathbone

Among Picasso's first patrons were the Americans Leo and Gertrude Stein, who had settled in Paris in 1903 and 1905 respectively. At the 1905 *Salon d'Automne*, they acquired Matisse's brilliant Fauve painting *Woman with the Hat* (Private Collection). Soon after, Leo purchased from the dealer Clovis Sagot his first Picasso, *The Acrobat's Family with a Monkey*, now in the Göteborgs Konstmuseum. Sagot then introduced Leo and his sister Gertrude to Picasso, and thus began their frequent meetings at the Steins' *salons* in their apartment in 27 rue de Fleurus.

The Steins' taste embraced not only the work of Matisse and Picasso, the two most significant painters of their generation, but also paintings by Impressionist and Post-Impressionist masters. In 1905, before meeting Picasso, they had acquired two Renoirs, two Gauguins, and two Cézanne figure compositions.

The letter to Leo Stein above the three witty caricatures of dancing figures, possibly representing Picasso's friends, reads as follows:

Mon cher Stein
Nous irons chez vous lundi prochain pour voir les Gauguins et avant pour dejeuner. Beaucoup de amites [sic] pour votre soeur et pour vous. Picasso

Whereas on stylistic grounds the three figure studies would appear to have been made about 1904, the letter obviously was written sometime after Picasso met the Steins in the winter of 1905-06. Both his spelling and construction are somewhat shaky, which makes it very difficult to understand exactly what Picasso is trying to say. Literally, the translation reads: "We will go to your place next Monday to see the Gauguins and before to have lunch. Friendly greetings to you and your sister. Picasso." The tantalizing reference to "les Gauguins" is, in the context of Picasso's very strange and illogical sentence structure, baffling to say the least. Was he referring to the two Gauguin paintings that Stein had acquired in 1905, along with the two Renoirs and two Cézannes? Surely if Stein had written asking him for lunch and to see the Gauguins, he would also have mentioned the other works. And the way the sentence reads, he would have lunch before seeing the paintings. Although Ron Johnson is mistaken in translating this sentence "We shall go with you next Monday in order to see the Gauguins,"[1] it is possible that Picasso meant that he would go first to the Steins' for lunch and then go to see the Gauguins, possibly a reference to the 1906 *Salon d'Automne* Gauguin Retrospective. In any case, this intriguing document provides concrete evidence of Picasso's interest in Gauguin, and his "danse barbare" confirms one of the fundamental concepts of the Post-Impressionist's art and life. "Barbarism," Gauguin had written, ". . . is for me a rejuvenation."[2]

1. Ron Johnson, *The Early Sculpture of Picasso 1901–1914* (New York and London: Garland Publishing, Inc., 1976), p. 64.

2. Robert Goldwater, *Paul Gauguin* (New York: Harry N. Abrams Inc., 1957), p. 40.

Mon cher Stein

nous irons chez vous lundi prochain
pour voir les Gauguins et avant pour
dejuner.

Beaucoup de amitiés pour votre
soeur et pour vous.

Picasso

Une tres belle danse barbare

43.
Pablo Picasso
Head of Woman (Fernande) 1906
Bronze: H. 34 cm
Inscribed on back of sculpture:
Picasso 2/9
Stephen Hahn, Inc., New York

The ten Picasso carvings and bronzes in this exhibition date from the first two major periods of his activities as a sculptor: 1902 to 1914 and 1928 to 1933. As with much of his three-dimensional work throughout his career, the sculptures from the first period are closely allied to his preoccupations as a painter and reflect the influence of Rodin.

In the autumn of 1904, at the Bateau Lavoir in Montmartre, Picasso met the beautiful Fernande Olivier, who was to become his mistress, companion, and frequent model for the next seven years. As Roland Penrose has written:

Her green almond-shaped eyes and regular features, crowned with the wild abundance of her auburn hair, could not be ignored. He spoke to her, and we know from her, as well as from many other sources, of the consequences of this chance meeting, which led to the first important attachment of his life.[1]

She is the subject of this *Head of a Woman (Fernande)* – the most beautiful of Picasso's early portrait sculptures – of the 1906 gouache *Nude with Clasped Hands* (fig. 26), and of the 1909 Cubist *Head of a Woman* (No. 52).

Chronologically, *Head of a Woman (Fernande)* falls mid-way between the 1903 bronze *Head of a Picador with a Broken Nose*, with its Rodinesque modelling, and the chunky, deeply faceted 1909 head (No. 52).

Although the hair and area around the neck reveal gently modelled surfaces, the face itself is smooth, enhancing the mood of reflective tranquility. Whereas the mouth (one of the most sensitive passages in Picasso's early sculpture) and nose are fully worked and complete, there is an obvious discrepancy in the treatment of the eyes. The almond-shaped left eye is blank but for the clearly indicated eyebrow. The right eye is defined only by the lightly incised linear outline. Did Picasso intentionally leave it unfinished? Or did he wish to contrast the two eyes,

Fig. 26
Pablo Picasso
Nude with Clasped Hands 1906
Gouache on canvas: 96.5 × 75.6 cm
Art Gallery of Ontario, Gift of Sam and Ayala Zacks, 1970

as he did in a number of earlier works, particularly in dealing with blindness? Whatever his intentions were, Picasso authorized the casting of this head in bronze. As he explained in another context:

I want to help the viewer discover something he wouldn't have discovered without me. That's why I stress the dissimilarity, for example, between the left eye and the right eye. A painter shouldn't make them so similar. They're just not that way. So my purpose is to set things in movement, to provoke this movement by contradictory tensions, opposing forces, and in that tension or opposition to find the movement which seems most interesting to me.[2]

Although *Head of a Woman (Fernande)* owes nothing to primitive art, the "contradictory tensions" anticipate, granted in a very minor way, the distortions and asymmetry that were soon to erupt in *Les Demoiselles d'Avignon* of 1907. In its classical serenity, this bronze represents a moment of poise soon to be shattered by Iberian and African sources, which were to alter radically the direction of Picasso's work.

1. Roland Penrose, *Picasso: His Life and Work* (London: Victor Gollancz Ltd., 1958), p. 97.

2. Ron Johnson, *The Early Sculpture of Picasso 1901–1914* (New York and London: Garland Publishing Inc., 1976), p. 42.

44.
Pablo Picasso
Kneeling Woman Combing Her Hair
1906
Bronze: H. 41.6 cm
Signed on base at left: Picasso
The Baltimore Museum of Art. The
Cone Collection, formed by Dr.
Claribel Cone and Miss Etta Cone of
Baltimore, Maryland
(B.M.A. 50.452)

Ingres' *Turkish Bath* and Gauguin's
wood relief *Be in Love and You Will
Be Happy* of 1889 (fig. 27) have been
cited as probable sources for this
bronze. According to D.H.
Kahnweiler, it was conceived as a
ceramic in the studio of the sculptor
and ceramist Francisco Durio, whom
Fernande Olivier described as fol-
lows:

> Durio, a small man with a big
> heart and a fine, artistic sensibility,
> had two heroes: Gauguin and
> Picasso. He had been a great
> friend of Gauguin's at the time
> they were both living in the rue de
> la Grande-Chaumière, before
> Gauguin's departure for Tahiti.[1]

It was almost certainly through his
friendship with "Paco" Durio, who
owned an impressive group of
Gauguin's drawings and woodcuts,
that Picasso became familiar with the
work and primitivistic attitudes of
the French painter-sculptor. The
poet Jaime Sabartés has described an
evening walk with Picasso, near the
end of his stay in Paris in 1901:

> The air of the street and the
> conversation with Durio pleased
> Picasso. He showed such interest
> in what Paco was doing that one
> might have thought that he had
> just discovered his sculpture.
> There was much talk about Gau-
> guin, Tahiti, the poem *Noa Noa*,
> about Charles Morice, and a
> thousand other things.[2]

The influence of Gauguin was
already quite evident before this
bronze was executed (see No. 42).
Picasso owned a copy of Gauguin's
Noa Noa (see No. 13) in which he
made his own drawings in 1903.

According to Ron Johnson, Picasso's
first known sculpture, *Seated Woman*
of 1902, derived from Gauguin's
ceramic *Vase in the Form of the Head
of a Woman* of about 1888 – 89.[3]

Kneeling Woman Combing Her Hair
is a transitional piece in which the
psychological themes of Picasso's
earlier work have been replaced by
one of Degas' favourite subjects:
femme a sa toilette. Werner Spies has
suggested that Ingres' *Turkish Bath*,
exhibited publicly for the first time
in the 1905 *Salon d'Automne*, was a
likely source of inspiration: "Ingres
helped him to progress from the
emotionally stressed, psychologically
exaggerated fact to sheer physical
representation: choreographic move-
ments, groping hands, the melodious
music of the body which denotes
nothing beyond itself."[4] For
Johnson, on the other hand, the
relief-like conception, the flowing
hair, and the crouching position are
related to Gauguin's sculpture: "If
the comparison with a specific work
of Gauguin's is to be made, the wood
relief *Be In Love and You Will Be
Happy* [fig. 27] is closest in pose,
style, and subject matter rather than
his ceramics."[5]

By 1907, in the most concentrated
single year of sculptural activity to
date, the primitivistic influences of
Iberian, African, and Oceanic art,
and of the wood carvings of Gau-
guin, are as marked in Picasso's
sculpture as are Iberian and African
sources in *Les Demoiselles d'Avignon*
(fig. 28).

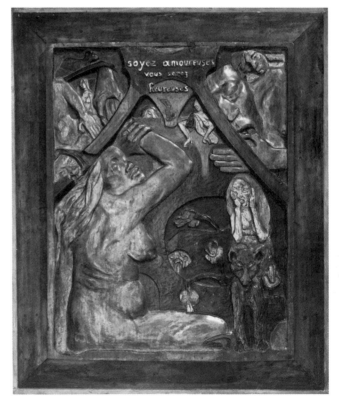

Fig. 27
Paul Gauguin
*Soyez Amoureuses Vous Serez Heureuses
(Be in Love and You Will be Happy)* 1889
Carved, polished, and polychromed
lindenwood: with original frame
119.4 × 96.5 cm
57.582, Arthur Tracy Cabot Fund.
Courtesy Museum of Fine Arts, Boston

1. Fernande Olivier, *Picasso and His
 Friends*, translated by Jane Miller
 (New York: Appleton-Century,
 1965), p. 29.

2. Ron Johnson, *The Early Sculpture of
 Picasso 1901–1914* (New York and
 London: Garland Publishing Inc.,
 1976), p. 48.

3. *Ibid*, p. 46.

4. Werner Spies, *Picasso Sculpture with
 a Complete Catalogue* (London:
 Thames and Hudson, 1972), p. 20.

5. Johnson, *Early Sculpture*, p. 58.

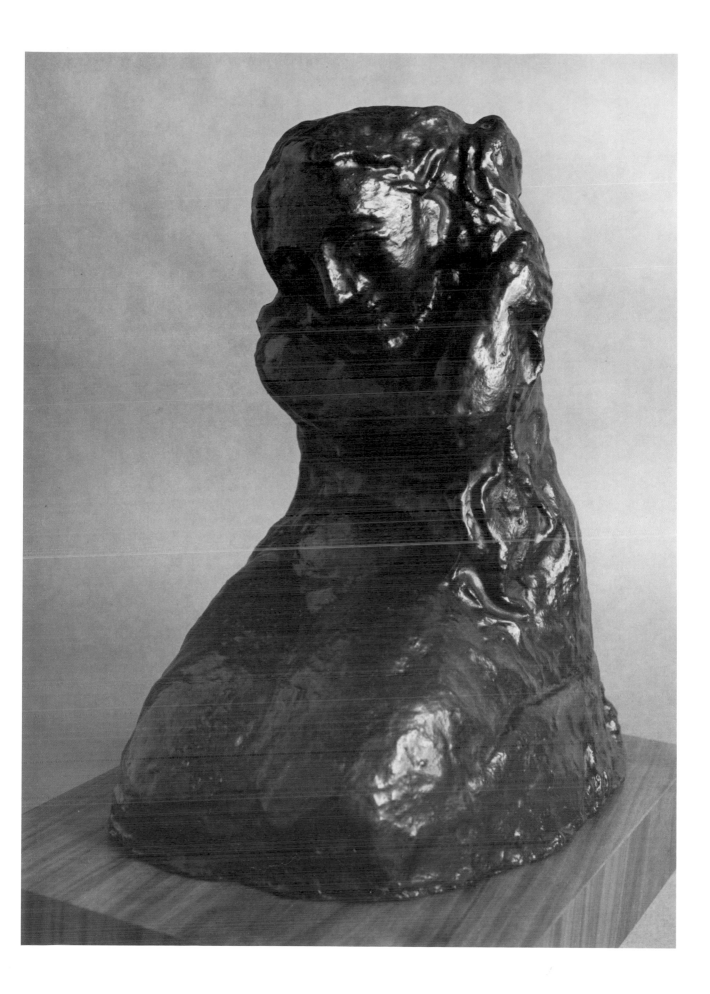

45.
Pablo Picasso
Three Nudes 1907
Beech wood: H. 32.0 cm
Musée Picasso, Paris

Until it was exhibited at the Grand Palais in *Picasso: Oeuvres reçues en paiement des droits de succession* (1979–80), this wooden mirror was unpublished and virtually unknown. It should be added to the group of one bronze, one stone, and seven wood carvings of 1907 in Werner Spies' *Picasso Sculpture with a Complete Catalogue* (1971), of which three are included in this exhibition (Nos. 46, 47 and 49). Both numerically and stylistically, 1907 was undoubtedly the most important year of the decade in the development of Picasso's sculpture.

Professor Ernst Gombrich, in his article "Psycho-Analysis and the History of Art," discusses the interest among the Fauves in the enigmatic forces of primitive art and writes of Picasso:

> And so it is to Negro masks and African fetishes that he turns. But even in this guise there was still some sentiment. If I am right in my interpretation, it is not before he abandons for a time his own medium, which had become so fatally easy for him, not before he takes to carving, where he can exploit his lack of skill, that he can find the way to the regressive forms from which all trace of Bouguereau had been expelled and which therefore made such an impression on his time.[1]

All but two of the ten known sculptures of 1907 were carved in wood. Picasso probably saw this material as an obvious one in which to translate some of the formal influences from Gauguin's wood carvings and from African and Oceanic art. While it is difficult to establish a chronology for the carvings of 1907, *Three Nudes* and *Standing Nude* (No. 47) are related to a number of datable paintings of the period. Whereas the three other 1907 carvings in this exhibition (Nos. 46, 47, 49) reflect Picasso's

complete assimilation of primitive forms, *Three Nudes*, is a transitional work between the famous 1906 *Portrait of Gertrude Stein* (The Metropolitan Museum of Art, New York)– in which he repainted the face, giving her features something of the mask-like character of the Iberian bas-relief *Negro Attacked by a Lion* – and *Les Demoiselles d'Avignon* (fig. 28) of 1907.

Like *Les Demoiselles*, this carving may ultimately derive from Cézanne's bather compositions, such as the 1879–82 *Three Bathers* owned by Matisse, which Picasso must surely have seen by early 1907. The features of the seated male (?) figure at right in *Three Nudes*, with the large rose flattened against the face, reflect – as do the heads of the two central figures in *Les Demoiselles* –

who had stolen them from the Louvre.[2] In *Les Demoiselles*, as John Golding has pointed out, the new features of the heads of the two central figures "are to be found in two Iberian stone heads of a different type, one of a man and one of a woman, which entered Picasso's possession in March 1907."[3]

The fact that the head of the figure at right in *Three Nudes* is close to the central figure in *Les Demoiselles* and to a number of related works from the spring of 1907 suggests that this carving was made in the spring of 1907 – before, in early July, under the influence of African sculpture, Picasso repainted the heads of the two figures at right in *Les Demoiselles*. Also to support this opinion, the central standing nude with the high, pinched waist is

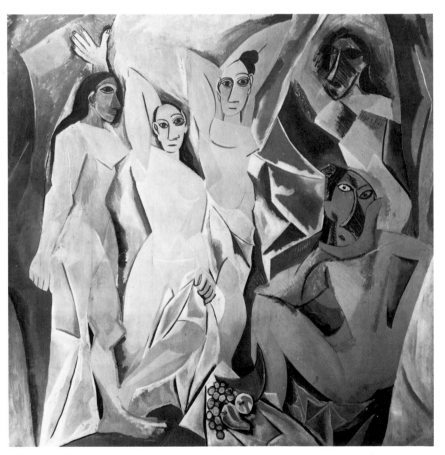

Picasso's continuing interest in Iberian sculpture. In the spring of 1906 a series of Iberian reliefs from Osuna were exhibited at the Louvre, and Picasso saw them before leaving for Barcelona in May. In March 1907 he bought two Iberian heads from Apollinaire's secretary, Géry-Piéret,

Fig. 28
Pablo Picasso
Les Demoiselles d'Avignon 1907
Oil on canvas: 243.9 × 233.7 cm
The Museum of Modern Art, New York
Acquired through the Lillie P. Bliss Bequest

related to an oil study for *Les Demoiselles* entitled *Full-Length Nude*, from the spring of 1907 (Private Collection).

The unfinished seated figure at left provides fascinating evidence of Picasso's working method in this relief carving. He may well have drawn the basic outline of the figure, as he did in another wood sculpture of 1907 entitled *Figure* (Musée Picasso), and then proceeded to the first cut around this outline before gently carving the entire surface of the body, as in the other two figures.

While the three-figure composition may be indebted to Cézanne and the heads to Iberian sources, the shallow relief carving may well have been inspired by Gauguin's sculpture, which Picasso almost certainly saw in the great 1906 retrospective at the *Salon d'Automne*,

at which Nos. 10 (?), 12 and 14 in this exhibition were shown. In May or June 1907 Picasso visited the ethnographic collections at the Palais du Trocadéro (now Le Musée de l'Homme); the impact of this contact with Oceanic – but above all African – art was soon to be realized in the heads of the two figures at right in *Les Demoiselles*.

1. E.H. Gombrich, *Meditations on a Hobby Horse* (London: Phaedon Press, 1963), p. 42.

2. For an account of this bizarre incident see John Golding, *Cubism: A History and an Analysis 1907–1914* (London: Faber and Faber Ltd., 1968), p. 53, footnote 1.

3. *Ibid*, p. 53.

46.
Pablo Picasso
Poupée 1907
Polychromed wood with traces of
paint and metal eyes: H. 26 cm
Art Gallery of Ontario. Purchase
1980

In a certificate signed by Picasso and
dated 28.2.1955, he wrote: "*Cette
poupée a ete faite pour Memene
Forrerod (Madame Masson).*"[1] In
another document, dated 25.7.64, he
authorized a bronze edition of twelve
to be cast from the original wood
carving now in the Art Gallery of
Ontario. On a photograph of the
wood *Poupée* he wrote: "*Ce bois est
de moi Picasso vers 1907 le 25.7.64.*"[2]

While Iberian and African art are
the two major primitive influences

Fig. 29
Marquesas Islands (Polynesia)
Tiki
Wood
Ex-collection Picasso

on Picasso's paintings of 1906–07,
this work and its pendant, the 1907
painted wooden *Figure*, reveal the
impact of Oceanic sculpture, in
particular the squat, block-like
forms of Marquesan *tikis* that Gau-
guin had incorporated in many of his
wood carvings (see Nos. 10, 11, 15).
According to D.H. Kahnweiler,[3] in
1907 Picasso owned a large Mar-
quesan *tiki* (fig. 29) which, with the
characteristic large head and with
hands placed on the stomach, is
typical of this distinctive style.

Picasso's interest in Oceanic art
may well have been stimulated by the
Gauguin carvings that he probably
saw in the 1906 *Retrospective*, which
included Gauguin's great toa wood
sculpture, *Wood Cylinder with Christ
on the Cross* (No. 10), incorporating

many Marquesan motifs. The circular metal eyes could have been suggested by countless examples of primitive art, such as the Fang *Reliquary Head* in the Musée National des Arts Africains et Océaniens, Paris (fig. 30). In common with the carvings of Gauguin and with much primitive sculpture, Picasso painted *Poupée* (only faint traces remain) and two other 1907 wood carvings in this exhibition (Nos. 47 and 49).

Because the sculpture is top-heavy and does not stand upright on the small feet, the hole at the back of the head may be an indication that Picasso intended this work to be hung on a wall. A photograph of Picasso taken about 1908 shows two New Caledonian figures hanging on his studio wall. If this was Picasso's intention it was, as Ron Johnson has suggested, "one of the more radical steps in breaking down distinctions between painting and sculpture in

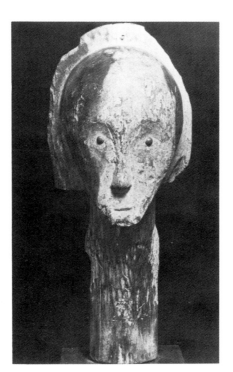

Fig. 30
Fang (Gabon)
Reliquary Head
Wood and metal eyes: H. 35.5 cm
Musée National des Arts Africains et
Océaniens, Paris

mode of display,"[4] and anticipates the sheet metal and wire *Guitar* of 1912 (The Museum of Modern Art, New York) and later Cubist constructions.

The fact that there are no paintings related to *Poupée* makes it difficult to date this work with any precision. Given its close stylistic affinities with Marquesan sculpture, perhaps with Gauguin's carvings as an intermediary, it was probably made before Picasso's discovery of African art at Trocadéro in May or June of 1907.

1. Information supplied by M. Knoedler & Co., Inc., New York.

2. *Ibid*.

3. Ron Johnson, *The Early Sculpture of Picasso 1901–1914* (New York and London: Garland Publishing Inc., 1976), p. 71.

4. *Ibid*, p. 72.

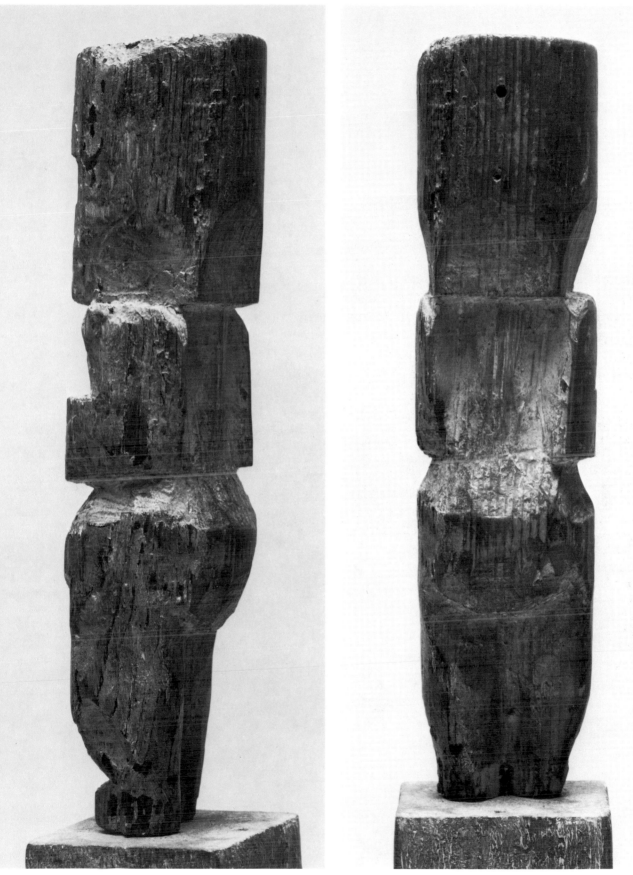

No. 46 b No. 46 c

47.
Pablo Picasso
Standing Nude 1907
Fruitwood, painted: H. 31.9 cm
On back: engraved and painted birds
Musée Picasso, Paris

In 1907 Picasso began his revolutionary break with the past, which would soon drastically alter the course of Western art. This carving, more than any other sculpture of 1907, is stylistically so closely related to a number of paintings and works on paper as to allow more accurate dating within that year. The enormous head, like that of the figure at right in *Three Nudes* (No. 45), reflects the influence of Iberian sculpture, while the treatment of the breasts, abdomen, and legs relates closely to studies for *Les Demoiselles* (fig. 28) from the spring of 1907 and to *Nude with Drapery* (The Hermitage) from the summer of that year.

In *Standing Nude* the way in which the arms, breasts, abdomen, and legs are treated – as clearly defined separate units – as well as the shape of the abdomen and the arched lower left leg are features found in *Female Nude with Raised Arms* (Private Collection) from the spring of 1907, one of the studies for the figure at right in *Les Demoiselles*. Another feature common to both works is the way in which one side of the buttock is (as in Braque's *Nude* of 1907 – 08) pulled around from behind; it is even more pronounced in *Standing Nude*, where the abdomen and head are shown frontally. Although the arched leg and buttock are treated in a similar manner in Picasso's great painting *Nude with Drapery* (summer 1907), by this time the mask-like face and the striations on both body and background clearly reflect an awareness of Kota reliquary figures from Gabon. The fact that these striations, which obviously obsessed Picasso in the many studies for *Nude with Drapery*, do not appear in *Three Nudes* (No. 45), and that the face in *Standing Nude* does not reflect African masks, would suggest that this carving dates from the spring or early summer of 1907. In this work, therefore, Picasso is experimenting in relief sculpture with many of the problems that occupied him in the initial stages of *Les Demoiselles d'Avignon*.

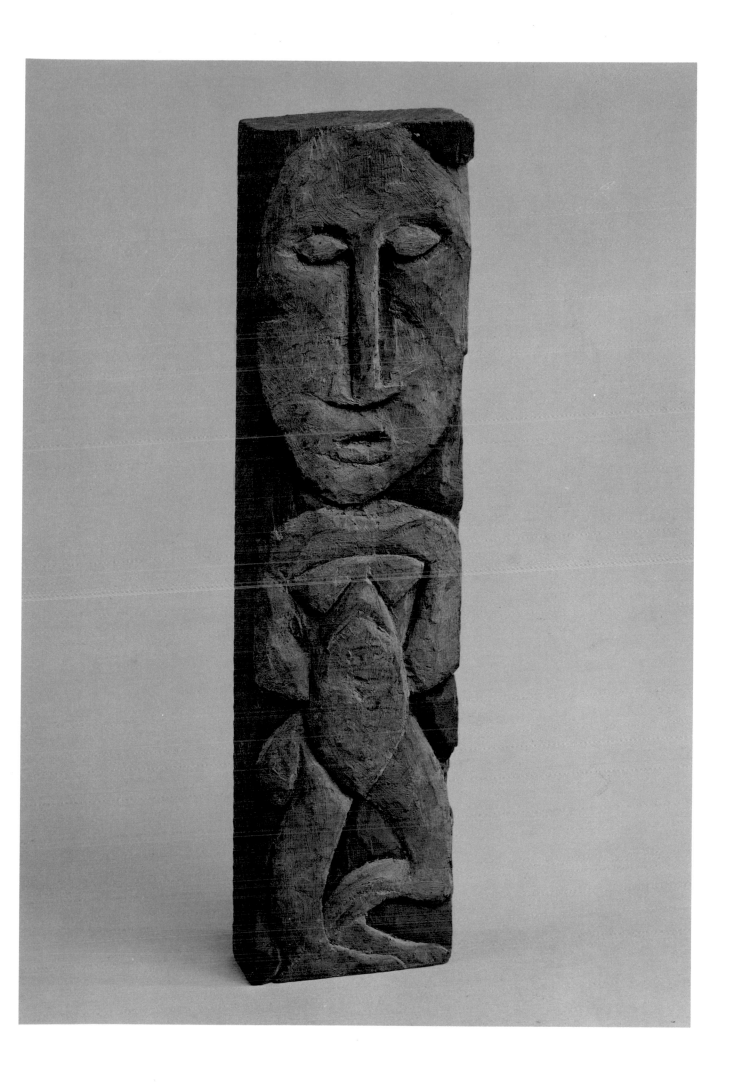

48.
Pablo Picasso
Study of Standing Nude 1907
Brush and ink: 30.2 × 19.0 cm
The Chrysler Museum, Norfolk,
Virginia. Gift of Walter P. Chrysler,
Jr.

Les Demoiselles d'Avignon of 1907 (fig. 28) marks not only the rudimentary beginning of Cubism, but also the sudden and explosive impact of African art. The heads of the two figures on the right of the canvas, which were repainted in early July after Picasso's visit to the ethnographic collections of the Trocadéro, are a dramatic manifestation of that impact. There are at least seventeen compositional sketches for this painting as well as many individual figure studies, such as this *Study of Standing Nude*, which is clearly related to the central nude in *Les Demoiselles*.

One of the earliest compositional studies would appear to be the early 1907 *Medical Student, Sailor and Five Nudes in a Bordello* (Kunstmuseum,

Basel). As Picasso explained in 1939, the central clothed figure is a sailor surrounded by five nude women. The moral implication of the man entering from the left carrying a skull, a kind of *memento mori*, is excluded in the final version, which retains only the three nudes in the right half of the Basel study. In the standing nude at centre, behind the seated sailor, the rounded, sensuous outlines recall the rhythms of the figure at the extreme left of Matisse's 1905–06 *Bonheur de vivre*. In the central figure in the definitive compositional sketch, *Five Nudes (Study for Les Demoiselles d'Avignon)* of May 1907 (Philadelphia Museum of Art), the short, sometimes overlapping curved lines in the Basel study give way to a bolder, more angular

treatment, particularly in the elbow, left breast, and in the two straight lines forming a ninety-degree angle at the hip (fig. 31).

The fact that the angularity of the elbows, breasts, hips, and knees in *Study of Standing Nude* is stylistically so closely related to the same figure in the Philadelphia watercolour suggests a similar date – that is, May 1907. The oval face and prominent ear probably reflect Picasso's continued interest in Iberian sculpture, which inspired him in the autumn of 1906 to repaint the face in his *Portrait of Gertrude Stein* (The Metropolitan Museum of Art, New York) and which informed the heads of the two central figures in *Les Demoiselles*.

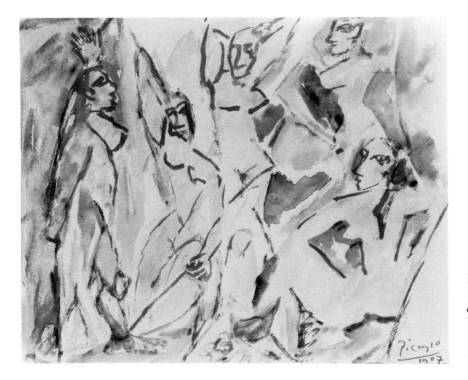

Fig. 31
Pablo Picasso
Five Nudes (Study for Les Demoiselles d'Avignon) 1907
Watercolour: 17.2 × 22.2 cm
Philadelphia Museum of Art:
A.E. Gallatin Collection

49.
Pablo Picasso
Standing Man 1907
Painted wood: H. 37 cm
Private Collection

Unlike the 1907 *Poupée* (No. 46), *Standing Man* does not appear to be closely allied to a specific style of primitive art. The short, rounded, plump legs echo any number of African carvings, while the disproportionately large head with concave face echoes Fang dance masks (fig. 32), as well as similar faces found in Oceanic art. Ron Johnson, on the other hand, suggests that this sculpture derives from Gauguin's large wood carving *Saint Orang* (fig. 33), which was exhibited at the 1906 retrospective and later was owned by the dealer Ambroise Vollard.

 Picasso not only follows Gauguin's figure in general structure, proportions, and in the treatment of the surface but in particular characteristics of the figure such as the unusual ears. The yellow colour of the *Standing Man* is also attributable to Gauguin with additional reinforcement from the Fauves. Solid yellows, browns, or ochers are applied to many of Gauguin's wood carvings and in even more dramatic contrasts in the paintings of the Fauves.[1]

Like Picasso, the German Expressionists Kirchner and Schmidt-Rottluff painted many wood sculptures in reds, greens, yellows, and blues (see Nos. 88, 89, 90).

 Of all Picasso's wood carvings of 1907, *Standing Man*, the most frankly primitive, is the one that could most easily be mistaken for a genuine example of primitive art, even though it is difficult to suggest a specific prototype. If indeed the sculpture was inspired by Gauguin's

Fig. 32
Fang (Gabon)
Dance Mask
Wood: H. 54.6 cm
Private Collection

Saint Orang, the obvious differences, particularly the concave face, suggest that Picasso had also assimilated the formal qualities of African art and that this work, like the two repainted heads in *Les Demoiselles*, was made after his visit to the Trocadéro in May or June 1907.

Fig. 33
Paul Gauguin
Saint Orang c. 1900–03
Wood: H. 94.0 cm
Musée d'Orsay (Galerie du Jeu de Paume)

1. Ron Johnson, *The Early Sculpture of Picasso 1901–1914* (New York and London: Garland Publishing Inc., 1976), p. 67.

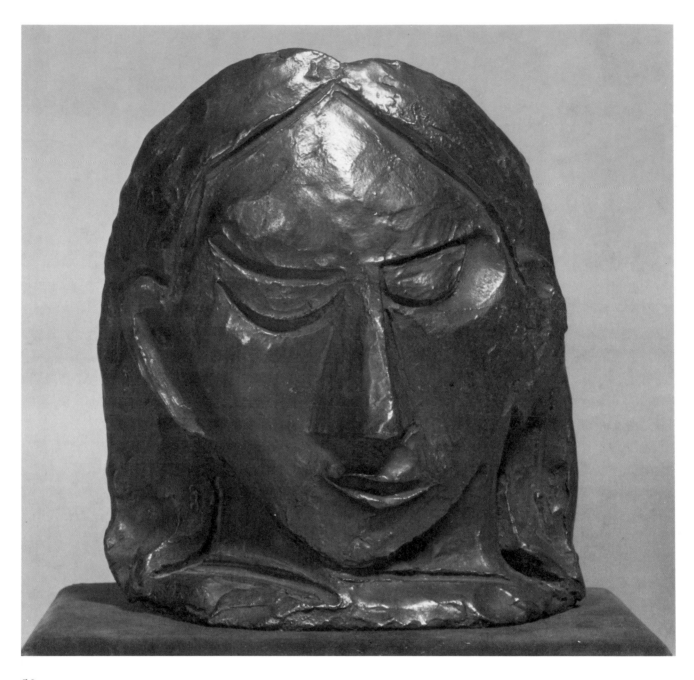

50.

Pablo Picasso
Mask of a Woman 1908
Bronze with paint: H. 18.3 cm
Inscribed rear centre: Picasso 5/6
1908
Hirshhorn Museum and Sculpture
Garden (Smithsonian Institution)

Mask-like faces were the subject of many of Picasso's figurative paintings in the winter and spring of 1908. As John Golding has remarked,

> Picasso approached Cubism, however, primarily through his interest in analyzing and investigation of the nature of solid forms.

This more sculptural approach can be seen in the second kind of Negroid painting. In fact, some of the canvases of this type have almost the appearance of being paintings of sculptures and masks.[1]

The narrow, elongated almond-shaped heads of 1907 were replaced in 1908 by broader faces less obviously African in inspiration (see also the drawing of a mask in No. 51). In this mask, the deep asymmetrical incisions around the eyes recall Picasso's statement (quoted in No. 43) that it was his intention to provoke movement by contradictory tensions. As in many works of 1907–08, the mask is also asymmetrical, with a wider plane on the right side, and the chin not in line with the mouth. The closeness of this mask to a number of works from early 1908, such as the gouache *Head of a Woman*, suggests that this sculpture is contemporary with it.

1. John Golding, *Cubism: A History and an Analysis 1907–1914* (London, Faber and Faber Ltd., 1968), p. 61.

51.
Pablo Picasso
Mask and Two Nudes 1908
Pen and ink: 30.5 × 47.0 cm
Signed lower left: Picasso
Marlborough Fine Art (London)
Ltd.

This brilliant example of Picasso's genius as a draughtsman shows, at centre, the unhesitating confidence and directness in the mask-like face, and, on either side, two nude studies that reveal the tentative exploratory outlines, shading, and *pentimenti*. The mask is related to the series of heads from the spring of 1908, in which the striated, almond-shaped heads of the previous year have been superceded by broader, simplified planes and curves. In this drawing, the way in which the heavily shaded eyes are deeply recessed beneath the forehead, and the way in which the top of the forehead ends abruptly, relate this mask to a work such as the painting *Head of a Man* (spring 1908) in the Kunstmuseum, Berne. In the latter, the sides of the head and curved linear top of the forehead give the impression of a mask, similar to the one in this drawing, but covering the face and hair.

The two nude studies are also related to several figure studies done in Paris in the spring of 1908. The featureless face, the proportions of the breasts, and the shape of the left hand of the seated woman at right are closely connected to the gouache *Reclining Female Nude* in the Picasso Estate. The nude at left with her hand on her hip is, apart from the raised right foot, close in pose and proportion to another gouache from the spring of 1908, *Standing Female Nude Turning to the Left* (Musée Picasso).

By the summer of 1908 the influence of Iberian and African art that had dominated Picasso's painting and sculptures for the past two years began to subside. In his work from the summer of that year, spent with Fernande at La Rue des Bois north of Paris, the late work of Cézanne replaces primitive sources, and ultimately leads, in 1909, to the early masterpieces of his analytic Cubist period.

52.
Pablo Picasso
Head of a Woman (Fernande) 1909
Bronze: H. 41.9 cm
Signed on left side of neck: Picasso
Art Gallery of Ontario, Purchase
1949

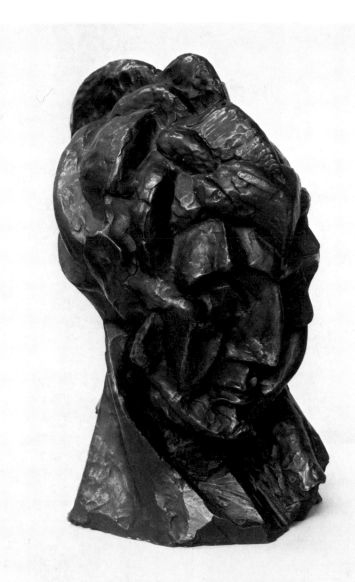

During the summer of 1909, which
he spent in Spain with Fernande
Olivier at Horta de Ebro, Picasso
executed a series of paintings of his
mistress that are a continuation of
the portraits made in the spring of
that year. In his exploration of
sculptural volume, the large, gener-
ally flat planes in the earlier studies
of Fernande are replaced by smaller,
more varied and tightly knit facets
and lumps, which mark the culmina-
tion of the first phase of analytic
Cubism. On his return to Paris in
September, Picasso executed in Gon-
zalez's studio *Head of a Woman
(Fernande)*, unquestionably the most
important early Cubist sculpture.

 This sculpture is so closely related
to his paintings and works on paper
from the summer of 1909 as to
suggest that Picasso may have based
it on one of them, such as Figure 34,
rather than working from the model.
While his interest in African and
Oceanic art and in the sculpture of
Gauguin found expression in the
series of primitivistic wood carvings
of 1907 (Nos. 46, 47, 49), this head
and two small clay and plaster works
of the same year are the only
examples of Picasso's efforts in 1909
to realize, in three dimensions, the
complex and intense pictorial
analysis of solid form. As John
Golding has written,

 He wished to give in his own
 canvases a dimension that in a
 sense already existed in sculpture,
 or at least in free-standing
 sculpture. For clearly one of the
 principal characteristics of
 sculpture in the round is that the
 spectator is able, and is indeed
 often encouraged or compelled, to
 walk around it and study it from
 all angles. In other words, he is
 free to do what Picasso was trying
 to do for him in his painting. This
 is probably why, even when a

'school' of Cubist painting came
into existence, there was at first
very little Cubist sculpture.[1]

And yet his paintings of this period
are so sculptural in character that, as
Picasso told his friend Gonzalez:

 It would have sufficed to cut them
 up – the colours, after all, being no
 more than indications of differ-
 ences in perspective, of planes
 inclined one way or the other – and
 then assemble them according to
 the indications given by the col-

our, in order to be confronted with
a "sculpture."[2]

Ron Johnson has suggested that the
Polish sculptor Elie Nadelman's
Head of a Man, of about 1907, may
have influenced Picasso's Horta de
Ebro paintings as well as this 1909
bronze.[3] He met Nadelman at the
Steins' and, according to Lincoln
Kirstein, visited his studio with Leo
Stein at the end of 1908. Despite the
superficial similarities between *Head
of a Woman (Fernande)* and the Na-

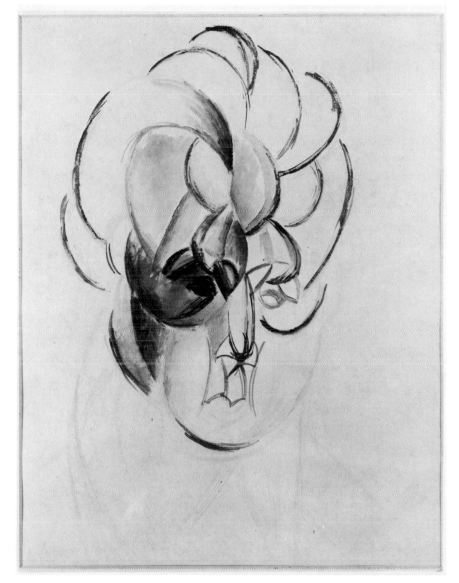

Fig. 34
Pablo Picasso
Head 1909
Brush and ink watercolour:
33.7 × 25.7 cm
The Art Institute of Chicago: Alfred
Stieglitz Collection (Courtesy of the Art
Institute of Chicago)

delman head, the complex faceting
and exploration of volume and space
in Picasso's painting and sculpture of
1909 surely derive from his study of
Cézanne's late work, and not from

the smooth if somewhat angular face
and curly hair of the Polish sculptor's
work.

It is interesting to compare this
bronze with the portrait of Fernande
of 1906 (No. 43). While much of the
powerful modelling is arbitrary and
exaggerated, the mouth and nose are,
in the 1909 version, relatively natu-
ralistic and obviously based on the
close observation of Fernande's fea-
tures. The neck, with its larger,
flatter planes, is closely related to
that of *Woman with Pears (Fernande)*

(The Museum of Modern Art, New
York), painted in the summer of
1909. In both the painting and the
bronze, the head is tilted forward; in
both examples, this expresses more
of the bulging volumes of the hair.
The fact that Picasso could produce a
work of such assurance, and realize
so completely in three dimensions
the complex formal language of his
first analytic Cubist paintings,
underlines the intensely sculptural
nature of his two-dimensional work
of the period. It is as if, as he told
Gonzalez in the statement above, he
had cut up the lumps and planes as
defined by colour in one of his
paintings from the summer of 1909
and re-assembled them, following
the structural logic inherent in them.

1. John Golding, *Cubism: A History and
 an Analysis 1907–1914* (London:
 Faber and Faber Ltd., 1968),
 p. 82–83.

2. Arts Council of Great Britain,
 *Picasso: Sculpture, Ceramics, Graphic
 Work*, an exhibition held at Tate
 Gallery, London, 9 June–13 August
 1967, p. 10.

3. Ron Johnson, *The Early Sculpture of
 Picasso 1901–1914* (New York and
 London: Garland Publishing, Inc.,
 1976), p. 105.

53.
Pablo Picasso
Bather 1932
Bronze: H. 128 cm
Musée Picasso, Paris

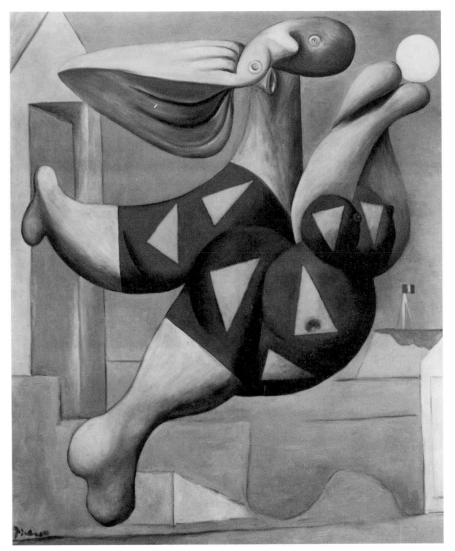

Fig. 36
Prehistoric France
Venus of Lespugue
Plaster cast from original: H. 15.0 cm
Private Collection

Fig. 35
Pablo Picasso
Bather with Beach Ball 1932
Oil on canvas: 146.2 × 114.6 cm
Partial gift and promised gift of Ronald
S. Lauder to the Museum of Modern
Art, New York

After his revolutionary Cubist constructions of 1912–14, Picasso made few sculptures until 1928. Then, with the help of Julio Gonzalez (see No. 112), he began work on his wire constructions of 1928–29, which were to have such a profound influence on the young American sculptor David Smith. In the early 1930s, with the series of wood sculptures all entitled *Woman*, his return to sculpture gathered momentum, culminating in the magnificent 1932 figures and the series of monumental heads inspired by his young mistress, Marie-Thérèse Walter (see No. 54). *Bather* and *Head of*

a Woman were made in the summer of 1932 in Picasso's sculpture studio at the Boisgeloup, near Gisors, which he had acquired in 1931. In *Bather*, the twisting movement of the figure, the small head, the swollen upper abdomen, and the massive, bulging legs are closely related to Picasso's August 30, 1932, oil *Bather with Beach Ball* (fig. 35).

As John Golding has pointed out, "Neolithic art also provides the key to some of Picasso's stylistic innovations during the second half of the 1920s and, like Miró, he exploits its sexual symbolism."[1] In the early 1930s, in works such as *Bather*, Picasso continued to draw inspiration from prehistoric art. After its discovery in 1922, the famous fertility goddess *Venus of Lespugue* (fig. 36) was often reproduced, as was the *Venus of Willendorf*; in fact, Picasso owned two plaster casts of the former. His *Bather* appears to be an adaptation of the contrasting thin and bulging forms of the Lespugue Venus. Picasso's bronze may be compared to Moore's *Woman* of 1957–58 (No. 136), a later interpretation of a similar theme also inspired by works such as the Paleolithic *Venus of Grimaldi*, which he had copied in a sketchbook of 1926 (fig. 116).

1. Roland Penrose and John Golding, eds., *Picasso 1881–1973* (London: Paul Elek Ltd., 1973), p. 92.

54.
Pablo Picasso
Head of a Woman 1932
Bronze: H. 128.5 cm
Musée Picasso, Paris

Marie-Thérèse Walter, whom
Picasso had met in 1927, was the
inspiration for many of his finest
paintings of the early 1930s, such as
Girl before a Mirror of 1932 in the
Museum of Modern Art, New York,
and for the magnificent series of
monumental bronze heads done in
the sculpture studio at the Chateau
de Boisgeloup in the summer of
1932. Picasso's introduction to her
was prophetic. Marie-Thérèse
recounted it many years later:
"Mademoiselle, you have an interest-
ing face, I would like to make your
portrait. I am Picasso."[1]

At that time Picasso was married
to the Russian ballerina Olga Kok-
lova and, not wishing to make his
liaison public, he did not include
Marie-Thérèse in his work until
1932, although the 1931 *Still Life on a
Pedestal Table* (Musée Picasso) is a
secret portrait of her.[2] As John
Golding has pointed out,

> the visual evidence of the paintings
> of 1932, which radiate so strong an
> air of erotic fulfilment and relaxa-
> tion, would suggest that their love
> was consummated early in this
> year. Marie-Thérèse's full, pas-
> sive, golden beauty was to preside
> over Picasso's art for the next four
> years; most typically she is seen in
> what appears to be a dreamless
> sleep.[3]

Like Matisse's five bronze heads of
Jeannette of about 1910–13 (see
No. 64), the heads of Marie-Thérèse
became progressively more dis-

Fig. 37
Baga (Guinea)
Dance Mask
Wood
Musée Picasso, Paris

torted, from the relative naturalism
of *Head of a Woman* (Spies catalogue
No. 128) to the extreme exaggera-
tions of the head in this exhibition.
In *Bust of a Woman* (Spies catalogue
No. 132), which probably falls
between the two works just men-
tioned, the way in which the large

nose is an unbroken continuation of
the hair recalls Matisse's 1930 *Tiari
with Necklace* (No. 65), which
Picasso may well have known. In the
Head of a Woman shown here, with
the enormous, continuous, disturb-
ing, bulging forehead and nose, there
is little resemblance to Marie-
Thérèse. This discrepancy may be
due to the influence of his Baga
dance mask, which Picasso placed in
the entrance hall of the Chateau de
Boisgeloup (fig. 37). These masks,
as William Fagg has explained, were
used in dances in the village before
the rice harvest. "The hollow bust
fitted over the head and shoulders of
a dancer, who saw through a hole
between the breasts."[4] A profile view
of this Baga mask would give a far
better indication of its large, project-
ing hooked nose, which prompted
the disturbing distortions in this, the
most disquieting of the series of
heads of Marie-Thérèse.

1. William Rubin, *Pablo Picasso: A
Retrospective* (New York: The
Museum of Modern Art, 1980),
p. 253.

2. *Ibid*, p. 253.

3. Roland Penrose and John Golding,
eds., *Picasso 1881–1973* (London:
Paul Elek Ltd., 1973), p. 110.

4. Eliot Elisofon and William Fagg,
The Sculpture of Africa (New York:
Frederick A. Praeger, 1958), p. 69.

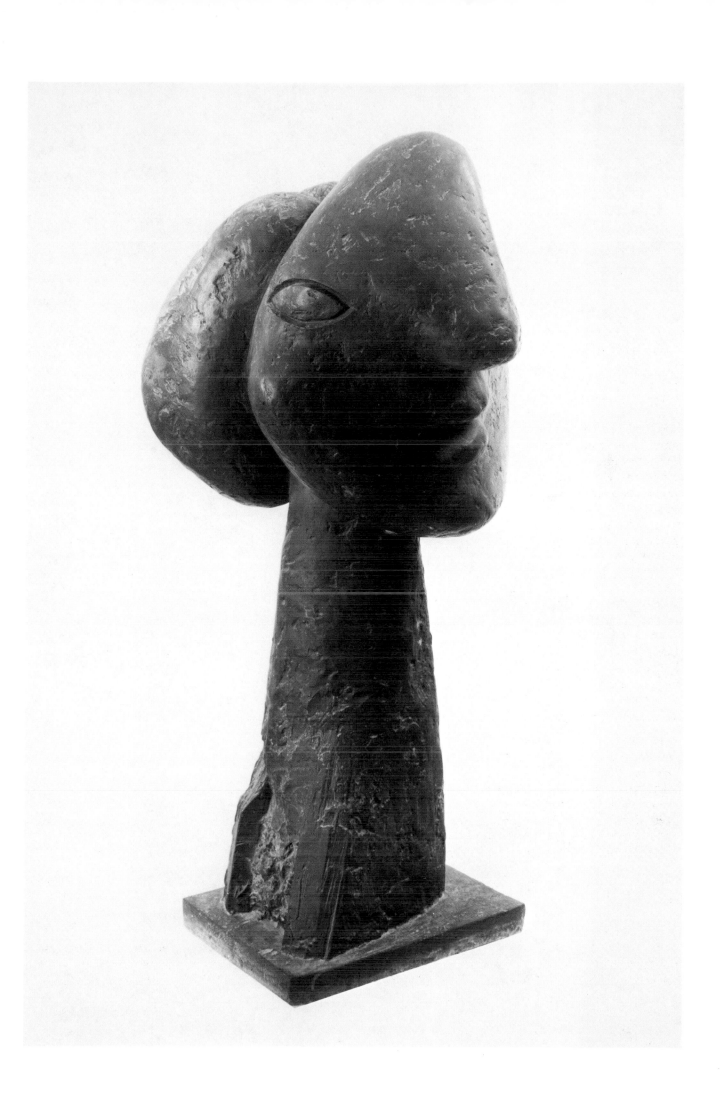

André Derain 1880–1954

French painter, sculptor, printmaker, and theatrical designer André Derain was born in Chatou (Yvelines) on the outskirts of Paris. He studied under Carrière at the Académie Camillo, where he met Matisse in 1898–99. In 1900 he shared a studio in Chatou with Vlaminck, whom he introduced to Matisse in 1901 at the van Gogh exhibition at the Galerie Bernheim Jeune. He did little painting during his military service, from 1901 to 1904, but in the summer of 1905 he worked with Matisse at Collioure and contributed to the historic exhibition of Fauve paintings in the *Salon d'Automne*. In 1906 he spent the summer in the south of France, where he befriended Picasso; the following year he married and moved to Montmartre, and subsequently was in constant contact with Picasso and the Bateau-Lavoir group. His first sculptures, carved in stone, were probably done as early as 1905–06.

Derain was working with Braque and Picasso near Avignon when World War I was declared; mobilized, he participated in the campaigns of the Somme, Verdun, and Vosges. In 1916 he had his first one-man exhibition at the Galerie Paul Guillaume. He returned briefly to sculpture, fashioning masks from shell casings. In 1919 he designed the costumes and sets for Diaghilev's ballet *La Boutique Fantasque*, marking the beginning of a lifelong involvement in stage design. He first went to London in 1905, sent by dealer Ambroise Vollard, and was to make several more visits in connection with his designs for the ballet and opera. In 1921 he travelled to Rome. In 1922 he exhibited in Stockholm, Berlin, Frankfurt, Munich, and New York, and in 1928 he was awarded the First Prize at the Pittsburgh International. In 1939 he took up sculpture again and produced a series of heads, masks, figurines, and reliefs in a primitive or archaic style.

Derain was one of the first to "discover" African art. He acquired from Vlaminck, probably in 1905, an African mask, and in a letter to Vlaminck dated 1906 he talks of his admiration for the "Musée Nègre" in London. In 1933 he sold part of his collection of Negro art, but at the 1955 posthumous sale of his collection it was obvious that he had never lost interest in exotic and primitive arts. He illustrated several books with woodcuts, lithographs, and etchings. He died September 8, 1954, in Garches, near Paris.

55.
André Derain
Head of a Woman II 1939–54
Bronze: H. 53.9 cm
Art Gallery of Ontario. Gift of Sam
and Ayala Zacks, 1970

The originality of Derain's early work is unfortunately overshadowed by that of three other artists who were also in the forefront of the Paris *avant garde* in the early years of this century: Matisse, Picasso, and Braque. Although by 1905–06 Matisse and Picasso were undoubtedly aware of African art, its influence was not immediately apparent in their work. By 1906 Derain, as John Golding has written, largely through his admiration for Gauguin "began to explore the aesthetic possibilities of 'primitive' art just before Picasso did."[1] In fact, exotic influences are at work in his large 1905–06 canvas *The Dance* (fig. 38), in which the pose of the figure at right is almost certainly indebted to Indian art. The Fauve painter Vlaminck claimed to have discovered African art about 1905,

yet Derain in his 1906 painting *The Bathers* (recently acquired by The Museum of Modern Art, New York) was, Golding states, "the first painter to combine in a single work the influences of both Cézanne and Negro art."[2]

In his earliest sculptures, the stone *Standing Figure* and particularly *Crouching Figure* (fig. 39), both of 1907, Derain was a forerunner of the doctrine of direct carving; he anticipated, both in form and material, Brancusi's *The Kiss* (No. 57). Derain's *Crouching Figure* (not available for this exhibition), which is one of the milestones of early twentieth-century sculpture because the artist carved directly in stone, was shown in Paris in the autumn of 1907 at D.H. Kahnweiler's new gallery in rue Vignon, where Brancusi no doubt saw it; later that year he began work on the first version of *The Kiss* (see No. 56), and it may well be that Derain's *Crouching Figure* convinced Brancusi to abandon modelling for direct carving.

Head of a Woman II belongs to the last fifteen years of Derain's life, when he renewed his interest in

sculpture. In 1933 he disposed of some of his African sculpture and began to acquire Hellenic and Cypriot works. The influences on his later sculpture were many and varied, and the confluence of styles makes it difficult to identify specific prototypes. As Mario Amaya wrote in connection with this work, Derain

studied the art of the Syro-Hittites, the Scythians, and the Celts, as well as Mesopotamian seals and Benin bronzes. . . . Several of his works bear a strong relation to those from Mycenae and the Ivory Coast and express what can only be called a "sophisticated barbarism."[3]

Both the shape and stare of the eyes are, no doubt fortuitously, reminiscent of Lipchitz's *Figure* of 1926-30 (No. 97).

Fig. 39
André Derain
Crouching Figure 1907
Stone: H. 33.0 × 27.9 cm
Museum d.20 Jahrhunderts, Vienna

Fig. 38
André Derain
La Danse c. 1906
Oil on canvas: 185.0 × 228.5 cm
Private Collection

1. John Golding, *Cubism A History and an Analysis* (London: Faber and Faber Ltd., 1968), p. 128.

2. *Ibid*, p. 139.

3. *A Tribute to Samuel J. Zacks from the Sam and Ayala Zacks Collection* (Toronto: Art Gallery of Ontario, 1971), catalogue No. 65.

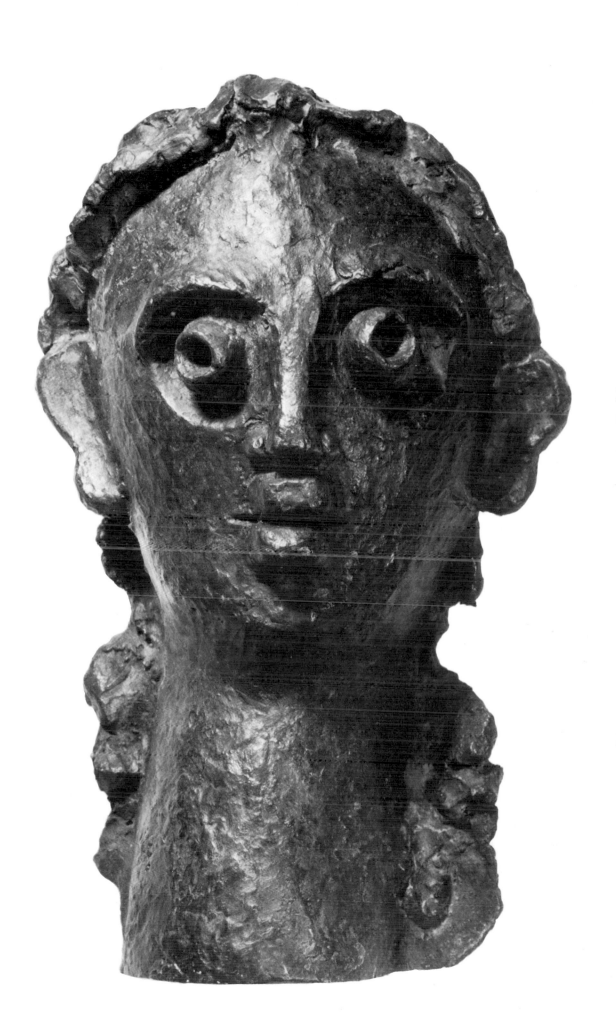

Constantin Brancusi 1876–1957

Rumanian-born sculptor Constantin Brancusi was born in Hobitza, a district of Gorj, and graduated from the Craiova School of Arts and Crafts and then from the Bucharest School of Fine Arts. In 1903 he set out on foot for Paris, where he arrived in the summer of 1904 after passing through Munich and Basel. In 1905–07 he studied at the Ecole des Beaux-Arts under Antonin Mercier. Influenced by Rodin but also drawn to primitive and ancient art, by 1907 he began to develop a personal vision of form that remained constant for more than forty years. He pursued a limited number of themes in series and emphasized pure, basic forms such as the ovoid; his marble carvings and bronzes had smooth surfaces, sometimes highly polished. His wood carvings have a link with the traditional folk carvings of his native country.

Brancusi was certainly aware of African sculpture; by 1909 he had met Matisse, who already had close to twenty pieces in his collection. Brancusi formed a close friendship with Modigliani and his patron, Dr. Paul Alexandre, who had an important collection of Ivory Coast Baule sculptures. In 1912 Brancusi protested to Epstein against the influence of primitivism, but it undoubtedly played a role in his development. Brancusi's innovations between 1907 and 1910, like those of Epstein and Gaudier-Brzeska, represent a break with Impressionist sculpture, but his work was not yet connected with Cubism. Five pieces were included in the Armory Show in New York in 1913, where they

created enough interest that, in the following year, he was given his first one-man exhibition in Stieglitz's Photo-Secession Gallery. Many exhibitions followed, especially in the United States, and many of his sculptures entered American collections. He was involved in a notorious lawsuit in 1927–28 against the American Customs, when they refused to admit one of his bronze *Bird in Space* series as a work of art.

In 1935 Brancusi received a commission for a war memorial for Tirgu Jiu in Rumania, and in 1937–38 he travelled to India and Egypt. In 1949 he completed his last work, the *Grand Coq*. He became a French citizen in 1956, and bequeathed his studio and its contents to the Musée national d'art moderne, Paris. He died in Paris on March 16, 1957.

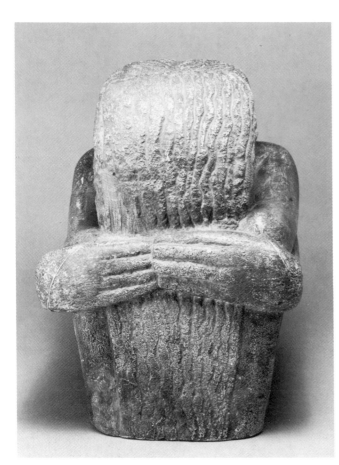
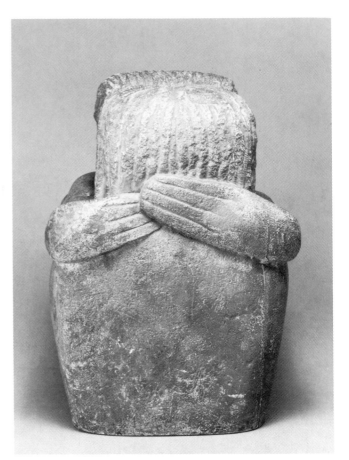

56.
Constantin Brancusi
The Kiss c. 1908–10
Plaster: H. 27.9 cm
Signed on underside of sculpture:
C. Brancusi
Latner Family Collection

This was one of at least three plasters that Brancusi cast from the 1907–08 stone version of *The Kiss* in the Muzeul de artă, Craiova. Another is in the Kunsthalle, Hamburg, and a third in a private collection. According to Athena Tacha Spear,[1] the Latner plaster was shown in the famous Armory Show in New York in 1913, which would indicate that Brancusi cast this work within three or four years after completing the stone carving. No evidence is known to this author that might lead to a more precise dating. Paradoxically, Brancusi's practice of casting his stone and wood carvings in plaster or bronze (see No. 57) seems to contradict his belief in truth to materials and direct carving. He states that "Direct carving is the true

path towards sculpture," and then adds, "and in the end, direct or indirect carving doesn't mean a thing – it's the finished work that counts." As Albert Elsen pointed out in a recent conversation with this author, Brancusi's practice of casting his stone or wood carvings allowed him to increase his production and make available more works for exhibition.

Two Brancusi scholars differ in their opinion as to which was the first version of *The Kiss*. Sidney Geist assumes that the Craiova stone carving from which this plaster was cast was the first version,[2] while Spear[3] argues that, because Brancusi usually proceeded from the whole to the part or fragment of a figure, the Montparnasse *Kiss* (fig. 40) came first, followed by the other versions, including the Craiova and Philadelphia sculptures. (For a more detailed discussion of *The Kiss*, see No. 57.)

Fig. 40
Constantin Brancusi
The Kiss 1907–09?
Stone: H. 89.5 cm
Montparnasse Cemetery, Paris
(After a photograph by Sidney Geist)

1. Athena Tacha Spear, "A Contribution to Brancusi Chronology," *The Art Bulletin* 48, No. 1 (March 1966): 52.

2. Sidney Geist, *Brancusi/The Kiss* (New York: Harper and Row, Publishers, 1978), p. 99.

3. Spear, "A Contribution," p. 46.

128

57.
Constantin Brancusi
The Kiss c. 1912
Limestone: H. 58.4 cm
Philadelphia Museum of Art. The
Louise and Walter Arensberg
Collection

If one were asked to name two of the best-known works of art from the early years of this century that represent the beginnings of modern art, the obvious choices would be two works completed in Paris within a year of each other: Picasso's 1907 *Les Demoiselles d'Avignon*, and Brancusi's first of many versions of *The Kiss*, which was begun in 1907. Much has been written about the problematic chronology of the various plaster and stone versions of *The Kiss*, and also about the seemingly endless iconographic precedents as possible sources, from a prehistoric carving of an embracing couple to Matisse's 1907 *Music (Study)*.[1] The Philadelphia carving, the largest of the half-length versions of 1907–12, is usually dated about 1912.

There is general agreement that in 1907 Brancusi abandoned the naturalism and modelling technique of his early work and began "*la taille directe*" – direct carving in stone. The artist himself said that his stone *Head of a Girl* of 1907 (fig. 41) was his first effort in stone carving. This sculpture, which Modigliani almost certainly saw when he met Brancusi in 1909, may well have influenced the Italian's series of limestone heads, which began about 1910. The importance of direct carving in the development of early twentieth-century sculpture cannot be over-emphasized. Almost all of Gauguin's sculptures from his Brittany and Polynesian periods are wood carvings, and following his example Derain, Picasso, Brancusi, Modigliani, Epstein, Gaudier-Brzeska, Kirchner, and Schmidt-Rottluff – and later Moore and Hepworth – reacted against Rodin's modelling technique and bronze casting, and the mechanical enlargement in marble of his work.

Undoubtedly Brancusi's commit-

ment to stone carving, and with it the demand of working with a hard, solid material, account in part for the sudden and radical stylistic changes that separate his 1907 modelled work, *The Prayer*, and *The Kiss*. Geist suggests that in all likelihood Brancusi saw Derain's block-like 1907 stone *Crouching Figure* (fig. 39) at D.H. Kahnweiler's new gallery in the autumn of that year. "If *The Kiss* by Rodin," Geist writes, "is the great negative influence on Brancusi's *Kiss*, Derain's work must be considered as the latest and most important of several direct influences."[2] In both these early examples of stone carving in the *oeuvre* of each artist, the sculptures retain the block-like shape of the material.

Geist discusses and illustrates many representations of the ageless theme of the kiss in his book devoted to Brancusi's *The Kiss*: a stone relief from Osuna, Spain; Giotto's *The Meeting at the Golden Gate*; an Ashanti goldweight; Rodin's 1888 marble *The Kiss*; and works by Munch and Picasso. In the context of this exhibition, the most relevant influence was certainly Gauguin. Among the wood carvings included in the great *Gauguin Retrospective* at the 1906 *Salon d'Automne* was the Art Gallery of Ontario's *Hina and Te Fatou* of 1892–93 (No. 12). In one of

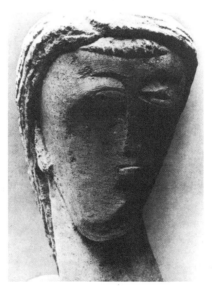

Fig. 41
Constantin Brancusi
Head of a Girl 1907
Stone
Whereabouts unknown

the two views representing a conversation between the goddess of the moon and god of the earth, the two figures kneel facing each other with their foreheads touching. Geist illustrates this side of the cylinder and states that *The Kiss* may be directly indebted to it.[3]

Various sizes and versions of *The Kiss* occupied Brancusi intermittently from 1907 to 1945, when he completed the stone *Boundary Marker*, the last work to employ the motif that had obsessed him for thirty-nine years. Brancusi had worked briefly in Rodin's studio in about 1906, but left with the realization that "Nothing can grow in the shadow of the great trees."[4] With *The Kiss*, the influence of the great French sculptor – apparent in some of Brancusi's modelled heads and figures of 1906–07 – and indeed the influence of traditional Western sculpture were completely severed. As devastating a break with the past as Picasso's 1907 *Les Demoiselles d'Avignon*, *The Kiss* – so deceptively simple yet profoundly original – marks a turning point in the history of European sculpture.

Like Gauguin and the Symbolist generation in the 1880s, Brancusi was, by late 1907, no longer interested in outward appearances. He wrote: "What is real is not the external form, but the essence of things. Starting from this truth it is impossible for anyone to express anything essentially real by imitating its exterior surface."[5] "The essence of things" may adequately describe the spiritual quality of the work he produced for the rest of his life.

1. See Sidney Geist, *Brancusi/The Kiss* (New York: Harper and Row, Publishers, 1978).

2. *Ibid*, p. 30.

3. *Ibid*, p. 38.

4. Sidney Geist, *Brancusi: A Study of the Sculpture* (London: Studio Vista, 1968), p. 2.

5. The Brummer Gallery, *Brancusi* (New York: 1926), quoted in the catalogue introduction by Paul Morand.

58.
Constantin Brancusi
The First Cry 1917
Polished bronze, edition of three:
L. 17.3 cm
Signed on back of head: C. Brancusi
Marlborough Fine Art (London)
Ltd.

The human head was one of the most important themes throughout Brancusi's career. Geist has calculated that of the 190 extant works made after the 1907 *The Prayer*, seventy-nine – or forty-two per cent – are heads and busts; of these, twenty-three are of children. This piece was cast from the head of *The First Step* of 1913 (fig. 42), Brancusi's first wood carving, which may have been based on a photograph, now lost, of the sculptor holding a standing child. As Geist points out, "*The First Step* clearly supposes a knowledge of African Negro sculpture; it has striking affinities with a wood-carving [fig. 43] from the Upper Niger region that was in the Musée d'Ethnologie in 1916 and surely earlier."[1] Soon after the sculpture was exhibited in New York in 1914, Brancusi destroyed all but the head, which is now in the Musée national d'art moderne in Paris. Epstein acknowledged the influence of African art on Brancusi but added that "to me he exclaimed against its influence. One must not imitate Africans, he often said."[2] If Brancusi destroyed *The First Step* because of its obvious debt to African art, as Geist suggests, it seems strange that he chose to preserve the head, whose features, particularly the mouth, are distinctly African in inspiration.

An edition of three bronzes was cast from the 1913 wood *Head of the First Step*, and *The First Cry* is one of the two highly polished versions. It may seem paradoxical that, on the one hand, Brancusi could write that "Direct carving is the true path toward sculpture,"[3] and on the other hand he had certain marble and wood sculptures cast in bronze. Yet he not only authorized the casting of this piece, but worked on the patina of the bronze himself. This cast was

Fig. 42
Constantin Brancusi
The First Step 1913
Wood: H. c. 112 cm
Destroyed

exhibited as No. 35, *Child's Head*, and dated 1917 in the Brancusi exhibition at the Brummer Gallery, New York, in November – December 1926. Whereas the 1913 wood *Child's Head* was shown in the same exhibition in an upright position, in this work the neck has been removed and the piece rests in a horizontal or sleeping position, like the 1909 – 10 marble and the 1910 bronze *Sleeping Muse* (The Hirshhorn Museum and Sculpture Garden, marble; The Art Institute of Chicago, bronze). In the

Fig. 43
Upper Niger
Ancestral Figure
Wood: H. 87.0 cm
Musée de l'Homme, Paris

1915 marble *The New Born* in the Philadelphia Museum of Art, Brancusi greatly simplified and refined the head of *The First Cry*, another example, like *The Kiss* and later the *Bird in Space* series, of Brancusi's use of variants of a single theme.

1. The Solomon R. Guggenheim Museum, *Constantin Brancusi 1876 – 1957: A Retrospective Exhibition* (New York: 1969), p. 64.

2. Jacob Epstein, *Epstein: An Autobiography*, with an introduction by Richard Buckle (London: Art Treasures Book Club, 1963), p. 49.

3. Sidney Geist, *Brancusi/The Kiss* (New York: Harper and Row, Publishers, 1978), p. 9.

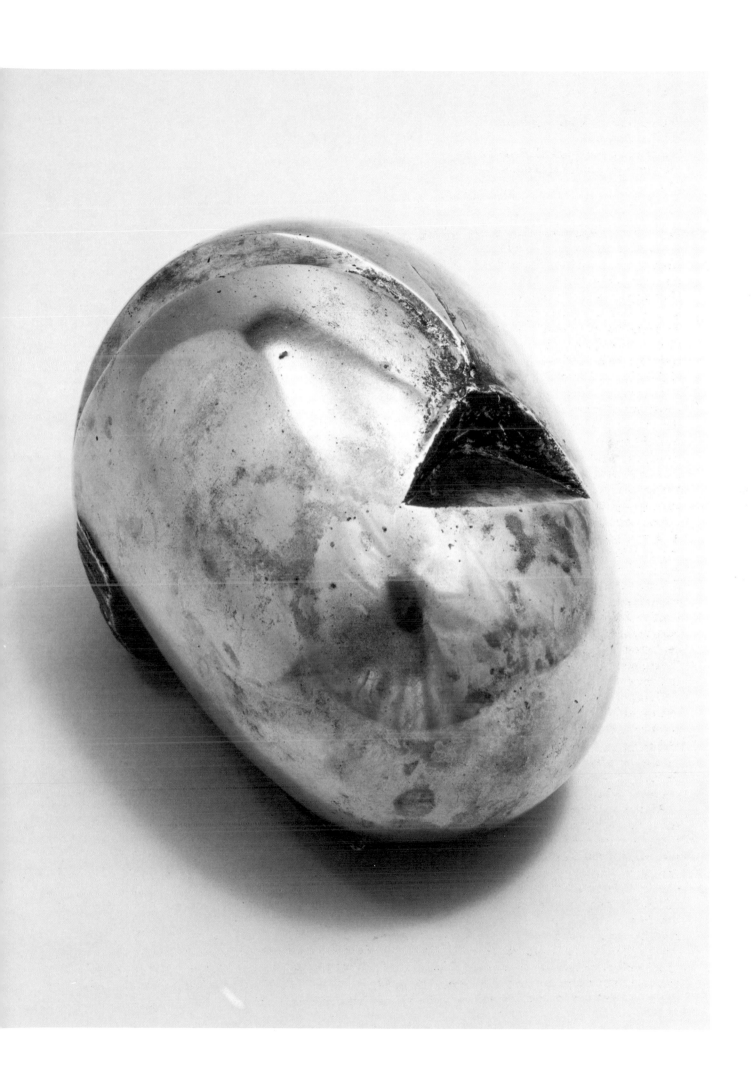

59.
Constantin Brancusi
Torso of a Girl III 1925
Onyx: H. 26.4 cm
Musée national d'art moderne,
Centre Georges Pompidou, Legacy
of the Artist

The human torso is, like the head, another important subject of Brancusi's sculpture. The earliest treatment of the theme is the small marble *Torso* of 1908, based on the central portion of the kneeling female figure in the 1907 bronze *The Prayer* (Muzeul de arta, Craiova). The work shown here is one of three very similar versions of the subject, one of which is in the Philadelphia Museum of Art, the other in a private collection. All three are approximately the same height, but with subtle variations in width. Whereas an earlier related carving, the 1918 onyx *Torso of a Young Woman*, retains anatomical features – the legs, buttocks, and pubic area – in

the three later versions such specific references to the human body have been eliminated and we are left with a rarefied image of great purity. As in Picasso's and Braque's Cubist paintings of 1910–11, Brancusi's work has almost reached the point of total abstraction. Whereas the subject matter of analytic Cubism was almost lost in the complex network of interpenetrating planes, fragmented forms, and a complex spatial structure, Brancusi's *Torso of a Young Girl* reaches a similar threshold by a different means – extreme simplification and distillation of his subject. The title identifies the subject; without it, the carving could equally well evoke images of an egg or fruit, suggestive of ripeness and fecundity.

In his most primitivistic carving, such as *The First Step* of 1913 and the *Little French Girl* of 1914–18 in The Solomon R. Guggenheim Museum, Brancusi worked in wood, the material of most African sculpture. As Geist perceptively remarked

about the 1918 *Torso of a Young Woman* and the three versions of *Torso of a Girl*: "Brancusi questions the primitivising, even africanising, vision of the previous years" and "reserves a more European vision for the paler, reflective marble and onyx."[1] By the 1920s the influence of African art had waned. Although certain works, such as the 1937 *Endless Column* (Tirgu, Rumania), reflect the rough vernacular art of his native Rumania, by and large his late work – the various versions of *Bird in Space*, the fish, seals, and turtles – continue the refined, elegant simplifications found in *Torso of a Girl III*, which may have been inspired by his admiration for Cycladic sculpture.

1. The Solomon R. Guggenheim Museum, *Constantin Brancusi 1876– 1957: A Retrospective Exhibition* (New York: 1969), p. 107.

60.
Constantin Brancusi
Head of a Woman n.d.
Pen and red ink: 43.2 × 27.2 cm
Signed lower right: C. Brancusi;
inscribed *a C.J. Bulliet un bon
souvenir*
The Art Institute of Chicago:
1954.1103. Gift of Mrs. C.J. Bulliet
and Jack Bulliet in Memory of C.J.
Bulliet

Little has been written on Brancusi's
activities as a draughtsman. In 1938
the sculptor is reported to have said,
"I don't work from sketches, I take
the chisel and hammer and go right
ahead."[1] While there are a number of
drawings of finished sculptures and
views of works in the artist's studio,
the only actual preparatory studies
for a sculpture would appear to be
the four large sheets related to *The
First Step* (fig. 42).[2]

Although the resemblance may be
purely coincidental, it is tempting to
see a connection between this draw-
ing and the 1907 stone *Head of a Girl*
(fig. 41). In both, the elongated neck
curves upward from right to left, the
eyebrows and nose are indicated by
two continuous lines joined at the
bottom, the eye sockets are empty
ovals, and there are bangs of hair on
the forehead. It is interesting to
compare the style of this drawing
with the two studies of heads by
Modigliani in this exhibition (Nos.
69, 70), as well as with Lipchitz's
1914 *Girl with Braided Hair* (No. 95).
Since these artists were friends, it is
doubtful that the similarities are
merely fortuitous.

1. Sidney Geist, *Brancusi/The Kiss*
(New York: Harper and Row, Pub-
lishers, 1978), p. 99, note 12.

2. Four Studies for *The First Step* are
illustrated in Sidney Geist, *Brancusi:
The Sculpture and Drawings* (New
York: Harry N. Abrams, Inc., 1975),
p. 32.

a C J Bulliet un bon souvenir C Brancusi

Henri Matisse 1869–1954

The French painter, sculptor, lithographer, etcher, and designer Henri Matisse was born in Le Cateau-Cambrésis (Nord). He first studied law, which he abandoned in 1890 to study art in Paris; briefly at the Académie Julian under Bouguereau, then at the Ecole des Beaux-Arts in the studio of the more liberal Gustave Moreau, and in 1899 at the Académie Camillo, where Carrière came to correct works of art every week, and where he met Derain. His first sculpture dates from 1894. In 1897 he met Pissarro and was influenced by Impressionism. When he began to work at sculpture, he chose as his models Antoine Barye and Rodin. For many months in 1900 he worked at night in the sculpture studio of the Ecole Communale de la Ville de Paris and then for several months with Bourdelle at the Studio of La Grande Chaumière. By 1908 he was self-assured enough to teach sculpture in his own art school, which he ran until 1911. In 1904 he met Maillol, and dealer Ambroise Vollard gave him his first one-man exhibition. In 1905 he became the leader of the informal group of painters dubbed "Les Fauves" when he exhibited vividly coloured works at the *Salon d'Automne* with the works of Derain, Vlaminck, Marquet, and others. One of his works was sold to Gertrude and Leo Stein, and through them he met Picasso.

Matisse's first period of sculptural activity was from 1900 to 1913, followed by a second from 1924 to 1932. By 1909, like his contemporaries – Picasso, Brancusi, and Duchamp-Villon – he had broken away from the early influence of Rodin.

His sculpture remained almost exclusively concerned with the human form, subordinating detail to an overall harmonious effect.

Matisse was introduced to African art in the early years of the century, and formed an important collection. His work was included in the Armory Show in 1913 and it was in New York that his first exhibition of sculpture was arranged by Stieglitz in 1912. Matisse travelled extensively; his journeys included a trip to Tahiti in 1930. He received several commissions, particularly for decorative projects. In 1943 he moved to Vence; he designed and decorated the Chapel of the Rosary of the Dominican Nuns (1948–51). The project included his last sculpture, a bronze crucifix. Matisse died November 3, 1954, in Cimiez.

61.
Henri Matisse
Two Negresses 1908
Bronze: H. 46.6 cm
Signed on plinth lower left: Henri
Matisse 1/10
Hirshhorn Museum and Sculpture
Garden (Smithsonian Institution)

I took up sculpture because what interested me in painting was a clarification of my ideas. I changed my method, and worked in clay in order to have a rest from painting where I had done all I could for the time being. That is to say that it was done for the purposes of organization, to put order into my feelings, and find a style to suit me. When I found it in sculpture, it helped me in my painting.[1]

Matisse, like Degas, Picasso, Daumier, and Renoir, is one of those painter-sculptors whose reputation as a great artist would be secure even if all that survived were his three-dimensional work. His sculptural *oeuvre* is relatively small – some seventy bronzes and one little-known wood carving of 1907 (fig. 45), most of which were done between 1899 and 1930. His early work includes a free copy of Antoine Barye's 1852 bronze *Jaguar Devouring a Hare*, made between 1899 and 1901, and *The Serf* of 1900–03, Matisse's best known early sculpture, probably influenced by Rodin's *The Walking Man* of 1875–78, which was exhibited in Rodin's one-man retrospective in June 1900.

Fig. 44
Photograph from a French periodical of the models used by Matisse for *Two Negresses*.

Matisse's debt to primitive art is more tenuous and difficult to pin down than that of any other artist in this exhibition. By the time he met Picasso in the autumn of 1906,

Matisse was undoubtedly aware of African art. Not long after, Gertrude Stein wrote, "Matisse in the mean-time introduced Picasso to Negro sculpture."[2] The early sculpture, which Alfred Barr discusses in connection with primitive art, includes the 1906 small bronze *Torso with a Head* (Metropolitan Museum of Art, New York), "so sharp-breasted and sharp-buttocked that it may be one of Matisse's few sculptures influenced by West African figures."[3] It is indeed tempting to surmise that his 1907 cylindrical wood carving, *The Dance*, in the Musée Matisse, Nice-Cimiez (fig. 45), was inspired by Gauguin's Tahitian-period relief wood carvings (many cylindrical), such as The Art Gallery of Ontario's 1892–93 *Hina and Te Fatou* (No. 12), which were exhibited in the 1906 *Gauguin Retrospective* in Paris. Although Matisse's heavy-limbed dancing figures owe little to Gauguin or to primitive sources, the small decorative flowers are remarkably similar to those that appear in the Toronto carving.

Two Negresses, Matisse's only sculpture with two figures, Barr says, "may well be influenced by African Negro sculpture which

140

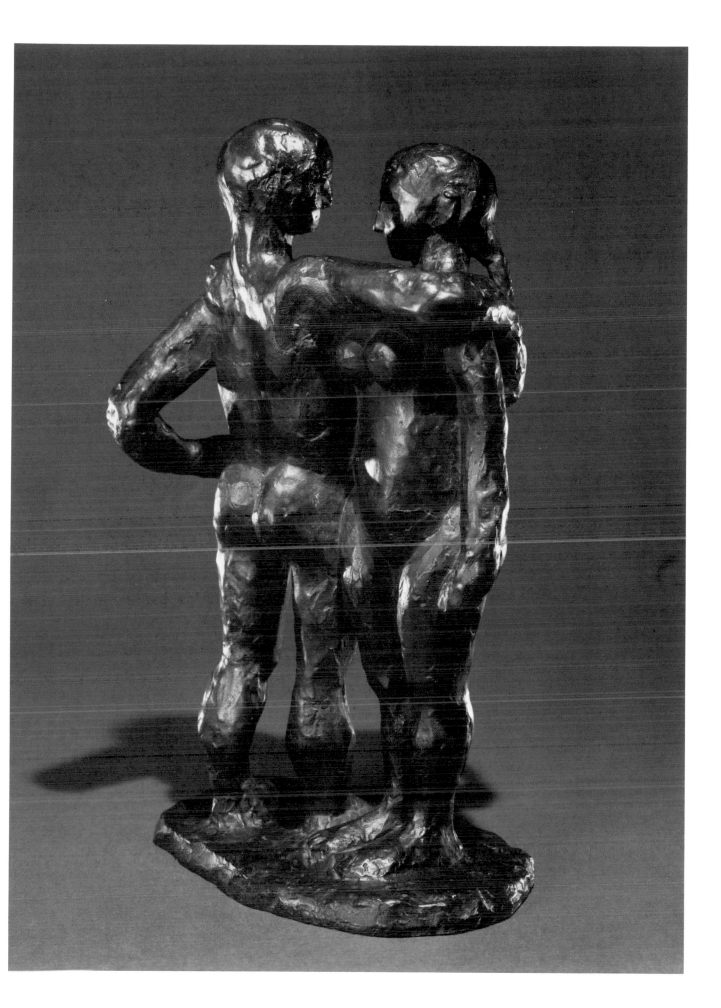

Matisse had been collecting for two or three years, particularly the rigid, thickset figurines of the Ivory Coast."[4] The sculpture was, however, based on a photograph (as was No. 62) from a French ethnographic periodical (fig. 44). Although a number of sources have been mentioned, such as Mali Dogon ancestor couples and Picasso's 1906 oil, *Two Nudes* (Museum of Modern Art, New York), the sculpture remains, with slight alteration in the proportions of the figures, a three-dimensional recreation of a two-dimensional image.

Like Gauguin in his sculpture of a Martinique negress (No. 4), his studies of Polynesians, and Rodin in his fascination with the facial features of the Japanese actress Hanako (Nos. 31, 32, 33, 34), Matisse may have seen these African girls, as Albert Elsen has speculated, in relation to the Arcadian world of his

Fig. 45
Henri Matisse
La Danse 1907
Wood: H. 44.0 cm
Musée Matisse, Nice

paintings; or they may have "offered him a personal challenge to work from sources similar to those that had inspired African carvers whose work he admired."[5]

1. Alicia Legg, *The Sculpture of Matisse* (New York: The Museum of Modern Art, 1972), p. 1.

2. Gertrude Stein, *The Autobiography of Alice B. Toklas* (New York: 1973), p. 77.

3. Alfred H. Barr, Jr., *Matisse: His Art and His Public* (New York: The Museum of Modern Art, 1951), p. 100.

4. *Ibid*, p. 139.

5. Albert E. Elsen, *The Sculpture of Henri Matisse* (New York: Harry N. Abrams, Inc., 1972), p. 83.

62.
Henri Matisse
La Serpentine 1909
Bronze: H. 56.5 cm
Signed on base: Henri Matisse 1/10
The Museum of Modern Art, New
York. Gift of Abby Aldrich
Rockefeller, 1939

Fig. 46
Photograph of the model used by Matisse
for *La Serpentine*.

Fig. 47
Bambara (Mali)
Seated Woman
Wood: H. 61.0 cm
Ex-collection Henri Matisse

In the autumn of 1909 Matisse moved to Issy-les-Moulineaux, a few miles southwest of Paris. It was here, in a studio recommended by Edward Steichen, that the American photographed Matisse modelling *La Serpentine* (see No. 63). In this sculpture Matisse worked both from a photograph and from a nude model, whose ample proportions would have appealed to Renoir and Maillol (fig. 46). As William Tucker perceptively remarked, working from a two-dimensional source gave Matisse "total freedom to develop the sculpture in volume and disposition according to his own sense of the architecture of the parts."[1] In *Two Negresses*, the proportions of the figure are more massive and monumental than the models in the photograph; in *La Serpentine*, the reverse is true. The academic pose of the sculpture originated, Barr has written,

in the 4th century BC and appears in such Praxitelean statues as the *Hermes* at Olympia and the *Satyr* of the Capitoline Museum in Rome both of which stand with gracefully curved figures, one elbow leaning on a convenient tree stump.[2]

Matisse obliterated any suggestion of classical proportion and radically reshaped the body in a way that seemed as daring and disturbing as Picasso's 1907 *Les Demoiselles d'Avignon*. "I had to help me," Matisse wrote, "a photograph of a woman, a little fat but very harmonious in form and movement. I thinned and composed the forms so that the movement would be completely comprehensible from all points of view."[3]

The extraordinarily long, thin torso and the high positioning of the small breasts are features found in a number of African tribal styles. Barr, for example, suggests Sudanese figures as a possible source.[4] The fact that Matisse admired African sculpture of this type is evident in the Bambara *Seated Woman* that he owned (fig. 47), which was exhibited in *Arts primitifs dans les ateliers d'artistes*, at the Musée de l'Homme, Paris, in 1967. Exactly when he acquired this work is not known, but it is a sculpture whose high breasts and thin torso are reminiscent of *La Serpentine*, and whose facial features and deeply carved hair or headdress are not unlike *Jeannette V* (No. 64).

1. William Tucker, *Early Modern Sculpture* (New York: Oxford University Press, 1974), p. 91.

2. Alfred H. Barr, Jr., *Matisse: His Art and His Public* (New York: The Museum of Modern Art, 1951), p. 139.

3. *Ibid*, p. 139.

4. *Ibid*, p. 139.

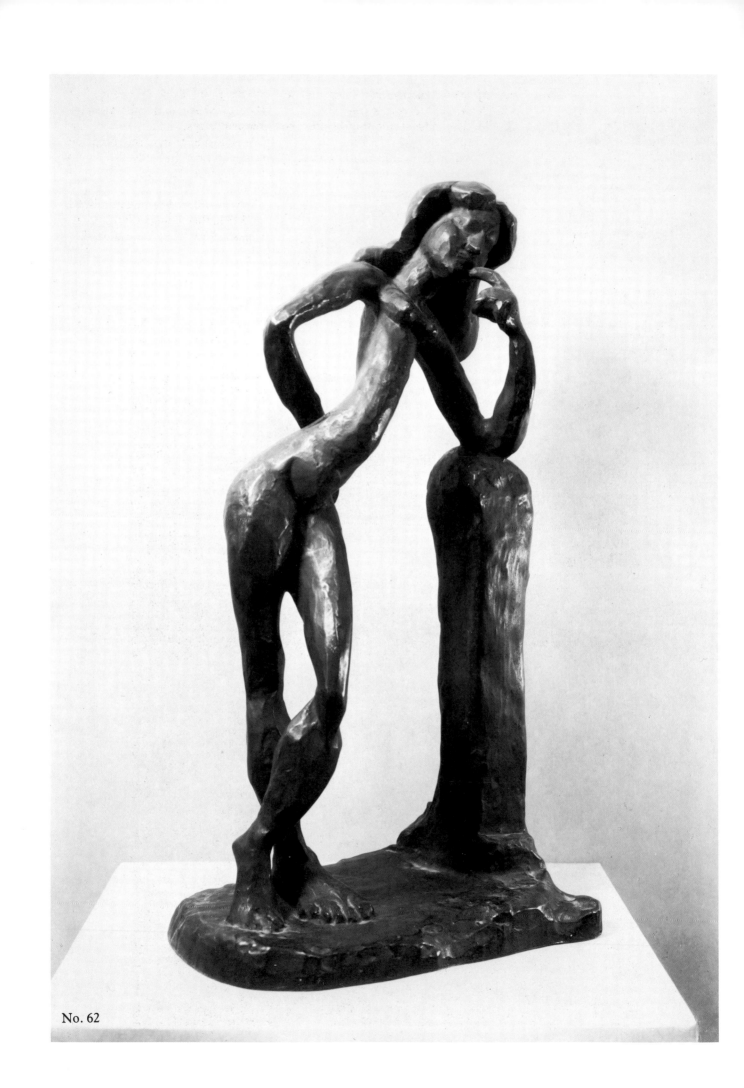

No. 62

63.
Edward Steichen
Henri Matisse 1909
Photogravure: 21.7 × 17.1 cm
Art Gallery of Ontario. Purchase,
1980

Edward Steichen photographed the
works of Rodin (see No. 41), and of
Henri Matisse as well. In 1908, in
one of his inspired, pioneering
ventures, Steichen arranged, with
Alfred Stieglitz, to exhibit Matisse's
watercolours and graphic work in
New York at The 291 Gallery –
Matisse's first one-man show outside
Paris. Steichen photographed
Matisse in his studio shortly after the
sculptor arrived at Issy-les-
Moulineaux. As Albert Elsen has
pointed out, the photograph

shows that originally he had
probably been close to the model's
proportions [see fig. 46] if not
totally true to them, and that as
with his paintings, such as *The
Dance*, this sculpture went
through various states. With the
Serpentine, unlike the paintings,
these states were all carried out on
a single sculpture.[1]

Although it is difficult to judge from
the view shown in the photograph,
the arms, legs, and torso do appear
less elongated than in the completed
sculpture, but they are still far from
the somewhat plump anatomy of the
model.

Henri Matisse was first published
in 1913 in the photographic journal
Camera Work (New York, Nos. 42–
43, pl. 6).

1. Albert E. Elsen, *The Sculpture of
 Henri Matisse* (New York: Harry N.
 Abrams, Inc., 1972), p. 93.

64.
Henri Matisse
Jeannette V c. 1910–13
Bronze: H. 58.4 cm
Signed at back of base: HM 9/10
Art Gallery of Ontario. Purchase,
1949

The five bronze heads of Jeannette of about 1910 to 1913 comprise one of the most remarkable portrait studies of twentieth-century sculpture. Although less penetrating as portraits of psychological states than are Rodin's studies of Hanako (Nos. 31, 32, 33, 34), they are, from a purely sculptural point of view, far more daring and original.

The dating of this work is problematic. Barr states that Matisse believed he may have made four or perhaps all five heads about 1910 at Issy-les-Moulineaux.[1] Elsen, who discusses the five heads in great detail, dates each 1910 to 1913.[2] According to Madame Matisse, *Jeannette I* and *II* were done directly from the model, Jeanne Vaderin, who posed for the 1910 charcoal

drawing *Young Girl with Tulips*, in The Museum of Modern Art, Moscow. As in his great relief sculptures of female backs, Matisse's heads of Jeannette became progressively bolder and more exaggerated, less tied to the appearance of the model.

As a point of departure for *Jeannette V*, Matisse began with a plaster cast of the third head in the series, which was the first he had worked on without the model. Barr remarks that "the modelling of *Jeannette III* resembles the faces of certain masks carved by artists of the Cameroon tribes whose sculpture seems haptic in character."[3] In fact, in the 1970 Munich exhibition *World Cultures and Modern Art*, a convincing comparison was made between *Jeannette V* and a Cameroon Grassland *Head* from the Reiss-Museum, Mannheim. Mention was made, in regard to *La Serpentine* (No. 62), of the similarities between *Head of Jeannette V* and the head of the African Bambara *Seated Woman* (fig. 47), which Matisse owned. The most striking differences between heads III and V is in the removal of the two

side and the back clusters of hair, and the slicing away of the area of the left eye. The flat plane that remains recalls Rodin's practice, in works like his *Flying Figure* of 1890–91, of leaving exposed areas of clay or plaster that he had cut away with a sharp tool.

Jeannette V is shown in this exhibition with two other of the finest portraits of the period: Picasso's 1909 *Head of a Woman (Fernande)* (No. 52) and Duchamp-Villon's 1911 *Baudelaire* (No. 71). It anticipates his 1930 *Tiari with Necklace* (No. 65), and Picasso's great series of heads of 1932 (No. 54), which were inspired by an African Baga dance mask in his own collection (fig. 37).

1. Alfred H. Barr, Jr., *Matisse: His Art and His Public* (New York: The Museum of Modern Art, 1951), p. 140.

2. Albert E. Elsen, *The Sculpture of Henri Matisse* (New York: Harry N. Abrams, Inc., 1972), pp. 122–134.

3. Barr, *Matisse*, p. 141.

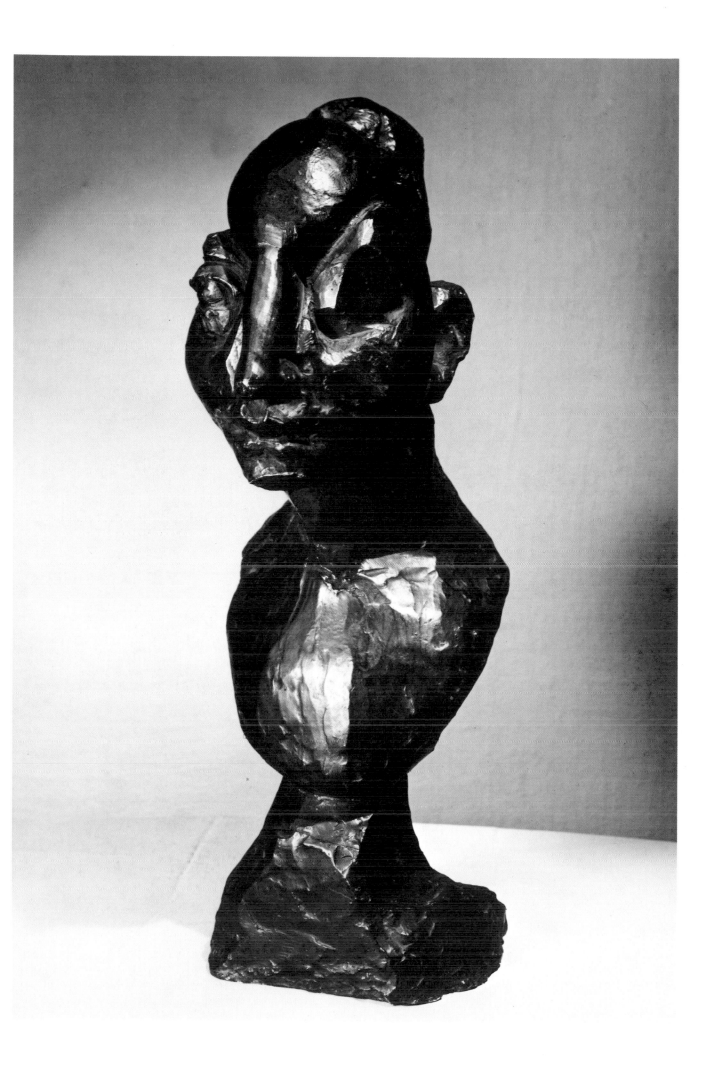

65.
Henri Matisse
Tiari with Necklace 1930
Bronze: H. 21 cm
Signed and numbered right rear:
HM 1/10
The Baltimore Museum of Art: The
Cone Collection, formed by Dr.
Claribel Cone and Miss Etta Cone of
Baltimore, Maryland (BMA 40.438)

Included in Matisse's second period of sculptural activity (1924–32) are the large *Seated Nude* of 1925, the two reclining nudes of 1927 and 1929, probably the second and third versions of *The Backs*, and two versions of *Tiari*, one with necklace.

For years, Matisse had dreamed of visiting the South Seas. In March 1930 he sailed via New York and San Francisco – thirty-nine years after Gauguin – on the first of his two trips to Oceania. Of Tahiti he wrote: "I stayed there three months absorbed by my surroundings without a thought in my head in front of the novelty of everything I saw, dumbfounded, yet unconsciously storing up a great deal."[1] He did no painting during his visit, but did some drawings of the landscape, flowers, and foliage. On his return to France in the summer of that same year, he modelled *Tiari*, based on a Tahitian flower worn by the women in their hair. Gauguin included the name of this flower in the title and inscription, "*Vahine no te Tiare*," on one of the earliest paintings from his first Tahitian trip, the 1891 *Woman with a Flower* (the translation of the inscription), now in the Ny Carlsberg Glyptotek, Copenhagen (fig. 48). In 1930 Matisse talked about his experience in Tahiti and about Gauguin:

> There is no memory of him there. Except, on the part of the people who knew him, a regret that his paintings are so expensive these days. There is also a tiny rue Gauguin just next to the Oceanic

Phosphates Company, but the director of this company had never noticed it.[2]

Only the Baltimore version of the

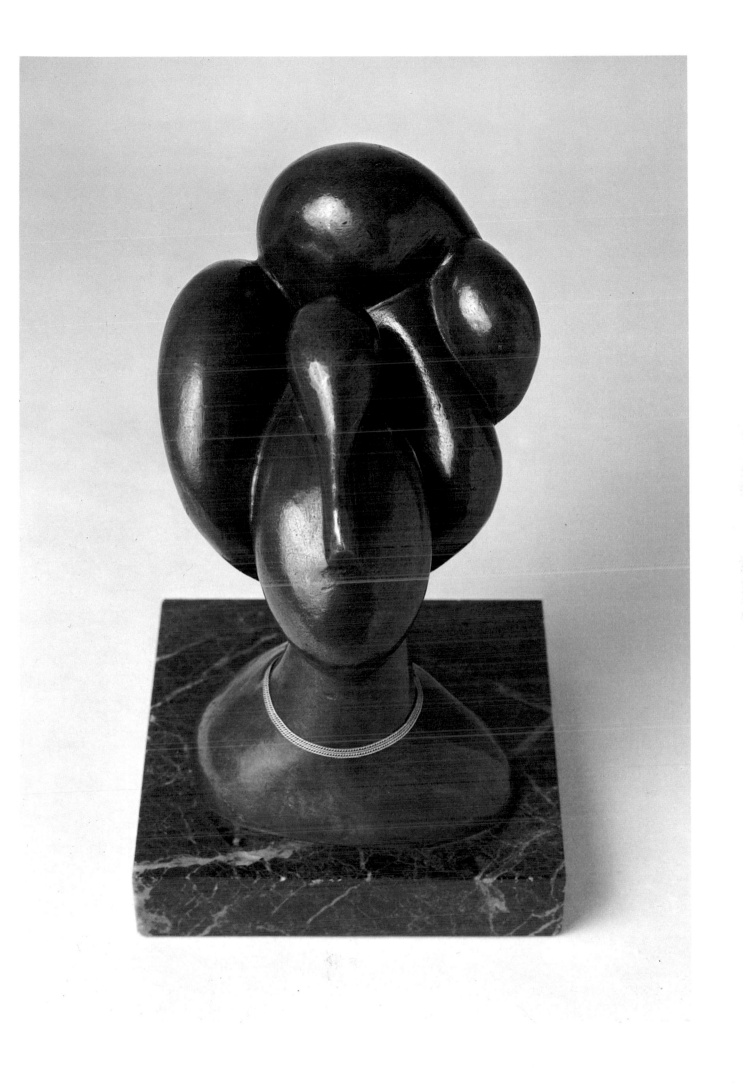

Tiari sculpture includes a necklace. The smooth, rounded clusters of hair recall the much more rugged lumps of hair in the 1910–13 bronze *Jeannette V* (No. 64). Elsen has suggested that possibly "Brancusi's purified heads encouraged Matisse to dispense with the eyes and mouth to facilitate the metaphor."[3] The nose, like an elephant trunk, flows out of the forehead, thus anticipating Picasso's heads of 1932 (No. 54). Not only the rounded forms but the idea of using a plant as a metaphor for the human body look forward to Arp's poetic, biomorphic sculptures, such as *Dancing Flower* of 1957 and *Torso with Buds* of 1961.

In one of the best known statements by a twentieth-century artist, Matisse wrote in 1908:

> What I dream of is an art of balance, of purity and serenity, devoid of troubling or disturbing subject matter...like a comforting influence, a mental balm – something like a good armchair in which one rests from physical fatigue.[4]

In *Tiari with Necklace*, one of the most seductive and beautiful sculptures of modern times, surely this dream was realized.

1. Alfred H. Barr, Jr., *Matisse: His Art and His Public* (New York: The Museum of Modern Art, 1961), p. 219.

2. Jack D. Flam, *Matisse on Art* (London: Phaedon Press, 1973), p. 61.

3. Albert E. Elsen, *The Sculpture of Henri Matisse* (New York: Harry N. Abrams Inc., 1972), p. 170.

4. *Matisse*, A retrospective exhibition at the Hayward Gallery, The Arts Council of Great Britain, 1968, p. 17.

Amedeo Modigliani 1884–1920

The Italian painter, sculptor, and draughtsman Amedeo Modigliani was born in Leghorn (Livorno) of Jewish parents. In 1895 an attack of pleurisy foreshadowed life-long ill health. Modigliani began to study art in 1898 under the Leghorn Macchiaioli painter Guglielmo Micheli. He visited Naples, Capri, Rome, Florence, and Venice to recuperate after the onset of tuberculosis in 1901. From 1902 to 1905 he studied at the Florence Academy under Giovanni Fattori and at the Instituto di Belle Arti, Venice. He moved to Paris in January 1906 and enrolled at the Académie Colarossi. First influenced by Gauguin, Toulouse-Lautrec, and the Fauves, then by Cézanne, in 1908 he met Dr. Paul Alexandre, a collector of African art, who became his friend and patron. In 1909 he became a neighbour of Brancusi and concentrated on sculpture. In 1912 he successfuly submitted seven sculptured heads to the *Salon d'Automne*, catalogued as *Têtes ensemble décoratif*.

Even though Modigliani probably did little sculpture after about 1913, his work has connections with the pioneers of modern sculpture: not only his neighbour Brancusi but Epstein, Archipenko, Lipchitz, and Zadkine were acquainted with him. From 1914 to 1920 he produced many paintings. In 1916 Leopold Zborowski became his dealer and financial supporter. In 1917 Modigliani had his first one-man exhibition at the Galerie Berthe Weill, Paris; it was closed by order of the police, who considered the nudes obscene. From spring 1918 to spring 1919 he worked in the south of France. He had taken to excessive drinking and drugs early in life, and his recovery from those abuses in the summer of 1919 did not last; he died in Paris on January 24, 1920.

66.
Amedeo Modigliani
Head c. 1911
Limestone: H. 46 cm
Perls Galleries, New York

Modigliani is, like Gauguin, best known as a painter, and the importance of his sculpture has not been fully appreciated. Early in his career he had decided to become a sculptor. In a postcard that has been dated 1902, Modigliani wrote to a friend from Pietra Santa, the marble-working town near Carrara, asking for an enlarged photograph of a sculpture he had made; unfortunately neither have survived.

Modigliani arrived in Paris in 1906 and soon was drawn to two centres of artistic activity, Montparnasse and Montmartre. As John Russell has written, "No city in the world, at no time in the history of art, can have been richer in profitable excitement than Paris between 1900 and 1914, but Modigliani's response to it was characteristically cautious and oblique."[1] During his brief and tragic career, he was to meet many of the best known painters and sculptors of the day – Picasso, Lipchitz, Epstein, Soutine – but none altered the course of his art as much as did Brancusi, whom he met in 1909. When Modigliani visited his family in Leghorn that same year, it was Brancusi that he spoke about. Soon his mother was writing to him in Paris as "Amedeo Modigliani, *sculpteur*."[2] Brancusi's dedication at this time to direct carving and the

simplified forms of his sculpture made a profound impression on Modigliani and almost certainly convinced him about 1909 to concentrate on sculpture. Although an exact chronology of his sculpture has not been (and probably never can be)

Fig. 49
Constantin Brancusi
The Wisdom of the Earth 1907
Stone: H. 50.5 cm
Muzeul de artă, Craiova

established, it is generally agreed that the surviving carvings were produced between 1909 and 1915. Of the twenty-five known sculptures catalogued by Ceroni, all are studies of heads, with the exception of a standing female and the Museum of Modern Art's *Caryatid*.[3]

The work shown here, one of two massive round heads, is distinctly reminiscent of Brancusi's 1907 stone *The Wisdom of the Earth* (fig. 49), which Modigliani may have seen when in the Rumanian's studio. Compared to its pendant, the lack of mouth and left eye suggests that the sculpture was unfinished. Of all his sculptures, these two plump heads are closest in conception to two of the most important early twentieth-century stone carvings, Derain's 1907 *Crouching Figure* (fig. 39) and Brancusi's 1907 *The Kiss* (see No. 57).

1. Edinburgh International Festival, 1963, *Modigliani* (London: Arts Council of Great Britain, 1963), p. 6.

2. *Ibid*, p. 6.

3. Ambrogio Ceroni, *I dipinti di Modigliani*, Milano, 1970, pp. 106–109.

67.
Amedeo Modigliani
Head IV c. 1911–12
Stone: H. 73 cm
Latner Family Collection

In 1912 Modigliani exhibited seven stone heads at the *Salon d'Automne*. This carving is one of four heads that emerge in high relief from a rectangular block of stone, a practice Rodin used in a number of his marble portraits. In contrast to the smooth surfaces of most of Modigliani's carvings, the small, rectangular cuts made by the chisel are visible, particularly on the sides of the head. Although this carving has the elongated head and nose that characterize all but six of the known heads, the features seem closer to Egyptian or possibly archaic Greek sculpture than to African Baule masks, which are generally cited as the major influence on Modigliani's stone heads (see No. 68).

By 1914 Modigliani appears to have given up sculpture and returned to his painting. Illness, the difficulty in obtaining stone, and the danger to his health from the dust generated by carving are all possible explanations.

Modigliani had thought of assembling many of his works in what he called a temple of beauty; but his dream of creating for it a great series of stone caryatids, *colonnes de tendresse* as he called them, was never realized. How many works were lost or destroyed will never be known. Modigliani's sculpture reflects the assimilation of disparate influences – Archaic Greek art, African art, Brancusi – yet remains uniquely personal and individual. Like Duchamp-Villon and Gaudier-Brzeska, his full potential as a sculptor was never realized.

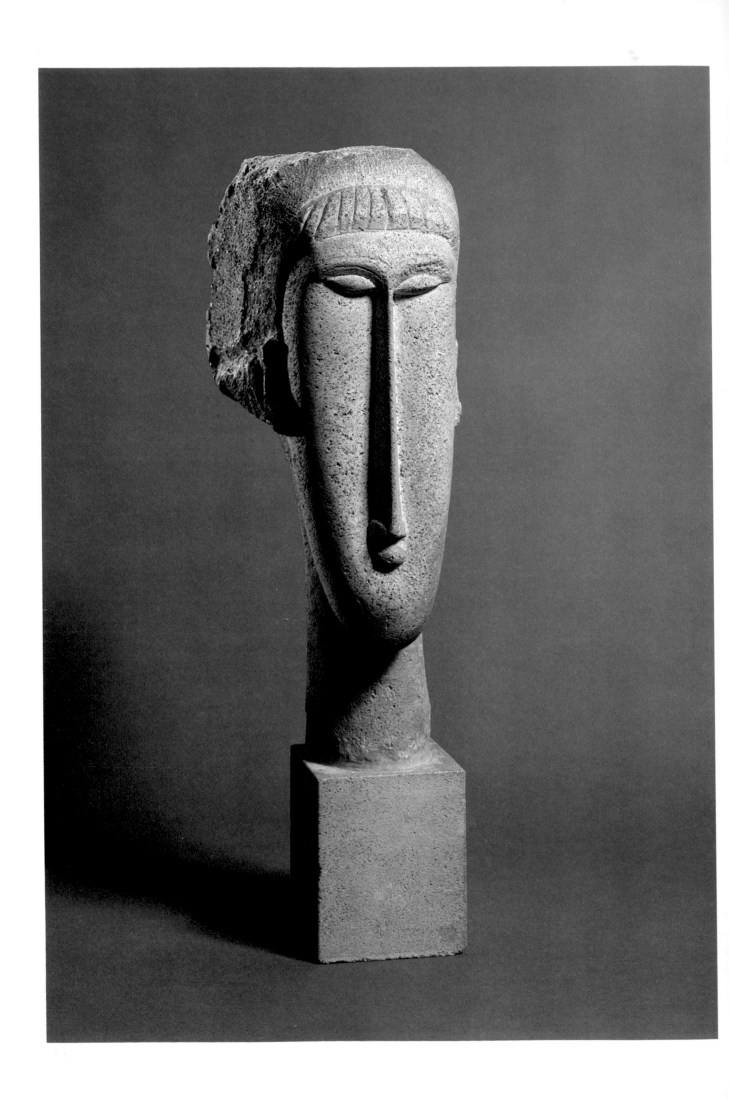

68.

Amedeo Modigliani
Head of a Woman c. 1910
Limestone: H. 65.2 cm
National Gallery of Art. Chester
Dale Collection 1962

This carving is one of the finest in the series of stone heads whose elongated features appear again and again not only in Modigliani's sculpture, but in many of his paintings and drawings. In looking to African art for inspiration, Modigliani followed the stylistic characteristics of Baule masks from the Ivory Coast, a style whose elegance and refinement was one of the first to appeal to European taste (fig. 50). Exactly when Modigliani became aware of African art has not been determined. His friendship with Picasso and Brancusi would have exposed him to examples of primitive art; he also would have seen how they assimilated African forms in their painting and sculpture. Compared to the Expressionist violence in many of Picasso's works from 1907 to 1908 (see fig. 28), Modigliani's primitivism is calm and contemplative.

Robert Goldwater discusses other influences on carvings like *Head of a Woman*:

Archaic Greek art certainly plays a role in the treatment of the hair, and perhaps even more in a handling of the stone surface which, though smooth, remains unpolished – very different from the high patinations of African wood. In other heads there is the pinched smile of the Greek *Koré*, or the fuller, more sensuous expression and fleshier modelling of Khmer sculpture.[1]

The bangs of hair in this piece are remarkably similar to those in Brancusi's first stone carving, the 1907 *Head of Girl* (fig. 41), while the long, thin nose and oval face are close to the 1910 *Baroness R.F.* (fig. 51).

Little attention has been paid to the stylistic relationships between the stone heads and the heads of the figures in the paintings and draw-

ings. For example, in an oil from about 1915 to 1916, the head and neck of *Lola de Valence* (Private Collection) are so close to some of the elongated stone heads that the painting seems as much like a study of one of the sculptures as a portrait from life. Conversely, it may well be that a number of the carvings do represent, granted in a highly stylized manner, features of some of the models of his paintings and drawings. Augustus John, who in 1909 visited Modigliani's studio in Montmartre, hints at this in his autobiography: "The stone heads affected me deeply. For some time afterwards I found myself under the hallucination of meeting people in the street who might have posed for them, and that without myself resorting to the Indian Herb."[2]

Jacob Epstein met Modigliani in 1912 and saw him almost daily for a period of six months. He wrote:

His studio at that time was a miserable hole within a courtyard, and here he lived and worked. It was then filled with nine or ten of those long heads which were suggested by African masks, and one figure. They were carved in stone; at night he would place candles on top of each one and the effect was that of a primitive temple.[3]

1. Robert Goldwater, *Primitivism in Modern Art* (New York: Vintage Books, 1967), p. 236.

2. *Augustus John Autobiography*, with an introduction by Michael Holroyd (London: Jonathan Cape, 1975), p. 148.

3. Jacob Epstein, *Epstein: An Autobiography*, with an introduction by Richard Buckle (London: Art Treasures Book Club, 1963), pp. 46 and 47.

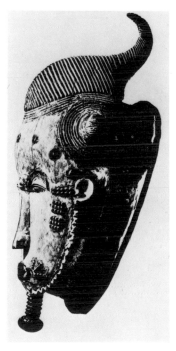

Fig. 50
Baule (Ivory Coast)
Dance Mask
Wood: H. 49.5 cm
Private Collection

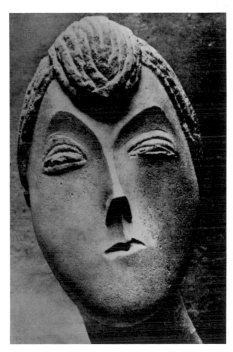

Fig. 51
Constantin Brancusi
Baroness R.F. 1910
Stone
Private Collection

69.
Amedeo Modigliani
Study for a Sculptured Head c. 1910
Blue crayon and pencil:
26.7 × 21.0 cm
Perls Galleries, New York

Modigliani was a prolific draughtsman and his subjects include portraits of his friends and fellow artists, nude studies, and drawings closely related to his sculptural preoccupations: heads and caryatids. This work is one of the studies of or for the elongated stone heads, such as the *Head of a Woman* (No. 67). Characteristically, the outlines of the head and neck are more heavily worked than the purely linear representation of the facial features. The summary treatment of the hair, forming strands curled at the ends, the large, blank, almond-shaped eyes, and the long, thin nose in most of the known drawings of this type consist of two or three almost parallel lines. Here a single vertical line connects the eyebrows to the bottom of the nose, itself a short horizontal line curling up at each side. This line continues in the same plane, joining the chin and the small bow-tie-shaped mouth. It is interesting to compare this drawing with Lipchitz's *Girl with Braided Hair* of 1914 (No. 95) and with Brancusi's undated drawing *Head of a Woman* (No. 60).

159

70.

Amedeo Modigliani
Woman in Profile 1910–11
Charcoal and pastel: 42.9 × 26.7 cm
The Museum of Modern Art, New
York. The Joan and Lester Avnet
Collection

In the notes for No. 68, mention was
made of the influence of Baule masks
and Archaic Greek art on Modig-
liani's stone heads. In a recent article,
Edith Balas argues that, contrary to
the generally accepted view that

African Negro sculpture was the
main stylistic source for Modigliani's
heads, it was Egyptian art that was
Modigliani's main inspiration. She
quotes from the memoirs of the
Russian poet Anna Akmatova, who
in 1911 was Modigliani's neighbour at
14 Cité Falguière:

In 1911 Modigliani was madly in
love with Egypt. He took me to
the Egyptian section in the
Louvre; he assured me that every-
thing else – *tous le reste* – was

unworthy of attention. He drew
my head in the headdress of an
Egyptian princess and in that of a
dancer.[1]

Balas argues convincingly that a
drawing entitled *Head* (Private Col-
lection, Milan) – whose features and
proportions are almost identical to
this one, suggesting a frontal repre-
sentation of the same head – was
based on Egyptian heads, and cites
the small wooden head of *Nefertiti*
and the eighteenth-dynasty *Royal
Head* in the Musée du Louvre. The
Egyptian character of *Woman in
Profile* is even more pronounced
because the head is shown in profile
but with the eye in a frontal aspect, a
convention governing the representa-
tion of the human head in Egyptian
painting and relief sculpture. The
thick, sensuous lips, the shape of the
eye, the lengthy curved eyebrow
(very similar to the *Royal Head* in
the Louvre), the necklace and ear-
rings, and above all the elongated,
egg-shaped head are all features
found in Egyptian art. Modigliani's
stone *Head of a Woman* (Musée
national d'art moderne, Centre
Georges Pompidou, Paris) is, Balas
suggests, the sculpture most closely
related to the Egyptian features in
the Milan drawing.[2]

Modigliani's *Woman in Profile*, like
Lipchitz's *Girl with Braided Hair*
(No. 95), is undoubtedly indebted to
Egyptian sources, as was Giacomet-
ti's 1933–34 bronze *Walking Woman*
(No. 105). Surely this was not his
main stylistic source, but one of
many outside influences that
inspired his remarkable and subtle
studies of the human head.

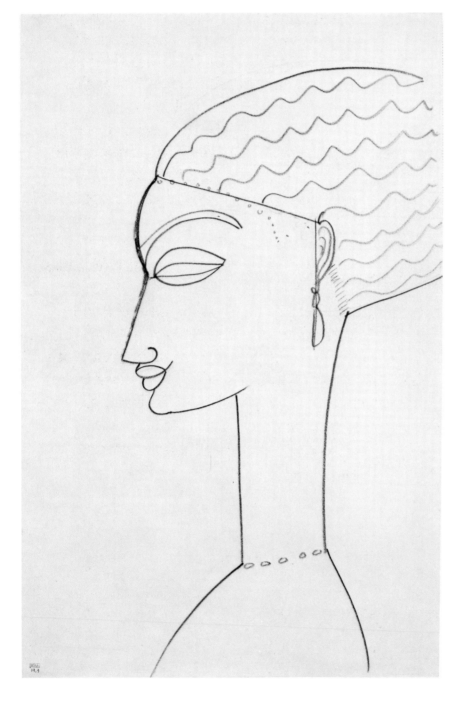

1. Edith Balas, "The Art of Egypt as
 Modigliani's Stylistic Source,"
 Gazette des Beaux-Arts 97, no. 6
 (Février, 1981): 87.

2. *Ibid*, p. 90.

Raymond Duchamp-Villon 1876 – 1918

Born Pierre-Maurice-Raymond Duchamp in Damville (Eure) near Rouen, this French sculptor was the brother of Jacques Villon and Marcel Duchamp. He first studied medicine, which he abandoned about 1900 for sculpture. He was self-taught and experimented with many styles, first exhibiting in 1902 at the *Salon de la Société Nationale des Beaux-Arts*. About 1910 or 1911 he became involved in the Cubist movement and participated with his brothers in the 1912 historic exhibition, *La Section d'Or*, at the Galerie La Boétie, Paris; among the practitioners of Cubism, only Braque and Picasso were absent. In 1913 Duchamp-Villon participated in the Armory Show, and in 1914 had his first one-man exhibition at the Galerie André Groult, Paris. As were many young artists at the time, he was first influenced by Rodin, but by 1910 his *Torso of a Young Man* seemed to repudiate not only Rodin's *Walking Man* but also Maillol's *Chained Action*.

Duchamp-Villon continued to experiment with form, making it more and more synthetist in style. Three heads illustrate his evolution; starting with *Baudelaire* in 1911, which remains a portrait; continuing the following year with the idol-like head of *Maggy*; and culminating in 1918 with the *Portrait of Dr Gosset*. Duchamp-Villon had seen African sculpture, which at the time was admired by the artists of the *avant garde*, especially by the Cubists.

Duchamp-Villon joined the army in 1914, and in 1916 contracted typhoid fever. He died in Cannes in October 1918.

71.
Raymond Duchamp-Villon
Head of Baudelaire 1911
Terracotta: H. 38.7 cm
Art Gallery of Ontario. Gift in
memory of Harold Murchison Tovell
(1887–1947) and Ruth Massey Tovell
(1889–1961) from their sons, 1962

Duchamp-Villon's 1911 *Baudelaire*, with Picasso's 1909 *Head of a Woman (Fernande)* (No. 52) and Matisse's five heads of Jeannette of 1910-13 (No. 64), is one of the undisputed masterpieces of early twentieth-century portrait sculptures. Yet in the way in which all surface modelling has been eliminated, the sculpture is closer to the work of Brancusi than it is to the rugged, deeply faceted surfaces of the Picasso and Matisse bronzes.

The sculptor and his brothers, Jacques Villon and Marcel Duchamp, grew up in an atmosphere in which they shared common interests in literature, music, and art. Of the three, Duchamp-Villon was the only one to devote himself entirely to sculpture. In 1911 the three brothers and other members of the Puteaux group – Metzinger, La Fresnaye, Léger, Picabia, Delaunay, Kupka, and Gleizes – met regularly to discuss a wide range of topics: art, philosophy, literature, photography, science, and mathematics. As George Heard Hamilton has written:

> Amid the emergent social ideals at Puteaux, Duchamp-Villon became intensely conscious of the need for an art appropriate to the twentieth century. His sense of the continuity of history focused on Baudelaire, his spiritual ancestor, who had proclaimed the advent of the modern era a half century earlier.[1]

Duchamp-Villon probably worked from photographs of the nineteenth-century French poet by Nadar and Carjat. He produced two small preliminary studies, one of which, in its overall surface modelling, seems related to Rodin's 1898 bronze *Head of Baudelaire*. There is a charcoal drawing in the Musée national d'art moderne, Centre Georges Pompidou, in which the shaded areas around the eyes and along each side of the head create planes and angles that were eliminated in the large finished sculpture. The sculpture does, however, emphasize the broad expanse of the forehead and the long thin mouth, turned down at the edges.

According to his brother Jacques Villon, the sculptor made five or six plaster casts of the Baudelaire head as well as three or four terracotta casts, one of which, in 1978, was presented by the artist's family to the Philadelphia Museum of Art.[2] There is also an edition of eight bronzes, three of which were cast during the artist's lifetime. As Brancusi did in *The Kiss* (No. 57) and in the 1910 marble *Sleeping Muse* (Hirshhorn Museum and Sculpture Garden), Duchamp-Villon has greatly simplified the head; by a process of reduction he has eliminated the busy modelled surfaces of the preliminary study and the Cubist faceting that appears in the drawing.

Hamilton discusses the sculptor's frequent trips to Chartres and remarks that "*Baudelaire* is remarkably close in spirit and contour to the heads of the Kings of Judah on the right bay of the Portail Royal at Chartres."[3] What of the possible influence of African art? Although Hamilton sees a resemblance between *Baudelaire* "and the masklike, totemic qualities of certain Gabon heads, primitive art was far beyond the restrained French sensibility of Duchamp-Villon."[4] Another stylistic source was suggested in 1914 when Louis Hautecoeur compared the sculpture to "an Egyptian bust in which all detail has been suppressed."[5]

The year 1911 marked the culmination of the analytical Cubism of Braque and Picasso. It would be difficult to imagine a more marked contrast to the complex faceting and spatial ambiguities of the hermetic stage of Cubist painting than Duchamp-Villon's powerful and cerebral image of *Baudelaire*.

1. George Heard Hamilton, *Raymond Duchamp-Villon* (New York: Walker and Co., 1967), pp. 56 and 58.

2. Judith Zilczer, "Raymond Duchamp-Villon," Exhibition, October 26, 1980 to January 4, 1981, *Bulletin Philadelphia Museum of Art* 76 no. 330 (Fall 1980): 6, 7.

3. Hamilton, *Duchamp-Villon*, pp. 59–60.

4. *Ibid*, p. 60.

5. "Raymond Duchamp-Villon," p. 7.

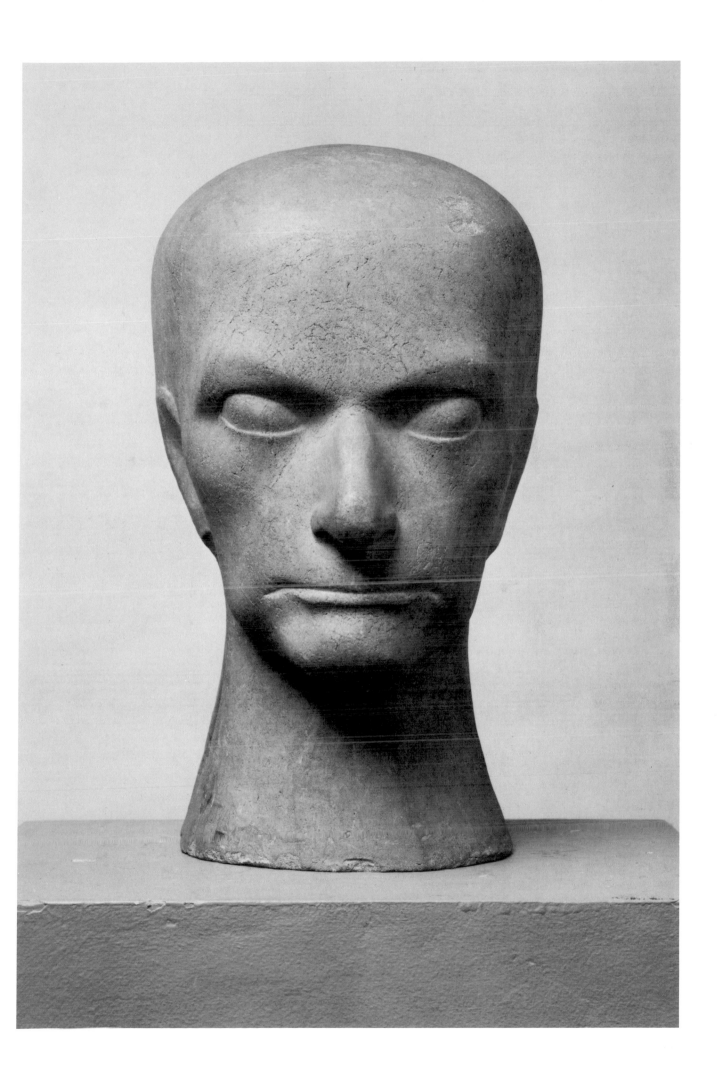

72.
Raymond Duchamp-Villon
Head of Professor Gosset 1917
Bronze enlarged and cast
posthumously: H. 29.6 cm
Signed rear lower left:
Duchamp-Villon
Hirshhorn Museum and Sculpture
Garden (Smithsonian Institution)

When Duchamp-Villon contracted typhoid fever late in 1916 while stationed with the army at Champagne, he was sent to the military hospital at Mourmelon. Toward the end of a long convalescence, he began work on his last sculpture, a portrait of Professor Gosset, one of the doctors who had looked after him. In May 1918 the sculptor wrote:

> I have, however, progressed rather far with a portrait of one of the surgeons who cared for me and with which I am not dissatisfied as a point of departure. But it is still necessary to finish it and I am counting on the weeks of my convalescence to accomplish it. All this is a great effort because of my weakness.[1]

According to Steven Nash, "The original version of this sculpture was only four inches high and was modelled with flattened clay pellets which impart a roughened texture."[2] A drawing in the estate of the artist reveals that Duchamp-Villon had considered fitting the head into an architectural structure. He may also have intended to suspend the sculpture, rather than mounting it on a base. A small plaster version is in the Philadelphia Museum of Art, and several bronze casts are known.

Only in the 1911 bronze *Maggy*, the 1917 *Head*, and the *Head of Dr. Gosset* does Duchamp-Villon's work reflect something of the demonic power of African masks. Naturally his *Head of Dr. Gosset* has been interpreted as a premonition of death. He died on October 7, 1918, leaving behind a work with the same terrifying presence we experience in Picasso's 1944 *Death's Head* and in the portraits by Francis Bacon.

1. Judith Zilczer, "Raymond Duchamp-Villon," Exhibition, October 26, 1980 to January 4, 1981, *Bulletin Philadelphia Museum of Art* 76 no. 330 (Fall, 1980): 21.

2. Steven A. Nash, *Painting and Sculpture from Antiquity to 1942* (Buffalo: Albright-Knox Art Gallery, 1979), p. 351.

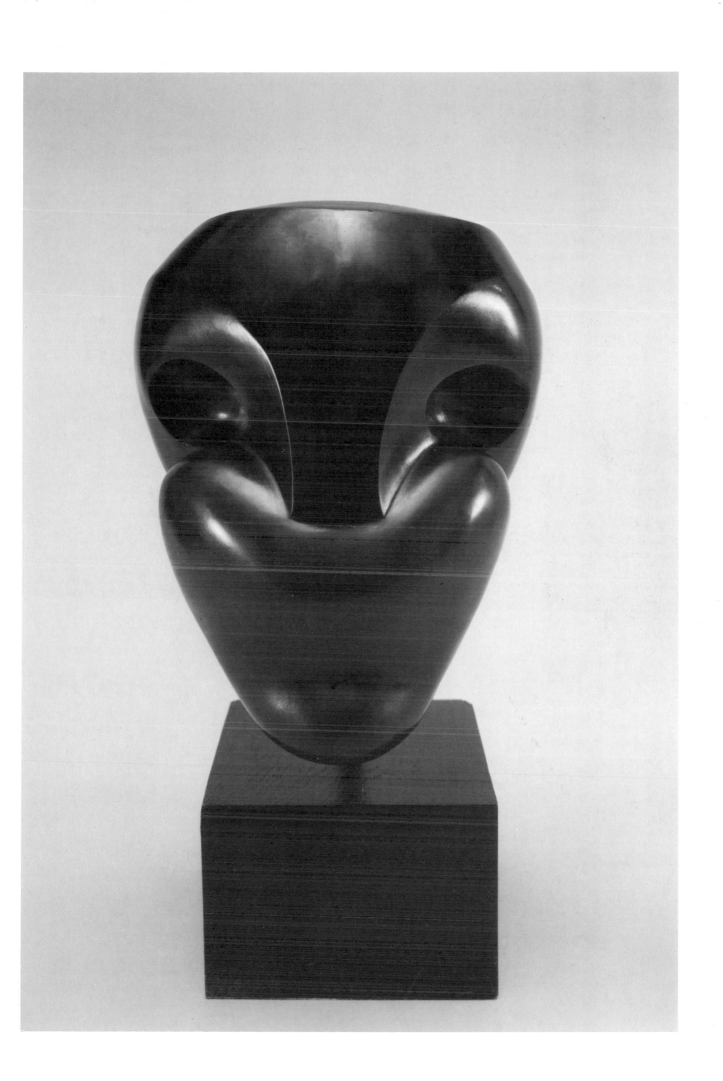

Jacob Epstein 1880-1959

Born in New York of Polish-Jewish parents, Jacob Epstein, sculptor and draughtsman, studied at the Art Students' League in the evenings. He worked in a bronze foundry and from 1899 to 1900 studied sculpture under George Grey Barnard. In 1902 he went to Paris, where he studied at the Ecole des Beaux-Arts and the Académie Julian. In 1904 he visited Florence and London, and began to buy African carvings. In 1905 he moved to London and in 1907 became a British citizen. From 1907 to 1908, he produced his first commissioned monument, eighteen over-life-size figures for the new British Medical Association Building, in the Strand, the first of many controversial public commissions. In 1908 he produced his first portraits. He was rejected for membership in the Royal Society of British Sculptors. About 1911 he was commissioned to carve the tomb of Oscar Wilde for Père Lachaise Cemetery, Paris.

Epstein met Gaudier-Brzeska, Ezra Pound, and T.E. Hulme about this time. In 1912 he spent six months in Paris, where he met Picasso, Brancusi, Modigliani, and Paul Guillaume. The tomb of Oscar Wilde, unveiled that year, evoked a violent reaction. From 1913 to 1914, Epstein was involved with the Vorticist movement and was an original member of the London Group, where he exhibited *Rock Drill*. His first one-man exhibition was at Twenty-One Gallery, Adelphi, London.

After being demobilized in 1919 Epstein travelled to Italy and visited Rome, Florence, and Carrara. In 1926-27 Epstein accompanied his works to New York for a one-man exhibition. He helped defend a Brancusi sculpture in court. In 1954 he received a knighthood and after the war produced numerous portrait busts of members of his family, friends, socialites, and famous figures of the day, modelled in an impressionist style; but his monumental works, many of which were carved, remained experimental, occasionally revealing his interest in archaic and primitive forms. In 1959, having just completed the modelling of a large group for a Bowaters Ltd. commission, he died on August 19. In 1960 the Arts Council of Great Britain held an exhibition of Epstein's collection of primitive sculpture.

73.
Jacob Epstein
Sunflower c. 1910
San Stefano stone: H. 58.5 cm
Anthony d'Offay Gallery, London

Epstein's initial exposure to primitive art almost certainly took place in 1902, when he arrived in Paris from New York. Almost immediately, he began exploring the museums – the Louvre, where he admired early Greek and Cycladic sculpture, and the Trocadéro (now Le Musée de l'Homme), where, he wrote in his autobiography, there "was a mass of primitive sculpture none too well assembled."[1]

He went to London in 1905 to see if he could settle down and work. His impression of the English was that they "were a people with easy and natural manners, and great courtesy, and a visit to the British Museum settled the matter for me."[2] Although he settled in London in 1905, it was not until about 1910 that he mentioned a tremendous interest in the Greek and Egyptian sculpture in the British Museum "and the vast and wonderful collections from Polynesia and Africa."[3]

If 1910 – the year generally assigned to *Sunflower* – is correct, this work is one of Epstein's earliest works to reflect his interest in African art.

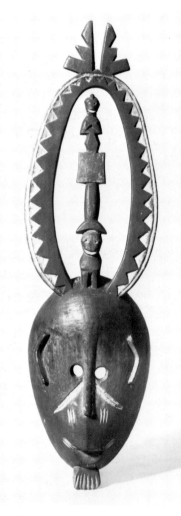

Fig. 52
Nupe (Northern Nigeria)
Mask
Wood: H. 65.5 cm
Museum of Mankind, London

Goldwater discusses the influence of Gabon Fang sculpture on *Sunflower*: "If in deference to the subject the petal-like surrounding mass is more jagged than in the *bieri* heads, it nevertheless frames the face in much the same way."[4] Since similar motifs occur in many African tribal styles, it is interesting to compare the jagged shapes in the Nupe mask (fig. 52) with Epstein's *Sunflower*.

1. Jacob Epstein, *Epstein: An Autobiography*, with an introduction by Richard Buckle (London: Art Treasures Book Club, 1963), p. 12.

2. *Ibid*, p. 18.

3. *Ibid*, p. 20.

4. Robert Goldwater, *Primitivism in Modern Art* (New York: Vintage Books, 1967), p. 239.

74.

Jacob Epstein
Design for the Tomb of Oscar Wilde
c. 1910
Pencil: 50.8 × 38.1 cm
Anthony d'Offay Gallery, London

In about 1910 Epstein received his second important commission: to design and carve a tomb for Oscar Wilde to be placed in the Père Lachaise Cemetery in Paris (fig. 53). Epstein had completed the British Medical Association's famous Strand statues, which had been violently attacked in the London press, and was excited to be able to tackle another important commission. "As you can imagine," Epstein said in conversation with Arnold Haskell, "this was an exceedingly difficult task from the point of view of pleasing people . . . for Wilde's enthusiastic admirers would have liked a Greek youth standing by a broken column."[1] Epstein said he made preparatory sketches, some of which he translated into sculpture.

When he was satisfied with the final design he went to the Hopton Wood stone quarries in Derbyshire and bought "this monolith, weighing twenty tons, on the spot, and had it transported to my London studio."[2]

One of the great Assyrian *Human-Headed Winged Bulls* in the British Museum (fig. 54) was the inspiration for the Oscar Wilde project. This is one of the few cases where a specific work of art, rather than a stylistic type, can be identified as the source of a sculpture.

> I conceived a vast winged figure, a messenger swiftly moving with vertical wings, giving the feeling of forward flight. It was of course purely symbolic, the conception of a poet as a messenger, but many people tried to read into it a portrait of Oscar Wilde.[3]

This fascinating drawing not only records an early compositional study, but also documents some of the ideas that Epstein associated with the symbolic theme of the commission. At bottom left he lists the following

vices: covetousness, envy, jealousy, anger, sloth, wandering thoughts, fornication, slander, sodomy, evil. Could that extraordinarily phallic reclining sphinx be whispering these thoughts into the ear of the poet? To the right of the inscription, two couples and a single figure appear to be immersed in water, as if imprisoned in Dante's Inferno. There is another couple at left: the smaller of the two figures fondles the other's breasts; the snake-like tongues of the couple at right are one, as lecherous a representation of a kiss as Brancusi's is spiritual (see No. 57). The winged figure in this drawing is far less massive and block-like than the Assyrian source or Epstein's finished carving. Here the arms are folded across the chest, whereas in the sculpture they run parallel to the body. Neither the whispering sphynx nor the emaciated male figure suspended on the front of the high headdress were included in the sculpture.

In 1912 Epstein went to Paris for the installation of the Wilde memorial at the Père Lachaise Cemetery. Once again his work became the subject of public controversy. Shocked by the male nudity, the French authorities had the tomb covered with a tarpaulin. Protests by fellow artists and writers, and letters to the Paris press, followed. The monument remained covered until the outbreak of the 1914–18 war. When, during his stay in Paris in 1912, Epstein met Picasso, Modigliani, and Brancusi, these encounters may well have encouraged his interest in primitive art, which was to strongly influence his carvings of the following years.

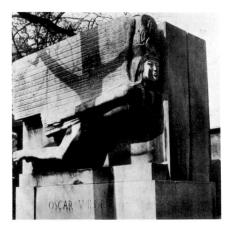

Fig. 53
Jacob Epstein
Tomb of Oscar Wilde
Stone
Père Lachaise Cemetery, Paris

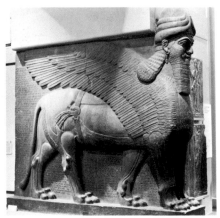

Fig. 54
Assyrian
Colossal Human-Headed Winged Bull
Stone
British Museum, London

1. Jacob Epstein, *The Sculptor Speaks: Jacob Epstein to Arnold L. Haskell* (London: William Heinemann Ltd., 1931), p. 19.

2. Jacob Epstein, *Epstein: An Autobiography* (London: Art Treasures Book Club, 1963), p. 51.

3. Epstein, *The Sculptor Speaks*, p. 20.

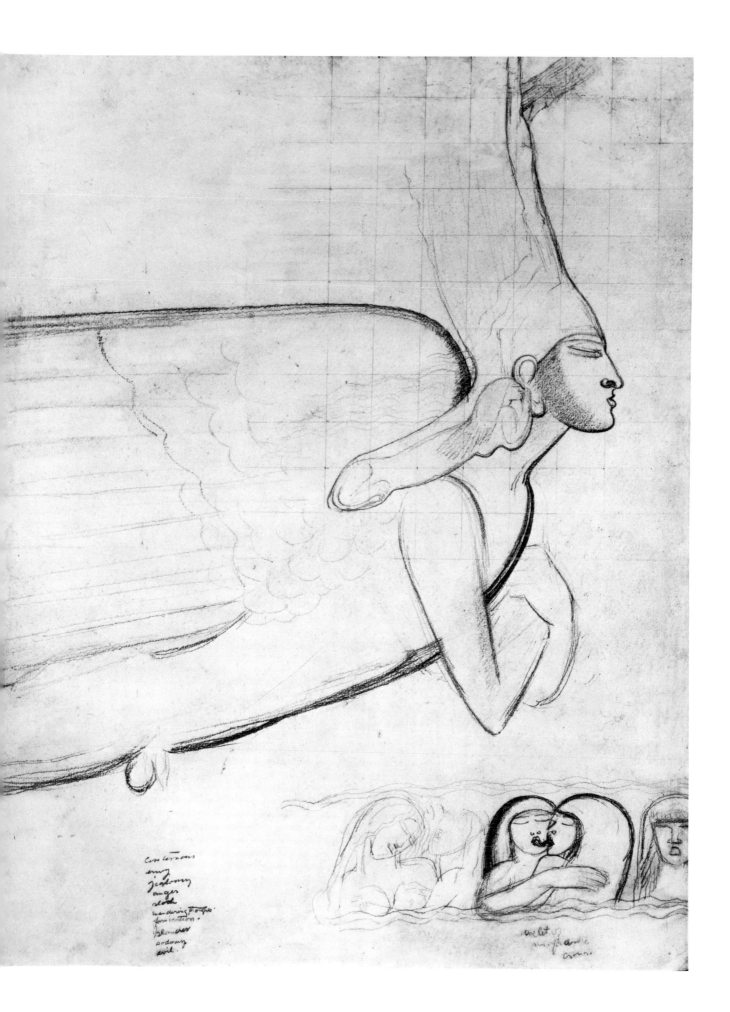

171

75.
Jacob Epstein
Female Figure 1913
Flenite: H. 60.9 cm
Lent by The Minneapolis Institute of
Arts, Gift of Messrs. Samuel H.
Maslon, Charles H. Bell, Francis D.
Butler, John Cowles, Bruce B.
Dayton, and Anonymous Donor

During his Sussex period, Epstein carved three figures in flenite – this work, The Tate Gallery's *Female Figure in Flenite* (fig. 55), and the rectangular, block-like *Flenite Relief*. The piece shown here and the Tate carving represent a pregnant woman; a pregnant woman was also the subject of one of the eighteen Strand statues of 1908. In both the Tate and Minneapolis sculptures, the woman is obviously close to birth. In fact, a 1913 red crayon drawing entitled *Birth* (The Museum of Modern Art, New York) does show the actual birth of the child, a sequel to *Study for Female Figure in Flenite* (No. 76), in which the child is positioned in the womb ready for birth. In this carving, in the 1913 drawing *Totem* (No. 78), and in the drawing *Birth*, Epstein has depicted the cycle of love, pregnancy, and birth.

In the two versions of the female figure in flenite, the facial features are very similar and no doubt were inspired by primitive art. In the Tate carving the S form is more pronounced, and the legs and feet are freed from the stone. In the version shown here the head is held upright above the large block of flenite beneath. Gaudier-Brzeska may have been referring to the flenite carvings when he wrote of Epstein: "He's doing most extraordinary statues, absolute copies of Polynesian work with Brancusi-like noses."[1] T.E. Hulme, in his December 25, 1913, article for *The New Age*, "Mr. Epstein and the Critics," discussed the frequent criticisms directed against the figures in flenite, namely:

that an artist has no business to use formulae taken from another civilization. . . . These "Carvings in Flenite", we are told, are deliberate imitations of Easter Island carvings.

Hulme argues that the same emotions are shared by all mankind and concludes that it is "the business of every honest man at the present moment to clean the world of these sloppy dregs of the Renaissance."[2]

Epstein's interest in the Egyptian sculpture in the British Museum is mentioned in the notes for No. 73. Might not the carving shown here, with the head rising above the solid block of stone, have been inspired by the block-like mass of Egyptian seated figures?

1. H.S. Ede, *Savage Messiah* (London: William Heinemann Ltd., 1931), p. 247.

2. Jacob Epstein, *Epstein: An Autobiography* (London: Art Treasures Book Club, 1963), p. 64.

76.
Jacob Epstein
Study for Female Figure in Flenite
c. 1913
Black crayon: 68.6 × 42.5 cm
Signed lower right: Epstein
Anthony d'Offay Gallery, London

This Vorticist drawing, with the mother looking down at her swelling stomach, is closer to the Tate carving (fig. 55) than the Minneapolis sculpture (No. 75). The child is shown in the mother's womb, with the head down ready for birth. The distortion of the elongated neck and upper torso, which has the appearance of an enormous bent arm, looks forward to Picasso's grotesque drawings of bathers, made in the summer of 1927.

Encircling the figure, the dynamic series of arched forms may represent the open vagina at the moment of birth. The child, centrally situated in this composition, is the vortex, as Wyndham Lewis defined it: "At the heart of the whirlpool is a great silent place where all the energy is concentrated. And there, at the point of concentration, is the Vorticist."[1]

1. Jane Farrington, *Wyndham Lewis* (Manchester: Manchester City Art Gallery, 1980), p. 26.

Fig. 55
Jacob Epstein
Female Figure in Flenite 1913
Flenite: H. 45.7 cm
The Tate Gallery, London

77.
Jacob Epstein
Mother and Child 1913
Marble: 43.8 × 43.1 cm
The Museum of Modern Art, New
York. Gift of A. Conger Goodyear,
1938

Epstein found it difficult to work in
Paris and decided to return to
England. He rented a bungalow on
the Sussex coast at Pett Level, where

> ...I could look out to sea and
> carve away to my heart's content
> without troubling a soul. It was
> here I carved the "Venus" [see No.
> 79], the three groups of doves, the
> two flenite carvings [see No. 75]
> and the marble "Mother and
> Child" [No. 77], now in the
> possession of Miss Sally Ryan of
> New York who has lent it to the
> Museum of Modern Art.[1]

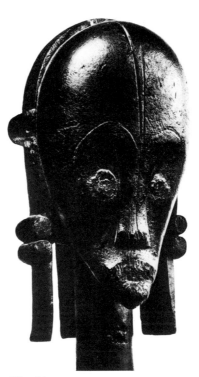

Fig. 56
Fang (Gabon)
Head of a Reliquary
Wood: H. 47.0 cm
Ex-collection Jacob Epstein

Epstein found this peaceful rural
setting an ideal environment for
work, as Moore was to find rural
Kent a perfect retreat in the 1930s.

It is difficult to suggest a specific
prototype for the marble *Mother and
Child*. The features of the mother
owe a debt to African art (fig. 56),
while the smooth, simplified form of
the child's head may reflect the
influence of Brancusi, whom Epstein
had met in Paris in 1912. During
1913-14, the years in which he
produced his most important and
original work, Epstein's carving
reflects an almost obsessive preoccu-
pation with sexuality, fertility, and
the theme of mother and child both
before and after birth. (See Nos. 75
and 78).

1. Jacob Epstein: *Epstein: An Autobiog-
raphy* (London: Art Treasures Book
Club, 1963), p. 49.

78.
Jacob Epstein
Totem c. 1913
Pencil and wash: 57.8 × 41.9 cm
Signed lower right: Epstein
Anthony d'Offay Gallery, London

In this drawing, one of Epstein's most extraordinary inventions, a totemic form is created by the bodies and splayed legs of a man who stands on his head as he makes love to a woman who holds a child high above her head. Images of procreation, pregnancy, and birth are the subject of other works by Epstein in this exhibition (see Nos. 75, 76) from the two productive years of 1913–14. The thrusting potency of the male sex is repeated in a mechanical form in various drawings related to his best known sculpture, the 1913–16 bronze *Rock Drill* (National Gallery of Canada, Ottawa) which was originally mounted on a drill that

Epstein had purchased second-hand.

When shown this drawing recently, William Fagg, who has an extraordinary visual memory, directed this author to consult illustrations in Leo Frobenius, *Das Unbekannte Afrika* (Munich, 1923) in which, on page 163 (fig. 57), are three drawings of Dogon (Mali) relief carvings in Priest's Dwellings in the village of Kani Kombole. These were based on earlier drawings made by Frobenius or Fritz Nansen during the 1908 German expedition (DIAFE). They were almost certainly published by Frobenius soon after 1908, but this author was not able to research these earlier publica-

tions before this catalogue went to press. Unquestionably the male and female couple in the Epstein drawing were based on the central sketch in fig. 57, while the child held above the mother's head probably derives from the upper figure at right. Almost certainly Epstein saw these relief carvings in an earlier publication, and therefore the date of about 1913 for this drawing is correct. I am indebted to William Fagg for pointing out Epstein's remarkable adaptation of the African works.

Fig. 57
Dogon (Mali)
Drawing by H. Hazler of Relief Carvings in Priest's Dwellings in the Village of Kani Kombole
(Photograph from Leo Frobenius, *Das Unbekannte Afrika*, Munich, 1923.)

79.
Jacob Epstein
Study for Second Marble Venus
1914–1915
Blue crayon: 62.9 × 41.3 cm
Anthony d'Offay Gallery, London

At Pett Level Epstein carved two marble Venuses; the first version is now in the Baltimore Museum of Art, the second in the Yale University Art Gallery (fig. 58). The sculptor mentioned in his autobiography that he carved a Venus during his stay in Sussex, presumably a reference to the Baltimore sculpture (H. 123.2 cm), the earliest of the two versions. According to the records at Yale, the second, more elongated version in their collection was begun at Pett Level in 1914, but not completed until 1917.

Goldwater describes the African influence and illustrates the Yale carving:

> The contours of the blunt faces, even though featureless, are once more reminiscent of Fang sculpture, as is the exaggerated length of the necks, while the heavy legs, so flexed that the figure seems half-kneeling, are, as in Gaudier's *Imp*, derived from African practice.[1]

Epstein owned superb examples of Gabon Fang sculpture, including *Head of a Reliquary* (fig. 56). There

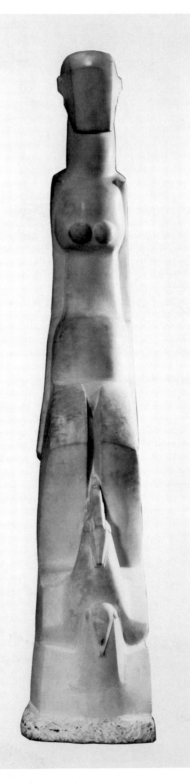

is a striking resemblance between the angular chin of both Venuses and that of the Fang carving.

In this drawing the elongated form of Venus is closer to the Yale carving, whereas the doves are more related to those in the Baltimore sculpture. The theme of the carving is related to the triumph of Venus, where the goddess of love is enthroned in her chariot drawn by doves or swans. In 1913 Epstein also did three carvings showing coupled doves, works that almost certainly influenced Barbara Hepworth's Parian marble *Doves* of 1927, now in the Manchester City Art Gallery.

Fig. 58
Jacob Epstein
Venus 1914–1917
Marble: H. 235.6 cm
Yale University Art Gallery, Gift of
Winston F.C. Guest

1. Robert Goldwater, *Primitivism in Modern Sculpture* (New York: Vintage Books, 1967), pp. 240 and 242.

Henri Gaudier-Brzeska 1891–1915

Born Henri Gaudier at Saint-Jean-de-Braye (Loiret) near Orléans, this French sculptor and draughtsman was the son of a carpenter. As a youth he travelled on scholarships – intended for students learning foreign business methods – to Great Britain in 1906 and again in 1908, and then to Germany in 1909. When he returned from Germany late in 1909 he was determined to become an artist and went to Paris, where he studied art in the evenings. In 1910 he decided to concentrate on sculpture. He met Sophie Brzeska and began using the joint name Gaudier-Brzeska.

In early 1911 they went to London, where Gaudier-Brzeska met Epstein; in 1912 he met John Middleton Murry. He contributed some drawings to *Rhythm* and in 1913 exhibited at the *Allied Artists Association Salon* held at the Albert Hall, London, in June. There he met Brancusi who, along with Epstein and primitive sculpture, was an important influence on the development of his style; it is also where he first met Ezra Pound. He was included in Roger Fry's Grafton Group exhibition at the Alpine Club Gallery in January 1914; in June he met T.E. Hulme and wrote for *The Egoist*. He was a founder-member of the London Group in 1913 and of the Vorticists in 1914–15. He contributed a manifesto to the first number of the Vorticist magazine, *Blast*, which appeared in the summer of 1914; a second Vortex piece was published posthumously in *Blast* in July of 1915.

Gaudier-Brzeska was a prodigious and versatile draughtsman, but his output of sculpture was limited – although remarkable for an artist who worked for such a short period. He joined the French army and was killed at Neuville-Saint-Vaast, Belgium, on June 5, 1915. A memorial exhibition was held at the Leicester Galleries, London, in July 1918.

80.

Henri Gaudier-Brzeska
Seated Woman 1914
Marble: H. 47 cm
Musée national d'art moderne –
Centre Georges Pompidou – Don de
la Collection Kettle's Yard

In Gaudier-Brzeska's letter to the
editor of *The Egoist*, published in the
March 16, 1914, issue, he wrote of
modern sculpture: "That this
sculpture has no relation to classic
Greek, but that it is continuing the
tradition of the barbaric peoples of
the earth (for whom we have
sympathy and admiration) I hope to
have made clear."[1] Like Gauguin
before him and Moore after, Gaudier
rejected the classical tradition and
sought inspiration from primitive
and non-European sources.

"In his carvings," Gaudier's friend
Horace Brodzky wrote, "he showed a
variety of influences. China, Egypt,
Michael Angelo, Rodin, and Bran-
cusi, and also Negro sculpture – from
all these he borrowed quite
frankly."[2] His meeting with Epstein
in 1912 may well have stimulated his
interest in carving. At the time,
Epstein was working on the Oscar
Wilde tomb (see No. 74), which
Gaudier saw and sketched in a letter
to Dr. Uhlemayr (fig. 59).

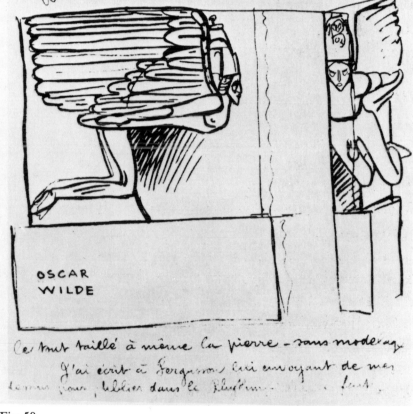

Fig. 59
Henri Gaudier-Brzeska
Letter to Dr. Uhlemayr, dated 18.6.1912,
with a sketch of Epstein's *Tomb of Oscar
Wilde* (see Fig. 53)

Gaudier's commitment to direct carving during the last two years of his life was something he shared with Epstein, Modigliani, and Brancusi, and his example in the 1920s was to inspire the young Henry Moore. His finest works from these years were carvings in a variety of materials: the 1914 Mansfield stone *Red Stone Dancer* in The Tate Gallery (fig. 64); the marble *Hieratic Head of Ezra Pound* (fig. 62); the red-veined alabaster *Stags* in The Art Institute of Chicago; and the 1914 *Seated Woman*.

Seated Woman embodies the sculptural principles Gaudier had formulated and published in the June 1914 issue of Wyndham Lewis' Vorticist publication, *Blast: Review of the Great English Vortex*:

> SCULPTURAL energy is the mountain.
> Sculptural feeling is the appreciation of masses in relation.
> Sculptural ability is the defining of these masses by planes.[3]

Like Epstein, the other important sculptor associated with the Vorticist movement, Gaudier often reflected both the influence of primitive art and the abstract tendencies of Cubism in his work. Both the pose and heavy limbs of *Seated Woman* are reminiscent of Modigliani's only surviving stone *Caryatid*, and of his numerous drawings and water-colours of this subject. Whereas the mask-like face may well be indebted to primitive art, the asymmetrical pose is clearly European in inspiration.

1. Ezra Pound, *Gaudier-Brzeska: A Memoir* (New York: A New Directions Book, 1970), p. 37.

2. Horace Brodzky, *Henri Gaudier-Brzeska 1891–1915* (London: Faber and Faber Ltd., 1933), p. 66.

3. Pound, *Gaudier-Brzeska*, p. 20.

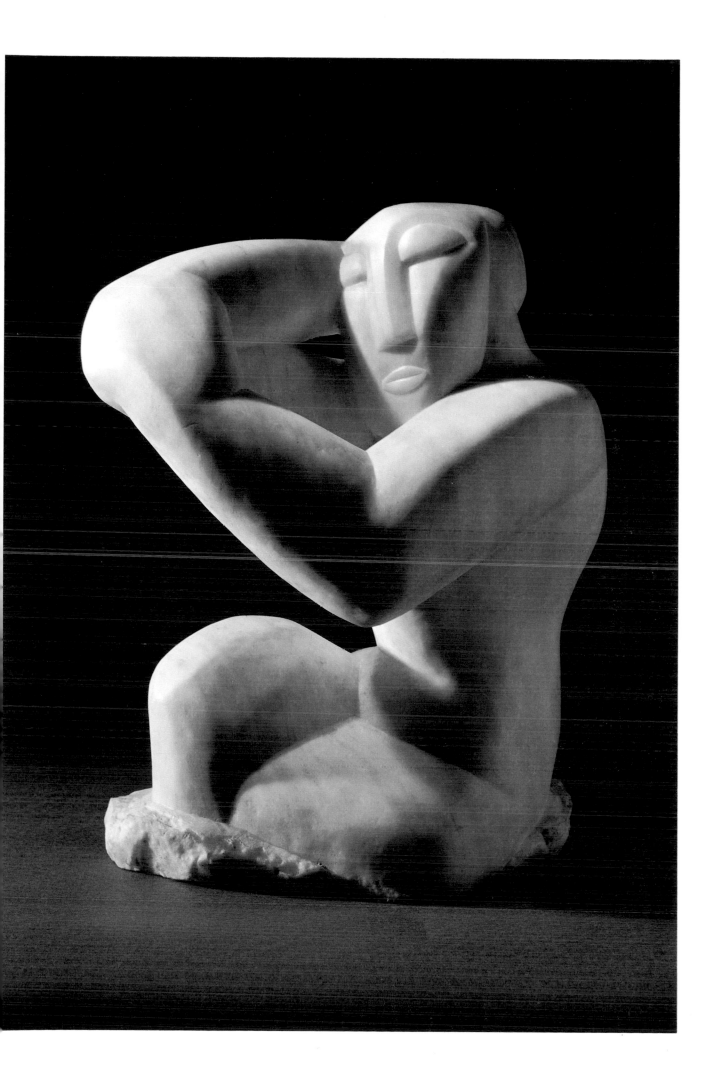

81.
Henri Gaudier-Brzeska
Doorknocker 1914
Bronze: H. 17.5 cm
The Trustees of The Tate Gallery

Cast from the original carved brass *Doorknocker*, at Kettle's Yard, University of Cambridge, this work is one of few of Gaudier's that can be related to a specific style of primitive art – the Maori jade ornaments (*hei-tiki*) from New Zealand (fig. 60). The drawing *Design for a Doorknocker in Kettle's Yard, Cambridge* (fig. 61) is closely related to the Tate sculpture and may well be the definitive study for it. The drawing makes explicit what is, in the sculpture, less obvious. Figure 61 shows a female form with upraised arms and a head looking down between large breasts; she is sitting or balancing cross-legged, about to be penetrated by the enormous erect male sex. Could Gaudier have seen Epstein's *Totem* drawing of 1913 (No. 78), which also represents a couple making love, with the male upside-down beneath the female? In the sculpture, Gaudier has modified the design, particularly the area above the waist of the woman, and although the work is less obviously figurative, the representation of the sexual act remains the focal point of this intriguing work.

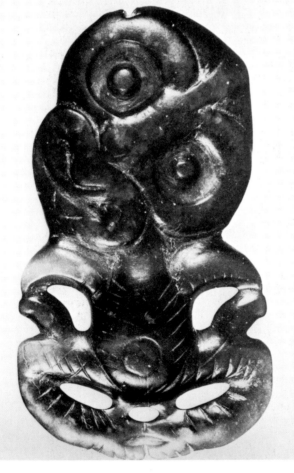

Fig. 60
New Zealand
Ornament (Hei-tiki)
Nephrite: H. 8.4 cm
Otago Museum, Dunedin, New Zealand

Fig. 61
Henri Gaudier-Brzeska
Design for Doorknocker c. 1914
Brush, ink, and watercolour
33.0 × 20.0 cm
Kettle's Yard, University of Cambridge

186

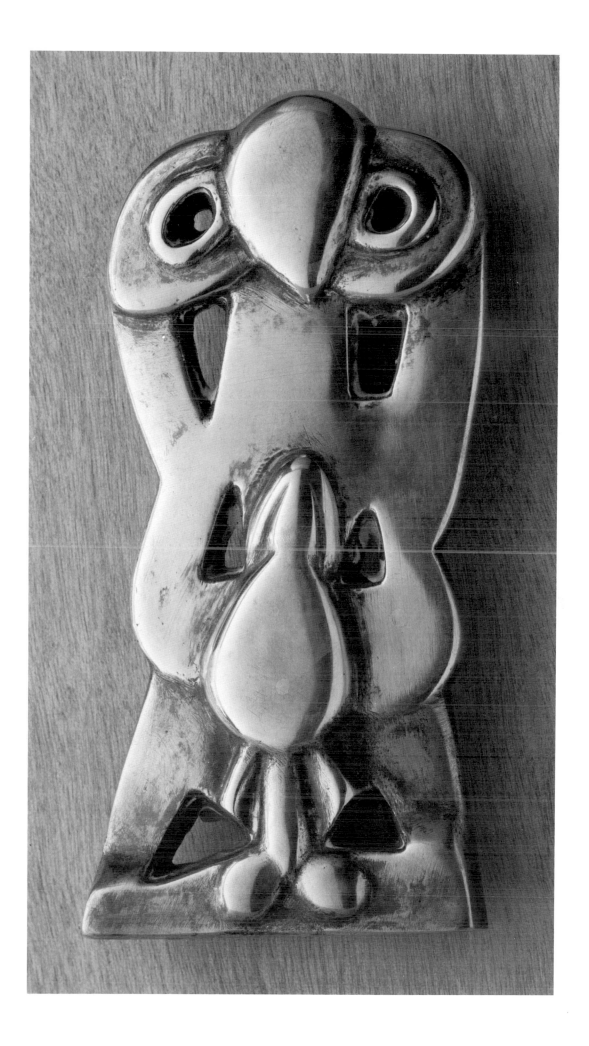

82.
Henri Gaudier-Brzeska
The Doorknocker (Study for Sculpture)
1914
Ink and watercolour: 21.5 × 15.0 cm
Anthony d'Offay Gallery, London

The Doorknocker (Study for Sculpture)
is related to the Tate sculpture (No.
81) and was also probably inspired by
Maori jade ornaments (fig. 60). In
this drawing a human figure that has
the triangular form of the head that
appears in The Tate Gallery's carving
Red Stone Dancer (fig. 64) appears to
be mounting a fox-like creature from
behind. Obviously intended as a
study for a sculpture like No. 81, the
idea was never translated into three
dimensions.

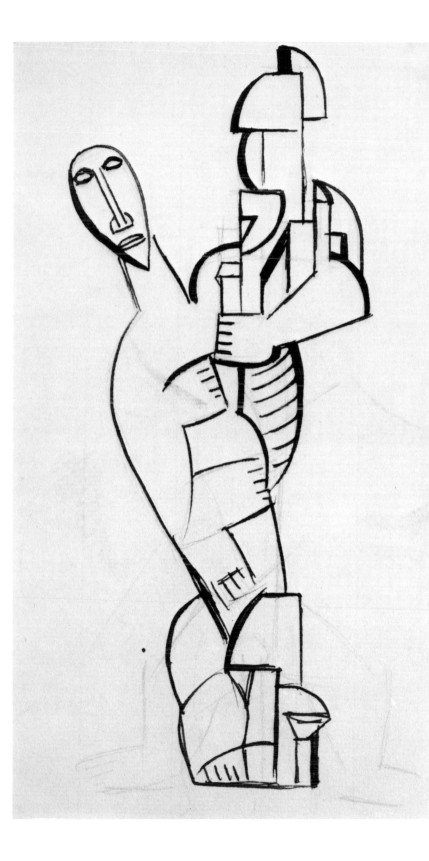

83.
Henri Gaudier-Brzeska
Drawing for Sculpture 1914
Pencil, pen and ink: 23.5 × 13.0 cm
Anthony d'Offay Gallery, London

The vertical linear grid in *Drawing for Sculpture* is reminiscent of Picasso's analytic Cubist drawings, for example *Nude Woman* of 1910 (Metropolitan Museum of Art, New York). The figure leaning to the left seems proportionally too large to represent a child, but seems nevertheless to be held in the arms of the slightly larger figure. While the upper portion of the latter is depicted in a geometrical idiom that anticipates Lipchitz's most austere Cubist sculptures of 1915, the head of the leaning figure is clearly based on primitive masks. In the lower third of this sheet the pencil outlines of splayed legs reveal a less abstract style.

84.
Henri Gaudier-Brzeska
Portrait of Ezra Pound 1914
Wood: H. 73.0 cm
Yale University Art Gallery

This little known wood carving is related to the much larger marble *Hieratic Head of Ezra Pound* (fig. 62). In Pound's *Gaudier-Brzeska: A Memoir*, first published in 1916, the poet describes the circumstances in which one of Gaudier's most blatantly primitivistic works was created. The bust was begun, Pound recalled, in the spring of 1914:

> Normally he could not afford marble, at least, not large pieces. As we passed the cemetery which lies by the bus-route to Putney he would damn that "waste of good stone".[1]

The sculptor had intended to do the bust in plaster but Pound objected to this material and purchased the stone himself. Gaudier's friend Horace Brodzky discusses the preparatory drawings Gaudier "made direct from Pound before and while the carving was in progress."[2] Brodzky also deals with the sexual implications of the work, noting that "Brzeska informed me of the fact that it was to be a phallus."[3] Pound himself is recorded as telling a friend of Brodzky's, "Yes, Brzeska is immortalising me in a phallic column!"[4]

In this carving the head, like the larger marble, was probably inspired by the great Easter Island statues (fig. 63), which were also the source for André Beaudin's portrait of the

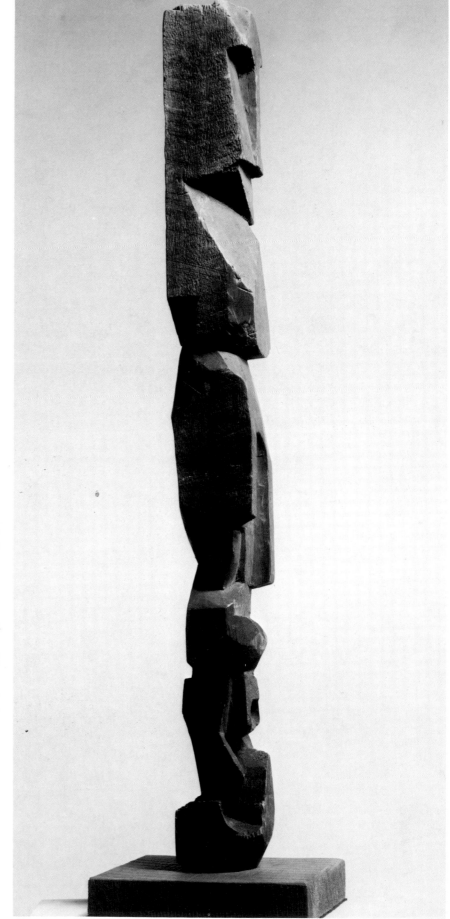

French poet Paul Eluard (No. 116). Here the form of the head is more abstract and severely geometrical than the form of the marble version. Below the head the masses are defined by semi-abstract planes, with, however, the suggestion of arms and navel. The upward-pointing form at the bottom, the same shape as the goatee in the marble carving, does have phallic implications. Pound mentioned that Gaudier preferred a small sketch, made later, to the actual statue, but there is no way of knowing if Pound was referring to the Yale wood carving or to a smaller version of the *Hieratic Head of Ezra Pound* (fig. 62).

Pound said the large marble did not look like him: "It was not intended to. It is infinitely more hieratic. It has infinitely more strength and dignity than my face will ever possess."[5] And then he quotes Gaudier:

> You understand it will not look like you, it *will...not...look...* like you. It will be the expression of certain emotions which I get from your character.[6]

1. Ezra Pound, *Gaudier-Brzeska: A Memoir* (New York: A New Directions Book, 1970), p. 48.

2. Horace Brodzky, *Henri Gaudier-Brzeska 1891-1915* (London: Faber and Faber Ltd., 1933), p. 59.

3. *Ibid.*

4. *Ibid*, p. 62.

5. Pound, *Gaudier-Brzeska*, p. 49.

6. *Ibid*, p. 50.

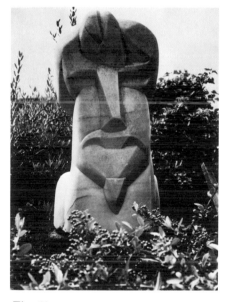

Fig. 62
Henri Gaudier-Brzeska
Hieratic Head of Ezra Pound 1914
Marble: H. 91.4 cm
Private Collection

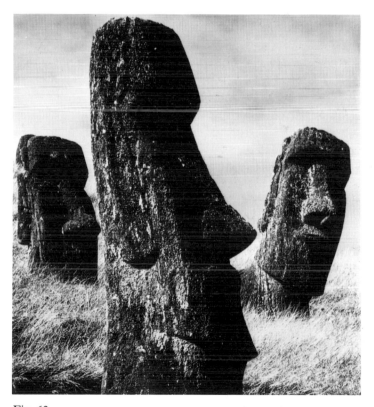

Fig. 63
Easter Island (Polynesia)
Colossal Heads
Volcanic tuff: H. up to 9 metres

85.
Henri Gaudier-Brzeska
Dancing Woman c. 1914
Charcoal and watercolour:
48 × 31 cm
Musée national d'art moderne –
Centre Georges Pompidou – Don de
la Collection Kettle's Yard

Thematically, *Dancing Woman* is
related to one of Gaudier's best
known carvings, the 1914 *Red Stone
Dancer* in The Tate Gallery (fig. 64).
It is, along with *The Imp* (No. 86),
one of a group of studies of 1914 that
share certain formal and stylistic
similarities: the African features of
the head, the pointed forms of the
figure, and the bold shading and
hatchings that create, particularly in
the arms and nose, large angular
planes. In *Red Stone Dancer*, as with
the carving *The Imp* in The Tate
Gallery (fig. 65), Gaudier did not
adopt this angularity, which owes an
obvious debt to Cubism, but created
smooth, rounded forms.

In this drawing, the arms are
thrust forward; in the carving (fig.
64), however, they are knotted
around the head, forming a
bunched, top-heavy figure. The
rectangular relief form on the head in
the sculpture, a feature which also
appears in *The Doorknocker (Study
for Sculpture)* (No. 82), may possibly
be an adaptation of an abstract
design from a Maori ornament (fig.
60), which inspired the small *Door-
knocker* sculpture. Did this area
represent, for Gaudier, the vortex,
the point of maximum energy,
which, for Wyndham Lewis, the
leader of the Vorticist movement,
meant the still circle in the centre of a
whirlpool?

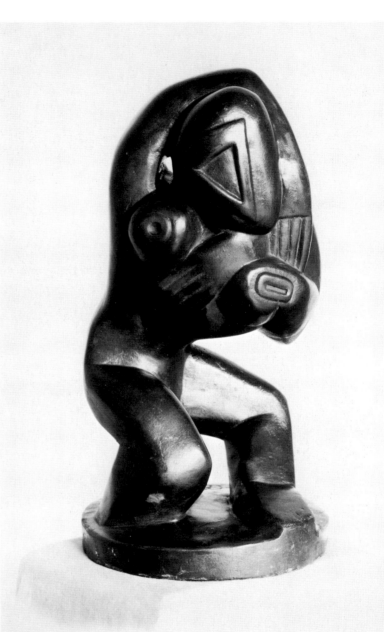

Fig. 64
Henri Gaudier-Brzeska
Red Stone Dancer c. 1913
Red Mansfield stone: H. 43.0 cm
Tate Gallery, London

86.
Henri Gaudier-Brzeska
The Imp 1914
Charcoal: 24.1 × 15.6 cm
The St. Louis Art Museum,
Purchase 15:1942

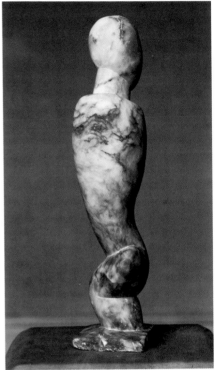

Fig. 65
Henri Gaudier-Brzeska
The Imp 1914
Veined alabaster: H. 40.5 cm
Tate Gallery, London

As with many works in this exhibition, the primitive influence on both the drawing *The Imp* and the carving of the same subject in The Tate Gallery (fig. 65) is of a general nature. In discussing the sculpture, Goldwater suggests that "the oval curves of the short bent legs, whose heaviness pulls down the figure's whole mass, is probably influenced by African proportions."[1] Whereas the legs and torso of the carving are smooth and rounded, the heavy shading in the drawing creates flat planes and a more angular treatment. The mask-like face, with its elongated nose, is closely related to the Yale carving, *Portrait of Ezra Pound* (No. 84).

1. Robert Goldwater, *Primitivism in Modern Art* (New York: Vintage Books, 1967), p. 240.

194

Erich Heckel 1883–1970

The German painter, sculptor, and printmaker Erich Heckel was born in Döbeln, Saxony. In 1901 he met K. Schmidt-Rottluff in a literary circle while they were both students at the high school in Chemnitz. They began to draw and paint together; for Heckel literature was, at first, as important as painting. In 1904 he moved to Dresden to study architecture at the technical high school and the following year joined with his fellow students F. Bleyl, E.L. Kirchner, and K. Schmidt-Rottluff to found the group *Die Brücke* ("The Bridge"). From 1907 to 1910, the artist spent the summer months painting in Dangast, Oldenburg, and at the Moritzburg lakes near Dresden. In 1909 he visited Rome. He was very impressed by Etruscan sculpture. In 1910 to 1912 he participated in the exhibitions of the *Neue Sezession*, Berlin. He moved to Berlin in 1911. In 1912 he met Marc, Auguste Macke, and Feininger and participated in the *International Sonderbund Exhibition* in Cologne.

While serving in the army medical corps in Belgium from 1915 to 1918, Heckel came in contact with the work of Constant Permeke, Ensor, and Beckmann. Back in Berlin in 1918 he became a member of the *Arbeitstrat für Kunst*. In 1937, 729 of his works in German museums were confiscated and declared degenerate by the Nazis. In 1944 he moved to Hemmenhofen, on Lake Constance, when his Berlin studio was destroyed. Between 1949 and 1955 Heckel was a professor at the Hochschule der Bildenden Künste in Karlsruhe (Karlsruhe Academy). He died January 27, 1970, in Hemmenhofen, Bodensee.

87.
Erich Heckel
Standing Girl 1910
Woodcut in black, green, and red:
54.2 × 40.0 cm
Signed lower right: E. Heckel 11
National Gallery of Canada, Ottawa

Heckel, Kirchner, and Schmidt-Rottluff are the three German Expressionists included in this exhibition. When Heckel, Kirchner, and Pechstein worked together by the lakes surrounding Moritzburg in the summer of 1910, they painted nudes (not professional models) moving freely through the landscape, one of the major themes of the Brücke group.

The model for *Standing Girl*, one of Heckel's first early woodcuts, was an adolescent girl called Fränzi, an orphan whom the Brücke artists adopted as a model and companion. She and her sister Marcella appear in the early primitivistic work of both Heckel and Kirchner. As Philip Larson has pointed out, this work, like many of Heckel's woodcuts, derives from a life drawing, also dated 1910.[1] Larson suggests that:

In 19th-century carvings by the Mbole tribe, solutions for dramatically outlining the facial features seem almost ready-made for Heckel's tightly contoured drawing style. The heart-shaped face, slit eyes, hourglass nose, and grossly exaggerated navel are borrowed from the Mbole type.[2]

But unlike the primitivism of Picasso, for example, the personal identity of the figure is retained. She is no surrogate African image, but a subtle blend of portraiture and primitive stylization.

This woodcut was included in the sixth annual portfolio of the Brücke group in 1911.

1. Philip Larson, "Brücke Primitivism: The Early Figurative Woodcuts," *The Print Collector's Newsletter*, New York Vol. VI no. 6 (January–February 1976): 159.

2. *Ibid*, p. 159.

Ernst Ludwig Kirchner
1880–1938

Ernst Kirchner, German painter, sculptor, and printmaker, was born in Aschaffenburg. In 1901 he began to study architecture at the technical high school in Dresden, where he obtained the degree of *Diplom-Ingenieur* in architecture in July 1905. In 1903–4 Kirchner studied drawing and painting for two semesters in Munich. In 1904 he discovered the arts of Africa and Oceania (the Palau Islands) in the museum of ethnology in Dresden. In 1905 he founded – with Heckel, Schmidt-Rottluff, and Fritz Bleyl, fellow students in Dresden – the group *Die Brücke* ("The Bridge") and in 1906 wrote its program. The year 1910, which saw the first exhibition of the *Neue Sezession* in Berlin, marked the emergence of *Die Brücke* group at the forefront of the German *avant garde*.

Kirchner moved to Berlin in 1911, where he founded the MUIM Institute (*Moderner Unterricht in Malerei*, or Modern Instruction in Painting). In 1912 he participated in the important *Sonderbund Exhibition* in Cologne, and was asked to decorate a chapel with Heckel; he also participated in the second exhibition of the *Blaue Reiter* in Munich. In 1913 he had his first one-man exhibition at the Folkwang Museum in Hagen and at the Gurlitt Gallery in Berlin.

In the army in 1915–16, Kirchner suffered a complete breakdown and spent time in a sanatorium in Königstein, Taunus. In October 1916 he had an exhibition at the Ludwig Schames Gallery, Frankfurt. In 1917 he was again obliged to seek treatment, this time in Kreuzlingen on Lake Constance in Switzerland. After his release in 1917 he settled in Längmatt, near Frauenkirch,

Switzerland. In 1925 Kirchner made his first visit to Germany since 1917. Between 1927 and 1932 he made numerous brief visits to German cities, but lived in Switzerland until his death. In 1928 he had an exhibition of his paintings at the Venice *Biennale*, and in 1929 his graphic work was presented in Paris. In 1931 he was elected to membership in the Prussian Academy, Berlin. In 1933 he was deprived of his membership by the Nazis, but 243 of his works were presented at the *Kunsthalle* in Bern. He had important retrospectives in the USA from 1936 to 1938. In 1937, 639 of his works were confiscated from German public collections by the Nazis, and thirty-two were shown in the *Degenerate Art Exhibition* in Munich that summer. Increasing illness and depression led to his suicide in Frauenkirch on June 15, 1938.

88.
Ernst Ludwig Kirchner
Bust of a Woman: Head of Erna 1912
Wood (oak), painted ochre-brown
and black: H. 35.5 cm
The Robert Gore Rifkind Collection,
Beverly Hills, California

Within a year, in 1904 or 1905, both Kirchner in Germany, and Vlaminck and Derain in France, discovered primitive art; the discovery was to radically alter the course of European painting, sculpture, and print-making. The French Fauve painter happened upon two African wood-carvings in a bistro outside Paris, while Kirchner discovered the painted house beams from the Palau Islands in the Ethnographic Museum in Dresden. Whereas in Paris the influence of African art on the work of Derain and Picasso occurred within a year or two of their initial contact with it, in Germany the shock of recognition was slower. It was not until the summer of 1910, spent near the Moritzburg lakes, that the work of Kirchner, Heckel, and Pechstein began to reflect primitive influences, which were to become one of the major stylistic and

iconographic sources of German Expressionist art during the next decade.

Manfred Schneckenburger has described the stylistic development in Kirchner's work between 1910 and 1912:

> In Kirchner the Palau style is evident in the pictures painted in 1910, associated with the Moritzburg idyll. It is interesting to note that Kirchner's island holiday in the summer of 1912 coincides with a return to the angular, stenographic style of the relief beams, whereas the Berlin pictures, enriched by the experience brought by the Ajanta frescoes, are full of the hectic life of the town, and of wartime.[1]

In Berlin in 1911 Kirchner met Erna Schilling, who became his model and lifetime companion. The summer of the following year they spent together at Hehmarn, where his painting style became more sensuous and sculpturesque. The work shown here, a portrait of Erna Schilling, would appear to relate to the primitive style of the carving from the Palau Islands, a style that also appeared in his painting from the summer of 1912. The rough handling of the shoulders and breasts is reminiscent of Picasso's first wood carvings of 1907 (No. 49), and, like Picasso, Kirchner painted a number of his sculptures, a practice found in much African and particularly in Oceanic art. In *Head of Erna*, the bright yellow face and bust are reminiscent of the anti-naturalistic colour of Fauve painters such as Matisse, who greatly influenced the Brücke painters. Kirchner used yellow in a number of his oils and pastels of 1912–13, such as the summer of 1912 painting *Burg auf Fehmarn* (Stadelsches Kunstinstitut, Frankfurt am Main), as did Nolde in his 1912 oil *The Life of Christ: Crucifixion* (Nolde-Stiftung Seebüll). While the concave shape of the face may well derive from primitive sources, this bust of Erna, like Heckel's woodcut (No. 87), remains very much a portrait of the model.

Among Kirchner's best known primitivistic wood sculptures are the utensils and furniture, inspired by Cameroon work, that he carved for his house in Davos, Switzerland, between 1919 and 1923.

1. *World Cultures and Modern Art* (Munich: Haus der Kunst, 1972), p. 269.

Karl Schmidt-Rottluff 1884–1976

Born Karl Schmidt at Rottluff near Chemnitz, Saxony, this German painter, printmaker, and sculptor met Erich Heckel in 1901 and began to paint. He studied architecture at Dresden Polytechnic in 1905 to 1906. Through his friendship with Heckel he met Kirchner and Bleyl and joined them in founding the group called *Die Brücke* ("The Bridge") in June 1905. In 1910 he participated in the *Neue Sezession Exhibition* in Berlin. He had his first one-man exhibition at the Commeter Gallery, Hamburg, in 1911. In 1912 he participated in the important *Sonderbund Exhibition* in Cologne. From 1911 he lived mostly in Berlin, but until 1943 he spent his summers on the Baltic or North Sea coasts, and from 1932 to 1943 he spent the spring months in the Taunus, Germany. He travelled to France, Italy, and Dalmatia.

Schmidt-Rottluff was influenced by van Gogh, Gauguin, and Munch. The influence of African sculpture can first be seen in his prints. In the army during World War I he produced a series of carvings in wood, mostly heads inspired by African art.

Schmidt-Rottluff was one of the artists persecuted by the Nazis. In 1933 he was expelled from the Prussian Academy, and in 1937 his works were confiscated; sixty-one were in the *Degenerate Art Exhibition* in Munich. In 1941 he was forbidden to paint and was placed under the supervision of the SS. In 1947 he was appointed professor at the School of Fine Arts in Berlin. He died in Berlin on August 10, 1976.

89.
Karl Schmidt-Rottluff
Blue-Red Head 1917
Wood: H. 30 cm
Signed at bottom: S. Rottluff
Brücke-Museum, Berlin

In 1912, Schmidt-Rottluff's interest in primitive art shifted from the idyllic exoticism and art of the South Seas to African sculpture. During the next seven or eight years his paintings, watercolours, woodcuts, and sculpture include some of the most blatantly primitivistic works of the twentieth century. The closest parallel in France would be Picasso's wood carvings of 1907 (Nos. 46, 47, 49) and the paintings and drawings of his Negro Period.

Schmidt-Rottluff, like Kirchner, painted a number of his wood carvings, and in this one and *Green Head* (No. 90), the colours used are included in the titles. Colour plays an important role in much primitive art, as it did in Gauguin's sculpture, in his early red-stained wood *La Petite Parisienne* (Private Collection) of about 1881, in his Brittany and Polynesian period sculpture. Picasso, too, had painted a number of his wood sculptures of 1907 (Nos. 47, 49) as well as his wood and metal constructions of 1914–15. The brilliant, non-descriptive use of colour by the German Expressionists has close affinities with the Fauve painters in France, and like them, colour has the same function that it had for van Gogh – to express emotional states.

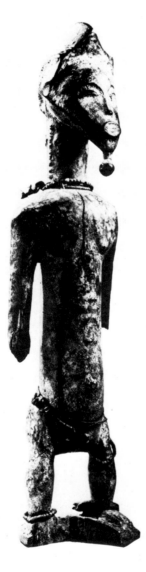

Blue-Red Head, Manfred Schneckenburger has written,

transmutes the flowing lines of Guro masks into receding concaves. It represents a conception of the primitive which is reflected in Stravinsky's "Sacre du printemps" and which Worringer referred to on many occasions between the years 1910 and 1920: fear, dread, ecstasy amidst an incomprehended environment. This immersion in the primeval fear of the "primitive" is fused with the reaction to the war year 1917.[1]

As with several of Picasso's carvings of 1907 (No. 49), *Blue-Red Head*, so closely related to Guro or Baule figures (fig. 66), is one of the few sculptures in this exhibition that could understandably be mistaken for an example of African art.

1. *World Cultures and Modern Art* (Munich: Haus der Kunst, 1972), p. 269.

Fig. 66
Baule (Ivory Coast)
Male Figure
Wood: H. 44.5 cm
Private Collection

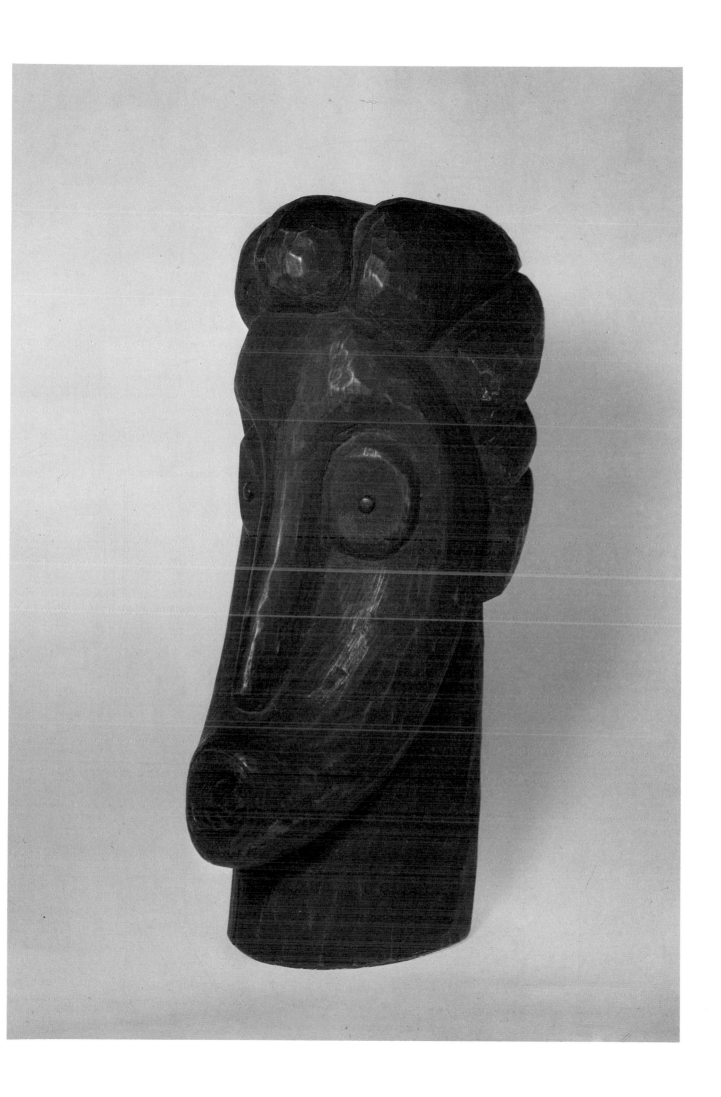

90.
Karl Schmidt-Rottluff
Green Head 1917
Wood: H. 41 cm
Signed on the back: S. Rottluff
Brücke-Museum, Berlin

Green is a colour used by Matisse
down the length of the face in one of
his greatest Fauve paintings, *The
Green Line* of 1905 (Statens Museum
for Kunst, Copenhagen). This carv-
ing has been compared to the head of
a Pangwe (Gabon) *Female Bieri
Figure* in the Museum für Völker-
kunde, Berlin.[1] In his work of this
period, such as *Blue-Red Head* (No.
89) and his famous 1918 woodcut
Girl from Kowno, based on the
elaborately carved Baule heads,
Schmidt-Rottluff imitated African
prototypes as freely as did Kirchner
in his Cameroon-inspired furniture
of 1919 to 1923.

1. *World Cultures and Modern Art*
 (Munich: Haus der Kunst, 1972),
 No. 1789.

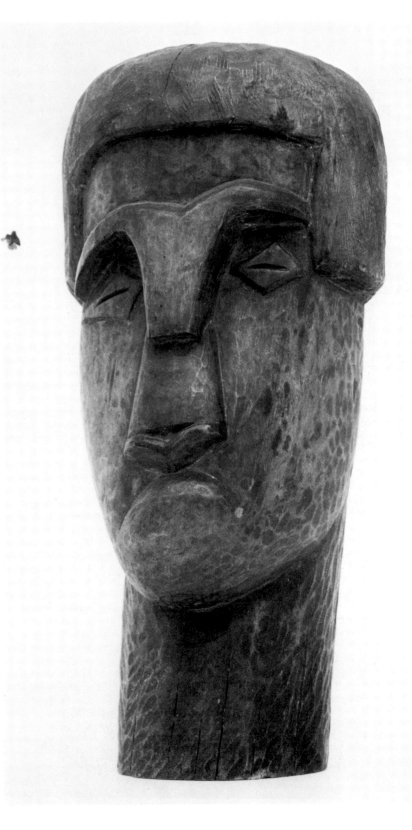

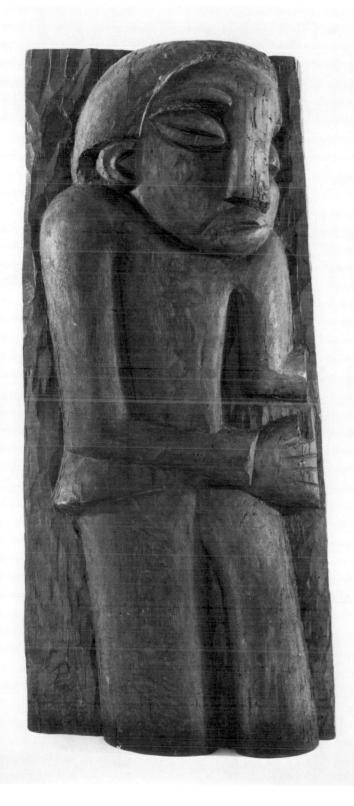

91.
Karl Schmidt-Rottluff
The Mourner 1920
Wood: H. 80 × 36 cm
Signed lower right: S. Rottluff
Brücke-Museum, Berlin

This monumental wood relief has something of the directness and power of Matisse's great series of bronze reliefs of the female back. The face and the broad, flattened nose of *The Mourner*, like that of *Seated Nude* (No. 92), recall those of Gaudier-Brzeska's marble *Seated Woman* of 1914 (No. 80), and one wonders if they were inspired by a common stylistic source of primitive art. Whereas his two earlier carvings in this exhibition are recreations of African prototypes, the subject of this relief is spirituality and the concern for the tragedy and torment of the human condition, a preoccupation that characterizes much of the work of the German Expressionists during and after World War I.

92.
Karl Schmidt-Rottluff
Seated Nude 1920?
Watercolour: 50.0 × 40.2 cm
Private Collection

The owners of this superb, unpublished example of Schmidt-Rottluff's bold watercolour technique have suggested 1920 as a possible date. With primitive influences running through much of his work from about 1912 to 1920, it is difficult to date a watercolour such as this one with any degree of certainty. The pose of the figure is, for example, reminiscent of his lithograph of 1911 entitled *Nude*. Unlike Schmidt-Rottluff's two carvings (Nos. 89 and 90), his 1918 woodcuts on the life of Christ, and his well known 1919 oil *Double-Portrait (Self Portrait with His Wife)*, Staatsgalerie Moderner Kunst, Munich, in which the mask-like faces suggest specific African prototypes, the primitive influence in *Seated Nude* is more generalized. As Horst Keller has written, the watercolours of Kirchner and Heckel, Kokoschka, Nolde, and Schmidt-Rottluff "often convey, in the grand period of German Expressionism, the purest renderings of the spiritual essence of the epoch."[1]

1. The Solomon R. Guggenheim Museum, *Expressionism: A German Exhibition* (New York: 1980), p. 24.

Jacques Lipchitz 1891–1973

Born Chaim Jacob Lipchitz in Druskieniki, Lithuania (then under Russian rule), Jacques Lipchitz went to Paris in 1909, where he studied at the Ecole des Beaux-Arts under Jean-Antoine Ingalbert and attended Raoul Verlet's sculpture classes at Académie Julian. He began collecting primitive and archaic art. In 1912–13 he was recalled to Russia for military service; he visited Saint Petersburg and discovered Scythian art. After receiving a medical discharge from the army, he returned to Paris and moved in next door to Brancusi. He exhibited in the Salon National des Beaux-Arts and, through Diego Rivera, met Cubist painters. Lipchitz formed friendships with Max Jacob, Picasso, Modigliani, and Soutine. In 1914 he visited Spain and in 1916 met and became a close friend of Juan Gris, who introduced him to Gertrude Stein. His first one-man exhibition was at the Galerie Léonce Rosenberg, Paris, in 1920.

In 1924 Lipchitz became a French citizen and commissioned Le Corbusier to design a house and studio in Boulogne-sur-Seine. He produced his *sculptures transparentes*, whose open work replaced the angular forms that had characterized his sculpture of the previous decade. He also sought inspiration in archaic and primitive works. About 1929–30, he began to use themes drawn from mythology and from the Old Testament. He moved to Toulouse in 1940 and emigrated to New York in 1941, leaving behind his collection and most of his work. In 1946–47 he returned to Paris and then returned to the United States, where he settled in Hastings-on-Hudson, New York.

In 1952 almost all Lipchitz's American works were destroyed in a fire at his New York studio. In 1954 a major retrospective was organized by The Museum of Modern Art, New York, and in 1958 he became a United States citizen. He visited Italy in 1961–62 and began working at the Luigi Tommasi foundry in Pietrasanta, near Carrara, and subsequently spent each summer working there. His first visit to Israel was in 1963. He had major retrospectives in Berlin and other European cities, as well as in Tel Aviv and in Jerusalem, in 1970–71. In 1972 there was a major exhibition at New York's Metropolitan Museum of Art, and he published his autobiography in that year. He died on the island of Capri on May 26, 1973, and was buried in Jerusalem.

93.
Jacques Lipchitz
Mother and Child 1913
Bronze: H. 57.1 cm
Signed on base: J. Lipchitz 2/7
Mr. and Mrs. B.J. Sampson

Like many artists of his generation – Picasso, Matisse, Derain, Epstein, and Moore – Lipchitz collected African sculpture, which he had done since arriving in Paris in 1909. The first works to reflect the influence of African art were executed in 1913. As with Brancusi's *The First Step* of 1913 (fig. 42), which Brancusi may have destroyed (only the head remains; see No. 58) because he found it too African, Lipchitz had reservations about his 1913 *Mother and Child*, which may have been made before he went to Spain in late 1913 or early 1914. "It is interesting," he wrote in *My Life in Sculpture*, "despite the fact that I never found it entirely satisfactory, because of the specifically Negro quality of the figures and particularly of the heads."[1]

In about 1912 Lipchitz met Modigliani, with whom he developed a close friendship. (Modigliani's *Portrait of Jacques Lipchitz and his Wife* of 1916 is now in The Art Institute of Chicago.) Lipchitz would certainly have been familiar with the Italian's stone carvings of 1909–14, which may well have influenced the thin head and long neck of the mother in the work shown here. In Lipchitz's charcoal *Study for Mother and Child* of 1913 (fig. 67), the similarities between the works of the two artists are even more striking.

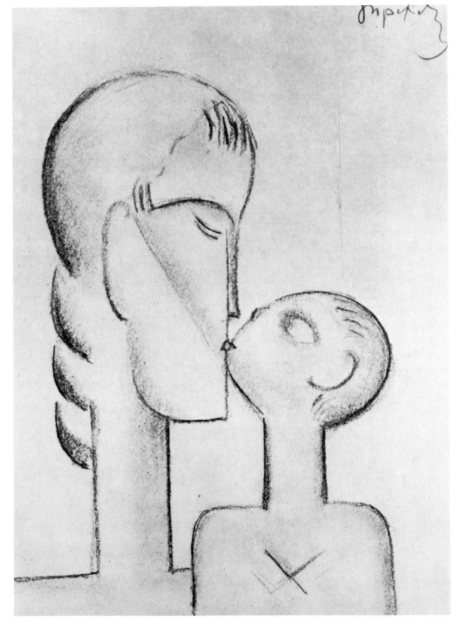

1. Jacques Lipchitz with H.H. Arnason, *My Life in Sculpture* (New York: The Viking Press, 1972), p. 19.

Fig. 67
Jacques Lipchitz
Study for Mother and Child 1913
Charcoal: 31.1 × 21.6 cm
Private Collection

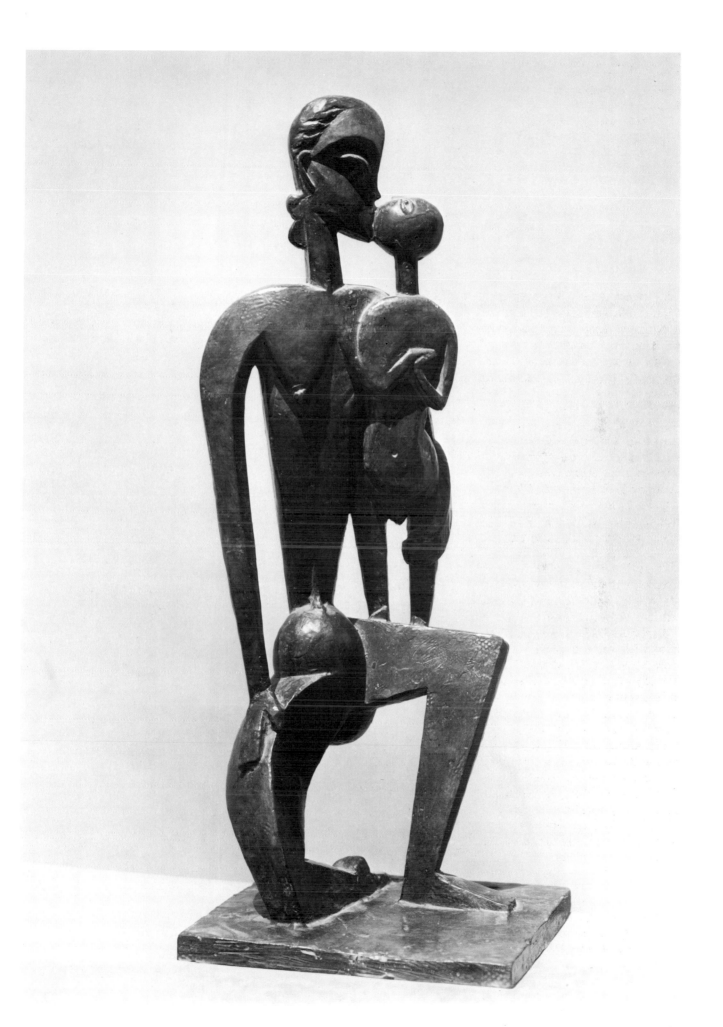

94.
Jacques Lipchitz
Mother and Children 1914
Bronze: H. 70.5 cm
Signed and numbered 6/7
Courtesy of Marlborough Gallery,
New York

In *Mother and Children*, which he began before he went to Majorca in 1914 and completed on his return, Lipchitz again explores the mother-and-child relationship in a work less obviously African in inspiration. He wrote:

Of the works of this period it is one I particularly like. . . . There is first of all the mother-and-child theme, deriving from my feeling for my own mother – a theme, as I said, to which I have returned again and again. There is also the

absolute frontality of the group, very different from the circular movement of the *Woman with Serpent* or the *Dancer*. There may be some reflection of my interest in African art in this frontality, but I think that the idea developed unconsciously from some recollection of a Russian Byzantine icon of the Madonna and Child.[1]

The scaffolding-like structure formed by the arms of the mother and child, and the way in which they frame and enclose the almost rectangular negative spaces, recall South African Zulu sculpture – such as *Figure of a Man* (fig. 68) – in the British Museum. Deborah Scott has remarked on the similarity to Brancusi's 1913 *The First Step* (fig. 42), and suggests that "the domed head and conical neck of the young boy are more Brancusian than African."[2]

Although this work and Epstein's drawing *Totem* (c. 1913, No. 78) were almost certainly conceived independently, there is nonetheless a remarkable similarity in the way in which the figures are locked together in a vertical structure within each work, the child held above the mother's head.

Fig. 68
Zulu (South Africa)
Figure of a Man
Wood: H. 62 cm
Museum of Mankind, London

1. Jacques Lipchitz with H.H. Arnason, *My Life in Sculpture* (New York: The Viking Press, 1972), p. 16.

2. Deborah Scott, *Jacques Lipchitz and Cubism* (New York: Garland Publishing Inc., 1977), p. 109.

95.
Jacques Lipchitz
Girl with Braided Hair 1914
Pencil: 19.9 × 15.8 cm
Signed upper right: Lipchitz
The Museum of Modern Art, New
York. Mr. & Mrs. Milton J. Petrie
Fund

While sculptors like Brancusi and
Hepworth rarely made preparatory
drawings for their sculptures, Lip-
chitz and Moore used drawing as a
means of working out ideas in
advance. Lipchitz wrote about his
work around 1915:

> I have always made drawings
> related to my sculptures both
> before and after the sculpture.
> These could be sketches prelimi-
> nary to the clay maquette or
> drawings after the sculpture. In
> the latter case, they did help to
> clarify my ideas about sculptural
> themes on which I was working
> and to suggest possible variations.[1]

This work is undoubtedly a study for
a bronze of the same year, *Girl with
Braid* (fig. 69). In his desire to move
away from the Classical and Renais-
sance traditions, Lipchitz studied
Egyptian and archaic Greek
sculpture, as well as African art. He
wrote:

> The Egyptians and archaic Greeks
> also used the multiple points of
> view that the cubists had adopted.
> In an Egyptian relief the head,
> arms and legs are normally shown
> in profile with the eyes and torso
> frontalized. . . . In *Girl with Braid* I
> even turned the head in profile and
> depicted the eyes in full face in the
> Egyptian manner.[2]

If one compares the girl's head in the
bronze with, for example, *King
Amenhotep I* of about 1550 BC

Fig. 69
Jacques Lipchitz
Girl with Braid 1914
Plaster: H. 83.7 cm
Musée national d'art moderne – Centre
Georges Pompidou

Fig. 70
Egypt
King Amenhotep I c. 1550 BC
Fragment of a relief from his temple near
Karnak

(fig. 70), it is tempting to surmise
that Lipchitz adapted his head
directly from an Egyptian source.

In *Girl with Braided Hair*, the
straight, elongated line of the nose
and the way in which the line of the
forehead slopes outwards from the
nose also relate this drawing to
Lipchitz's bronze *Head* of 1914. It is
interesting to compare *Girl with
Braided Hair* with Modigliani's draw-
ing, *Woman in Profile* (No. 70),
which was almost certainly also
inspired by Egyptian art.

1. Jacques Lipchitz with H.H. Arna-
son, *My Life in Sculpture* (New York:
The Viking Press, 1972), p. 31.

2. *Ibid*, p. 25.

215

96.
Jacques Lipchitz
Study for Figure 1926
Bronze: H. 25.4 cm
Signed and thumb print on base
Bruce A. Beal

This work evolved from a sculpture entitled *Ploumanach*, the name of a resort on the Brittany coast where Lipchitz spent the summer of 1926. He was intrigued by rock formations in the water off shore, in which very large stones balanced on other stones that had been eroded by water. The suspended rocks moved and swayed in the wind. In another small related work, the reclining figure in relief on the upper oval section is similar to *Ploumanach*, but as Lipchitz wrote, "I must have begun to see this as a primitive totem, for in the next sketch [No. 96] I transformed the upper part into a head with an indication of staring eyes."[1]

1. Jacques Lipchitz with H.H. Arnason, *My Life in Sculpture* (New York: The Viking Press, 1972), pp. 89–90.

97.

Jacques Lipchitz
Figure 1926–30
Bronze (cast 1937): H. 216.6 cm
Signed on back of base: J. Lipchitz
1926-30
The Museum of Modern Art, New
York. Van Gogh Purchase Fund,
1937

In 1930 Lipchitz was asked by a collector named Madame Tachard if he would enlarge the maquette (No. 96). This was the first instance in which the sculptor decided to develop, on a very large scale, a work originally conceived as a small study, a practice that was to continue for the rest of his life. An interesting parallel is found in the working method of Henry Moore, who reached a similar stage in 1948–49 when he enlarged, for a bronze edition, one of the small 1945 family-group maquettes.

As often happens when a sculpture is enlarged, certain changes are made. In the large version of *Figure*, Lipchitz has left out the parallel vertical lines on the central axis, and

in their place are two deeply incised areas. The longer, lower section suggests legs, while the upper incised area, despite its position, clearly represents the female sex. Lipchitz saw *Figure* as:

a work that summarized many of my ideas dating back to 1915. Specifically, it pulled together those different directions of massive, material frontality and of aerial openness in which I had been working during the 1920s. It is also very clearly a subject sculpture, an image with a specific and rather frightening personality. Although the *Figure* has been associated with African sculpture and the resemblance is apparent, it is now evident to me that it emerged, step by step, from findings I made in my cubist and postcubist sculpture over the previous fifteen years.[1]

The way in which the sculpture has been opened up in so many places anticipates Moore's *Reclining Figure* of 1951 (fig. 71). Moore's description of this work applies equally well to Lipchitz's *Figure*:

The "Festival Reclining Figure" is perhaps my first sculpture where the space and the form are completely dependent on and inseparable from each other. . . . In my earliest use of holes in sculpture, the holes were features in themselves. Now the space and the form are so naturally fused that they are one.[2]

In *Figure*, with its hypnotic stare and its open and closed spaces, Lipchitz produced a work that combines the influences of primitive art with the sophisticated forms dating back to his Cubist sculpture of 1913–20. Along with Moore's *Glenkiln Cross* of 1955–56 (see No. 135), *Figure* is one of the greatest totemic images of twentieth-century sculpture.

1. Jacques Lipchitz with H.H. Arnason, *My Life in Sculpture* (New York: The Viking Press, 1972), p. 90.

2. Henry Moore, *Henry Moore*, photographed and edited by John Hedgecoe (London: Thomas Nelson, 1968), p. 188.

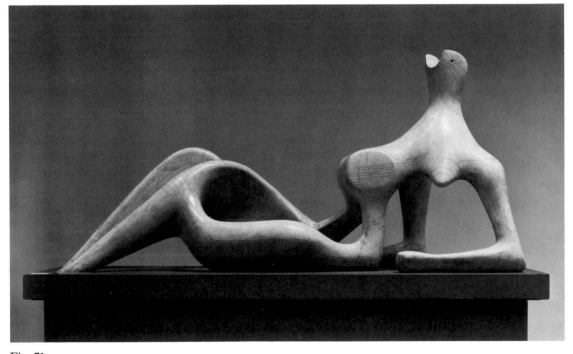

Fig. 71
Henry Moore
Reclining Figure 1951
Plaster cast: L. 231.2 cm
Art Gallery of Ontario, Gift of Henry
Moore, 1974

Alberto Giacometti 1901–1966

Swiss-born sculptor, painter, and draughtsman Alberto Giacometti was born in the village of Borgonovo, Grisons, the son of the Post-Impressionist painter Giovanni Giacometti. Encouraged by his father, he began to draw, paint, and sculpt at an early age. In Geneva in 1919–20 he enrolled in the painting classes at the Ecole des Beaux-Arts and studied sculpture and drawing at the Ecole des Arts et Métiers with Maurice Sarkissoff, a former associate of Archipenko. In 1920 Giacometti accompanied his father, who was the Commissaire for Switzerland, to the Venice Biennale, where he saw Cézannes and Archipenkos, but was also impressed by the primitive and Egyptian art in Italian collections. He returned for a six-month stay in 1921. In January 1922 he arrived in Paris; he studied first in Archipenko's studio, then under Bourdelle at La Grande Chaumière. He frequented the Musée de l'Homme and met Laurens, Lipchitz, and Brancusi. In 1927 he had his first one-man exhibition, at the Galerie Aktuaryus in Zurich.

Giacometti went through an eclectic period, experimenting with polychromy, open, cage-like structures, erotic forms, and movement; abandoning working from the model, he came near to abstraction. He met Aragon, then Breton and Dali, and participated in the Surrealist movement from 1930 until 1935, when, because he again began to use models, he was excluded from the *Groupe surrealiste*. His sculptures became smaller and smaller and were almost always destroyed. Between 1935 and 1947 he did not exhibit; in 1941 he went to Geneva, and only returned to Paris after the Liberation.

In the late forties, the elongated figures with eroded and scarred surfaces emerged in Giacometti's work, and remained the basis of his characteristic style. His first exhibition after the war was at the Pierre Matisse Gallery, New York, in 1948. It was followed by a series of exhibitions and honours in Europe and America – he was awarded the first prize for sculpture at the Pittsburgh International in 1961; the main prize for sculpture at the Venice Biennale in 1962; the Guggenheim International Award for Painting in 1964; and in 1965 he received the Grand Prix National des Arts de la France. Also in 1965 three retrospectives took him to London, New York, and Copenhagen. He died in Coire, Switzerland, on January 11, 1966, and was buried in Borgonovo. The Alberto Giacometti Foundation was inaugurated in Zurich in 1966.

98.
Alberto Giacometti
The Couple 1926
Bronze: H. 59.7 cm
Signed on rear of base: A. Giacometti
4/6
The Art Institute of Chicago. Gift of
Mr. and Mrs. Harry L. Winston

In about 1925, Giacometti gave up working from the model and began to create from memory and from the imagination. For the rest of his life, his work reflected these two polarities: the real and the imagined – the need for a model from which to draw, paint, or sculpt, and the freedom to work from memory. Two of his earliest surviving sculptures reflect the influence of two of his contemporaries. The conception of the 1925 bronze *Torso* is almost a paraphrase of Brancusi's 1917 *Male Torso*, but its angularity and flat planes are more akin to the Cubist sculpture of Laurens and Lipchitz. Giacometti's compact *Little Crouching Man* of 1926 is distinctly reminiscent of Derain's 1907 stone *Crouching Figure* (fig. 39), which is discussed in connection with Brancusi's *The Kiss* (No. 57).

In 1926, primitive art became a major influence on Giacometti's sculpture, and was to remain so for the next nine years. *The Couple*, one of the first sculptures made from memory and the imagination, is a transitional work, on the one hand almost certainly indebted to Brancusi's *The Kiss* (No. 57), on the other incorporating certain features borrowed from African and prehistoric art. Elizabeth Nesfield has suggested that the closest sources in African sculpture are the carved Makonde body shields, which are ornamented in the breasts and navel.[1] Whereas in

Fig. 72
Saint-Sernin-sur-Rance, France
Neolithic Menhir with Female Figure in Relief
Sandstone: H. 122.0 cm
Musée Lapidaire de La Sociétée des Lettres, Sciences et Arts à l'Evêché, Rodez

Brancusi's *The Kiss* only the long hair and somewhat compressed breasts distinguish female from male, in Giacometti's *The Couple*, the two figures are treated completely differently. The slightly recessed female form (see No. 99) presents

the image of a shallow vessel with, at the top, an oval mouth above the breasts; rectangular hands, with incised lines that define the fingers in much the same way as those in *The Kiss*; and the sex contained within the shallow, concave space. In contrast to the curved sides of the woman, the rigidity of the male suggests at once a phallic column and an abstracted figure, with the eye, hands, and navel standing out in high relief.

The many striking similarities between various styles of prehistoric and primitive art from disparate geographical regions often make it difficult to identify specific influences on works by twentieth-century painters and sculptors. For example, *The Couple* is, in its relief-like conception and in some of its anatomical details, remarkably close to a Neolithic sandstone *menhir* with a schematic female figure in relief from Saint-Sernin-sur-Rance, France (fig. 72). As with many sculptures in this exhibition, it is probably impossible to point to a specific example of primitive art that inspired *The Couple*, one of Giacometti's finest and most original early works.

1. Elizabeth Nesfield, *The Primitive Sources of Surrealism*, unpublished M.A. Report, submitted to the Courtauld Institute of Art, University of London, 1970, p. 46.

99.
Alberto Giacometti
Spoon Woman (Femme-cuiller) 1926
Bronze: H. 144.7 cm
Signed on right side of base:
A. Giacometti 3/6
The Solomon R. Guggenheim
Museum, New York

Whereas the primitive influences in
The Couple (No. 98) are various,
Spoon Woman is related to a specific
tribal style of African art – the wood
rice spoons of the Dan tribe from
Liberia (fig. 73). Although this work
predates, by four years, Giacometti's
acceptance into André Breton's Sur-
realist circle, the poetic image of a
spoon as a metaphor of the female
body would undoubtedly have
appealed to that circle – Arp, Mag-
ritte, Miró, Ernst, and Dali. A
plaster version of *Spoon Woman* was
one of the Giacometti sculptures that
Ernst stored for him in the mid-
1930s, and may well have been in the
back of Ernst's mind when he
incorporated the image of a kitchen
spoon in the 1944 *Young Man with
Beating Heart* (No. 111). The spoon
motif appears again three years later
in Giacometti's 1929 bronze *Reclining
Woman*.

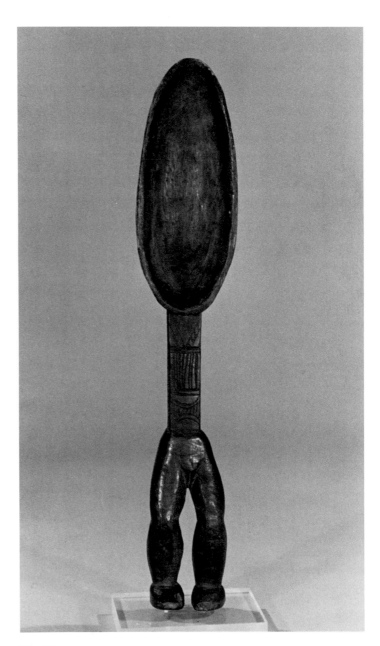

Fig. 73
Dan (Liberia)
Rice Spoon
Wood: H. c. 43.0 cm
Private Collection

100.
Alberto Giacometti
Composition (Man and Woman) 1927
Bronze: L. 40 cm
Inscribed on base: Giacometti 1/6
The Milton D. Ratner Family
Collection

In his illuminating letter of 1947 to
his New York dealer, Pierre Matisse,
Giacometti wrote of his work of the
late 1920s and early thirties: "Figures
were never for me a compact mass
but like a transparent construction.
Again, after making all kinds of
attempts, I made cages with open
construction inside, executed in
wood by a carpenter."[1] Two of the
eight drawings that appear on the
same typed page of this letter include
the 1930–31 plaster and metal *Sus-
pended Ball* in the Alberto
Giacometti Foundation, and the 1931

wood *Cage* in the Moderna Museet,
Stockholm. Although the work
shown here, and two bronzes of
1929 – *Three Figures Outdoors* and
Man (Nos. 101 and 102) – are not fully
three-dimensional cage sculptures,
they do, nevertheless, anticipate the
transparent, open, scaffolding-like
cage constructions of 1930–32,
which are among Giacometti's most
important Surrealist sculptures.

Thematically, *Composition (Man
and Woman)* deals with the same
subject as does the 1926 *The Couple*
(No. 98). In the earlier work, despite
the schematic treatment, the separate
male and female images are easily
read. In this work, however, the two
figures are locked or coupled
together in a complex, almost
abstract construction of bars and
struts, rectangular blocks, and con-
cave discs, in which certain passages,
particularly the two blocks joined at

one end, anticipate in a remarkable
way the late *Cubi* sculptures of
David Smith. Here bodily parts are
fragmented and reassembled – the
parallel, diagonal struts suggest the
rib cage; the disc at the top probably
represents a head, as in *Man*
(No. 102).

Of all Giacometti's constructions
and later cages, *Composition (Man
and Woman)* is the most compressed
and compact, with, despite the open
spaces between the units, the great-
est feeling of density and impenetra-
bility.

1. The Museum of Modern Art, *Alberto
 Giacometti*, with an introduction by
 Peter Selz and an autobiographical
 statement by the artist (New York:
 1965), p. 20.

101.
Alberto Giacometti
Three Figures Outdoors 1929
Bronze: H. 52 cm
Inscribed inside plinth:
Epreuve unique
The Milton D. Ratner Family
Collection

The year 1929 was crucial in Giacometti's development. He met Masson, Leiris, Miró, and Ernst and other members of the Surrealist circle, with whom he was associated for the next six years. He signed a contract with the Surrealist dealer Pierre Loeb, with whom he exhibited in 1931 with Arp and Miró. As William Rubin has written:

> *Three Personages Outdoors*, completed at the time of Giacometti's formal adhesion to Surrealism, developed an idea proposed in Lipchitz's "transparencies" but remained true to Giacometti's personal form-language. Its central "figure" also suggests an awareness of Picasso's wire constructions of 1928.[1] [See notes for No. 112.]

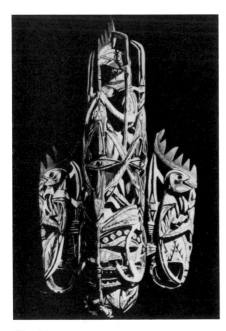

Fig. 74
New Ireland (Melanasia)
Mask
Wood, paint: H. 93.0 cm
Barbier-Müller Collection, Geneva

While the two spike-like forms are closely related to the bronze *Man and Woman* (winter 1928–29), in which the single pointed spike clearly represents the male sex, the rectangular frame anticipates the cage sculptures of 1930–33, particularly the 1931 wooden *Cage* in the Moderna Museet, Stockholm.

In this, one of Giacometti's most abstract works, it is misleading to attempt too liberal an interpretation of the somewhat ambiguous figurative elements. The central structure probably represents a female figure, whose form is touched or penetrated by the two pointed forms of a male figure at right; these forms are so much like the male sex in the 1928–29 *Man and Woman* as to suggest a similar identification. Sexual violence and mutilation were two important themes of Giacometti's Surrealist sculpture, culminating in the 1932 bronze *Woman with Her Throat Cut* (No. 104).

The fact that Giacometti shared the enthusiasm of his Surrealist colleagues for Oceanic art, which they found more lyrical, imaginative, and fantastic than African sculpture, is reflected in *Three Figures Outdoors* and in his cage constructions of the early 1930s. The elaborately carved cage-like sculpture from New Ireland, Melanesia, such as the painted wooden *Mask* (fig. 74), may well have inspired Giacometti at this time. The spike-like forms in *Three Figures Outdoors* and in the 1928–29 *Man and Woman* could have been suggested by carvings from the Sepik River and Karawari River regions in New Guinea, in which two of the pointed forms curve around and protect the projecting male penis (fig. 75). Moore has remarked on the

Fig. 75
New Guinea, Karawari River
Figure
Wood: H. 218.5 cm
Museum of Primitive Art, New York

characteristics of New Ireland sculpture, which may have appealed to Giacometti (see Moore's wood and string *Bird Basket* of 1939, No. 128).

1. William S. Rubin, *Dada, Surrealism, and Their Heritage* (New York: The Museum of Modern Art, 1968), p. 115.

102.
Alberto Giacometti
Man 1929
Bronze with paint: 40.7 × 30.2 cm
Signed rear lower left: 3/6, Alberto
Giacometti, 1929
Hirshhorn Museum and Sculpture
Garden, Smithsonian Institution

Three Figures Outdoors and *Man* (Nos. 101, 102), both of 1929, are, unlike the 1927 *Composition (Man and Woman)* (No. 100), "transparent constructions," to borrow Giacometti's term for his cage sculptures of the early 1930s. Instead of a four-sided rectangular cage, these two works present in a single, almost two-dimensional plane (like one side of a cage) simplified schematic references to the human anatomy. *Man* retains, in the symmetrical grid of bars or struts, the stiff rigidity of the male figure in *The Couple* of 1926 (No. 98). Without the disc-like head, echoing three of the forms in *Composition (Man and Woman)* (No. 100), and the legs beneath the lowest horizontal bar, little else would suggest a figurative work. Like Lipchitz's 1914 *Mother and Children* (No. 94), *Man* is reminiscent of the almost abstract treatment of the human body in works such as the Zulu *Figure of a Man* in the Museum of Mankind, London (fig. 68).

103.
Alberto Giacometti
Objets mobiles et muets 1931
Lithograph: 32.7 × 50.5 cm
Inscribed lower left: 26/30; signed
lower right: Alberto Giacometti
Art Gallery of Ontario, Gift of Dr. &
Mrs. Robin S. Harris, 1975

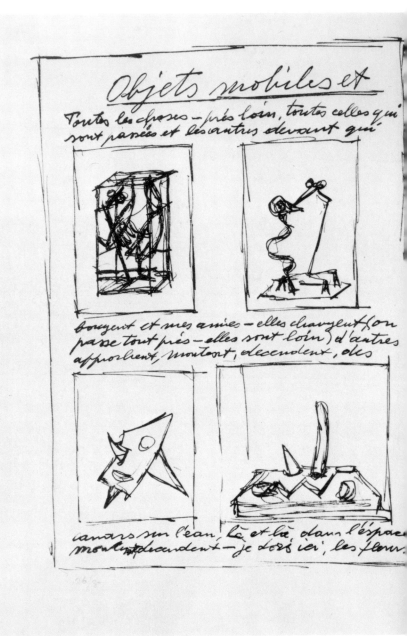

In this illustrated prose poem, the artist's earliest print and one of the most important graphics of the Surrealist movement, Giacometti has drawn seven sculptures of his Surrealist period, of which five are identifiable. Within the rectangular frame on the left side of the sheet are: upper left, *Cage* of 1931 (Moderna Museet, Stockholm); lower left, *Disagreeable Object to Be Disposed of* of 1931 (Private Collection); lower right, *Model for a Square* of 1932 (Private Collection). Within the rectangular frame on the right side of the sheet: upper left, *Suspended Ball*

The handwritten drawing page:

mirets,
de la tapisserie, l'eau du robinet mal fermé,
les dessins du rideau, mon pantalon sur
une chaise; on parle dans une chambre.

plus loin; deux ou trois personnes – de quelle
gare? les locomotives qui sifflent, il n'y a
pas de gare par ici – on jetait les pelures
d'oranges du haut de la terrasse dans la

rue étroite et profonde, la nuit les mulets
braillaient désespérement le matin on les
abattait, elle approche sa tête de mon oreille.

Fig. 76
Easter Island (Polynesia)
Bird Figure
Wood: L. 17.2 cm
Museum für Völkerkunde, Berlin

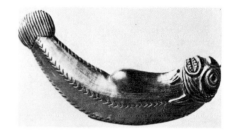

of 1930–31 (Alberto Giacometti Foundation); at bottom, *Disagreeable Object* of 1931 (Private Collection). Two of the sculptures, *Cage* and *Suspended Ball*, are discussed with Nos. 100 and 101. The 1931 wood *Disagreeable Object*, shown at the bottom in the right half of the lithograph, is one of the works by Giacometti for which a specific stylistic source in primitive art can be found. It was, as Reinhold Hohl has shown, based on carvings of birds from Easter Island such as one in the Museum für Völkerkunde, Berlin (fig. 76).[1]

1. Reinhold Hohl, *Alberto Giacometti: Sculpture, Painting, Drawing* (London: Thames and Hudson, 1972), p. 295, No. 32.

104.
Alberto Giacometti
Woman with Her Throat Cut 1932
Bronze: L. 87.5 cm
Signed and dated underneath open
hand: A Giacometti 1932
Scottish National Gallery of Modern
Art

Of all Giacometti's sculptures made during his brief association with the Surrealists, *Woman with Her Throat Cut* of 1932, in its violence and horrific treatment of a sexual theme, was probably the one that would have appealed most to his colleagues like Masson, Ernst, Dali and Picasso. In his famous letter written to his New York dealer, Pierre Matisse, in 1947, Giacometti described the dichotomy in his work of the early 1930s and briefly mentioned this sculpture:

> There was also a need to find a solution between things that were rounded and calm, and sharp and violent. It is this which led during those years (32–34 approximately) to objects going in directions that were quite different from each other . . . a woman strangled, her jugular vein cut.[1]

Anyone writing about this bronze is indebted to Douglas Hall's comprehensive article on *Woman with Her Throat Cut*,[2] which, with new insights and discoveries, lucidly discusses the work in relation to Giacometti's earlier sculpture and in the context of Surrealism. The present author's summary treatment of one of the most complex and disturbing sculptures of the twentieth century relies heavily on Hall's research.

Themes of violence and pain were of great interest to the Surrealists. The November issue of their periodical, *Documents*, included photographs of Parisian slaughterhouses, where André Masson went to sketch.[3] One of the most excruciating, almost unbearable scenes in modern cinema is the opening sequence in Luis Buñuel's 1928 film *Un Chien Andalou*, which shows an eyeball being sliced with a razor blade.

Sexuality was an important theme in Giacometti's early sculpture – at times explicit, as in the 1928–29 *Man and Woman*, in which the thin, pointed male sex almost penetrates the small female sex; and at times less obvious, as in the geometric grid of *Composition (Man and Woman)* of 1927 (No. 100). A little known work of 1930 entitled *Woman, Head, Tree* anticipates *Woman with Her Throat Cut* both in the loose open arrangement of forms and in particular in the central diagonal pod-shaped form around which the tree/head grows. As Hall has written:

> If we interpret the cigar-shape as a phallus, the piece becomes a quite explicit sexual symbol. This is the first appearance of this cigar or pod shape which is a prominent feature of *Woman with Her Throat Cut*.[4]

Two other early works, the wood *Disagreeable Object To Be Disposed of* of 1931 and the plaster *Project for a Passageway (The Labyrinth)* of 1930–31, also anticipate the 1932 bronze. The former was also called *Sculpture without Base* and the latter, like *Woman with Her Throat Cut*, was made to lie on the floor, a concept of far-reaching consequences for the generation of David Smith and Anthony Caro. Brassaï's 1932 photograph of Giacometti's studio shows *Woman with Her Throat Cut* lying on the floor.

The most obviously related precedent was the bronze *Metamorphic Creature* (about 1930-1931), which owes much to Masson's 1928 plaster *Metamorphosis*, on which he collaborated with Giacometti (fig. 77). Despite the curved, distorted limbs,

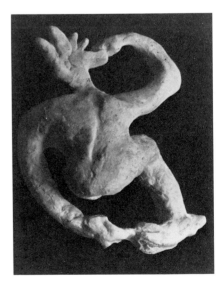

Fig. 77
André Masson
Metamorphosis 1928
Plaster: 25.1 × 21.0 cm
Whereabouts unknown

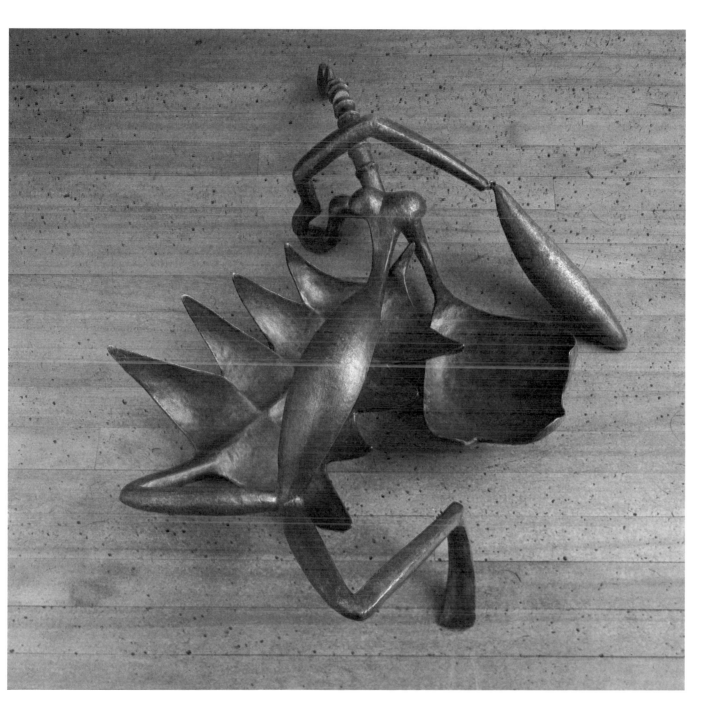

Masson's sculpture lacks the aggressive, mutilated sexuality of Giacometti's later bronze.

Two drawings of 1932 are relevant. In *The Artist's Studio* there is, as Hall writes, "on the floor, a more recognizable human figure with contorted limbs and thrown-back head."[5] But the obvious preparatory sketch appears on another sheet of 1932, *Studies for Woman with Her Throat Cut*.[6] Giacometti must have been familiar with Christian Zervos's review, *Cahiers d'Art*. The present writer was struck by two possible sources, more of a suggestive than an exact nature, of works illustrated in two issues of 1930. The first, in *Cahiers d'Art* 1, 1930, is a bronze crocodile – which belonged to the Surrealist writer, Tristan Tzara – seen from above (fig. 78). Not only is the position of the arms and legs in the lower study in the Giacometti drawing related in a general way to those of the crocodile; also, the notched form of the windpipe is remarkably similar to the crocodile's spine, which runs from the neck to the end of the tail. Another possible source for the splayed limbs in the Giacometti work is the rock painting from the district of Marandellas, Zimbabwe, of a seated man; it appeared in *Cahiers d'Art*, 1930, Nos. 8–9, p. 402 (fig. 79). In *Woman with Her Throat Cut*, the way in which thin legs, bent at the knees, double back in one direction is distinctly reminiscent of this African figure.

Hall has described the complex body imagery of the sculpture:

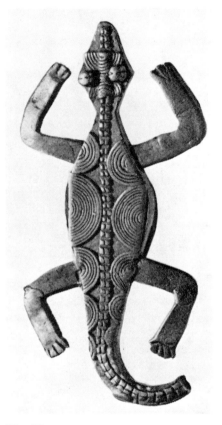

Fig. 78
Akan (Ivory Coast)
Crocodile
Bronze weight for weighing gold dust:
L. 9.0 cm
(ex-collection Tristan Tzara)

The wind-pipe shape forming the neck is automatically fairly realistic, while the nick in it, that suggests or supports the title, is merely a formal sign. The torso with its arched stomach and small breasts is a graceful abstraction from the female nude. Yet even

that is not ambiguous – is it not also a male organ? The limbs in their wild abandonment are again no more than sign language but they terminate in forms which are highly specific, though not representational. One leg ends in a remarkable jagged shape under the body, like a hard segmented shell that has been split open. One arm ends in an open scoop shape, an immensely exaggerated hand, while the other has attached to it the pod shape already noted.[7]

Images from the insect world, which had inspired Picasso's 1930 *Seated Bather*, have been cited as another possible source for this Giacometti sculpture, such as the sequence of scorpions fighting in Luis Buñuel's 1930 film *L'Age d'Or*.[8] In addition to the rich and varied associations with the sources already mentioned, the sculpture has also been discussed in connection with Donna Madina Gonzaga, who visited Giacometti's studio on a number of occasions in 1932. He completed the work soon after she stopped seeing him. As Hall has written:

Donna Madina was a classic beauty with a long neck, which fascinated Giacometti and of which he spoke to her, saying that she risked strangulation or having her throat cut. The ambiguity between that fascination and the sexual attraction she may have had for him, would have been enough to create the ambiguity already noted in the sculpture.[9]

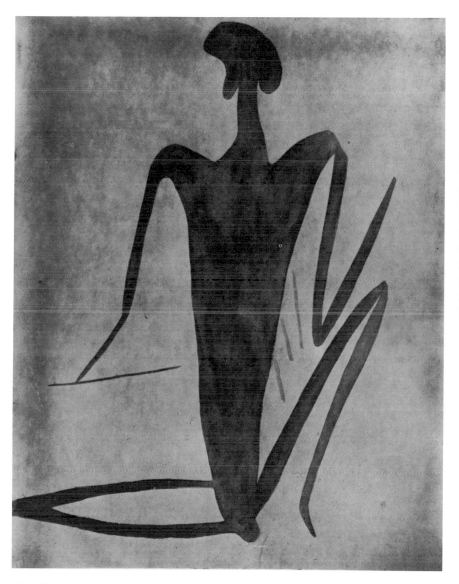

Fig. 79
Zimbabwe (District of Marandellas)
Seated Man
Copy by or after Abbé Henri Breuil of a
cave or rock painting
(Illustrated in *Cahiers d'Art*, Nos. 8–9,
1930.)

Like the greatest works of Sur-
realism, *Woman with Her Throat Cut*
is open to various interpretations on
many levels. It suggests at once
mutilation and murder and, as Hall
has suggested, sexual ecstasy. It
reflects the work of his contempo-
raries Masson and Picasso, and was
almost certainly an influence on
Moore's *Four-Piece Composition* of
1934 (No. 126), which is displayed
beside it in this exhibition. Much of
its impact lies not only in its
ambiguities and violence, but in its
scale and position on the floor. It
forces the viewer to look down on
this victim, Giacometti's most enig-
matic and powerful sculpture from
his brief Surrealist period.

1. The Museum of Modern Art, *Alberto Giacometti*, with an introduction by Peter Selz and an autobiographical statement by the artist (New York: 1965), p. 38.

2. Douglas Hall, *Alberto Giacometti's Woman with Her Throat Cut* (Edinburgh: Scottish National Gallery of Modern Art, 1980).

3. *Ibid*, p. 7.

4. *Ibid*, p. 10.

5. *Ibid*, p. 19.

6. Illustrated in Hall, *Giacometti's Woman*, p. 19.

7. Hall, *Giacometti's Woman*, p. 22.

8. *Ibid*, p. 24.

9. *Ibid*, p. 26.

105.
Alberto Giacometti
Walking Woman 1933–34
Bronze: H. 150.0 cm
Incised on top of base behind right
foot: Alberto Giacometti IV/IV
Museum of Fine Arts, Boston,
Henry Lee Higginson and William
Francis Warden Funds

Just as the disparate styles of
Picasso's work in 1915 ranged from
semi-abstract Cubist compositions to
meticulous, realistic drawings such
as *Portrait of Ambroise Vollard* (The
Metropolitan Museum of Art, New
York), Giacometti, in 1932–33, was
working on two images of the female
figure that in style and mood could
not be further apart: *Woman with Her
Throat Cut* (No. 104), which the
artist described as "a woman
strangled, her jugular vein cut,"[1]
and the elegant, hieratic *Walking
Woman*. In 1947 the artist explained
the dichotomy in his work of this
period:

> It was no longer a question of
> reproducing a lifelike figure but of
> living, and of executing only what
> had affected me, or what I really
> wanted. But all this alternated,
> contradicted itself, and continued
> by contrast. There was also the
> need to find a solution between
> things that were rounded and
> calm, and sharp and violent.[2]

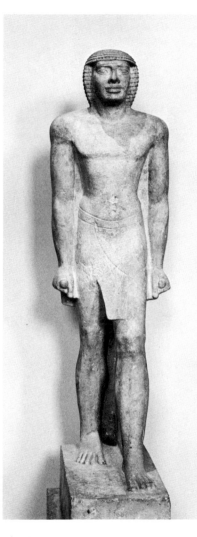

Fig. 80
Egypt, 26th Dynasty
Standing Figure of Tjayasetimu c. 630 BC
Limestone
British Museum, London

Works such as the cage sculptures,
the 1931 wood *Disagreeable Object*
and the 1932 *Woman with Her Throat
Cut* (No. 104) represent the "sharp
and violent," while *Walking Woman*
and its pendant, *Statue of a Headless
Woman* (1932–36), represent the
"rounded and calm."

Giacometti's love of Egyptian
sculpture dates from a trip to Rome,
where he was fascinated by the
Egyptian collection in the Vatican
Museum. Egyptian art, which had
influenced the work of Modigliani
and Lipchitz earlier in the century
(see Nos. 70 and 95), was undoubt-
edly Giacometti's inspiration for
Walking Woman. Although the thin
torso and extraordinarily elongated
legs, which anticipate much of his
post-World War II sculpture, reflect
Giacometti's unique formal vocabu-
lary, the rigid stance of the figure,
with the left leg forward, was based
on any number of Egyptian pro-
totypes, such as *Standing Figure of
Tjayasetimu* (fig. 80). Perhaps the
smooth headless and armless torso
owes something to the work of
Archipenko, in whose studio
Giacometti had worked when he first
arrived in Paris in 1922.

1. The Museum of Modern Art, *Alberto
 Giacometti*, with an introduction by
 Peter Selz and an autobiographical
 statement by the artist (New York:
 1965), p. 24.

2. *Ibid*, pp. 22 and 24.

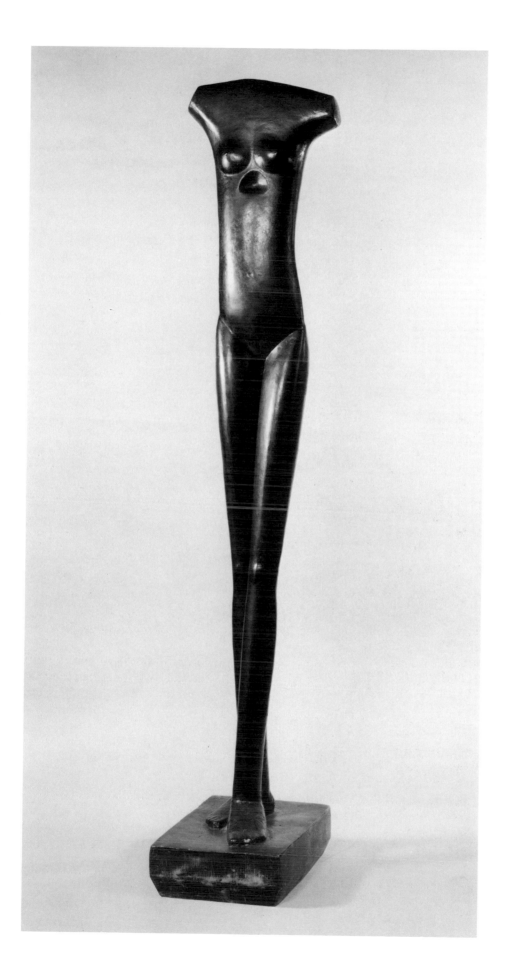

239

106.
Alberto Giacometti
Hands Holding a Void 1934–35
Engraving: 30.4 × 24.4 cm
Signed lower right: Alberto
Giacometti; inscribed lower left:
12 34-35.
The Museum of Modern Art, New
York. Gift of Victor S. Riesenfeld.

Giacometti's first two engravings,
Cubist Head of 1933 and *Hands
Holding a Void*, were based on or
related to actual sculptures.
Although the first has been dated
1933, it is certainly related to the
1934 *Cubist Head* sculpture, and may
possibly have been a study for it.
Hands Holding a Void is undoubtedly
based on the completed sculpture,
*Invisible Object (Hands Holding a
Void)* (fig. 81). According to Rein-
hold Hohl:

> Giacometti had borrowed the
> stylized human shapes from a
> Solomon Islands *Seated Statue of a
> Deceased Woman*, which he had
> seen at the Ethnological Museum
> in Basel, and had combined them
> with other elements of Oceanic
> art, such as the bird-like demon of
> death. These formal origins,
> together with the impact of a
> hieratic frontality, should be con-
> sidered above all for their mythical
> content.[1]

In the sculpture, the rigidity and
proportions of the figure are so
closely related to *Walking Woman* of
1933–34 (No. 105) as to suggest
Giacometti's continuing interest in
Egyptian art.

1. The Solomon R. Guggenheim
 Museum, *Alberto Giacometti: A Ret-
 rospective Exhibition* (New York:
 1974), p. 22.

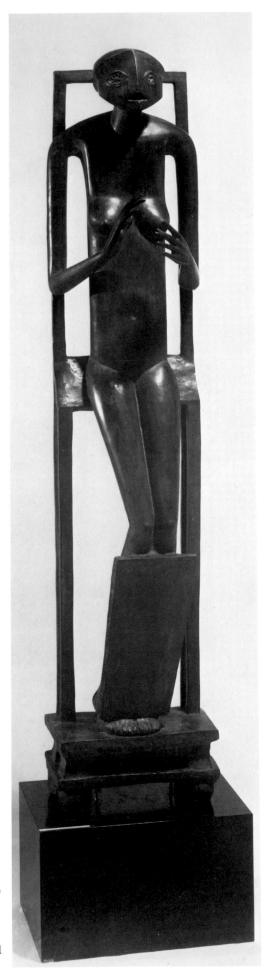

Fig. 81
Alberto Giacometti
Invisible Object (Hands Holding a Void)
1934
Bronze: H. 154 cm
Albright-Knox Art Gallery, Buffalo,
New York; Edmund Hayes Fund, 1961

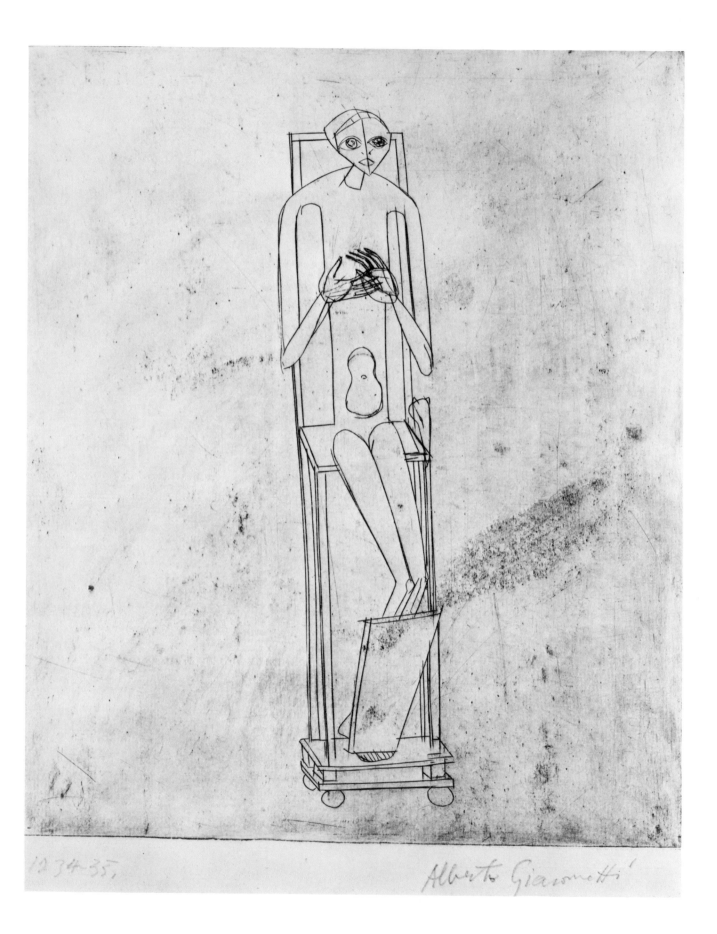

1934-35,

Alberto Giacometti

107.
Alberto Giacometti
The Nose 1947
Bronze, wire, rope, steel: H. 37 cm
Inscribed on right bottom on the
neck: Alberto Giacometti 3/6
The Milton D. Ratner Family
Collection

In 1935 Giacometti began to work again from life, concentrating on a portrait bust of his brother Diego. For five years he modelled from nature – from Diego in the mornings and in the afternoons from a model named Rita. He was expelled in 1935 from the Surrealist group and by 1938 was classed by André Breton as "a former Surrealist sculptor."[1] For the rest of his career he worked both from the model and the imagination. Creating from memory, Giacometti found "to my terror the sculptures became smaller and smaller, they had a likeness only when they were small, yet their dimensions revolted me, and tirelessly I began again, only to end several months later at the same point."[2] He lived in Geneva from 1941 to 1946 and, according to his friend Albert Skira, took the work of those years back to Paris in six matchboxes.

The year 1947 was particularly productive. Giacometti made his first major series of large sculptures since the mid-1930s. These include three life-size figures – *Walking Man*, *Large Figure*, and *Man Pointing*; as well as *Hand*, *Head of a Man on a Rod*, and *The Nose*. The latter is a continuation of the cage sculptures of the early 1930s. As in *Suspended Ball* of 1930 – 31, the head and nose are suspended by a wire from a cross-bar at the top of the cage. But unlike the earlier Surrealist work, in which the crescent-shaped object on the platform slices into the suspended ball, in *The Nose* there is none of the tension, the painful bodily sensation, or the erotic symbolism of *Suspended Ball*. But in working from the imagination, Giacometti again turns to Oceanic art for inspiration. As Elizabeth Nesfield has pointed out, the 1947 bronze *Head of a Man on a Rod* may be compared to monumental grade poles from the New

Hebrides,[3] while Reinhold Hohl suggests *Blowgun Mask* of the Baining tribe of New Britain, Melanesia (fig. 82) as a convincing source.[4] In contrast to still, isolated, shrunken figures – the subject of

Fig. 82
New Britain (Melanasia)
Blowgun Mask of the Baining
Painted bamboo: 80.0 × 122.9 cm
Museum für Völkerkunde, Basel

much of Giacometti's work from 1947 until his death in 1966 – *The Nose*, half-insect, half-human, has something of the threatening, vicious animation of his Surrealist period.

1. Arts Council of Great Britain, *Giacometti: Sculptures, Paintings, Drawings* (London: 1981), p. 13.

2. The Museum of Modern Art, *Alberto Giacometti*, with an introduction by Peter Selz and an autobiographical statement by the artist (New York: 1965), p. 28.

3. Elizabeth Nesfield, *The Primitive Sources of Surrealism*, unpublished M.A. Report, submitted to the Courtauld Institute of Art, University of London, 1970, p. 51.

4. Reinhold Hohl, *Alberto Giacometti: Sculptures, Paintings, Drawings* (London: Thames and Hudson, 1972), p. 295, No. 61.

108.
Alberto Giacometti
Venetian Woman I 1956
Bronze: H. 104.7 cm
Signed right side base: Alberto
Giacometti 4/6
Art Gallery of Ontario, Gift of Sam
and Ayala Zacks, 1970

In a conversation with David Sylvester in 1964, Giacometti discussed his best known figurative work, the thin, elongated sculptures that had deeply impressed Sartre in the mid-1940s:

At one time I wanted to hold on to the volume, and they became so tiny that they used to disappear. After that I wanted to hold on to a certain height, and they became narrow. But this was despite myself and even if I fought against it. And I did fight against it; I tried to make them broader. The more I wanted to make them broader, the

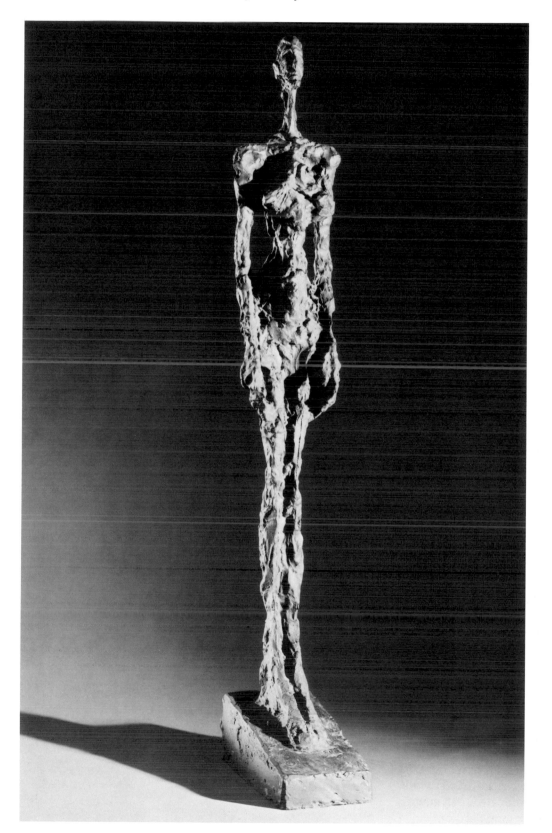

243

Fig. 83
Etruscan (Umbria)
Votive Statue
Bronze
Museo Etrusco, Volterra

narrower they got. But the real explanation is something I don't know, still don't know.[1]

A number of stylistic sources are often cited in connection with Giacometti's elongated figures. One is Egyptian sculpture, the source for the 1933–34 *Walking Woman* (No. 105). As Reinhold Hohl has written: "Every motionless *Standing Woman* from 1947 to 1949 is an allusion to Egyptian burial figures or to early Greek *Korai*, whose hair style they even occasionally borrow."[2] Etruscan bronzes are another obvious prototype (see fig. 83). Yet however much works like *Venetian Woman* are reminiscent of Etruscan or Egyptian sculpture, Giacometti has, in the struggle he describes above, created one of the most personal and individualistic images of twentieth-century man.

1. Arts Council of Great Britain, *Giacometti: Sculptures, Paintings, Drawings* (London: 1981), p. 6.

2. The Solomon R. Guggenheim Museum, *Alberto Giacometti: A Retrospective Exhibition* (New York: 1974), p. 24.

Max Ernst 1891–1976

Max Ernst, German-born painter, sculptor, and printmaker, was born in Brühl, near Cologne. He painted as a youth but in 1909 started to study philosophy and abnormal psychology at the University of Bonn. Friendships with German Expressionists led to increased interest in art. The influence of the dream-like fantastic images of de Chirico can be seen in his Dadaist work starting in 1919. He founded the Cologne Dada group with Baargeld and Arp in 1919–21. His first one-man exhibition was at the Galerie au sans Pareil, Paris, in 1921.

Ernst moved to Paris in 1922 and established friendships with André Breton and Paul Eluard. He participated actively in the Surrealist movement until he quarrelled with Breton in 1938 and left the Surrealist group. His research in automatism led to his technique of *frottage*: at random, he dropped pieces of paper on the floor and then rubbed them with black lead. The images suggested could then be combined into drawings.

In 1934, after spending the summer with Giacometti at his house in Switzerland, Ernst began making free-standing sculpture; he worked on free-standing pieces intermittently for the rest of his life. Much of the work in plaster only became known when it was cast in bronze in the 1950s. Ernst created, in his sculpture, a world of fantasy creatures, ranging from the haunting to the whimsical. In 1936 he showed two sculptures in the important exhibition of The Museum of Modern Art, *Fantastic Art, Dada, Surrealism*.

In 1941 Ernst went to the United States as a refugee and lived in New York, where he was married to Peggy Guggenheim; then he settled in Sedona, Arizona. His friendship continued with several of the Surrealists also living in the United States. He was able to indulge his life-long interest in primitive art and started to form his collection. In 1950 he returned to France, where he continued to paint and make collages and sculpture until his death in Paris on April 1, 1976.

109.
Max Ernst
Oedipus I 1934
Bronze: H. 62 cm
Signed on front of base: max ernst
IV/VI
Menil Foundation Collection,
Houston

The heroic period of visual Surrealism emerged between 1924 and 1929, the years of the first and second Surrealist manifestos, in the abstract automatism of Miró and Masson and in the meticulous illusionist dream imagery of Magritte, Tanguy, and Dali. But the development of Surrealist sculpture did not gather momentum until the late 1920s and early 1930s in the work of Arp and Giacometti. Ernst, the third important Surrealist sculptor, who had made a major contribution to the movement in his paintings of the 1920s, did not take up sculpture seriously until 1934.

Ernst spent the summer of 1934 with Giacometti in Maloja, Switzerland, where, in a nearby glacial stream, he found small stones and boulders which, using Giacometti's tools, he carved in low relief and then painted. These first experiments in sculpture were, to use Duchamp's terminology, "assisted ready-mades"; not man-made, utilitarian objects – a bicycle wheel or urinal – but found objects in nature. Photographs of these stones in Giacometti's mother's garden show that they vary in size from small pebbles to boulders weighing up to 400 kilos. These sculptures have much in common with the carved and incised pebbles that Moore and Hepworth had found on a beach at

Happisburgh on the Norfolk coast three years earlier, during the summer of 1931.

Oedipus I (one of two versions) is among the eight sculptures Ernst made in Paris during the winter of 1934–35. Again he used found objects, this time closer in conception to Duchamp's ready-mades. Lucy R. Lippard has explained Ernst's working method and the psychological implication of the work:

The two phallic forms were created by placing casts of wooden sand pails upon each other in various combinations. According to Ernst's usual methods, the forms suggested their final position, which, in turn, freely suggested the title. In addition, the Oedipus myth and its psychoanalytical ramifications were much discussed at the time; Ernst himself had devoted a whole *cahier* of his collage-novel *Une Semaine de bonté* to the theme in 1934, and as early as 1922 had titled a painting *Oedipus Rex*.[1]

As Lippard has pointed out, the head of *Oedipus I* may be indebted to Marquesan *tiki* sculpture (fig. 29). While the broad slit of the mouth is reminiscent of Brancusi's wood *The Chief* of 1925, could the nose, curving down from the top of the

head (an addition stuck on the cast of the pail) be derived from Picasso's heads of 1932 (No. 54)? The facial features and the way in which the upper half of the figure balances somewhat precariously to one side of the lower section give this sculpture a mood of disquiet that one associates with the work of de Chirico, who influenced Ernst's painting in the early 1920s. The stunted, horn-like arms, often interpreted in the context of Ernst's work as references to sexual power, are a disturbing and prophetic image of Thalidomide children of the 1960s.

By 1935 Giacometti was again working from the model in a more traditional way, and Arp was making his "concretions," as he called his rounded sculptures suggestive of growth and forms in nature that have little in common with Surrealism. This left Ernst as the only Surrealist sculptor. Much of his later work, such as *Moonmad* of 1944 (No. 110), although informed by primitive sources, evokes a mood of playfulness; none presents an image as disturbing as *Oedipus I*.

1. Lucy R. Lippard, "Max Ernst and a Sculpture of Fantasy," *Art International* II no. 2 (February 20, 1967): 39.

110.
Max Ernst
Moonmad 1944
Bronze: H. 92.8 cm
Museum of Fine Arts, Houston; Gift
of D. and J. de Menil

While the time and conscious effort required to model, cast, and assemble sculpture made it unsuitable to express the spontaneous "pure psychic automatism" that characterized much Surrealist painting, drawing, and writing, sculpture was the most obvious medium in which to incorporate directly the forms of primitive art. By the time Ernst moved to New York in 1941 he was, like many of his Surrealist colleagues, familiar with a wide range of primitive art. As early as 1921, in his oil *Celebes* (The Tate Gallery, London), he based the gigantic monster on a corn-bin, which he had seen in an English anthropological journal, made by the Konkombwa people of Southern Sudan.

In the summer of 1944, spent at Great River, Long Island, Ernst embarked on his third period of sculptural activity. Julian Levy, his friend and dealer, with whom Ernst and Dorothea Tanning shared a home, has described the genesis of *Moonmad*:

> The plaster disappeared, and I found Max in the garage casting a ghostly array of white shapes in any and every mould available from the kitchen and the back yard, from utensils, milk cartons, and eggshells and even from a few spare automobile parts. Within two days he had put his random castings together into a construction, a two-faced haunting figure which he later carved in wood – *Moonmad*.[1]

The horns in *Moonmad* and in *The King Playing with the Queen*, also of 1944, were anticipated in the stumplike arms of *Oedipus I* (No. 109). Many examples of horned masks and headdresses may be found in primitive art: Bambara (Mali) antelope headdresses, Senufo (Ivory Coast)

Fig. 84
Senufo (Ivory Coast)
Dance Mask
Wood: H. 33.0 cm
Private Collection

dance masks (fig. 84); and in a photograph of masked dancers from the French Sudan that appeared in the June 1933 issue of the Surrealist artistic and literary review, *Minotaure*. The legs of *Moonmad*, like those of *Young Man with Beating Heart* (No. 111), may be related to those of Gabon Kota reliquary figures (fig. 85). Unlike the emotionally charged, often aggressive primitivism of Picasso and Giacometti, Ernst's primitivism, as Diane Waldman has written, "exploits the primitive forms for humor."[2]

1. *Max Ernst: Sculpture and Recent Painting* (New York: The Jewish Museum, 1966), p. 43.

2. Jeffrey J. Spalding, *Max Ernst from the Collection of Mr. and Mrs. Jimmy Ernst* (Calgary: Glenbow Museum, 1979), p. 8.

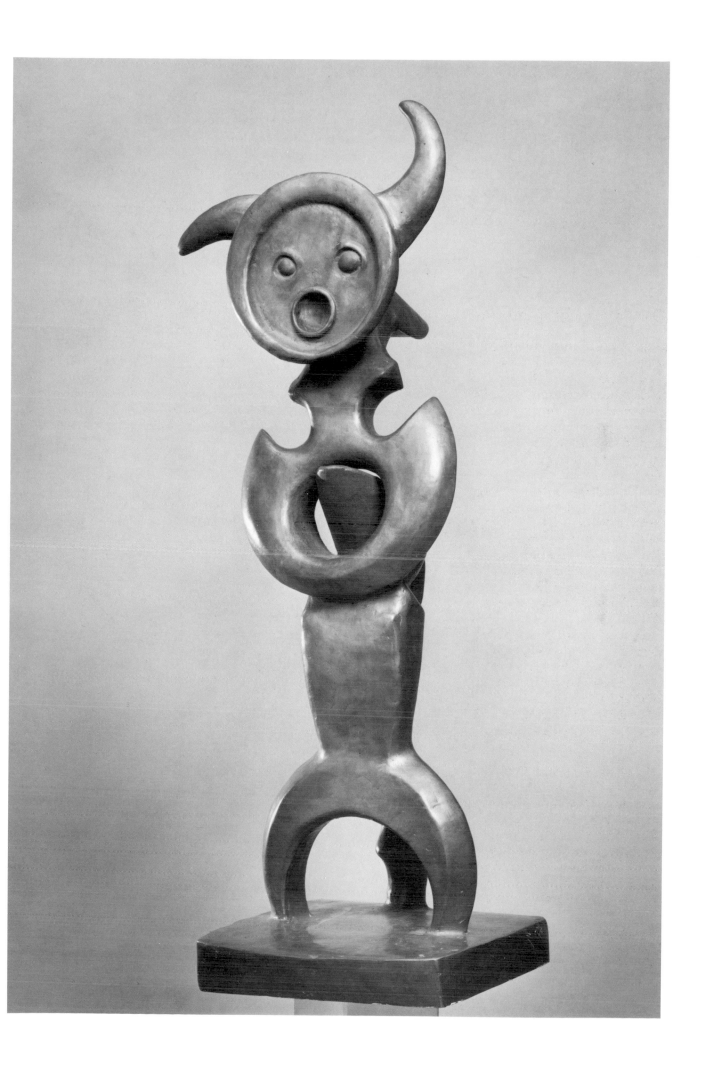

111.
Max Ernst
Young Man with Beating Heart 1944
Bronze (cast 1954): H. 63.5 cm
Private Collection, USA

During the 1930s Ernst was in close contact with Giacometti (see No. 109) and was familiar with much of his work from the late twenties and early thirties. According to the artist's son, Jimmy Ernst, in 1934 his father offered to store a number of Giacometti's plasters, including *Spoon Woman* of 1926 (No. 99).[1] This sculpture and the 1929 *Reclining Woman*, which derive from wooden spoons of the Dan tribe (fig. 73), may well have suggested incorporating the spoon-like head in *Young Man with Beating Heart*, which, like No. 110, was made at Great River in the summer of 1944. Although, as Julian Levy explained in connection with another sculpture, an actual kitchen spoon may have been the initial stimulus, its metaphorical use in a figurative sculpture is in keeping with the Surrealists' use of man-made utilitarian objects.[2] Also in *Young Man*, the position and shape of the concave area below the chest are remarkably close to a similar feature in Giacometti's *Walking Woman* of

Fig. 85
Kota (Gabon)
Reliquary Figure
Wood, iron, brass, copper: H. 53.0 cm
The Barbara and Murray Frum
Collection, Toronto

1933–34 (No. 105). Although the curved, truncated legs have none of the angularity of Kota reliquary figures (fig. 85), their squat proportions are remarkably similar.

Like most of Ernst's sculpture from the 1930s and forties, the three works in this exhibition were originally conceived in plaster and not cast in bronze until the 1950s and sixties. Although he continued sculpting into the 1960s, Ernst's activities in this medium were sporadic throughout his career. In his finest sculpture he managed to evoke something of the dream-inspired images of Surrealism with formal borrowings from primitive art, which Ernst and his generation so passionately admired.

1. Jeffrey J. Spalding, *Max Ernst from the Collection of Mr. and Mrs. Jimmy Ernst* (Calgary: Glenbow Museum, 1979), p. 13.

2. *Ibid*, p. 33.

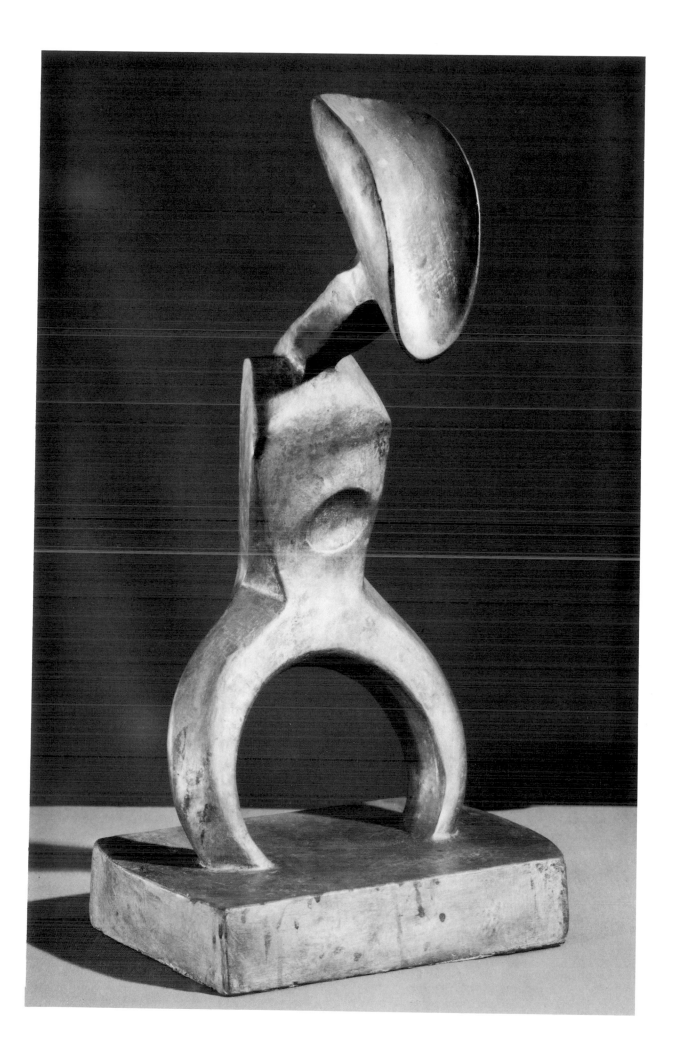

Julio Gonzalez 1876–1942

Spanish sculptor, metalworker, painter, and draughtsman Julio Gonzalez was
born in Barcelona to a family of goldsmiths and metalworkers, in whose
workshop he learned to weld and braze many kinds of metals. He studied
painting at the School of Fine Arts and became acquainted with the *avant garde*
in Barcelona. In 1900 his family moved to Paris, where he frequently saw Picasso,
whom he had met in Barcelona. In 1908 the loss of his brother resulted in about a
ten-year period of withdrawal; Brancusi was one of the few people he maintained
contact with. About 1918 he learned oxyacetylene welding in a Renault factory.
At the time he was painting and also showing metal *repoussé* masks. In 1921 he
had a one-man exhibition at the café-gallery Caméléon and in 1922 at the Galerie
Povolovsky.

About 1926–27 Gonzalez decided to abandon painting to devote himself to
sculpture. In 1928 he began to assist Picasso to construct a number of welded
metal figures; his technical expertise enabled Picasso to realize daring ideas in
metal, and Gonzalez obtained a better perception of the possibilities of the
welded-metal medium. He developed his concept of the figure as an open,

skeletal, almost entirely abstract configuration. In the 1930s he exhibited with the Constructivist group *Cercle et Carré* and with the Surrealists. His *La Montserrat* was exhibited in the Spanish Pavilion at the 1937 World Exposition in Paris.

Because of the shortage of welding supplies during the war, Gonzalez concentrated on drawing and modelling in plaster. Among his earlier works in metal are masks of African inspiration. A pioneer of welded iron sculpture, he inspired later generations of sculptors. He died in Arcueil, outside Paris, on March 27, 1942.

112.
Julio Gonzalez
Mask of the Screaming Montserrat
1936–37
Bronze: H. 22.6 cm
Marlborough Fine Art (London)
Ltd.

Gonzalez was five years older than his friend and compatriot, Picasso. He grew up in Barcelona, where he worked in his family's workshop making decorative metalwork. He supported himself by making metalwork and jewellery, as well as painting and sculpture. By the late 1920s he decided to give up painting and devote himself to sculpture. In one of his earliest metal sculptures, *Three Elements* of about 1927 (Musée national d'art moderne–Centre Georges Pompidou), the mask-like head at upper left anticipates his drawings of masks of 1936–42 (Nos. 113 and 114).

It would be difficult to overestimate the importance of Gonzalez's knowledge and technique of welded-metal sculpture. In March 1928 Gonzalez and Picasso renewed their acquaintance and by October Picasso was working in his friend's studio, where together they completed Picasso's 1928 painted metal *Head* and *Wire Construction* (both in the Musée Picasso, Paris), the first of four metal-rod sculptures based on the Dinard drawings from the summer of that year. This collaboration was not only a turning point in Picasso's career but was soon to have a profound influence on the American sculptor David Smith. As the latter wrote:

> Fall of 1933 made up some things and took them to Barney Snyder's garage – a garage in Bolton and welded them together. First iron sculptures I made (prompted by seeing the work of Picasso which I have been told were created jointly with Gonzalez).[1]

In 1936–37 Gonzalez worked on a life-size sheet-metal sculpture of a peasant woman holding a child, of which this bronze is one of the studies. Like Picasso's *Guernica* of 1937, it was shown at the Spanish Pavilion at the 1937 Paris International Exposition. Called *La Montserrat*, after Spain's holy mountain, it symbolized the suffering of the Spanish people during the civil war.

La Montserrat is in the Stedelijk Museum, Amsterdam; the original iron sculpture from which the mask shown here was cast is in the Musée national d'art moderne–Centre Georges Pompidou. The cry is the subject of Munch's famous painting of 1893, of Rodin's undated bronze *Le Cri*, and of several of the figures in Picasso's *Guernica* of 1937. In this work, the open mouth and the roughly forged, uneven eyes give the mask an Expressionist violence and anguish that is closer in spirit to Picasso's representations of the sufferings of war than of the somewhat subdued and stoical face of *La Montserrat*. The theme was continued in some of the twenty-seven drawings of masks and faces made in 1940, such as *Screaming Head* (in The Art Institute of Chicago) (fig. 86). Although less closely related to African masks than are Nos. 114 and 115, the work shown here has much of the demonic and emotional power of primitive art.

1. David Smith, *David Smith by David Smith*, edited by Cleve Gray (New York: Holt, Rinehart and Winston, 1968), p. 25.

Fig. 86
Julio Gonzalez
Screaming Head 1940
Pen and ink, gray wash, over pencil:
31.6 × 23.9 cm
The Art Institute of Chicago, William McCallin McKee Memorial Collection, 1957.358 (Courtesy of The Art Institute of Chicago)

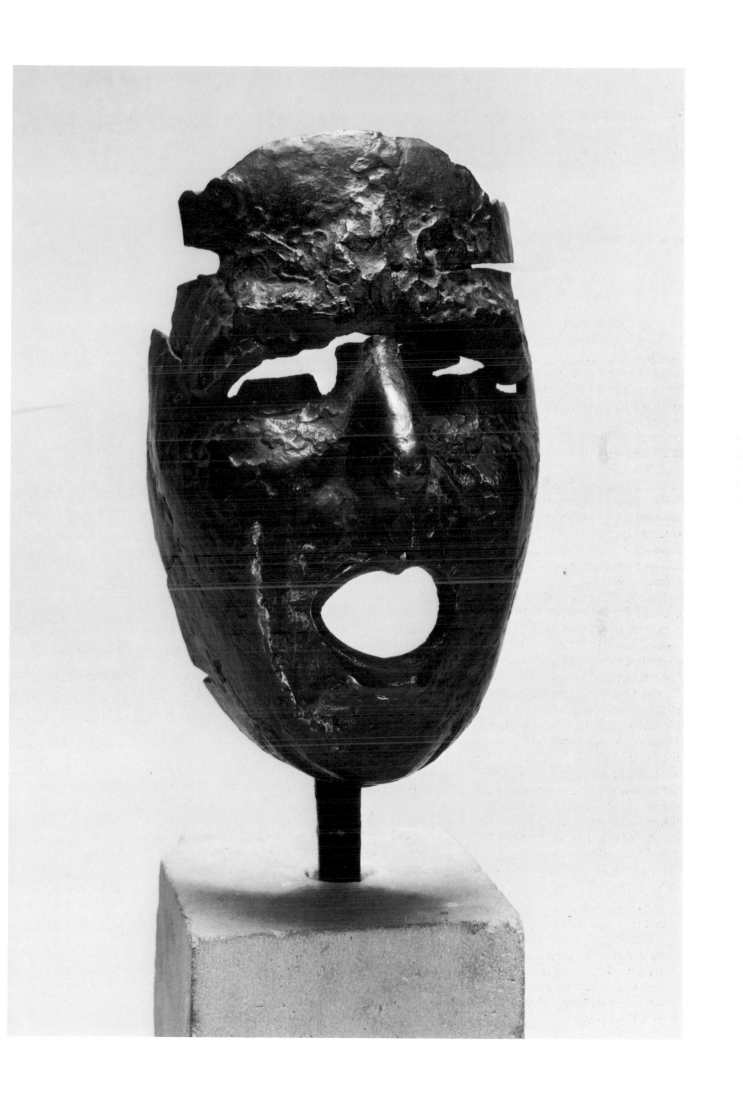

113.
Julio Gonzalez
The Bearded Man 1936
Pen and India ink and coloured
pencil: 21.5 × 17.0 cm
Signed and dated lower right: J.G.
1936 – 18.11
Musée national d'art moderne –
Centre Georges Pompidou – Don de
Mme R. Gonzalez

The angularity, distortions, and deep
recesses of this head anticipate
Beaudin's bronze head *Paul Eluard*
of 1947 (No. 116) although, unlike
the latter, which was inspired by the
great Easter Island statues (fig. 63),
this work does not suggest a particu-
lar style of primitive art.

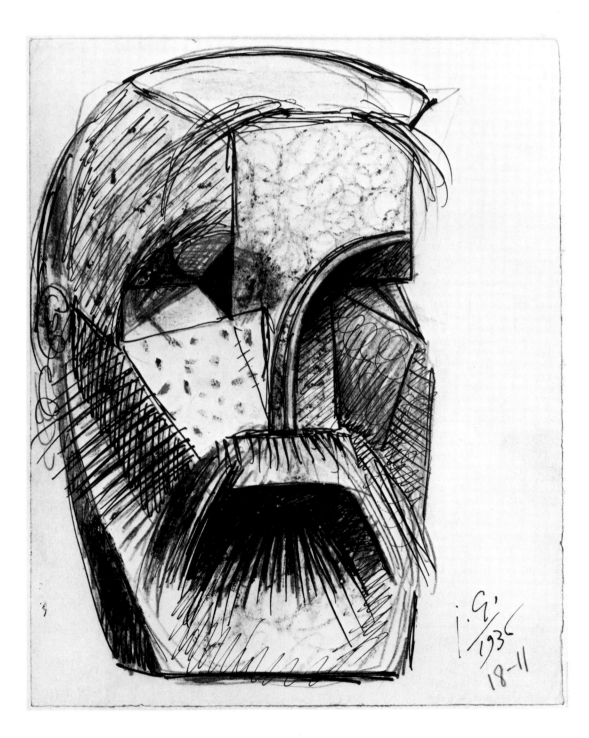

114.
Julio Gonzalez
Maltese Face 1940
Pencil, pen and ink, and wash:
31.8 × 24.2 cm
Inscribed bottom right: 28-4-40/J.G
The Trustees of The Tate Gallery

This is one of fifty drawings by Gonzalez that his daughter, Madame Roberta Gonzalez-Richard, presented to The Tate Gallery in 1972. According to Ronald Alley,

Gonzalez made a series of about 27 drawings of mask-like faces between 25 April and 25 May 1940, the earliest, like this, having a strong resemblance to African masks. . . . The title *Maltese Face (Visage maltais)* inscribed on the verso by Roberta Gonzalez is puzzling, as the head has a distinctly African character.[1]

In both his sculpture and drawing, Gonzalez was often preoccupied with the problem of shadows, and in some instances the various light and dark planes suggest an invented rather than a logical source of light. Like Henry Moore, Gonzalez made drawings for sculpture, and although this work was never realized in three dimensions, the flat planes, sharp edges, and angles, and the way in which the large lips appear fixed to the face, are in conception very much the work of a welder in metal.

1. Ronald Alley, *Catalogue of The Tate Gallery's Collection of Modern Art: Other than Works by British Artists* (London: The Tate Gallery, 1981), p. 321.

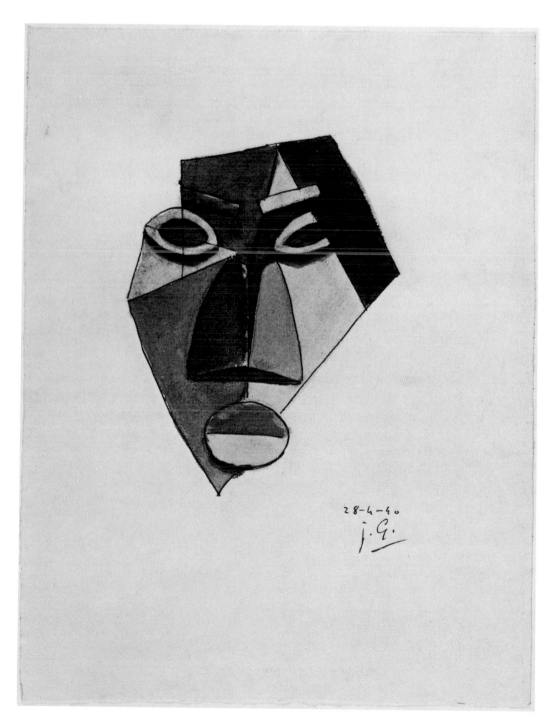

257

115.
Julio Gonzalez
Masque dit du religieux (Mask Known
As The Monk) 1942
Bronze: H. 17 cm
Inscribed on left side: © by R.
Gonzalez .H.C.
Musée national d'art moderne –
Centre Georges Pompidou

The shortage of oxygen and
acetylene necessary for welding may
account for the fact that Gonzalez
made few sculptures after the out-
break of World War II. The pinched,
angular features of this little mask,
made in the last year of his life, may
owe a debt to African sculpture,
although it is difficult to suggest a
specific stylistic source.

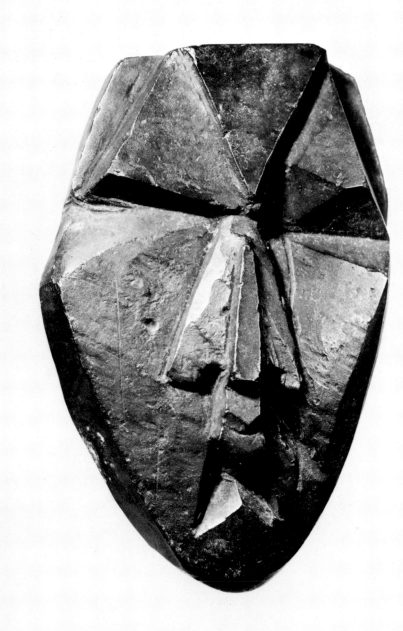

André Beaudin 1895–1979

French painter, sculptor, and illustrator André Beaudin was born in Mennecy (Seine-et-Oise) and studied at the Ecole des Arts Décoratifs, Paris, from 1911 to 1915. In 1921 he travelled in Italy and in the following year met Juan Gris, who had an important influence on his artistic development. More a painter than a sculptor, it was only in 1930 that he began to work in plaster and in clay to be cast in bronze. His style retained the aesthetic principles of Cubism. He first exhibited at the Galerie Percier in 1923 and received the *Grand Prix National des Arts* in 1962. He also illustrated the books of his friends, the poets Eluard, Hugnet, Frénaud, and Ponge. He died in June, 1979.

116.
André Beaudin
Paul Eluard 1947
Bronze, cast 0/6: H. 42 cm
Galerie Louise Leiris, Paris

Better known as a painter closely tied to the Cubist tradition, Beaudin produced sculpture that reflected his preoccupations as a painter, especially his sense of order and simplified forms.

Paul Eluard (1895–1952) was one of the major poets of the Surrealist generation. He published in the Dadaist review *Littérature* and contributed to the review *La Révolution Surréaliste*. Ernst, Miró, and Dali were his close friends, but above all he valued his friendship and rapport with Picasso, who in 1936 did a pencil *Portrait of Eluard*.

In Beaudin's bronze *Paul Eluard*, the artist combines the angles and greatly simplified flat planes, which one associates with the Cubist sculpture of Lipchitz and Laurens, with strong echoes of the great Easter Island head (fig. 63), which had almost certainly influenced Gaudier-Brzeska in his two sculptures of another poet, Ezra Pound (No. 84 and fig. 62). Although historically the most important primitivistic work was that produced by Picasso and his generation in Paris between 1907 and 1920, by Kirchner and Schmidt-Rottluff in Germany during these years, and by Moore, Ernst, and Giacometti in the 1920s and thirties, sculptors and painters continued to draw inspiration from numerous non-European cultures during the 1940s and fifties, as shown by this Beaudin bronze.

Henry Moore 1898–

English sculptor and draughtsman Henry Moore was born at Castleford, Yorkshire, the son of a miner. He studied at the Leeds School of Art from 1919 to 1921 and at the Royal College of Art, London, from 1921 to 1925. Residence in London enabled him to pay constant visits to the British Museum, and there he got his first exposure to the rich collection of Egyptian, Sumerian, Pre-Columbian, African, and Oceanic sculpture. In 1925 he spent six months in France and Italy on a Royal College of Art travelling scholarship. From 1922 until 1939 he made more or less annual visits to Paris. He taught part time at the Royal College of Art from 1925 to 1932 and then at the Chelsea School of Art from 1932 to 1939. In 1928 he had his first one-man exhibition at the Warren Gallery and received his first public commission for a relief carving on the London Transport Headquarters, St. James's Park Station, London. He was a member of the London Group (1930–37), the 7 & 5 Society (1932–35), the National Society (1931–32), and Unit One (1933).

Moore participated in the *International Surrealist Exhibition* in London in 1936. He visited Spain in 1936 and made a tour of the cave paintings in the Pyrenees and at Altamira. He visited New York for the first time in 1946, Greece in 1951, Brazil and Mexico in 1953, and on several occasions travelled to Europe and America. In 1940, when his London studio was damaged during the Blitz, he moved to a house at Much Hadham, Hertfordshire, where he has lived since. He was an official war artist from 1940 to 1942. He had a retrospective exhibition in The Museum of Modern Art, New York, in 1946, and in 1948 was awarded the International Sculpture Prize at the Venice Biennale.

Moore's work has been more widely exhibited than that of any other living sculptor. He has received several major commissions, among them in 1952 a commission to carve a screen for the façade and to make a bronze *Draped Reclining Figure* for the terrace of the Time-Life Building, Bond Street, London; in 1956 the *Reclining Figure* for the UNESCO building in Paris (1958). In 1966 *The Archer* was unveiled in the square in front of the new city hall in Toronto.

Moore's many honorary degrees and decorations include The Companion of Honour in 1955 and The Order of Merit in 1963. In 1967 Moore promised a major donation to The Tate Gallery of his sculpture, which was first shown in 1978. In 1974 the Henry Moore Sculpture Centre opened in Toronto, the result of a donation by the artist of more than 101 original plasters and bronzes, fifty-seven drawings, and an almost complete collection of his prints to the Art Gallery of Ontario. This exceptionally generous gift, as well as earlier and more recent purchases and donations, forms the most important and comprehensive public collection of Henry Moore's work in the world.

117.
Henry Moore
Snake 1924
Marble: H. 15.2 cm
The Henry Moore Foundation

The world has been producing sculpture for at least some thirty thousand years. Through modern development of communication, much of this we now know and the few sculptors of a hundred years or so of Greece no longer blot our eyes to the sculptural achievements of the rest of mankind. Paleolithic and Neolithic sculpture, Sumerian, Babylonian and Egyptian, Early Greek, Chinese, Etruscan, Indian, Mayan, Mexican and Peruvian, Romanesque, Byzantine and Gothic, Negro, South Sea Island and North American Indian sculpture; actual examples or photographs of all are available, giving us a world view of sculpture never previously possible.[1]

Moore's statement, from a 1930 article on "The Nature of Sculpture," sums up the theme and many of the stylistic sources of works in this exhibition. Four years earlier, he had written in his *No. 6 Notebook* of 1926: "Keep ever prominent the world tradition/the big view of sculpture;" and this he did from the moment he arrived in London in 1921 by countless visits to the British Museum and by studying books on the history of sculpture. His many

sketches of paintings, sculptures, drawings, and artifacts comprise an invaluable record of specific works that particularly interested Moore, and provide concrete evidence of his far-ranging interest in the art of the past, from the Paleolithic *Venus of Grimaldi* to Cézanne. Moore's copies of works of art are discussed in detail in the author's exhibition catalogue, *The Drawings of Henry Moore* (The Tate Gallery and Art Gallery of Ontario, 1977, pp. 19–20, catalogue numbers 62–72, and pgs. 143–150).

Pre-Columbian sculpture was undoubtedly the most important formative influence on Moore's work of the 1920s, from the small alabaster *Head* (fig. 89) of 1923 to the *Chacmool*-inspired Leeds and Ottawa reclining figures of 1929 and 1930 (fig. 93 and No. 124). In describing the fine collection in the British Museum, Moore wrote:

Mexican sculpture, as soon as I found it, seemed to me true and right, perhaps because I at once hit on similarities in it with some eleventh-century carvings I had seen as a boy on Yorkshire churches. Its 'stoniness', by which I mean its truth to material, its tremendous power without loss of

sensitivity, its astonishing variety and fertility of form-invention and its approach to a full three-dimensional conception of form, make it unsurpassed in my opinion by any other period of stone sculpture.[2]

Moore's interest in African and Pre-Columbian art was first aroused by Roger Fry's *Vision and Design* (1920), which he read in 1920 or 1921 while studying at the Leeds School of Art. Certain passages in the chapters on "Negro Sculpture" and "Ancient American Art" not only prepared the young Yorkshire sculptor for the richness of the collections in the British Museum, but profoundly influenced the direction his own work was to take in the 1920s: direct carving, truth to materials, and full, three-dimensional realization. Fry speaks of "the magnificent collection of Mexican antiquities in the British Museum" and then remarks:

Still more recently we have come to recognize the beauty of Aztec and Maya sculpture, and some of our modern artists have even gone to them for inspiration. This is, of course, one result of the general aesthetic awakening which has

followed on the revolt against the tyranny of the Graeco-Roman tradition.[3]

Within two years of arriving in London in 1921, Moore's work began to reflect the influence of Mexican sculpture. As with almost all Moore's sculpture from 1921 to the early 1950s, the marble *Snake* was based on preparatory drawings, which appear on page 81 of *Notebook Number 2* of 1921–22, above a group of Cézannesque figure studies (fig. 87). This marvellous little sculpture, which embodies the characteristics mentioned in an inscription on page 80 of *Notebook No. 2* – "eternal grinding and interlacing of forms" – is one of the most fully three-dimensional of Moore's early work. It was almost certainly based on the coiled basalt snakes of the Aztec culture (fig. 88).

1. Henry Moore, *Henry Moore on Sculpture*, edited with an introduction by Philip James (London: Macdonald, 1966), p. 57.

2. *Ibid*, p. 159.

3. Roger Fry, *Vision and Design* (1920; reprinted Middlesex, Eng.: Pelican Books, 1961), p. 92.

Fig. 87
Henry Moore
Page 81 from No. 2 Notebook 1922–24
Pencil, pen and ink: 22.4 × 17.2 cm
The Henry Moore Foundation

Fig. 88
Mexican, Texcoco, Valley of Mexico
Coiled Serpent Late Postclassic period
Basalt: H. 28.0 cm
Field Museum of Natural History, Chicago

118.
Henry Moore
Mask 1927
Stone: H. 21 cm
The Henry Moore Foundation

Moore's earliest Mexican-inspired carvings were the little alabaster *Head* of 1923 (fig. 89), the marble *Snake* (No. 117), and the *verdi di prato Mask*, both made the following year. From the years 1927 to 1930, eleven masks are listed in the catalogue *raisonné* of Moore's sculpture. On page 97 of *No. 6 Notebook* (fig. 90) is the inscription: "Head of Christ in Alabaster Mexican" and below this a drawing of a head inspired by Teotihuacán Pre-Columbian masks. In addition to Moore's frequent visits to the British Museum, his many mask carvings from 1927–30 may also have been inspired by a book he acquired in 1928, Adolphe Basler and Ernest Brummer's *L'Art Précolumbian* (Paris, 1928), which includes numerous illustrations of masks.[1] In addition to the carvings are a number of drawings of masks (No. 120).

In this 1927 *Mask* it is difficult to suggest a stylistic source. An early photograph of this carving shows two eyes, which appear to have been attached separately. Writing of another Mexican-influenced stone *Mask* of 1929, Moore described the importance of the eyes:

> I wanted to give the eyes tremendous penetration and to make them stare, because it is the eyes which most easily express human emotion. In other masks, I used the asymmetrical principle in which one eye is quite different from the other, and the mouth is at an angle bringing back the balance.[2]

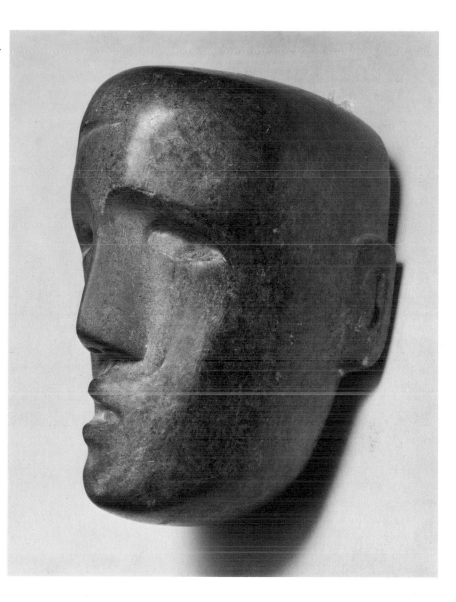

1. The artist's copy of this book is inscribed on the fly leaf: Henry Moore 1928.

2. Henry Moore, *Henry Moore*, photographed and edited by John Hedgecoe (London: Thomas Nelson, 1968), p. 56.

267

119.
Henry Moore
Mask 1929
Cast concrete: H. 20.3 cm
The Henry Moore Foundation

This work is a substitute for the more obviously Pre-Columbian-inspired stone *Mask* also of 1929 (not available for this exhibition).

Moore's earliest experiment with cast concrete was the 1926 *Baby's Head*. In 1929 he made six works in this material, including three masks, of which this is one. He has described the two ways in which he worked in concrete in the late 1920s:

At the time reinforced concrete was the new material for architecture. As I have always been interested in materials, I thought I ought to learn about the use of concrete for sculpture in case I ever wanted to connect a piece of sculpture with a concrete building. The first method of using concrete I tried, was building it up on an armature and then rubbing it down after it had set. This I had to do very quickly because the cement and the gritty aggregate mixed with it set so hard that all my tools used to wear out. Secondly, I tried casting in concrete.[1]

The fact that all the concrete sculptures from the 1920s were cast and the six sculptures of 1932–34, including the original version of No. 126, were carved indicates that, in fact, Moore began casting this material and later carved it, after building it up on an armature.

1. Henry Moore, *Henry Moore*, photographed and edited by John Hedgecoe (London: Thomas Nelson, 1968), p. 58.

Fig. 89
Henry Moore
Head 1923
Alabaster: H. 14 cm
Private Collection

Fig. 90
Henry Moore
Page 97 from No. 6 Notebook 1926
Pencil: 22.2 × 17.2 cm
The Henry Moore Foundation

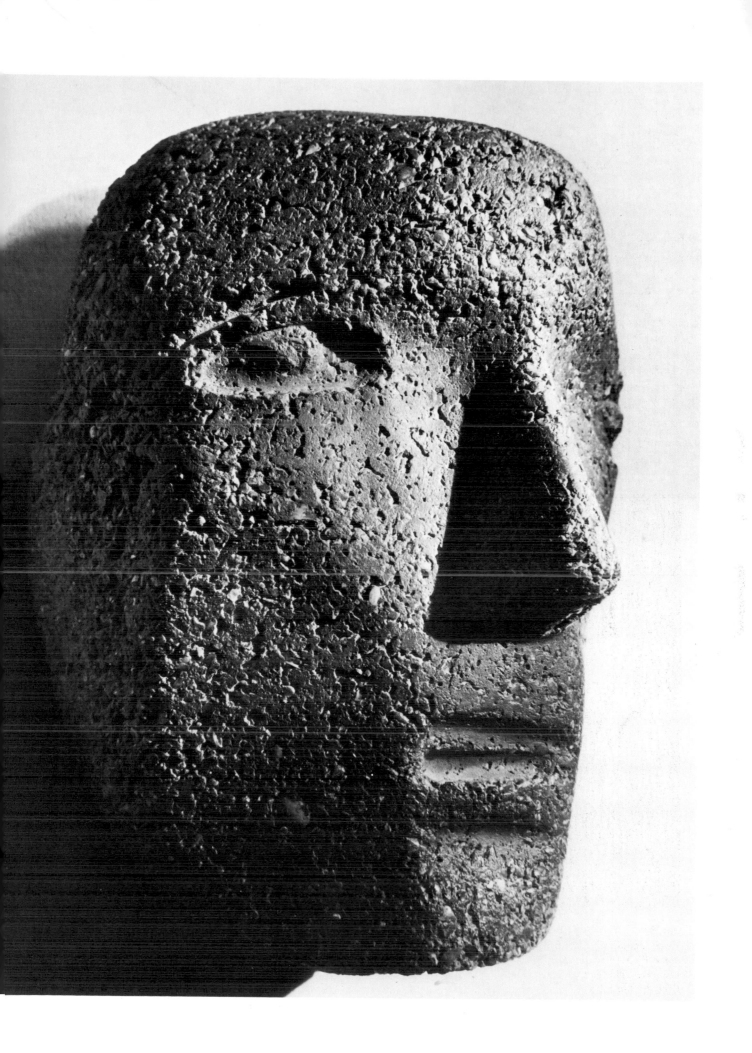

120.
Henry Moore
Ideas for Sculpture: Masks 1929
Pencil: 13.3 × 13.8 cm
Inscribed lower right: Moore 29
Art Gallery of Ontario. Gift of Henry
Moore, 1974

This is one of three known drawings of masks of about 1929; the Pre-Columbian-inspired *Drawing for Mask Carving* (fig. 91) is in a private collection, and *Studies of Heads* is in the Staatsgalerie, Stuttgart. In the notes on two of the twelve heads and masks from the 1920s included in this exhibition (Nos. 118 and 119), the importance of this subject and of the Mexican influence are discussed. Although none of the studies in this sketch was translated into sculpture, they do relate to the mask-like features that appear in a number of life-drawings of the period. In the mask at lower left, the continuous line defining the nose and mouth, which appear flattened against the face, reflects the influence of Picasso's work of the late 1920s, such as the profile outline of the head in *Seated Woman* of 1927 (Art Gallery of Ontario).

Fig. 91
Henry Moore
Drawing for Mask Carving c. 1929
Pen and ink, chalk and wash:
17.8 × 22.9 cm
Private Collection

270

121.
Henry Moore
Ideas for West Wind Relief 1928
(verso)
Pen and ink: 36.6 × 22.6 cm
Art Gallery of Ontario. Gift of Henry
Moore, 1974

In 1928, the architect Charles H. Holden commissioned seven sculptors to carve architectural decorations for his new building, the headquarters of London Transport at St. James's Park Station. Jacob Epstein did two large groups entitled *Day* and *Night*. Henry Moore, Eric Gill, Allan Wyon, Eric Aumonier, A.H. Gerrard, and F. Rabinovitch were asked to do eight reliefs of horizontal figures representing the four winds for the central tower of the building. Gill carved three of them; the other five sculptors each did one.

Moore was somewhat reluctant to accept his first public commission (fig. 92). Relief sculpture was the antithesis of the full spatial richness for which he was striving in his own work. But Holden was very persuasive, and Moore began a series of preparatory drawings in his *1928 Sketchbook for the Relief on the Underground Building*. In addition to the many studies of reclining figures in the *Sketchbook*, three large and two smaller sheets of drawings are

known: this one, one in the collection of the Arts Council of Great Britain, and the remainder, including the two smaller sheets, belonging to The Henry Moore Foundation.

The *West Wind* relief carving of 1928, and the numerous preparatory drawings for it, are important on several counts. They mark the beginning of Moore's total obsession with the reclining figure motif, which was soon to become and has remained to this day one of the dominant themes in his work. Secondly, the sculpture and drawings prefigure the Leeds *Reclining Figure* of 1929 (fig. 93), the first carving to reflect the impact of the eleventh- and twelfth-century Toltec-Maya *Chacmool* reclining figure (see Nos. 123-24). Certain studies in *Ideas for West Wind Relief* echo, although in a less obvious way than the Leeds carving and the definitive drawing for it (No. 123), the pose and the mask-like head of the *Chacmool*. In the sketch at lower left, showing a female figure reclining on her side, the position of the arm and

the angular head are certainly reminiscent of the Mexican sculpture. It is interesting to note, in some of the spaces between the reclining figures, abstract block-like forms and L-shaped lines intersecting at right angles. It is as if Moore was consciously forcing himself to adopt a more angular, geometrical approach. This is also reflected in several of the figurative passages. One is reminded of Gaudier-Brzeska's remark about drawings such as his 1912 *Standing Nude*:

> I draw square boxes altering the size, one for each plane, and then suddenly by drawing a few lines between the boxes they can see the statue appear.[1]

1. H. Gaudier-Brzeska to Sophie Brzeska, November 28, 1912, quoted in *Henri Gaudier-Brzeska* (London: Mercury Graphics, 1977), p. 15.

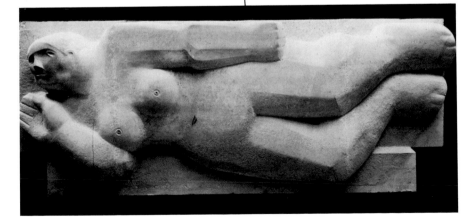

Fig. 92
Henry Moore
West Wind 1929
Portland stone: L. c.244 cm
London Transport Executive Headquarters, St. James's Park, London

122.
Henry Moore
Reclining Figure c. 1928 (verso)
Brush and coloured washes:
30.8 × 51.1 cm
Art Gallery of Ontario. Gift of Henry
Moore, 1974

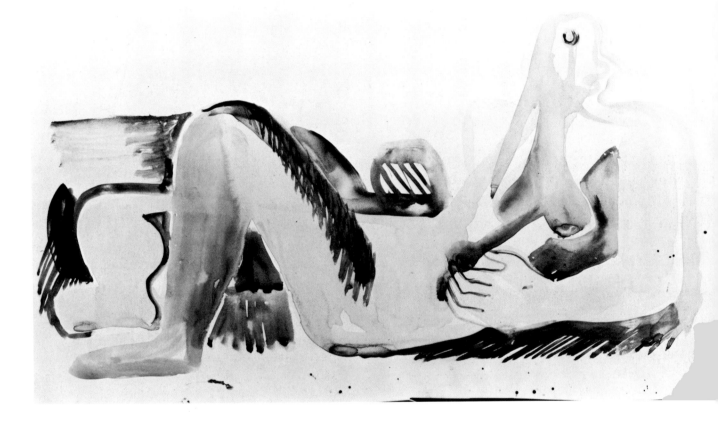

Whereas the naturalism of the three reclining figures on the recto of this sheet[1] is both in style and subject matter a continuation of the European tradition of the nude-bather theme – as exemplified in the work of Cézanne and Renoir, whom Moore greatly admires – this bold and powerful study echoes the pose and passive character of the *Chacmool* reclining figure from Chichén Itzá (fig. 95).

As in the Leeds and Ottawa carvings (fig. 93 and No. 124), Moore has created a variation on the pose of the Mexican sculpture. The position of the left arm, the ninety-degree angle formed by the bent elbow, and the opened hand are features found in the right arm of the Ottawa *Reclining Woman* of 1930 (No. 124). While the right leg is leaning away from the central axis of the figure, the left one is, as in the *Chacmool*, raised and brought in towards the body. When asked why the Mexican sculpture had made such an impact on him, Moore singled out the raised legs. What he admired, he said, was "its stillness and alertness, a sense of readiness – and the whole presence of it, and the legs coming down like columns."[2]

1. See Alan G. Wilkinson, *The Moore Collection in the Art Gallery of Ontario* (Toronto: Art Gallery of Ontario, 1979), No. 21, p. 36.
2. Henry Moore in conversation with the author.

123.
Henry Moore
Study for Leeds Reclining Figure 1928
Pencil (the figure has been cut out
and mounted on another sheet):
12.1 × 18.1 cm (mount size);
L. 14.5 cm (image)
Inscribed lower right: Moore 28
Art Gallery of Ontario. Gift of Henry
Moore, 1974

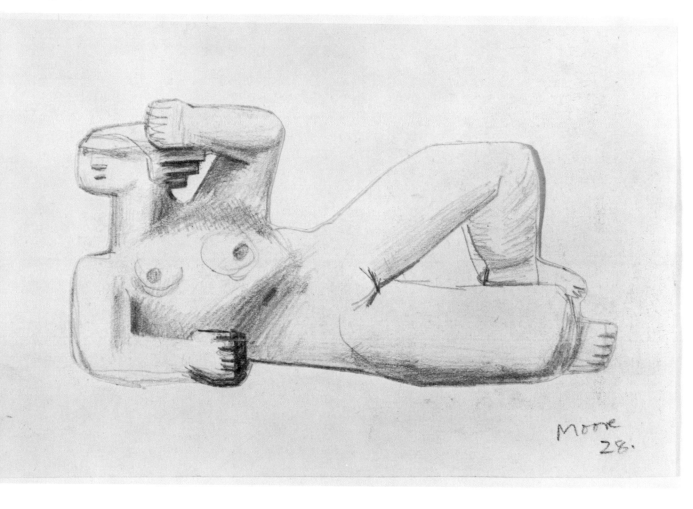

This is the definitive drawing for the brown Hornton stone *Reclining Figure* of 1929 in the Leeds City Art Gallery (fig. 93), the first carving to reflect the influence of the Pre-Columbian *Chacmool* (fig. 95). On the evidence of the two small studies of a reclining figure at the bottom of page 93 of *No. 2 Notebook* of 1922–24 (fig. 94), Moore's initial contact with the Mexican work was recorded in a drawing long before it found expression in sculpture. When shown the two sketches at bottom right in Figure 94 the artist remarked, "Here is the first bit of influence of the Mexican reclining figure. I might have seen a plaster cast of it in the Trocadéro."[1] He was probably referring to his first visit to Paris in 1922.

In the notes for *Ideas for West Wind Relief* of 1928 (No. 121), mention was made of the similarities between some of the studies and the *Chacmool* figure. In fact, the initial drawings related to the Leeds *Reclining Figure* developed from a series of studies for a garden relief, which appear towards the end of *1928 Sketchbook for the Relief on the Underground Building*, and which are in turn a continuation of the *West Wind* pre-

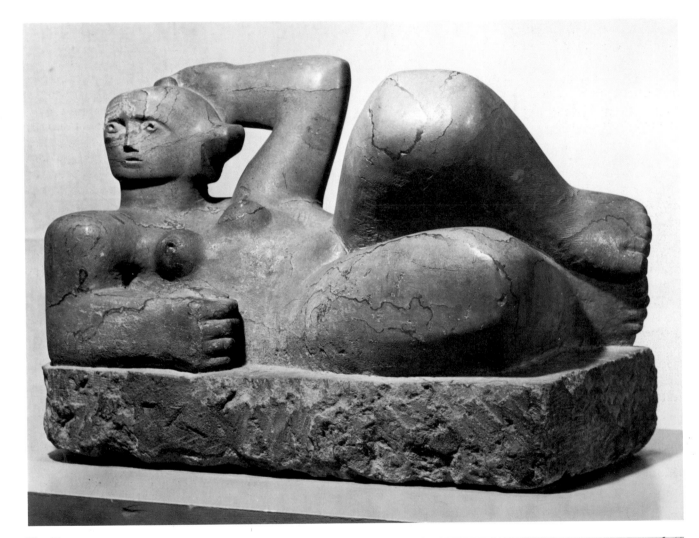

Fig. 93
Henry Moore
Reclining Figure 1929
Brown Hornton stone: L. 83.9 cm
Leeds City Art Galleries

paratory drawings. The Leeds
Reclining Figure and related draw-
ings are discussed in detail in the
author's exhibition catalogue, *The
Drawings of Henry Moore* (The Tate
Gallery and Art Gallery of Ontario,
1977), No. 80. (See also *Reclining
Woman*, No. 124.)

1. Henry Moore in conversation with
the author.

Fig. 94
Henry Moore
Page 93 from No. 2 Notebook 1922–24
Pencil: 22.4 × 17.2 cm (detail)
The Henry Moore Foundation

124.
Henry Moore
Reclining Woman 1930
Green Hornton stone: L. 92.7 cm
National Gallery of Canada, Ottawa

Reclining Woman and the brown Hornton stone *Reclining Figure* of 1929 in the Leeds City Art Gallery (fig. 93) are so closely related in style that it is impossible to discuss one without frequent reference to the other. With some justification it may be asserted that these two stone carvings occupy a place in Moore's career similar in importance to that of *Les Demoiselles d'Avignon* (fig. 28) in the *oeuvre* of Picasso.

The abrupt changes in style represented by these works, marking new departures for both artists, owe a great deal to primitive sources: *Les Demoiselles* to Iberian stone heads and African masks from the Ivory Coast and the French Congo, the Moore carvings to the eleventh- and twelfth-century Toltec-Maya *Chacmool* from Chichén Itzá (fig. 95). The stone figure of a Mexican rain spirit was, Moore said recently, "undoubtedly the one sculpture which most influenced my early work."[1] The Leeds and Ottawa reclining figures of 1929 and 1930 mark the culmination of Moore's Mexican period, which by 1931 was superseded by the influences of Picasso, Arp, and Giacometti.

The accounts of when and where Moore first became aware of the *Chacmool* vary considerably, and are discussed in some detail in the author's article on the 1930 *Reclining Woman* in the National Gallery of Canada *Annual Bulletin*, 1979. Moore told David Sylvester that he saw an illustration of the *Chacmool* in Walter Lehmann's *Altmexikanische Kunstgeschichte* (Berlin, 1922) in Zwemmer's bookshop, probably around 1927.[2] Herbert Read dated Moore's initial contact with the Toltec-Maya figure to a visit to Paris in 1925, but concludes that "it was four years before the 'shock of recognition' that had been experienced in the Trocadéro found complete expression in the *Reclining Figure* of 1929."[3] The earliest visual evidence of the *Chacmool*'s influence is found in the two small studies of reclining figures at the bottom of p. 93 from *No. 2 Notebook* of about 1922–24 (fig. 94). These the artist described as "the first bit of influence of the Mexican reclining figure. I might have seen a plaster cast of it in the Trocadéro."[4] Other sketchbook drawings, such as the three studies of reclining figures on p. 39 from *No. 3 Notebook* of about 1922–24, strongly support the thesis that the memory of *Chacmool* surfaced again and again in the drawings.

It was not until 1928, in the numerous studies for the *West Wind* relief carving (see No. 121), from which the definitive study for the Leeds *Reclining Figure* evolved (see No. 123), that the full impact of the *Chacmool* was manifest. In many ways the Ottawa *Reclining Woman* is closer to the Mexican prototype than the Leeds carving, so close as to be, in David Sylvester's words, "almost a paraphrase of it."[5] But in contrast to the symmetrical pose of the *Chacmool*, Moore has made his sculpture asymmetrical in almost every respect. The legs of the *Chacmool*, raised and drawn in towards the body with the knees at the same height, are parallel and perpendicular. In the Ottawa carving, the legs are not parallel, and the right one is closer to the head and breasts than the left one. The head and torso are twisted around to the right, creating almost parallel diagonals of shoulders, breasts, and knees. Whereas the head of the *Chacmool* is turned at right angles to the line of the body, the head in *Reclining Woman* is turned around even farther, so that she looks over her right shoulder with a sense of both anxiety and watchfulness. With the two protuberances of hair at the back, the head, though less mask-like than that of the Leeds carving, is related to it and to a number of masks of the late 1920s, such as the cast concrete *Mask* of 1929 (Private Collection). Unlike the Leeds *Reclining Figure*, there is no known definitive drawing for the Ottawa carving, although earlier studies, such as the monumental *Two Recumbent Nudes* of about 1928–29 (fig. 96), clearly anticipate certain features of the 1930 *Reclining Woman*.

During the 1920s and thirties Moore, like Brancusi, Epstein, Modigliani, and Gaudier-Brzeska, had what he described as an almost fanatical belief in the "truth to materials" doctrine. He also believed that a sculptor should make use of the various stones indigenous to his own country, and went to a quarry at Edgehill, Oxfordshire, to choose the Hornton stone for the Leeds and Ottawa carvings. Running through the brown Hornton stone of the 1929 Leeds *Reclining Figure* are small veins of pure iron ore, which are clearly visible in the legs (fig. 93). He found it difficult to carve across the veins, and when he came to select the material for the 1930 *Reclining Woman*, he selected green Hornton stone, which has less iron in it. He described to the author the special appeal of this material:

What I liked about Hornton stone is that when a carving is finished, it does not look like new, as if it were made yesterday. Marble is so clean and pure it always looks like new. I didn't want one's sculpture to look as if it had just been made yesterday.[6]

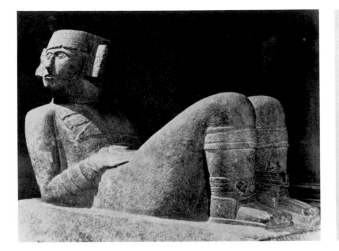

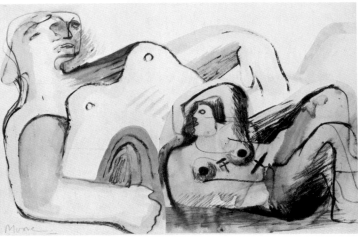

Fig. 95
Toltec-Maya (Mexico)
Chacmool 11–12th century, AD
Stone
Museo Nacional de Antropologia,
Mexico City

Fig. 96
Henry Moore
Two Recumbent Nudes c. 1928–29
Charcoal, wash: 22.8 × 35.5 cm
Dr. and Mrs. Henry M. Roland

One of Moore's greatest contributions to the language of twentieth-century sculpture has been the use of the human figure as a metaphor for landscape. His interest in relating his sculpture to landscape elements was, by 1930, apparent in both his writing and carvings. No doubt echoing Gaudier-Brzeska's dictum, "SCULPTURAL energy is the mountain,"[7] Moore wrote in 1930 that the sculpture that moves him most "is static and it is strong and vital, giving out something of the energy and power of great mountains."[8] When R.H. Wilenski illustrated the Ottawa *Reclining Woman* in *The Meaning of Modern Sculpture* (London, 1932), it was called *Mountains*, a title suggested by the artist. Particularly when viewed from the feet end, the dramatic rising thrust of the legs, the hollowed-out area between them, and the upward

pointing breasts evoke a landscape of valleys, plateaux, and mountains rising to a summit in the head.

Few works in this exhibition better illustrate such a direct and overwhelming influence of non-European art on a work of modern sculpture. In Moore's *oeuvre* it represents on one hand, the culmination of his Mexican period, and on the other it establishes the reclining female figure as a metaphor for landscape, a strong personal idiom with far-reaching possibilities. Now, as Moore said of the reclining figure theme: "The subject-matter is given. It's settled for you, and you know it and like it, so that within it, within the subject that you've done a dozen times before, you are free to invent a completely new form idea."[9] And for fifty years, in single and in two-, three-, and four-piece variations on this theme, it has remained so to this day.

1. Henry Moore in conversation with the author.

2. David Sylvester, *Henry Moore* (London: Arts Council of Great Britain, 1968), p. 156.

3. Herbert Read, *Henry Moore* (London: Thames and Hudson, 1965), p. 72.

4. Henry Moore in conversation with the author.

5. David Sylvester, *Henry Moore*, p. 6.

6. Henry Moore in conversation with the author.

7. Ezra Pound, *Gaudier-Brzeska* (New York: A New Directions Book, 1970), p. 37.

8. Philip James, ed. *Henry Moore on Sculpture* (London: Macdonald, 1966), p. 58.

9. John Russell, *Henry Moore* (Harmondsworth: Penguin Books, 1973), p. 48.

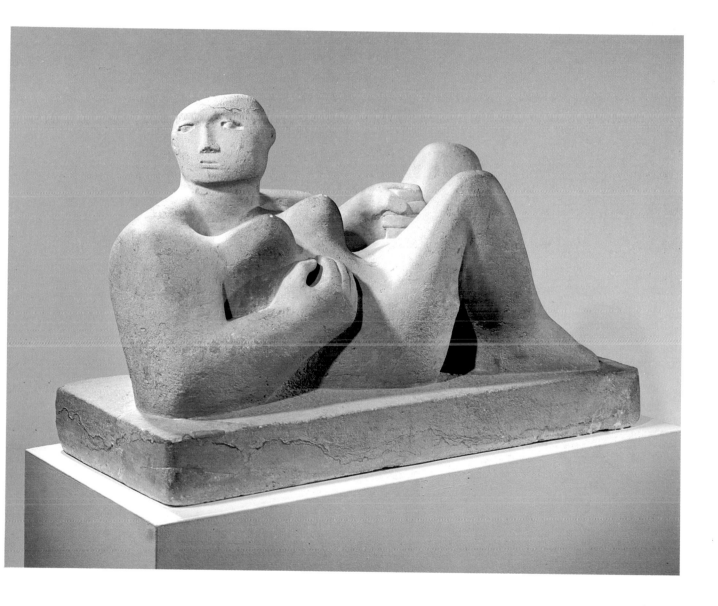

125.
Henry Moore
Seated Figure 1930
Alabaster: H. 47 cm
Art Gallery of Ontario. Purchase, 1976

This beautiful carving was made a
year before the blue Hornton stone
Composition of 1931 (Private Collec-
tion). Whereas the latter sculpture
heralds a radical and sudden trans-
formation in Moore's art, allying it to
the work of Picasso and to the
biomorphic forms of the Surrealists,
Seated Figure marks the culmination
of the previous decade, reflecting
some of the influences which
informed his work of this period.
The mask-like face and cubic bun of
hair are features found in the Leeds
and Ottawa reclining figures (fig. 93
and No. 124). The massive,
simplified feet are close to the
Ottawa carving, and may ultimately
derive from the *Chacmool* figure
(fig. 95).

The carving is rich in associations
with the art of the past. Moore
himself has compared *Seated Figure*
to a Cycladic sculpture that he
greatly admires, the *Lyre-Player*
(c. 2500 BC) in the National
Museum, Athens (fig. 97). Moore
pointed out to the author the
remarkable way in which in this
work the sculptor opened out the
stone, hollowed out certain areas,
completely freeing the chair and the
figure from the original block of
marble. Although *Seated Figure* is
more massive and solid than the
Cycladic musician, Moore has carved
through the alabaster in five areas:
between each arm and the body;
under the lower left arm and the
legs; and between each leg and the
block upon which the figure sits.

Fig. 97
Greece, Cycladic Islands
Lyre-Player 2300–2000 BC
Marble
National Museum, Athens

Fig. 98
Sumerian
Gudea, Ruler of the City State of Lagash
c. 2100 BC
Black diorite: H. 71.1 cm
British Museum, London

280

When one compares this sculpture with a work of the mid-1920s, such as the massive block-like Manchester *Mother and Child* of 1924–25, it is obvious that Moore was no longer intimidated by the material; nor, as he said in connection with some of his early work, was he "frightened to weaken the stone."[1]

Sumerian sculpture had greatly impressed Moore on his many visits to the British Museum, some of which, he wrote, has "a contained bull-like grandeur and held-in energy, very different from the liveliness of much of the early Greek and Etruscan art in the terracotta and vase rooms."[2] In *Seated Figure* and another carving of 1930, *Girl with Clasped Hands* (British Council, London), the clasped and cupped hands may well derive from the British Museum's Sumerian *Gudea, Ruler of the City State of Lagash* of about 2100 BC (fig. 98).

1. Henry Moore, *Henry Moore*, photographed an edited by John Hedgecoe, (London: Thomas Nelson, 1968), p. 45.

2. *Henry Moore on Sculpture*, edited with an introduction by Philip James (London: Macdonald, 1966), p. 157. p. 157.

126.
Henry Moore
Four-Piece Composition 1934
Bronze: L. 43 cm
Inscribed inside bottom of base:
Moore 1/9
Hirshhorn Museum and Sculpture
Garden (Smithsonian Institution)

Moore's series of two-, three-, and four-piece compositions of 1934 were to have far-reaching implications in the development of his art. Some are clearly composed of individual forms that, although organically related, are not dislocated parts of a single figure; others, like this one, represent dismembered elements of the human anatomy. Although in the 1930s Moore continued to draw inspiration from primitive and non-European sources, the most decisive influences were the work of Picasso, Arp, and Giacometti. The blue Hornton stone *Composition* of 1931–

with its probable debt to Picasso's sculpture, *Metamorphosis* of 1928 – marks the sudden and abrupt change in direction that allies this carving to the biomorphic abstractions current in the work of the Surrealists.

In discussing with Richard Morphet[1] The Tate Gallery's carving *Four-Piece Composition: Reclining Figure* (fig. 99), a work closely related to this one, Moore confirmed that the following were in some way influential and of special significance: Arp's *Bell and Navels* of 1931, Picasso's two pages from *An Anatomy* of 1933 and *Drawing: Project for a*

Monument of 1928, and Giacometti's *Woman with Her Throat Cut* of 1932 (No. 104) and his *Objets mobiles et muets* of 1931 (No. 103). While a work such as Moore's 1934 *Head and Ball* is closely allied to Arp's *Bell and Navels*, *Four-Piece Composition* (No. 126) is, with the angular, splayed limbs of the reclining figure, a direct descendant of Giacometti's ferocious *Woman with Her Throat Cut* (No. 104).

Moore told the author that the original *Four-Piece Composition* was made directly in concrete and later cast in a bronze edition. He wrote of

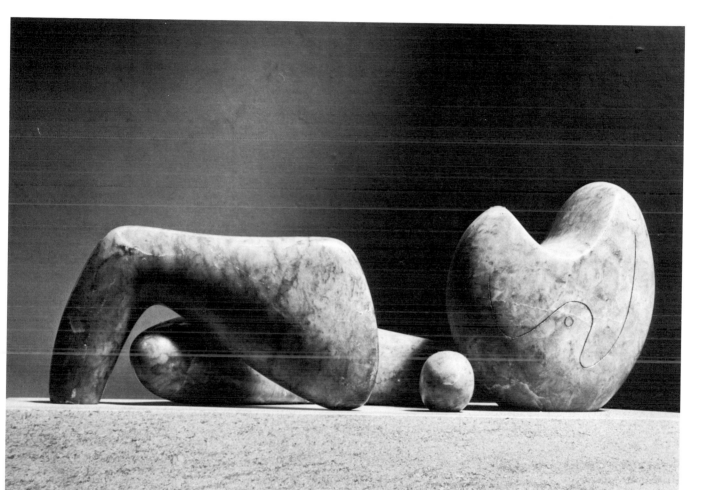

this work: "Although this sculpture looks abstract, it has organic elements. These are two separate forms – a head and a torso – but related with their base."[2] As in a number of multi-part compositions of 1934, including The Tate Gallery carving (fig. 99), the circular form is an umbilicus which, as Morphet has written, "was important to Moore as a symbol, for it represented the connection of our life with the other life."[3] Historically, *Four-Piece Composition* and the related carvings of 1934 are important not only in the context of Surrealism, but as the earliest examples in Moore's work using the divided-figure motif, a subject that has occupied him intermittently to this day.

Fig. 99
Henry Moore
Four-Piece Composition: Reclining Figure
1934
Cumberland alabaster: L. 45.7 cm
Tate Gallery, London

1. *The Tate Gallery 1976 – 8: Illustrated Catalogue of Acquisitions* (London: The Tate Gallery, 1979), p. 121.

2. Henry Moore, *Henry Moore*, photographed and edited by John Hedgecoe, (London: Thomas Nelson, 1968), p. 76.

3. *The Tate Gallery 1976 – 8*, p. 121.

127.
Henry Moore
Head 1937–68
Serpentine: H. 33.6 cm
The Henry Moore Foundation

Among the most cryptic sculptures of Moore's career are the series of heads and square form carvings of 1936–37. This one was based on the small original plaster *Maquette for Head* of 1937 in the Art Gallery of Ontario, a work that has never been cast in bronze. Several of these, including this carving, appear to have been inspired by *hachas* (the Spanish word for "axes") from the Gulf coast of Mexico and from Guatemala. As Manfred Schneckenburger has written:

> These hatchet-shaped, flat heads, which close together on the profile side like the blade of an axe, are not ceremonial axes. "Hachas" or "flat heads" (as it was suggested they might be more precisely called) are thought to have been used as part of the scenery for ritual ball games on the Gulf coast of Mexico and Guatemala. Their aesthetic value lies not only in their high degree of abstraction, but even more in the perfect combination of natural form and abstract art form."[1]

Fig. 100
Guatemala (from Itzapa)
Hacha (Axe-head) 7th to 9th Century AD
Stone
Private Collection

In Moore's *Head*, the thin axe-like form and the two holes are closely related to works like the stone *hacha* from Itzapa (Guatemala) (fig. 100). In the view of Moore's piece shown here, a face is clearly indicated on the left side of the sculpture, with a gaping mouth, an eye, and at the top the suggestion of a peaked helmet.

1. *World Cultures and Modern Art* (Munich: Haus der Kunst, 1972), p. 303.

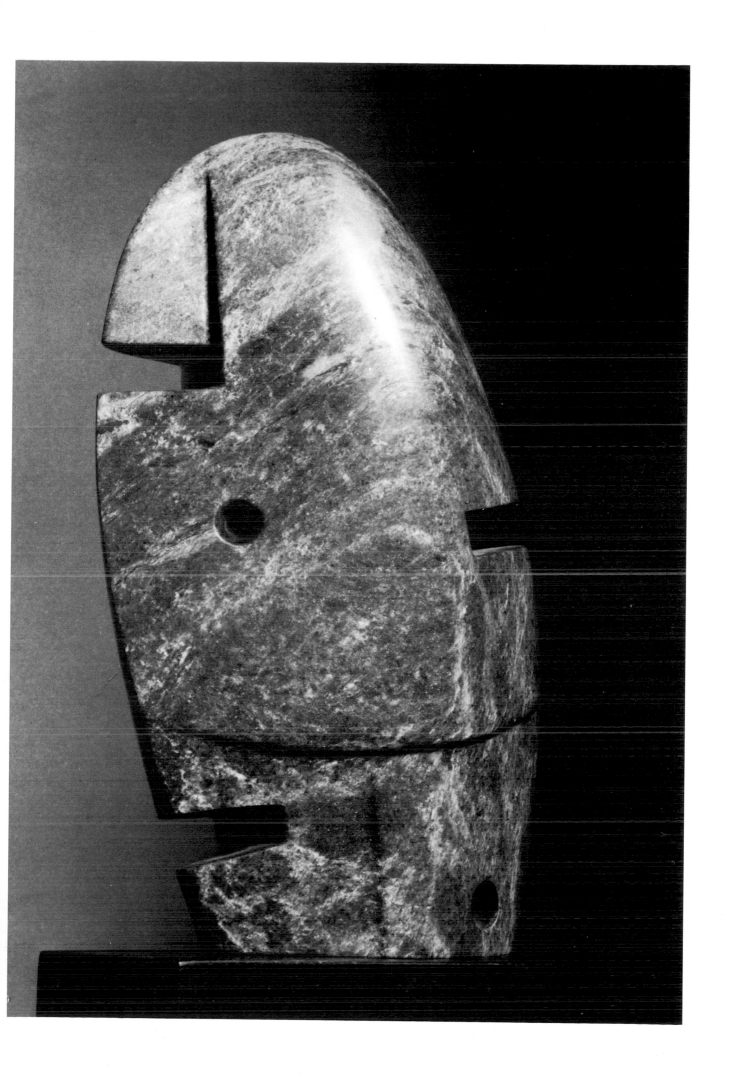

128.
Henry Moore
Bird Basket 1939
Lignum vitae wood and string:
L. 41.9 cm
Private Collection

In keeping with the Surrealists' interest in Oceanic art, which had influenced the work of Miró, Picasso, and Giacometti (No. 101) in the late 1920s and early thirties, a number of Moore's drawings and sculptures of the thirties were inspired by various tribal forms from the Pacific Islands. Although Oceanic sculpture had little if any direct influence on his work of the 1920s, as early as 1922–24 he had made copies on page 105 of *No. 3 Notebook* of, at centre right, a club with the head in the form of a bird; at lower right, what is probably a New Caledonian carving from the Solomon Islands; and at lower right, a wood carving in the British Museum of a human head from the Baga of French Guinea.[1] Moore's 1937 drawing of a work from New Ireland, Melanesia (fig. 114), was later adapted to form the rectangular relief of the lower half of the 1955 *Upright Motive: Maquette No. 1* (No. 135).

In his 1941 article on "Primitive Art," Moore described the unique character of Oceanic art:

> The many islands of the Oceanic groups all produced their schools of sculpture with big differences in form-vision. New Guinea carvings, with drawn out spider-like extensions and bird-beak elonga-tions, made a direct contrast with the featureless heads and plain surfaces of the Nukuoro carvings; or the solid stone figures of the Marquesas Islands against the emasculated ribbed figures of Easter Island. Comparing Oceanic art generally with Negro art, it has a livelier, thin flicker, but much of it is more two-dimensional and concerned with pattern making. Yet the carvings of New Ireland have, besides their vicious kind of vitality, a unique spatial sense, a bird-in-a-cage form.[2]

Fig. 101
Naum Gabo
Sketch for a Stone Carving 1933
Pencil and crayon: 16.5 × 15.2 cm
Tate Gallery, London

Certain of these descriptions could be taken out of context and applied to Giacometti's sculpture: "bird-beak elongations" to *The Nose* of 1947 (No. 107); 'bird-in-a-cage form" to his cage constructions of the early 1930s. And of course "bird-in-a-cage form" is descriptive of Moore's most beautiful stringed figure sculpture, the *Bird Basket*.

"Undoubtedly," Moore has said, "the source of my stringed figures was the Science Museum. Whilst a student at the R.C.A. I became involved in machine art, which in those days had its place in modern art."[3] He became particularly fas-cinated by the mathematical models in the Science Museum, which he described as

> hyperbolic paraboloids and groins and so on, developed by Lagrange in Paris, that have geometric figures at the ends with coloured threads from one to the other to show what the form between would be. I saw the sculptural possibilities of them and did some. I could have done hundreds.[4]

Moore was almost certainly aware of the work of the Constructivist sculptor Naum Gabo, who had moved to London in 1935. Gabo's stringed-figure drawings and con-structions pre-date Moore's use of string, as seen, for example, in Gabo's 1933 *Sketch for a Stone Carving* in The Tate Gallery (fig. 101), and may well have influenced the work of both Moore and Hep-worth in the late 1930s. The actual shape of *Bird Basket* is remarkably similar to friction gongs (*livika*) from New Ireland.

Moore has explained the sculpture as follows:

> It has got an organic form to it although the strings are abstract straight lines. The carving is in lignum vitae wood and at one end is the head and the other end the tail. When I was working on it, I used to pick it up like a basket by the loop over the top. So the two words "Bird" and "Basket" are significant because they were arrived at in a practical way.[5]

1. See Alan G. Wilkinson, *The Draw-ings of Henry Moore* (London: The Tate Gallery with the Art Gallery of Ontario, 1977), Catalogue No. 63, illustrated, p. 68.

2. Henry Moore, *Henry Moore on Sculpture*, edited and with an intro-duction by Philip James (London: Macdonald, 1966), p. 159.

3. Henry Moore, *Henry Moore*, photo-graphed and edited by John Hedge-coe (London: Thomas Nelson, 1968), p. 105.

4. Henry Moore, *Henry Moore on Sculpture*, p. 209.

5. Henry Moore, *Henry Moore*, p. 109.

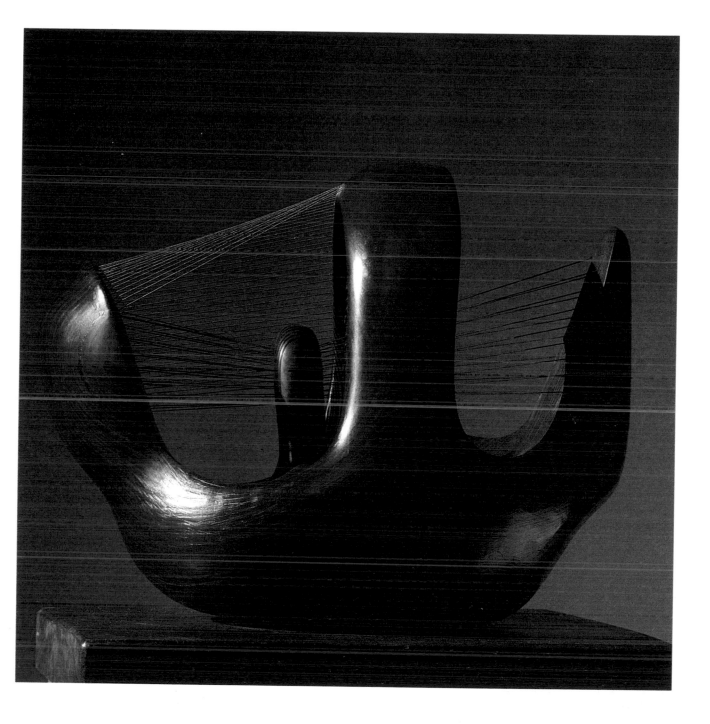

129.
Henry Moore
The Helmet 1939–40
Bronze: H. 29.2 cm
The Henry Moore Foundation

When, in 1930, Moore wrote of the need to remove "the Greek spectacles from the eyes of the modern sculptor,"[1] he was referring to the Classical period of Greek sculpture that matured in the fifth century BC.

Sketches in his early notebooks of the 1920s and a carving such as the 1930 alabaster *Seated Figure* (No. 125) clearly indicated his interest in pre-Classical Greek art. On page 131 of *Notebook No. 3* of 1922–24 is a drawing of a Cycladic *Lyre-Playing Idol* (c. 2500 BC) in the National Museum, Athens.

At the top of *Page from Sketchbook* of c. 1937 (fig. 102), the two helmet-like objects were copies from plates 4 and 5 in Christian Zervos' *L'Art en Grèce des temps préhistoriques au debout du XVIII siècle* (*Cahiers d'Art*, 1934); the plates illustrate two prehistoric utensils or implements whose use or function is not known (fig. 103). Two years later Moore began work on *The Helmet*, the first of a series of internal/external-form helmets that have occupied him intermittently to this day. The hollowed-out shape with two circular holes at the back may very well have been inspired by the prehistoric Greek implements.

1. Henry Moore, *Henry Moore on Sculpture*, edited with an introduction by Philip James (London: Macdonald 1966), p. 57.

Fig. 102
Henry Moore
Page from Sketchbook c. 1937
Pencil, pen and ink: 27.0 × 18.4 cm
Private Collection

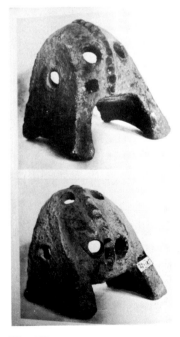

Fig. 103
Prehistoric Greece
Two Implements
Bronze
National Museum, Athens

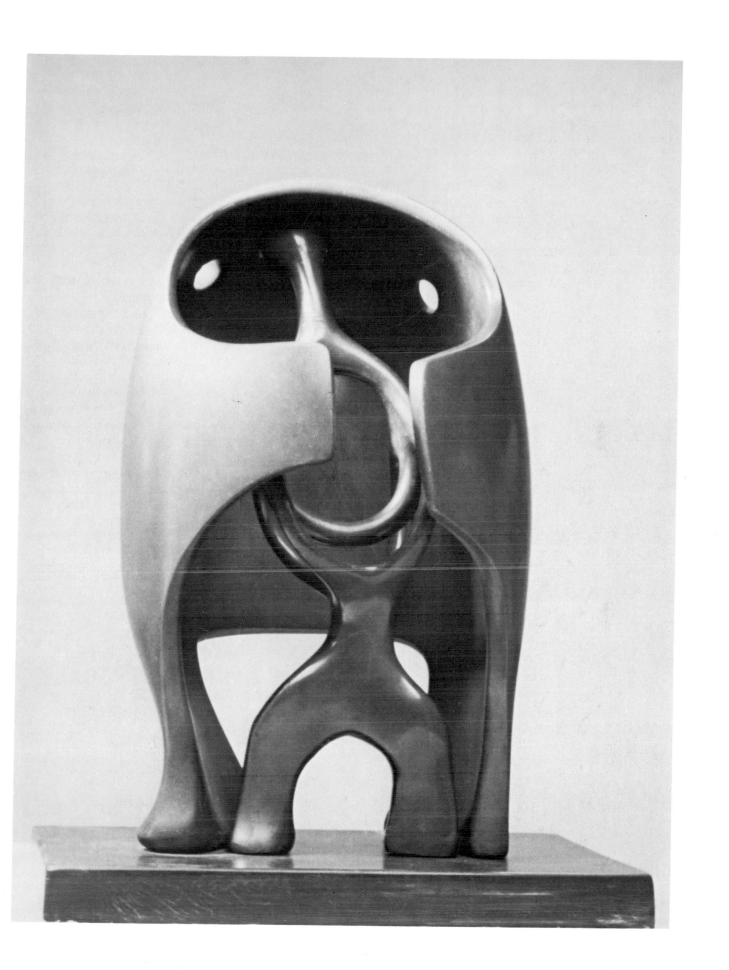

130.
Henry Moore
Crowd Looking at a Tied-up Object
1966
Etching: 34.9 × 49.5 cm
Inscribed lower left: Artist's Proof;
signed lower right: Moore
Art Gallery of Ontario. Gift of Henry
Moore, 1974

This etching is based on one of
Moore's best known pictorial draw-
ings, the 1942 *Crowd Looking at a
Tied-up Object*, in the collection of
Lord Clark (fig. 105). With its
Surrealistic overtures, the drawing
falls chronologically midway
between Man Ray's 1920 *The Enigma
of Isidore Ducasse* (cloth and rope
over a sewing machine and no longer
extant) and Christo's *Lower Manhat-
tan Packed Buildings* of 1964–66
(Private Collection; collage of photo-
graphs and pasted paper). The artist
said that the idea of a tied-up object
may have been suggested by an
occurrence commonplace in many
sculptors' studios.[1] As a student in
the modelling class at the Royal
College of Art, Moore remembers
having kept clay moist by covering it
with a damp cloth and tying string
around it.

The exact source for the drawing
was not a work of primitive art, but a
tribal ritual that appears in a
photograph in Leo Frobenius' book
Kulturgeschichte Afrikas (1933),
showing a group of Nupe tribesmen
from northern Nigeria standing
around two veiled (but not tied up)
Dako-cult dance costumes (fig. 104).
Moore must have bought his copy of
the book soon after it was published,
for one of his earliest pictorial
compositions, the 1936 *Figures in a
Cave*, was also based on a photo-
graph in Frobenius, showing a cave
in southern Rhodesia.

1. In conversation with the author.

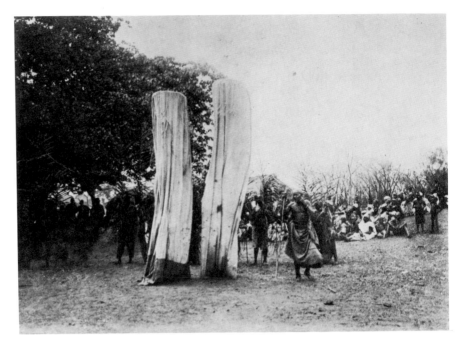

Fig. 104
Northern Nigeria
*Nupe Tribesmen Standing around Two
Veiled Dako Dance Costumes*
(Photograph from Leo Frobenius, *Kul-
turgeschichte Afrikas*, 1933)

Fig. 105
Henry Moore
Crowd Looking at a Tied-up Object 1942
Pencil, black and coloured chalks, wax
crayon: 40.0 × 55.0 cm
Lord Clark

Artists Proof Moore

131.
Henry Moore
Mother and Child 1953
Original plaster: H. 52.0 cm
Art Gallery of Ontario. Gift of Henry
Moore, 1974

Mother and Child is one of the most extraordinary transformations from a source in primitive art in twentieth-century sculpture. For Erich Neumann, this sculpture represents "perhaps the most negative expression of the mother-and-child idea in the whole of Moore's work."[1] Herbert Read has speculated:

> This group is so close an illustration of the psycho-analytical theories of Melanie Klein that it might seem the sculptor had some first-hand acquaintance with them; but the artist assures me that this is not so. It may be that, in Neumann's words, "it is a picture of the Terrible Mother, of the primal relationship fixed forever in its negative aspect," but if so, it is a picture that comes from the artist's unconscious: it has no direct connections with any psycho-analytical theory."[2]

The preparatory sketch for this sculpture, at lower left in *Page 146 from Sketchbook 1950–51: Studies for Seated Figures* of 1951 (fig. 106), which was followed by *Maquette for Mother and Child* in 1952, derived neither from the psycho-analytical theories of Klein nor from the artist's unconscious. The idea was based on the low relief on a Peruvian pot (fig. 107), which was illustrated in Ernst Fuhrmann's *Peru II* (1922), a copy of which the artist owns. The exact identity and significance of the forms in the Peruvian work are unclear. At left is a man with the head of a bird, and on the right a fish with an enormous mouth and a face like a crescent moon. The bird-man holds with both hands a long neck with a bird-like head, which the fish is about to devour. Moore has transformed this complex image into a seated mother and child. The snake form with the head of a bird becomes the child with gaping mouth, straining to reach the single breast of the mother. The serrated head of the mother, her breast and the outstretched arm derive from the teeth, tongue, and arm, of the fish form.

This negative and disturbing expression of the mother-and-child relationship is unlike anything else in Moore's entire *oeuvre*. The beak-like mouth of the child struggles to devour rather than feed at the breast, but is held back by the outstretched arm of the mother, whose hand appears to be strangling the extremely long neck of the child. Moore's obsession with the mother-and-child theme is nowhere better illustrated than in the amazing metamorphosis of the Peruvian work. It brings to mind the artist's remark about the theme: "that I was conditioned, as it were, to see it in everything."[3]

1. Erich Neumann, *The Archetypal World of Henry Moore*, translated from the German by R.F.C. Hull (New York: Harper and Row, 1959), p. 174.

2. Herbert Read, *Henry Moore* (London: Thames and Hudson, 1965), p. 176.

3. Henry Moore, *Henry Moore*, photographed and edited by John Hedgecoe (London: Thomas Nelson, 1968), p. 61.

Fig. 106
Henry Moore
Page 146 from Sketchbook 1950–51:
Studies for Seated Figures 1951
28.5 × 23.0 cm
Kunsthaus, Zürich

Fig. 107
Chimu (Peru)
Black War Pot c. 800–1300 AD
Naturhistorisches Museum, Vienna

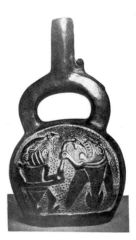

292

132.
Henry Moore
Time-Life Screen: Working Model
1952
Original plaster: 38.5 × 101.0 cm
Art Gallery of Ontario. Gift of Henry
Moore, 1974

While he was working on the 1952–53 *Draped Reclining Figure* for the terrace of the Time-Life building at the corner of Bond and Bruton Streets in London, the architects approached Moore about the possibility of a carved screen for the Bond Street end of the terrace (fig. 108), and he welcomed the opportunity to work simultaneously on two such entirely different projects.

It seems to me that the *Screen* should look as though it was part of the architecture, for it is a continuation of the surface of the building – and an obvious part of the building.

The fact that it is only a screen with space behind it led me to carve it with a back as well as a front, and to pierce it, which gives an interesting penetration of light,

Fig. 109
Chimu (Peru)
Two Small Masques of Jaguars 12th–13th Century AD
Gold: H. 4.1 cm
Museum für Völkerkunde, Hamburg

and also from Bond Street makes it obvious that it is a screen and not a solid part of the building.[1]

Moore made four preparatory maquettes, and decided *Time-Life Screen: Maquette No. 4* of 1952 "was better and more varied and so this became the definitive maquette, although a further working model [No. 132] produced other changes."[2] In the working model (both in this original plaster and in the bronze edition), each of the four forms is fixed at top and bottom with pins, so they can be turned independently within the fixed framework of the screen itself. Moore had hoped that a turntable could be fixed to each of the Portland stone carvings so that each month they could be turned at various angles. This proved impractical, because each carving weighs four or five tons; it was thought that having them hinged and turned could be dangerous to the pedestrians in the street below.

In this working model the four forms are less organic than those in

Fig. 108
Henry Moore
Time-Life Screen 1952–53
Portland stone: H. 304.8 × 807.7 cm
Time-Life Building, London

the first three maquettes. Their square forms, with the suggestion of semi-abstract heads and particularly the circular holes through two of the four sections, recall the heads and square-form carvings of 1936–37, such as the serpentine *Head* (No. 127). Moore's 1952 *Maquette for Mother and Child* (see No. 131) incorporates Peruvian imagery; in the same year, in the *Time-Life Screen: Maquette No. 4* (upon which this model was based) he may also have drawn inspiration from other Peruvian works, two small gold jaguar masks from the twelfth- to thirteenth-century Chimu civilization (fig. 109), which are very close indeed to the top half of the forms at each end of the screen.[3]

1. Henry Moore, *Henry Moore on Sculpture*, edited with an introduction by Philip James (London: Macdonald, 1966), pp. 231 and 235.

2. *Ibid*, p. 235.

3. These two masks are illustrated in Heinrich Ubbelohde-Doering's *L'Art du vieux Péru* (Paris: A. Marancé, 1952).

133.
Henry Moore
Maquette for King and Queen 1952
Bronze: H. 26.7 cm
Mr. Gustav Kahnweiler

About *King and Queen* Moore commented:

> Perhaps the "clue" to the group is the King's head, which is a combination of a crown, beard, and face symbolizing a mixture of primitive kingship and a kind of animal, Pan-like quality. The King is more relaxed and assured in pose than the Queen, who is more upright and consciously queenly.

Fig. 110
Henry Moore
Head 1930
Ironstone: H. c.20 cm
Private Collection

Fig. 111
Ibo (Eastern Nigeria)
Dance Headdress
Wood: H. 83.5 cm
Nigerian Museum

> When I came to do the hands and feet of the figures they gave me a chance to express my ideas further by making them more realistic – to bring out the contrast between human grace and the concept of power in primitive kingship.[1]

In fact, the initial idea for the sculpture began with Moore modelling directly in wax. "Whilst manipulating a piece of this wax, it began to look like a horned, Pan-like, bearded head. Then it grew a crown and I recognized it immediately as the head of a king. I continued, and gave it a body."[2] As early as 1930 in the small ironstone *Head* (fig. 110), Moore carved a single hole through the form to represent an eye. In 1951 Moore visited in London with William Fagg the exhibition *Traditional Art from the Colonies*, held during the Festival of Britain. In looking at the Bende Ibo headdress from the Nigerian Museum (fig. 111), Fagg has written that Moore was greatly interested

> to see how the Ibo artist had used this method of opening up the human head. This seems to have led him to re-explore his own idea of 1930, and it appeared not only

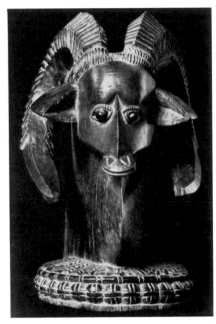

Fig. 112
Yoruba (Nigeria)
Ram's Head
Wood: H. 49.5 cm
Private Collection

in the *King and Queen* of 1952 but in many of his major works through the 1950s.[3]

The horned head of the King, which Moore mentions in the passage quoted above, may, according to Fagg, be related to a Yoruba ram's head (fig. 112).

Whereas the heads of the king and queen derive from African art, the hieratic pose of the figures, the positioning of the arms and legs, and the simplified use of drapery are distinctly reminiscent of the Eighteenth-Dynasty Egyptian *Dyad of Man and Wife*, in the British Museum (fig. 113).

Fig. 113
Egypt, Eighteenth Dynasty
Dyad of Man and Wife c. 1350 BC
Limestone
British Museum, London

1. *Henry Moore on Sculpture*, edited with an introduction by Philip James (London: Macdonald, 1966), p. 246.

2. Henry Moore, *Henry Moore*, photographed and edited by John Hedgecoe (London: Thomas Nelson, 1968), p. 221.

3. William Fagg and Margaret Plass, *African Sculpture: An Anthology* (London: Studio Vista Ltd., 1964), p. 30.

134.
Henry Moore
Warrior with Shield 1953–54
Bronze: H. 152.5 cm
Art Gallery of Ontario. Gift from the
Junior Women's Committee Fund,
1955

Like the *Maquette for King and
Queen* of 1952 (No. 133), the *Warrior
with Shield* presents stylistic dis-
parities between the naturalism of
the body and the severe axe-like
head. The point of departure for this
sculpture, Moore has written,

> evolved from a pebble I found on
> the seashore in the summer of
> 1952, and which reminded me of
> the stump of a leg, amputated at
> the hip. Just as Leonardo says
> somewhere in his notebooks that a
> painter can find a battle scene in
> the lichen marks on a wall, so this
> [pebble] gave me the start for *The
> Warrior* idea. First I added the
> body, leg and one arm and it
> became a wounded warrior, but at
> first the figure was reclining. A
> day or two later, I added a shield
> and altered its position and
> arrangement into a seated figure
> and so it changed from an inactive
> pose into a figure which, though
> wounded, is still defiant.[1]

Whereas in the *King and Queen* there
is a single hole through each head,
here there is a hole through each of
the thin axe-like forms, which
suggest mutilation suffered in battle.
And, like the earlier of the two

works, the holes may have been
suggested by the Nigerian Bende Ibo
headdress (fig. 111), which Moore
had admired in the 1951 exhibition,
Traditional Art from the Colonies.

1. Henry Moore, *Henry Moore on
Sculpture*, edited with an introduc-
tion by Philip James (London:
Macdonald, 1966), p. 250.

135.
Henry Moore
Upright Motive: Maquette No. 1 1955
Original plaster: H. 31.4 cm
Art Gallery of Ontario. Gift of Henry
Moore, 1974

This work is the definitive study for the large *Glenkiln Cross* of 1955–56, named after Sir William Keswick's Glenkiln Farm in Dumfrieshire, Scotland. There the first cast was placed on a hillside, not far from a cast of the *King and Queen* (see No. 133). Understandably, a number of writers on Moore's art see this work as one of his greatest achievements, which must rank, with Lipchitz's bronze *Figure* of 1926–30 (No. 97), as one of the most powerful totemic images produced in this century.

Although it is tempting to compare Moore's series of thirteen upright-motive maquettes of 1955, of which five were enlarged, to Northwest-Coast Indian totem poles, there is no direct stylistic connection between them. This maquette is made up of three distinct units. At the top of the upper section the small orifice, a feature found in a number of carvings of the 1930s, is suggestive of a mouth of some primeval creature. The compressed and eroded shoulders and truncated arms give the sculpture the appearance of a crucifix. This part of the sculpture

was almost certainly based on a flint stone. Below this is the middle section, the smooth, bone-like form of the torso, upon which the head and arms balance and are joined not precariously but with an organic inevitability. The swelling knob at the bottom resembles waist and hips. Moore has described the third section, with its rectangular front, as "the column and on it are little bits of drawing which don't matter sculpturally, which represent a ladder and a few things connecting it with the Crucifixion."[1]

Fig. 114
Henry Moore
Inside Back Cover of Sketchbook B 1935
Pencil: 21.5 × 14 cm
The Henry Moore Foundation

Fig. 115
Henry Moore
Page from Sketchbook 1935 and 1942
Chalk and watercolour: 26 × 17.8 cm
The Henry Moore Foundation

300

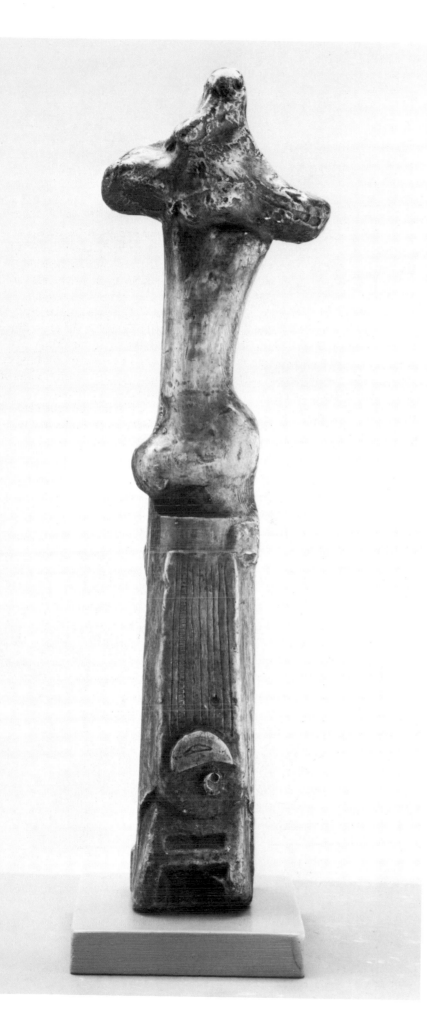

Indeed, the relief at the front of the sculpture was based on several of Moore's own drawings of an as yet unidentified Oceanic work from New Ireland, possibly, as William Fagg suggested to the author, a *kepong* (head), or part of a panel from a Malanggan house. The earliest of these appears at left in the *Inside Back Cover of Sketchbook B* of 1935, with the inscription "New Ireland" at upper left (fig. 114). In a more finished drawing, *Page from Sketchbook*, 1935 and 1942 (fig. 115), the object from New Ireland forms the body of a bird in this study of lyre birds made for a cover design for the magazine *Poetry London*. In the *Glenkiln Cross* the rectangular front was based on the study at left in Figure 115.

The fact that Moore translated one of the herringbone designs in the 1935–42 drawing into a single ladder, incised in the plaster in this maquette, suggests that he may have been consciously, as he said, connecting the work with the crucifixion. In the drawing the crescent shape, and below this what becomes the eye of the bird are, in the sculpture, built up in low relief.

At The Tate Gallery, London, the Kröller-Muller Museum, Otterlo, and the Amon Carter Museum of Western Art, Fort Worth, casts of the large *Upright Motives Nos. 1, 2* and 7 are grouped together, with the *Glenkiln Cross* in the centre. In Moore's mind, they "assumed the aspect of a Crucifixion scene, as though framed against the sky above Golgotha. But I do not especially expect others to find this symbolism in the group."[2]

1. "Henry Moore looking at his work with Philip James," sound and film strip unit. Sound editor John Gorke. Two 12-inch, double-sided 33⅓ rpm records. Visual Publications, London.

2. Henry Moore, *Henry Moore on Sculpture*, edited with an introduction by Philip James (London: Macdonald, 1966), p. 257.

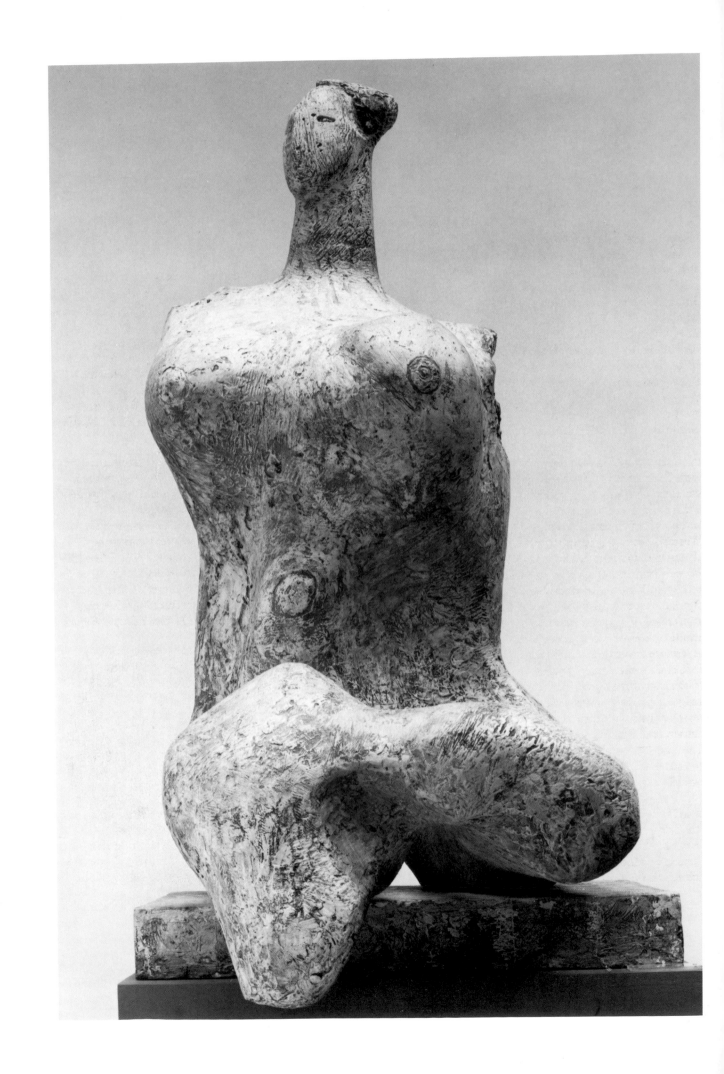

136.
Henry Moore
Woman 1957–58
Original plaster: H. 149.9 cm
Art Gallery of Ontario, Gift of Henry
Moore, 1973

137.
Henry Moore
Moon Head 1964
Original plaster: H. 47 cm
Art Gallery of Ontario, Gift of Henry
Moore, 1974

Woman is a mid-twentieth-century descendant of some of the earliest works of art in the world – the prehistoric sculptures of fertility goddesses. Moore's interest in prehistoric art dates from his frequent visits to the British Museum in the 1920s, where he studied, in the Stone Age Room, originals and casts of Paleolithic sculpture made some 20,000 years ago. On page 74 of *No. 6 Notebook* of 1926 (fig. 116) he made drawings of the well-known Paleolithic *Venus of Grimaldi*.

Almost all Moore's figurative sculpture is based on the female form. Early in his career he often associated the female figure with fertility and in fact wrote in a sketchbook of the mid-1920s: "Woman – fecundity fertility." Of this sculpture Moore has written, "*Woman* emphasises fertility like the Paleolithic Venuses in which the roundness and fullness of form is exaggerated."[1] Like the *Venus of Grimaldi*, *Woman* has no arms, and the legs are truncated at the knees. Moore has concentrated on the central part of the figure, emphasizing the gigantic proportions of the breasts and the swollen belly, images of birth, fertility, and nourishment. "The smallness of the head," Moore has explained, "is necessary to emphasise the massiveness of the body. If the head had been any larger it would have ruined the whole idea of the sculpture."[2]

Asymmetry, one of the fundamental tenets of Moore's art, is in evidence throughout the figure. The

Fig. 116
Henry Moore
Page 74 from No. 6 Notebook 1926
Pencil: 22.2 × 17.2 cm
The Henry Moore Foundation

small but alert head is turned to the right; the left breast is larger and projects farther forward than the right one; the belly is to the right of centre; the right leg overhangs the base. No two viewpoints are alike. Moving around the figure, one experiences the irregular swelling forms of one of the most potent images of fertility produced in the twentieth century.

1. Henry Moore, *Henry Moore*, photographed and edited by John Hedgecoe (London: Thomas Nelson, 1968), p. 326.

2. *Ibid*, p. 326.

The small version of this piece was originally called "Head in Hand", the hand being the piece at the back. When I came to make it full size, about eighteen inches high, I gave it a pale golden patina so that each piece reflected a strange, almost ghostly, light at the other. This happened quite by accident. It was because the whole effect reminded me so strongly of the light and shape of the full moon that I have since called it "Moon Head."[1]

The thin, knife-like forms are reminiscent of the 1937–68 serpentine *Head* (No. 127) which was inspired by *hachas* from Mexico and Guatemala, and of Giacometti's bronze and marble versions of *Observing Heads* of 1928. The admiration of both artists for Cycladic sculpture is reflected in their early work, in Giacometti's *Observing Heads* and in Moore's *Seated Figure*

Fig. 117
Mama (Northern Nigeria)
Mask of a Buffalo
Wood: H. 49.5 cm
Nigerian Museum, Lagos

of 1930 (No. 125). Both had made copies of Cycladic art in their sketchbooks. Although it is tempting to see a connection between *Moon Head* and Cycladic sculpture, the precise source for the hand-shaped form was, in fact, as William Fagg explained to the author, a Mama mask of a buffalo from Nigeria (fig. 117), which is illustrated (Plate 137) in Fagg's *Nigerian Images* (1963). According to Mr. Fagg, Henry Moore's friend and dealer, the late Harry Fischer, gave Moore a copy of this book soon after it was published. Moore has transformed the perfectly symmetrical crescent-shaped mask into an abstracted asymmetrical hand.

1. Henry Moore, *Henry Moore*, photographed and edited by John Hedgecoe (London: Thomas Nelson, 1968), p. 466.